A Generous Vision

OXFORD CULTURAL BIOGRAPHIES

Series Editor
Gary Giddins

Cathy Curtis
A Generous Vision:
The Creative Life of Elaine de Kooning

A Generous Vision

The Creative Life of Elaine de Kooning

CATHY CURTIS

OXFORD
UNIVERSITY PRESS

OXFORD
UNIVERSITY PRESS

Oxford University Press is a department of the University of Oxford.
It furthers the University's objective of excellence in research, scholarship,
and education by publishing worldwide. Oxford is a registered trade mark of
Oxford University Press in the UK and certain other countries.

Published in the United States of America by Oxford University Press
198 Madison Avenue, New York, NY 10016, United States of America.

Library of Congress Cataloging-in-Publication Data
Names: Curtis, Cathy (Writer on art), author.
Title: A generous vision : the creative life of Elaine de Kooning / Cathy Curtis.
Description: New York : Oxford University Press, 2017. | Series: Oxford
cultural biographies | Includes bibliographical references and index.
Identifiers: LCCN 2017016260 | ISBN 9780190498474 (cloth : alk. paper) |
ISBN 9780190498504 (oxford scholarship online)
Subjects: LCSH: De Kooning, Elaine. | Painters—United States—Biography. |
Women painters—United States—Biography.
Classification: LCC ND237.D3339 C87 2017 | DDC 759.13 [B]–dc23
LC record available at https://lccn.loc.gov/2017016260

9 8 7 6 5 4 3 2 1
Printed by Sheridan Books, Inc., United States of America

To Svetlana Alpers, professor emerita, University of California, Berkeley, who introduced me to close looking and independent thinking

Contents

Foreword

ONE NEED NOT be a lawyer, only a veteran of courtroom TV shows, to know that nothing rouses a jurist to bellow "Objection!" like an attempt by opposing counsel to indulge in hearsay testimony. Yet hearsay provides the primary texture of way too many biographies, where uncorroborated, unsourced scuttlebutt is casually asserted as fact to fill in blanks or enliven a narrative. Cathy Curtis is, of course, not that kind of biographer, and her *A Generous Vision: The Creative Life of Elaine de Kooning* is admirable not least in its refusal to pass off a good yarn as history or adjudicate conflicting accounts with Voice of God certainty. Interviews are habitually freighted with hearsay, but in weighing, balancing, and pinpointing her choir of sources, Curtis earns and keeps the reader's trust. As the first biographer of an artist long relegated to the category of great man's wife, she has a unique perspective from which to traverse a much-chronicled time and place. At center stage is a subject so personably large and stubbornly anarchic—not to mention artistically under-valued and deserving of serious reconsideration in her own right—that she exerted undeniable gravity in her world and leaps off the page into ours.

Curtis begins with a brief preface, enumerating the standard biographical tools that were *not* at her disposal: an unfinished memoir, journals and notes that seemingly disappeared, lost or unavailable correspondence. Nothing daunted, she weaves her story out of a comprehensive mastery of previously published works amplified by exhaustive original research, which included the judicious perusal of de Kooning's often overlooked critical writings. Despite a few major exhibitions of her paintings in recent years, Elaine de Kooning has been treated rather shabbily by critics and historians of her era, who recall her more for her extravagances than her talent. *A Generous Vision* is a necessary corrective, refocusing our attention on her as artist, writer, and teacher.

Is this a feminist biography? You bet. Curtis is particularly sensitive to the rules and assumptions of sexual power. From early childhood, Elaine Fried refused to be defined by gender expectations; when she married Willem de

Kooning, at a time when he could barely finalize let alone exhibit a painting and each dollar had to be allocated to paint, food, or rent, she brooked no condescension from him or anyone else. Before she published and long before she established her domain in portraiture, she alluringly shouldered her way into the world of downtown artists, whether it meant the Club (which previously barred women) or Cedar Tavern. Esteban Vicente remarked, "No one could keep [Elaine] out of anything she wanted to be part of." She made her mark at Black Mountain, although she attended as wife and student. She was as adept as the men at musical beds, perhaps more so, since the men usually contented themselves with nubile worship, while she took lovers who could and did influence the art world on behalf of herself and her husband. She could be an indifferent, uncaring, and callous wife, but she always kept faith with her muse. Willem expected her to stop painting when they got married, and when he asks her to support them, she responds, "I never ask you to get a job. Don't ask me. I want to paint as much as you do, and I'm willing to starve along with you."

De Kooning was an incisive critic and an influential teacher, but it is through her paintings that she has the most to say to posterity. Not surprisingly, this book is especially stimulating in passages that allow us to see how she worked. She is best known for her portraiture, a field in which she occupies a singular middle ground between formalist representation and caricature. Her use of abstract expressionist techniques to elucidate familiar images helped to make those techniques accessible to the general public. At the same time, she pioneered a redefinition of the female gaze. Curtis alerts us up front that de Kooning demanded "the freedom to paint the opposite sex as sex objects." Her most celebrated portrait is that of President Kennedy, and Curtis has dramatized this fascinating episode—the commission, the process ("At one point I had thirty-six canvases going at once, all different stages," de Kooning recalled), and the denouement—with copious and telling details. She is equally absorbing in describing the genesis and realization of de Kooning's splendid basketball paintings, a process that began with the artist's epiphany that grainy black-and-white newspaper photos, seen from a distance, are like "abstract compositions," freeing her to "invent her own color schemes" and to infuse pure action with a sense of the tragic. When de Kooning first saw the prehistoric paintings in caves at Niaux and Bédeilhac, she remarked on "the fantastic courage it must have taken for those first artists to go *into* the caves." *A Generous Vision* encourages us to consider the courage of Elaine de Kooning.

Gary Giddins, Series Editor

About This Book

EVERYONE KNOWS THAT the painter Willem de Kooning was one of the titans of twentieth-century art. But few people realize that his wife, Elaine de Kooning, was a prime mover among New York artists at mid-century. Elaine[1] was an incisive writer who pinpointed the essence of painters as dissimilar as Franz Kline and Auguste Renoir, and deftly refuted pompous critical rhetoric. She was a celebrated portrait painter whose sitters included leading artists and writers in her circle and (most famously) President John F. Kennedy. Her fascination with people and animals in motion led her to paint subjects as diverse as bullfighting, basketball, Paleolithic cave paintings, and a multi-figure sculpture in the Jardin du Luxembourg in Paris.

Elaine was also a vivacious social catalyst. Her sparkling wit enlivened meetings of the Club, nights at the Cedar Tavern, and chance conversations on the street. Her generosity of spirit, droll sense of humor, and freewheeling spending were as legendary as her ever-present cigarette. ("Take care of the luxuries," she liked to say, "and the necessities will take care of themselves.") So many people spoke at her memorial in New York in 1990 that it lasted nearly three hours. Yet no one had written her biography.[2]

I soon realized that Elaine—a quicksilver personality who lived in the moment and reveled in impulsive adventures and constant activity—is an elusive subject for a biographer. Her surviving correspondence is scarce and scattered in other people's archives. The journals she kept for decades have resisted efforts to locate them. Illness kept her from completing a memoir; the notes she made have disappeared. Versions of her life story that she recounted to interviewers over the years don't always bear chronological scrutiny—perhaps partly because she claimed a birth date two years later than her real one (1918). Similarly, reminiscences of artist friends are often rich in anecdotes but vague about exactly when they occurred.

For these reasons, I decided to present Elaine's activities, opinions, creative work, and interactions with people in and out of the art world thematically rather than attempting to follow a strict chronology. As a result, some chapters have overlapping dates. The narrative expands during periods when I can amply document her experiences and projects, and contracts when little reliable information is available.

In this biography, I have attempted to illuminate Elaine's formation and development as a fiercely intelligent and beguiling woman, her signal importance as an elucidator of mid-century art in America, her strikingly individual approach to portrait painting and other genres of art, her teaching methods, her extraordinary capacity for friendship, her boundless zest for life, and, of course, her relationship with her husband.

It is a tall order, and I remain in awe of her ability to dazzle on so many fronts, and to find an outlet for her talents in the creative construction of a self.

ABOUT THE ILLUSTRATIONS: The vast majority of Elaine's works are in private collections; many are untraceable or could not be photographed. Although I felt free to write about some of these works (reproduced elsewhere, often online), the color plates in this book necessarily consist of images that could be properly sourced and credited. While it was not possible to secure reproduction rights to certain iconic black-and-white photographs of Elaine, I am happy to be able to include some rarely seen vintage images.

A Generous Vision

1

Drawing and Discovering

ELAINE ONCE VOUCHED for her independent spirit in a roundabout manner—by naming the two people whose influence shaped her entire life. "I didn't need anything but my mother and Bill," she said. "The rest was 'going my way.'"[1] Her mother's fascination with the arts and outlandish, autocratic personality exerted a powerful dual influence—as a portal to the realms of art and literature, and as a cautionary example of the dark side of eccentricity.

She sometimes admitted that her mother was "challenging"[2] or "an extremely autocratic person"[3]—using an adjective she also applied to herself. In one late-life interview, she acknowledged that "most artists, in their childhood, have some hot/cold situation from their parents."[4] But when the interviewer probed further, Elaine shut down, claiming that the typical ways people compensate for a bad family situation had nothing to do with her.

Elaine's buoyant public persona effectively sealed off aspects of herself she preferred not to think about. Reminiscing about her childhood, she would mention only the cultural enrichment her mother provided. She would say that she grew up believing half the world's artists were women, because her mother had decorated the family home with reproductions of work by Rosa Bonheur[5] and Elizabeth Vigée-Lebrun,[6] as well as Michelangelo[7] and Raphael.[8] She would mention that she was five years old when her mother introduced her to the glories of the Metropolitan Museum of Art; that she was seven when her mother presented her with "the greatest gift I ever received in my entire life"—a library card.[9] Unspoken was a shattering event involving her mother that occurred when Elaine was six years old.

BORN IN 1888, Elaine's mother, Marie (originally Mary Ellen) O'Brien, was the eldest child of a man from County Mayo who owned a bar in Manhattan and an Irish-American woman who died when Marie was seven years old. She told Elaine that she was "totally ignored as a child" and had a storybook "wicked stepmother" who drove her to take refuge in the library.[10] In an era

when most American women married in their early twenties,[11] Marie was twenty-seven when she wed Charles Frank Fried on September 4, 1915. (Whether she felt ambivalent about marriage or lacked earlier suitors is unknown.[12])

Charles Fried was a baker, the grandson of a Bavarian immigrant farmer who had settled in upstate New York.[13] A mail-order course in bookkeeping led to his moves up the ladder at General Baking Company—from twelve-dollar-a-week baker to bookkeeper, accountant, office manager, and plant manager.[14] According to Elaine, her father treated the children to "horse shows, rodeos, the circus, sporting events" at Madison Square Garden.[15] Charles lacked Marie's high-toned cultural interests—dragged to the opera, he opted to smoke a cigar in the lobby; apropos a painting by Rembrandt, he remarked that all art gave him "the creeps."[16] He also took a back seat to Marie's outspokenness. She reigned supreme as the family's decision maker, issuing an unstoppable torrent of pronouncements.

By the time Elaine was born, the couple had moved from the Bronx to the Sheepshead Bay neighborhood of Brooklyn so that their children would have "a back yard...to play in," Elaine told an interviewer.[17] Christened Elaine Marie Catherine Fried, she was born at home on March 12, 1918—a long three and a half years after the wedding.[18] Perhaps that's why Marie lavished so much attention on her.

Marie was so close to Elaine that she seems to have had little attention to spare for the three younger children, Marjorie, Conrad, and Peter. Elaine reveled in her position as the favored eldest and enjoyed ordering her siblings around. Fortunately for Marjorie—who was just a year and a half younger than Elaine and shared her bedroom—the sisterly bond was close and long lasting. A photograph from circa 1944 that shows them in a tight embrace may have been posed, but the underlying emotion was true. As we shall see, Marjorie, who had solid organizational skills, became an invaluable stabilizer in Elaine's life. All the siblings were unusually close,[19] accustomed to supporting one another through hard times.

Because Charles Fried came from German Protestant stock, the couple likely had to promise to raise their children as Catholics in order to be married in the Catholic Church.[20] According to Marjorie, when they were eight or nine years old, Marie told them, "If you'd rather go to a Protestant church, go right ahead." Yet they apparently didn't choose to do so, and their childhoods were permeated with Catholic teachings. As public school students, the young Frieds were obliged to go to catechism class after Mass.[21] "We lived in fear of the nuns," Marjorie said. "We used to try to escape, but those nuns

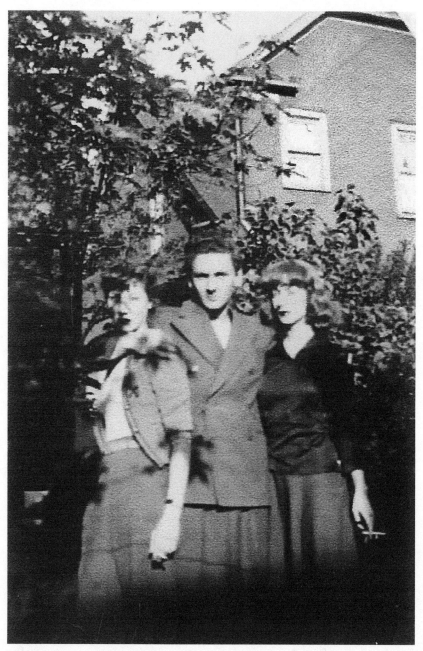

Marjorie, Peter, and Elaine Fried outside their home, 1942.
Courtesy of Charles and Mary Anne Fried.

would grab you. But we stayed with it until our mid-teens. We stayed Catholic." Vestiges of the faith would occasionally creep into Elaine's art—one of her experiments involved bronze crucifixes that were supposed to resemble birds in flight—and may have deepened her affinity for El Greco's religious paintings.

ELAINE REMEMBERED BROOKLYN as a child's paradise of empty lots filled with wild flowers, old trees perfect for climbing, and "marvelous dangerous places to play"—a lumberyard, excavations, and abandoned construction sites. A guidebook published in 1920[22] saluted the borough's "rare intellectual life"[23] and singled out Erasmus Hall High School—which Elaine would attend—for its high academic standing among New York public schools. Describing Brooklyn as "a city of churches," with "long streets and avenues of homes," the authors complained that the borough "cannot seem to outgrow its village origin," a viewpoint shared by the scornful Marie.

As a proud New Yorker (according to family lore, she rode the subway on its first day of operation in 1904), she enjoyed showing her children Manhattan's cultural glories, piling them on the subway on Wednesdays for theatre matinees and visits to museums. "She loved the opera and the theatre and classical music," Marjorie said.[24] Marie was also a devoted reader. She "wouldn't just give me a book," Elaine said, "She gave me the whole author"—an awareness that "this is an author who has written a great many books; you need to read them all."[25] Beginning with Dickens, her mother fed Elaine a literary diet that included George Eliot, George Bernard Shaw, Jane Austen, the Brontës, Proust, and Henry James—with no distinction made between male and female authors.

Although Marie was highly intelligent, she was also, as Willem de Kooning's biographers wrote, "a histrionic romantic."[26] After Marie's death, Marjorie described her as "very difficult, because she was so impractical."[27] To Conrad, his mother was "kooky" and "irresponsible."[28] Acquaintances[29] remarked on her odd appearance, with exaggerated makeup and rumpled clothes. Her domineering behavior was impossible to avoid. Willem de Kooning—whose own mother was argumentative and overbearing—said that Marie "always wins an argument because she jumps all around you."[30] A friend of Elaine's recalled how Marie was always "insisting on the rightness of her own opinions and her own wisdom."[31] She believed that girls were smarter than boys, but men were smarter than women—which is why, she told Elaine, she had wanted only male children. Elaine would always have it both ways, as a woman who took pains to be alluring to men and wanted to be catered to, but who also insisted

on parity with male privilege—sexual freedom and the freedom to paint the opposite sex as sex objects.

LIKE MANY MOTHERS of the era, Marie urged the children to finish their suppers by invoking "the starving children in China." This admonition "made us so sad," Elaine said later, ascribing it to her first stirrings of a social consciousness.[32] Yet, by 1924, meals in the Fried household were a sometime thing. The icebox was often empty. Conrad had rickets. Lost in her own world, Marie was failing to look after her children's daily needs. Finally, a neighbor who noticed the children's dirty clothes and malnourished appearance notified the authorities.

Conrad recalled that he was four years old when Marie "went to a mental institution for child neglect," identified by de Kooning's biographers as Creedmoor Psychiatric Center in Queens, New York.[33] Two policemen came to the house "and there was some woman there, and I ... was holding onto her skirts and peeking out from behind her. And my mother got into a fight, because a policeman held out his hand to her, and she stood on the chair and ... and kicked ... so they grabbed her and dragged her, screaming, out."[34] Charles hired a housekeeper whom the children liked; they called her "aunt." But six-year-old Elaine was thrust into a frightening situation reminiscent of Marie's at age five: her mother was gone.

Marie's behavior might have been at least partly due to a form of postpartum depression, after giving birth to four children between 1918 and 1922. But in the 1920s, there was little attempt at understanding a woman who fell short of the nurturing ideal of motherhood. Charles's son Conrad called him "a very warm, loving kind of man" who was "very involved in our lives."[35] But why did he turn a blind eye when his children were suffering from her neglect? Was it was impossible to get Marie to focus on her children's wellbeing? Marjorie, who would inherit his businesslike manner, remembered him as "very steadfast, very practical,"[36] a description that sounds more suited to his General Baking Company career than his role as a father. As a Mason, Charles may have taken refuge in the brotherhood of his lodge during a family crisis.

Marie's dominance seems to have left an undercurrent of troubled silence in its wake. A story Elaine told about her father involved a birthday present— a watch he had bought for her. Peter, who was four years younger, had discovered it and accidently broken it. When she opened the box and realized the watch had stopped, her look of disappointment, mirrored on their father's face, left Peter stricken. The point of the story was that Elaine knew who had

broken her present, but the children's bond—formed, as she did not say, in the absence of parental attention—was iron-clad and permitted no "snitching."

As a teenager, Elaine once tried to get a rise out of her taciturn father by telling him that she got "knocked up" the previous night. He asked what she meant; the phrase usually connotes a sexual encounter resulting in pregnancy, so he may have feared the worst. (In fact, she was already having an affair with the young painter Milton Resnick—an involvement carefully shielded from her parents.) Elaine clarified: "I had so much to drink." Her father seemed relieved.[37] Alcohol was by far the lesser of those two evils.

When Charles brought Marie home, a year after she was committed, he had to promise to assume responsibility for her behavior. Months of relief from family obligations apparently had a positive effect, though she retained a skewed way of looking at the world. Elaine once related a story told by her mother about a woman who was said to have thrown her children off the roof. "My mother said, 'I understand just how she did it. One of them must have fallen off, and she thought, Oh, I don't want to live, and I'll throw the rest of them off.' "[38] The troubling aspect of this remark is her mother's vigorously empathetic response to the voice of mental illness, which Elaine somehow failed to credit as such.

Willem de Kooning shrewdly observed that Marie seemed to be the only person Elaine feared.[39] Her mother liked to challenge her, dismissing her youthful drawings—praised by her teachers—as "run of the mill."[40] Marie may have been jealous of her daughter's skill, or perhaps she wanted to give her powerfully self-assured child an awareness of her own vulnerabilities; her nickname for red-haired Elaine was "Samson."[41] But a story told by Marjorie suggests that Elaine learned how to handle her mother. On one occasion when Marie hit Elaine's hand with a ruler—standard punishment in the Fried household—she tried to undermine her mother by laughing. Marie smacked her daughter's hand harder, and Elaine laughed again. "Well," Marie concluded, "I guess that's the end of corporal punishment."[42]

ELAINE'S COMPETITIVENESS SURFACED in her early childhood. When Marie drew a clumsy portrait of seven-year-old Elaine, she realized that her own drawings were more skillful. At school, her friends were already calling her an artist; her younger brother Conrad watched her draw and paint, hoping to pick up some pointers.[43] Her determination to succeed even pitted her against the Old Masters. After reading that Raphael's talent was evident at age twelve, she worried that she was already behind the curve. It was a relief to discover that another artist had triumphed at age twenty: there was still time to make her mark.

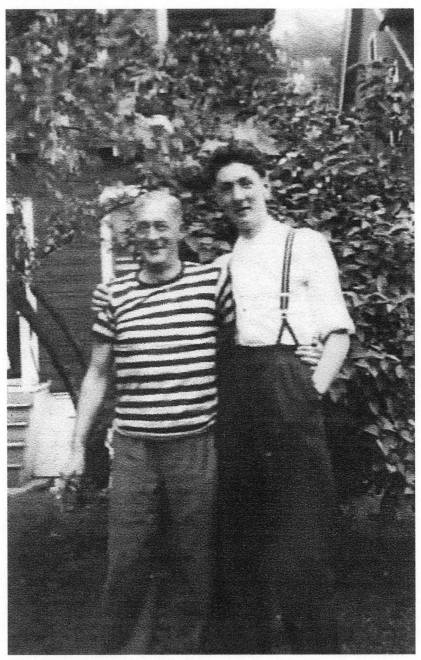

Charles and Conrad Fried, 1942.
Courtesy of Charles and Mary Anne Fried.

Playing sports with neighborhood boys also fed Elaine's competitive streak. "I played with boys exclusively until I was thirteen," she said. "Baseball, football, field hockey, handball."[44] A boy she knew was often taunted by other children for playing with girls. "I saw a caste structure," she told an interviewer. "So I played with boys and became a tremendous tomboy."[45] Her high energy also found an outlet in dance lessons—the blend of ballet, tap, and acrobatics that children were taught in the early twentieth century. As a teenager, she considered pursuing a career as a dancer. But the prospect of practicing for hours every day was daunting, and anyway, she was more interested in drawing. (Decades later, she would say that she viewed painting as "something akin to dancing, when people dance just out of a sense of exuberance."[46])

During her childhood, she was influenced as much by illustrations in books and newspaper cartoons as by Old Master paintings. Nell Brinkley, known for her "Brinkley Girls"—frothy images of active young women dressed in the latest flapper fashions—was a special favorite. Always a quick study, Elaine imitated Brinkley's manner of shading (using very fine lines) when she tried to copy paintings by Thomas Gainsborough and Joshua Reynolds. Drawing Spanish women with mantillas allowed her to perfect her skill in duplicating lace patterns—a gift for fine detail that would surface again in her pencil portraits of the 1940s and '50s.

Elaine roamed Manhattan from the age of nine, when she was first allowed to ride the subway by herself. Decades later, she reminisced that she was fourteen years old when she encountered one of Paul Cézanne's *Bathers*. The figures struck her as "stiff and wooden." Yet, she said, "I was enthralled by it. I knew there was something there that was going to take me a lifetime to understand."[47] Elaine was fourteen in 1932. But she maintained the fiction that she was born in 1920, so her first sighting of a Cézanne would have been in 1934, the year the Museum of Modern Art acquired its first works by the French artist from the estate of Lillie P. Bliss,[48] including a lithograph, *The Bathers* (1896–97). The puzzle of Cézanne's idiosyncratic style led Elaine to other modernists: Matisse, Picasso, Degas, Soutine. Yet she remained in thrall to Old Master paintings and also continued to enjoy the here-and-now relevance of contemporary illustration. Unswayed by fashion or the dictates of modern art gurus, she would always make up her own mind about what was worth looking at—which was just about everything.

On visits to her aunt and uncle's dairy farm in Roscoe, New York, Elaine was captivated by the way one of her cousins would keep up a running commentary as they took walks around the property. "The whole countryside was full of stories and information for him,"[49] she marveled, in her city-girl way.

Elaine sketched cows on these trips, the beginning of a fascination with the shapes and movements of cattle that would preoccupy her throughout her life. She also noticed another thing: "At the farm, I saw a division of labor," Elaine recalled. "The women were in the kitchen … [t]he men were out with these horses, the hay wagon, and I thought, that's for me."[50]

One of Elaine's elementary school teachers told her that she looked like Amelia Earhart. In 1928, when Elaine was ten, Earhart had made headlines by flying across the Atlantic as a passenger and then setting off for a solo flight across the United States. Four years later, she made her first transatlantic solo flight. The resemblance was based on Elaine's bangs, which her mother said she needed "to hide my brains"—presumably a reflection of the prevailing belief that a girl should not appear too clever. (Willem de Kooning disagreed; he asked her to lift the bangs off her forehead for his portraits of her.)

At an age when many girls dreamed of being swept away by a dashing hero, Elaine saw herself as the hero(ine) of her own story. Never interested in tales about a passive fairy princess awakened by a kiss, she wanted to be the fairy *godmother*, who made things happen. (Decades later, she would be a real-life godmother to several young people who were enchanted by her enthusiasms and appreciative of her intuitive understanding of their feelings.) Even as a nine-year-old, "I was always very autocratic," she told an interviewer. "I knew exactly what I wanted to do with my time, and if other people had other ideas, I found that irksome."[51]

Elaine's early female role models included Babe Didrikson, who won two gold medals and a silver medal for track and field at the 1932 Los Angeles Olympics and was a champion basketball player.[52] With a mindset akin to an athlete's, Elaine would insist that she viewed obstacles as challenges: "An obstacle is simply something that 'change[s] the course of the rhythm.' And the energy goes somewhere else. So it can free you to do something you would not otherwise have thought of in a million years."[53] Throughout her life, Elaine was able to draw upon a seemingly boundless supply of compulsive energy. Coupled with it was the impulsive behavior that—depending on the context—could either be endearing or self-defeating. As she once said, "I would have made at least twelve quiet, well-balanced people."[54]

Elaine later said that someone told her to show her watercolors to the imperious Hilla Rebay, director of the Museum of Non-Objective Painting (later, the Guggenheim Museum), with the notion that she would pay for them.[55] Rebay praised the girl's sense of color but said it was typical of women artists. Affronted, Elaine walked out. She claimed that Rebay sent her a telegram the next day, asking her to return, but she never responded.

ONE OF MARIE'S eccentric goals for the children was to learn the Greek alphabet. She enrolled her daughters at Erasmus Hall—which involved a subway trip—because it was the only high school in New York that taught Greek. (They actually never took classes in the language.[56]) Yet, it was a serendipitous choice. Elaine thrived as a member of the art and Spanish clubs, and she was one of a handful of young women singled out for their prowess in baseball and hockey. As a member of the Leader's Club (girls "trained in leadership, loyalty, and sportsmanship"[57]), she also served as an athletic coach—an experience that may have influenced her brisk, forthright approach to teaching painting.

Among her own teachers, Elaine was especially fond of elderly Miss Ragan, who led the Art Club; she had studied with the German émigré painter Hans Hofmann a few years earlier. Ragan hung reproductions of paintings by Picasso, Matisse, and Cézanne on the classroom walls. She introduced her students to the Museum of Modern Art and An American Place, the gallery where photographer Alfred Stieglitz showed work by Georgia O'Keeffe, Arthur Dove, John Marin, and other American modernists. Elaine especially remembered an excursion to the 44th Street Theatre to see the opera *Four Saints in Three Acts*. Its libretto by Gertrude Stein emphasizes the sounds of words rather than a cohesive plot; Virgil Thomson's score was inspired by American hymns and folk tunes. Years later, poet and dance critic Edwin Denby, who had championed this work, would help Elaine understand its specialness.

Her Erasmus Hall yearbook entry bore the tribute "Elaine the fair, Elaine the lovable, Elaine the lily maid of Brooklyn."[58] In her photo, she poses with fluffy hair and an expression that splits the difference between demure and self-assured, à la movie star Barbara Stanwyck.[59] After graduating in January 1936—midyear graduations were common at the time—Elaine entered Hunter College, founded in 1870 by Irish immigrant Thomas Hunter to train teachers. As she recalled decades later, "I felt something was missing. I looked around for two months and I realized it was *boys*."[60] She also disliked the way college "jumped you from subject to subject." Why couldn't she be free to study whatever she was interested in? Walking down the street one day, she ran into a boy she knew in high school. He asked if she was painting. Well, no, she was busy studying physics and calculus and German. The boy told her she should be going to art school instead. What about the Leonardo da Vinci Art School, down on 34th Street and Third Avenue?

Founded in 1923 by sculptor Onorio Ruotolo to offer free art tuition to the working poor (everyone else paid six dollars a month), the school accepted any student who showed talent. By the time Elaine presented her

drawings of sculptures for admittance, the school was entirely tuition free. (None of the teachers were paid, either.) A wide range of classes was offered, including instruction in fresco painting, mural painting, easel painting, drawing, and cartooning.[61] "They had nude models," Elaine said later. "And I just felt, this is living!"[62] She studied with painter Conrad Marca-Relli—whom she would encounter again in the late forties as a member of the Club—and became involved with fellow student Milton Resnick.[63]

A year younger than Elaine, Resnick had immigrated to New York from Ukraine with his family. He was studying commercial art at the Pratt Institute when a teacher who admired his drawings suggested that he take up painting. A career in art was unacceptable to Resnick's father, so the seventeen-year-old painter left home and began taking classes at the American Artists School. It was a precarious existence. He breakfasted on nickel cups of coffee and rolls left behind by customers at the Bradley Cafeteria on Sixth Avenue; when he got lucky, a woman might cook him dinner (the food, he recalled later, was "better than sex"[64]). To pay the rent and buy art supplies,[65] he cobbled together money from modeling, selling his blood, running errands, and operating the school's elevator.

In the depths of the Great Depression, artists barely eking out a living were passionate adherents to left-wing ideology. The Artists Union, formed in 1933 to demand government assistance for artists, became a popular social center in New York. Two years later, it would pressure the Federal Art Project of the Works Progress Administration (WPA) to institute favorable pay and conditions. Resnick met Elaine when they were both representing their art schools at a Union-related political action convocation.[66] He encouraged her to switch to the more radical socially progressive American Artists School on West 14th Street. This was the reincarnation of the Marxist-allied John Reed Club School of Art, said to be a recruiting center for the Young Communist League.

Elaine could hardly have chosen a school more perfectly suited to her temperament. A statement that was published in the 1939–40 catalogue announced the need for "a new aggressive and independent art." Freedom of expression was a paramount aim of the school; there was to be no "slavish academic imitation of the instructor." Rather than turning out skilled artists "with nothing to say," the school intended "to make artists with minds as well as hands." Students, who paid a small monthly fee,[67] were encouraged to be independent thinkers whose work reflected "an understanding of social patterns and class psychology."[68] To that end, Wednesday evening lectures provided a background in "the ... natural and social sciences which have influenced the course of the development of modern art."[69]

In this atmosphere, Elaine said later, "Goya and Daumier were giants," and the Mexican muralists were a major influence.[70] Working as an artist's model to waive the tuition, she took classes in sculpture with Milton Hebald, in watercolor with Ben Wilson, and in oil painting with Nahum Tschacbasov.[71] She also received instruction in lithography, etching, and silk screening, all of which would pay off in later years. Elaine was a feisty student. "If the instructors had any criticism, I generally got indignant and left the room," she said.[72] But she loved "the conviviality...the endless arguments over politics after class in cafeterias or parks."[73] (There were also heated arguments at home; her parents were staunch Republicans.) Elaine's lifelong sympathy for people she believed to be unfairly treated, including convicted criminals, was born here. For an evening's entertainment, she sometimes went to the Village Vanguard, on Seventh Avenue, to see the Revuers—a sketch comedy troupe that included Betty Comden,[74] Adolph Green, and Judy Holliday. Other nights, she would watch a foreign film at the Rialto Theatre on 42nd Street or whirl with a partner at a dance hall downtown or in Harlem.

While Elaine's instruction at the American Artists School developed her skills, someone she had met in 1937 at the da Vinci School would change the course of her life. Supervisor Robert Jonas[75] had spotted her in class, where she stood out not only by virtue of her good looks and fashion sense—a fellow artist recalled her "dashing" black trench coat and beret[76]—but also by the thick book about schizophrenia that she was carrying. (She may have been researching possible reasons for her mother's behavior.) Jonas was impressed by Elaine's interest in Freud, considered the last word in hipness. Elaine, always keen to impress the opposite sex, had figured he would notice her "because I had [on] my little blue sweater."[77] He asked her for a date—they would have a brief relationship—and took her to see the first exhibition of the American Abstract Artists group. "I was just dumbfounded," she said, "because I thought all artists were either in Europe or they were dead." Then he told her that the two best artists in America—Arshile Gorky and Willem de Kooning—were not in the show, "and they are my best friends."

In the fall of 1938, Jonas took Elaine to see de Kooning, who lived and worked in an immaculate studio at 156 West 22nd Street. He had covered the floor with industrial linoleum, frugally acquired from its former owner, which he painted battleship gray. On his easel was the figure of a bald-headed man wearing a loose jacket, painted in ochre and olive green. Elaine had never seen anything like this mysterious painting. She felt certain that de Kooning was a genius. It didn't hurt that he was good looking, blond and blue-eyed—"he had that limpid, open gaze," she recalled[78]—with a compact physique. ("His

no-nonsense comebacks [and] the humor lurking in his eye"[79] were equally attractive to women.) That night, Elaine confided to her sister how smitten she was. "It was pretty instantaneous," Marjorie said, "although she was very involved with Milton."[80]

There are competing how-they-met stories: before the studio visit, Elaine had spied him across a table at Stewart's Cafeteria,[81] or at a bar,[82] captivated by his "seaman's eyes that seemed as if they were staring at very wide spaces all day"[83]—and likely also by his burgeoning reputation among the downtown artists. As befits such a quasi-mythical event, the supposed date of this first encounter ranges from 1936 to 1938, depending on who is telling the tale.

BORN IN 1904 in the Netherlands, de Kooning immigrated to the United States in 1926 as a ship's stowaway. As a teenager, he had worked at a leading decorating firm and as a designer for a large department store while taking a rigorous four-year course in drawing at the Academy of Visual Arts and Technical Sciences in Rotterdam.[84] Jonas met him in the early 1930s, when he worked as a window-display designer for the A.S. Beck shoe store—his first and last nine-to-five job in America. (It enabled him to buy a staggeringly expensive state-of-the-art record player for his beloved jazz and classical records.[85])

Elaine later said that de Kooning quit when he was offered a raise—double his salary—because he was worried about being overly tempted by commercial art. But the immediate reason was his hiring in the autumn of 1935 by the Federal Art Project. De Kooning started working in the easel painting division but soon moved to the mural division, which employed abstract artists to paint decorations for sites that included a public housing project in the Williamsburg section of Brooklyn. Two years later, when Congress increased its scrutiny of artists on the payroll, he quit the FAP, fearful of being deported because he was not a citizen.[86] But he was grateful for the $23.86 weekly pay as long as it lasted and enjoyed the camaraderie with fellow artists. On payday, the artists would head to Stewart's Cafeteria for coffee and a sandwich, and often linger until after midnight.

By the time de Kooning met Elaine, he was in a complicated relationship with Juliet Browner—a pretty, waiflike former dance student who worked as an artist's model and would later marry the much older artist Man Ray—and Virginia (Nini) Diaz, a vaudeville tightrope walker whose parents were European émigrés.[87] (There was also a third woman on the scene, Elsie Walker, a close friend of Browner's, who lived with her and de Kooning one summer.) When de Kooning and Browner's kitten jumped onto a neighboring fire escape, he went out to look for it and wound up meeting its rescuers, Edwin

Denby and photographer Rudy Burckhardt, who were lovers at the time, sharing a loft on West 21st Street. They both would play important roles in de Kooning's and Elaine's lives.

In 1935, just before de Kooning's mother came to visit from the Netherlands, he had gone so far as to rent a temporary space for himself and Diaz, so they could pose as a married couple. Why would a thirty-one-year-old man who lived an ocean away from his mother bother to set up this costly and awkward fiction? It testifies to his mother's hugely dominant personality and de Kooning's frantic hope to keep her temper in check. His parents had divorced when he was three, and his father was awarded custody. Although his mother—tough enough to run a bar and restaurant patronized by sailors—had visitation rights, she kept grabbing her son back. If he angered her, she would threaten to kill herself. Now, as luck would have it, she saw through the ruse, learned that Diaz had had an abortion, and discovered the existence of Browner.

Elaine would claim that her presence had enabled de Kooning to switch from portraits of men, often based on his own appearance, to images of women.[88] It was surely no coincidence that the quiet mood of the male portraits became brash and colorful ("turbulent," in his words[89]) when Elaine sashayed into his life. She was a slender five-foot-five. A woman friend remembered her rolled bangs and pageboy bob "like a movie star," the white plastic daisies on bobby pins that held her red hair away from her face, and her red lipstick. Dressed in a tight turtleneck sweater cinched with a wide belt and a ballerina skirt, Elaine stood apart from the more relaxed, bohemian style of women on the art scene.[90] (In later decades, she would favor business-like slacks and shirts, a style congruent with her public life as an artist and teacher, though she always loved to buy shoes and hats.)

Elaine had been sharing a thirty-dollar-a-month loft on Fourth Avenue[91] and 29th Street with Resnick and her friend Ernestine Blumberg, whom she had inveigled to live with them to quell her mother's worries. Marie was as strict as any mother of the era when it came to men. Elaine, still underage, was required to be home by 10 P.M., which put a big crimp in her dating. Living in these lofts—abandoned by manufacturing businesses—was unlawful, but artists figured out ways of convincing the building inspectors that no overnight stays ever happened. Beds? They were for the models. Elaine would swear that she would "never live in a place like this." Ernestine was the only one of the three with steady job—she toiled at Eastern Color Printing Company, "coloring comics"—so she held the lease, though each of them chipped in ten dollars a month. For additional income, they once rented the loft during the day

to an opera singer who needed a practice space.[92] In 1938, the trio moved to a larger space, on East 22nd Street between Broadway and Fifth Avenue.

When de Kooning came to visit, he saw the kind of painting she was doing—"women with their eyes reaching to the sky, with blood running down their arms," inspired by the Spanish Civil War.[93] He told her that artists-in-training should focus on spatial relationships—best conveyed with a still life painting, because teacher and pupil were both looking at the same objects. Elaine was finally willing to be a patient pupil. He asked her to come to his studio, where he set up a tableau consisting of "a coffee pot, a large shell, a yellow cup, an old blue cotton shirt, and an army blanket."[94] She would spend three months trying to paint it while de Kooning talked to her about the spaces between objects—the tension created between them—and the way an object "sits." Listening to him, she said, "it was as if you had never seen a cup before."[95] De Kooning "would talk about two inches in a way that was so profound, that I'd … have to go lie down. I'd get brain tired."[96] He taught her "to paint a glass right down to the particles of dust on it," a hard-won discipline that, she said, later enabled her "to explode" into abstract painting.[97]

De Kooning was "more alert visually than anyone I ever met," Elaine said. "He was constantly pointing out billboards ('Isn't that magnificent!')" and even "grease spots from gasoline stains on the sidewalk."[98] Elaine viewed de Kooning as an oracle of art, his words inevitably expressing "something that was absolute and true." (Resnick's view was that de Kooning "seduced her, by teaching her art."[99]) She learned from him "that painting was not about presenting literary ideas, but … [about] the wordless part of the brain."[100] He also made her aware of the extraordinary effort involved in his own work. "When he finished a painting he liked very much," she said, he thought he could paint the next one at that same high level, "but instead, it's as if you slide all the way back."[101]

Arshile Gorky, the other Federal Art Project artist Jonas had mentioned, was a friend of de Kooning's. Born shortly after the turn of the century (the date is uncertain), he was also a fellow immigrant. Gorky had come to the United States in 1920 after fleeing the Armenian genocide in 1915 with his mother and sister, a harrowing experience during which his mother died of starvation. In his adopted country, he created a new identity for himself, changing his name from Vostanig Adoian and claiming a kinship to the Russian writer Maxim Gorky—especially improbable because "Gorky" was the pseudonym of Alexei Maximovich Peshkov. Although he studied at two art schools in New York, Arshile Gorky was largely self-taught, a long-distance disciple of Cézanne, Picasso, and Joan Miró. Sculptor Red Grooms wrote

that Gorky was "the first person de Kooning had ever seen learning classical techniques by trying to recreate masterpieces, old or new."[102]

Elaine was bowled over by Gorky's productivity—his nearby studio was filled with his paintings—and impressed by his facility. Gorky and de Kooning visited galleries and the Metropolitan Museum of Art together—excursions on which Elaine sometimes accompanied them, feeling free to insert her opinions into their discussions about the art. (She once asked de Kooning if things would have been different if she were a young *man* who contradicted them all the time, and he said, "Are you kidding?") But she was also soaking up information that would inform her writing years later. At a show of paintings by Joan Miró, "Gorky was talking about the way Miró laid on the paint, sort of scrubbed it on so it had a transparent quality," she recalled. Because of his extraordinary technical skills, he could study another artist's work and then "go home and work that way."[103]

One night, at a party at de Kooning's loft, Elaine performed a stunt that involved picking up a handkerchief with her teeth, and Bill threw himself into a Russian Cossack dance that ended in his painful collapse on the floor.[104] Gorky had taken refuge under the table while the other artists spoke fretfully about their dim prospects in New York, where galleries ignored the American and émigré avant-garde in favor of blue-chip Europeans. Then came a voice from below: "Nineteen miserable years have I lived in America!" The artists hooted with laughter; Gorky's darkly comic lament had reinstated the party mood. Elaine understood that his Old World outlook required high standards of appearance and behavior for any woman he would pursue. She was also annoyed at the amount of time de Kooning was spending with him, away from her.[105] So, in January 1941, she would coax Gorky to attend another party, to meet nineteen-year-old Agnes Magruder ("very beautiful, very elegant"). She became his second wife eight months later.

It was around this time that Elaine began claiming she was born in 1920 instead of 1918. As the years went by, she never corrected the error, and no one ever seemed to question her. Was it simply vanity, so often indulged in by actresses and other women in the public eye? Or was it a way of exaggerating the gulf of years that separated her from de Kooning, to preserve her self-image as the clever ingénue? One day, Elaine offered to row de Kooning, Gorky, and fellow artist Raoul Hague—all in their thirties—around the lake in Central Park. Gorky said to de Kooning, "That's very smart, to have a teenager [*sic*] American girl. They're very strong, you know." She may have been strong, but she was no longer a teenager. When she praised de Kooning and Gorky as her "two great role models," they told her that her drawings were "very advanced,

way beyond theirs when they were eighteen." She returned the compliment: "You two didn't have you two when you were eighteen." Her "stroke of luck," she said, was "to have met them at that crucial age."[106] But her "crucial age" was actually twenty.

Elaine turned twenty-one in 1939; no longer under her parents' thumb, she moved into de Kooning's studio. Spending time with him involved hanging out with his male friends, who were either unmarried or had wives who worked during the day. ("There were no women around, no women artists at all," she claimed later.) Elaine always basked in the attention of men. Despite her infatuation with de Kooning, she continued dating Resnick, setting up a pattern that would continue for decades.[107]

In November, a Picasso retrospective opened at the Museum of Modern Art. Among the paintings was *Guernica* (1937). Elaine and de Kooning had already seen it in May, at the Valentine Gallery, one of several New York galleries that showed modern European art.[108] With its images of dying and dead victims of the German bombing of the Basque town of Guernica,[109] the huge canvas transmuted headlines into an anguished testimony. In view of Elaine's later fascination with bulls, it's worth noting that this animal—an alter ego for Picasso, who employed it often—is one of the dominant elements in this painting.

AT A CONCERT of new music in 1940, Elaine and de Kooning happened to sit next to painter Joop Sanders. Chatting with him, Elaine was intrigued that he shared her boyfriend's nationality and introduced them to each other—the beginning of her lifelong penchant for bringing together people with mutual interests. Around the same time,[110] the middle-aged composer Edgard Varèse took a shine to Elaine, inviting her to his basement studio, where he had compiled a library of electronic sounds. He played her the sound of a kiss that he had manipulated; it sounded to her like a lion roaring. He also took her on what she laughingly called "a bender"—visits to five of his favorite Italian ice cream parlors to sample the best flavors.

De Kooning's friends considered him a confirmed bachelor; he had played a passive role in his other relationships.[111] But he had fallen for Elaine. He became friendly with her siblings and her father—who, despite initial doubts about the value of art as a vocation, became especially fond of him; they had a similar sense of humor and both liked to work with their hands. Marie liked de Kooning, too; one day she took him and Elaine's brother Peter swimming at the Park Central Hotel, then to dinner and a movie. Bill wrote to Elaine, who had a modeling gig out of town, to tell her what a good time he had.[112]

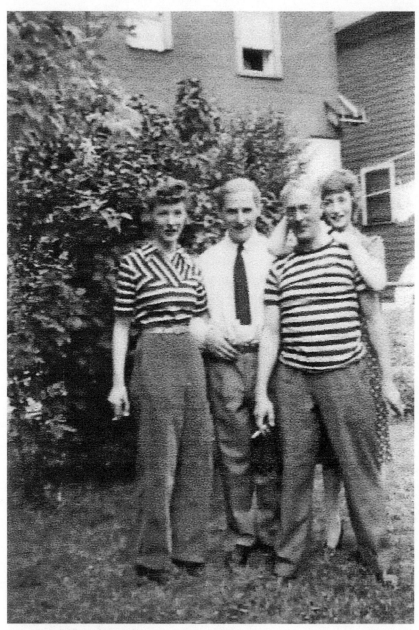

Marjorie, Willem de Kooning, Charles, and Elaine, 1942.
Courtesy of Charles and Mary Anne Fried.

Sanders recalled how transported de Kooning was by Elaine's beauty, "especially her hair, which was thick, a lustrous shade of reddish brown and curly."[113] De Kooning made his case for marriage in a conversation with Marjorie. Yet, smitten as Elaine was, she did not run after him. An acquaintance recalled that she would play the princess, lying on the sofa and calling for de Kooning to get her a cigarette.[114]

During World War II, many artists served in the armed forces. De Kooning, as a citizen of the Netherlands who was ineligible for the U.S. draft, remained in New York. But Elaine did her part. Beginning in late 1942 or early 1943, she worked at the Liquidometer defense plant on 36th Street in Long Island City, using a pantograph to trace numbers for the dials used in airplanes. She traced with her right hand while maneuvering the pantograph dial (which copied the numbers in miniaturized format) with her left hand and controlling the pressure with her foot, "exactly like Charlie Chaplin in [the film] *Modern Times*," she joked. At midnight, when the workers' shift was over, "everyone … would go and bowl" to relax and shake out the tensions of work.[115] "We would all have our little radios next to us, and I would have WQXR, which played classical music," she said. "That was the year when I read, from beginning to end, *Remembrance of Things Past*. … I was in a defense plant, they thought, but I was really in these drawing rooms with the duc de Guermantes."[116]

War work took her away from painting—one of only two years in her adult life when she didn't pick up a brush. Afterward, she declared herself to be "in a totally different place."

2

Life with Bill

ELAINE LIKED TO SAY that she decided to marry Willem de Kooning "from the moment I first met him."[1] Bill—as he was known—was equally smitten, telling Elaine's brother Conrad, "When you meet someone you think you can't live without, then you get married."[2] On a day when Conrad offered to paddle the couple in his racing canoe on Sheepshead Bay, Elaine showed up in a revealing bathing suit. Bill—whose passion seems to have been exacerbated by his nervousness, as a non-swimmer, about crossing the bay—declared, "We have to get married!"[3]

The wedding was a barebones affair, conducted at City Hall on the morning of December 9, 1943, which Elaine would remember as Emily Dickinson's birthday, as well as "two years and two days" after Pearl Harbor. Elaine wore a navy blue dress she already owned and borrowed her sister's purse; the plain wedding ring cost Bill nine dollars and fifty cents. Her mother did not attend—she declared twenty-five-year-old Elaine too young to marry[4]—nor did her brother Conrad, who stayed away out of sheer indifference because the couple were already living together.[5] The witnesses included Charles Fried; Elaine's brother Peter; artist Janice Biala and her husband, French émigré artist Daniel Brustlein;[6] Max Margulis, a photographer and musician; and de Kooning's friend Bart Vanderschellen. Elaine recalled that the wedding party moved on to a bar,[7] but other sources say that Biala and Brustlein—who had also recently married—hosted a wedding lunch at a downtown cafeteria.[8]

After these muted festivities, the bride and groom returned to Bill's 22nd Street studio: time to get back to work. Bill had told Elaine's sister Marjorie, "I'll build her the most beautiful house in the world."[9] While Elaine was working at Liquidometer, he had spent months fixing up the top-floor loft for the two of them, painting the walls white, laying linoleum, and building bookshelves, cabinets, and a folding table for the kitchen he installed. In the center of the space, he constructed a bedroom with pale pink walls and a closet, which Elaine filled with her clothes. He made a Murphy bed—which

folds up against the wall—and kept it covered with a painting during the day so that inspectors would not suspect they lived in the loft. His built-in furniture had no spaces underneath because he already realized that Elaine would never dust there.[10] Bill took the front of the studio, with windows facing the street, and Elaine had her own painting space under a skylight.

She had sweet-talked the landlord into letting them move up to this space from Bill's bachelor studio. "Because it's a flight higher, it really should be a little less per month," she said. "We're willing to pay the same rent, but perhaps you could forget the three months that we owe you?" Myron Boyce, the landlord, called in his attorney and asked her to repeat her outrageous request. The men rolled their eyes.[11] But he must have found her beguiling, because he agreed.

The loft was an urban paradise—2,500 square feet for thirty dollars a month (about $423 in today's money). But they had a hard time scraping together the rent and were usually three or four months behind. When Boyce knocked on their door, they wouldn't answer. So he would go up to the roof, walk down the fire escape, and bang on a window, yelling that he was a sick man and needed his rent money. "And we'd invite him in for tea, you know," Elaine said.[12] Once, when the rent was several months late, she saw that an envelope had been slipped under the door. She suspected that the hundred dollars inside was probably a gift from their friend Edwin Denby.[13]

ON A TYPICAL DAY, the de Koonings would sleep late; Elaine was a heavy sleeper who said she could be dead to the world for ten hours, if she chose. After a breakfast consisting mostly of coffee—at a time when refrigerators were a luxury, milk was a cold-weather treat, stored outside on the window ledge—they would paint in their separate parts of the loft until late into the night. Friends often dropped in: Denby ("who would knock tentatively and call out in his light voice"); Gorky ("deep voice"), fellow painters Joop Sanders and Aristodemos Kaldis ("very peremptory, always angry"); photographers Rudy Burckhardt, Max Margulis, and Ellen and Walter Auerbach. Some visitors would sit quietly; others would talk among themselves. If the chatter went on too long, Elaine recalled, "Bill would begin to get very angry. He'd build up a head of steam."[14] She was always the voluble one, surrounded by people even in her studio; he preferred to be silent and alone.

When she started painting still lifes, Elaine figured that she could pursue this genre forever[15]—a willingness to focus intensely on a single theme that she would later express by working in series. In one of few surviving paintings from this period, *Still Life (Dead Bird and Leaves)*, from 1942, Elaine demonstrated

what she had learned from Bill about capturing fine details. A piece of crumpled cloth becomes a landscape of hills and hollows; painterly daubs in white and brown evoke the texture of the stuffed bird's feathers. Yet, as art writer Helen Harrison has observed, the still lifes of this period "have the hermetic feeling of technical exercises."[16]

Elaine had made several pencil portraits of de Kooning early in their courtship, capturing his pensive side. In a spare drawing from 1938, he sits sideways on a bentwood chair, one fist propping up his cheek, his eyes slit-like. The following year, Elaine rendered his head with downcast eyes in a finely detailed sketch. Now, inspired by Bill's tutelage of a businessman who wanted to learn portraiture ("I thought, I'm going to get in on this"[17]), she turned to painted portraits. Bill—who had drawn an exquisite pencil portrait of Elaine before their marriage and was now abstracting her face and figure in his first series of *Woman* paintings—told her that she had a gift for likeness. She realized that the close looking he had instilled in her as a still-life painter would serve equally well in portraiture. But painted portraits were much harder to achieve than pencil sketches. She labored over one small self-portrait for four months, working every day, all day.[18]

In 1946, Elaine painted two images of herself in her studio, with the help of a full-length mirror. The *Self-Portrait* now owned by the Metropolitan Museum of Art (plate 1) shows her in a blue smock and brown trousers, perched on the edge of a pillow-covered chair with her sketchbook. Two of her still-life drawings are tacked on the wall, along with a large swatch of asymmetrically patterned fabric. (It has been identified as an embroidered raffia cloth made by the Kuba people of the Democratic Republic of Congo; for Elaine, it may have signified a link with Matisse, who collected Kuba textiles.[19]) A glass bottle on a shelf and a gaping paper bag—it almost seems to be yawning—on the floor are the fruits of her diligent study of inanimate objects. Growing from a small pot on the shelf, a plant reaches out a tendril toward her head. This may have been the self-portrait that Elaine's sister Marjorie—who had a job that paid a munificent fifteen dollars a week—persuaded her to part with for twenty dollars.[20]

A similar painting from the same year, with the same title, now owned by the National Portrait Gallery (plate 2), seems more evolved in some ways—Elaine's sketches on the wall are shown with more detail; a cup on the floor is more carefully rendered; the folds of her smock and trousers are more convincingly three dimensional; her hair looks less schematic. (She also added her ever-present ashtray.) But her self-portrait sketches from the same year[21] display an ease and assurance that still eluded her in painting.

During this period, Elaine and the de Koonings' friend Joop Sanders, took turns being each other's "slave." One day a week, she would sit for him all day while he painted; the next day, he would sit for her charcoal sketches, which she used as the basis for at least twelve painted portraits. Constantly canceling out the image she had just painted, she tried to find "the contours"—a sense of bodily outline that would forever preoccupy her—and to render the abstract patterns of folds of cloth to her satisfaction. Sanders's angular face seems to have inspired her experimental impulse. From painting to painting, his expression shifts from an aloof stare to an unfocused brooding. In *Joop #5*, the bright whites of his eyes give him an eerie malevolence. The abstract patterning of the creases in his jacket in *Joop-Angel #3* (plate 3) rivals his face for the viewer's attention. In the most extreme version, *Joop Pink*, Sanders barely inhabits a jacket that dematerializes into disconnected swaths of paint, and the aggressive pink background that invades his neck almost detaches it from his head. This painterly freedom was a major step forward.

COUNTERMEN AT THE CAFETERIAS were especially friendly to artists, "heap[ing] our plates with double portions."[22] In the 1930s and '40s, the two locations of Stewart's Cafeteria—23rd Street and Seventh Avenue, and Sheridan Square in Greenwich Village—were crowded at midnight and never closed. They served as meeting places for young people trying to make their way in the city, eating dinner for a quarter.[23] But the Horn & Hardart Automat[24] on 23rd Street, which offered good, plain food in regrettably small portions, seems to have been the de Koonings' favored hangout. A longtime friend remembered watching the de Koonings dining at the Automat in their early days as a couple, their heads turned toward each other in mutual devotion.

Strolling home as late as three or four in the morning, Elaine passed streets of darkened warehouses. "But the top floors, where the skylights were, were all lit," she recalled. "That's where the artists were."[25] With no neighbors to make a fuss, artists felt free to play their 78 rpm records late at night. Elaine loved the "blue-collar worker life" that existed in the neighborhood, now known as Chelsea. "Artists always like the company of working people," she said. "When they pick bars or restaurants to go to, it's always working people's places. Where you can go in your blue jeans."[26] (Back then, middle-class people did not wear jeans in public.) Once, when the de Koonings were out walking, Bill said, "Things could be worse. We could be living in that place." He gestured toward a doorman outside a building. "Wouldn't it be horrible to have to talk to the doorman every day.... And we'd have to get dressed up when we walked out."

Experimental artists in different fields were a close-knit group during this period. John Bernard Myers and Tibor de Nagy ran a short-lived marionette theatre before they opened their gallery. The de Koonings went to see *Fire Boy*, based on a Pueblo Indian story, about a boy's quest for a magical hunk of turquoise guarded by a dragon. While manipulating the characters' strings, Myers intoned songs by a young Ned Rorem, set to lyrics by poet and film critic (and later, experimental filmmaker) Charles Boultenhouse. A newcomer from upstate who had come to Manhattan to work on an avant-garde magazine, Myers was eager to meet the de Koonings. But he was baffled by Bill's paintings, unable to tell "what was in front and what was in back." According to Myers, Bill cheerfully agreed: "It's my problem, too."[27]

Bill devoted most nights to painting. Elaine's brother Conrad recalled that when they would call up from the street at 10 or 11 P.M. ("We're going to Joop's—he's having a party"), Bill would decline to join them.[28] His progress was slow because of his enormously self-critical approach, which often involved wiping out days of work on a painting. Elaine later recalled "a masterpiece...a great big red bull" that met this fate because Bill worried that it looked too much like the style of Joan Miró.[29] As a painter, she was always the quick one. But in the early days, she didn't always trust herself.

Marie Marchowsky—a former dancer with Martha Graham, on the verge of forming her own company[30]—commissioned Elaine to paint her portrait and kindly paid the fifty dollar fee in advance. Although the small painting pleased her sitter, Elaine felt it wasn't sufficiently ambitious. She labored for months over a three-by-two-foot portrait on a Masonite panel, obliging Marchowsky to keep coming in for sittings. Her patience exhausted, the dancer begged to keep the original painting. Elaine soon reused the Masonite panel to paint a portrait of art dealer Charlie Egan, which she was able to complete in one evening to her satisfaction (plate 4). Years later, she would attribute this sudden triumph to "the year's work underneath."[31] There was also another element in play: Elaine and Egan, an alcoholic with little business sense who glided through life on good looks and charm, would soon become lovers.

THE DE KOONINGS' nagging concern—which they shared with most of their friends—was making enough money to live on. It was probably Elaine who convinced the ever-reticent Bill to use their photographer friend Rudy Burckhardt's connections with *Harper's Bazaar* to try for a fashion illustrator's gig. She was Bill's model for a series of sketches of hairstyles for the March 1940 issue, which brought in a generous seventy-five dollars per sketch.[32]

(Elaine later said that when she met Bill, she asked why he always painted men. "He said, 'Well, I don't understand hair.' "[33] By now, he had figured it out.)

Alexey Brodovitch, the magazine's fabled art director, had no further use for Bill's services, but Burckhardt would continue to figure in Elaine's life. When she hoped to break into high-fashion modeling, he photographed her in dresses she managed to borrow from the discount department store S. Klein. Elaine posed in the gowns, keeping the price tags out of sight, before returning them to the store. In a surviving black-and-white photo, she assumes a haughty stance—her slender figure, wavy hair, and delicate features making her look every bit the model.[34] A few years later, Burckhardt's photographs of street scenes viewed from rooftops prompted her to tote a sketchbook to lower Manhattan, where she made precise drawings of buildings. He also cast Elaine in his improvisational films. In *Mounting Tension* (1950), she gracefully deflects the advances of a sex-obsessed artist (Larry Rivers); in *The Dogwood Maiden* (1949; see chapter 3), she plays the Sorceress, a role perfectly suited to her lithe dancer's body and high spirits.

One Christmas Eve, Elaine found a wallet in a phone booth with about fifty dollars in cash and asked Bill what to do. "Keep it," he said. "I don't care if it's [the owner's] last dime."[35] Apart from such serendipity, it was Bill's earnings, meager as they were, that kept the two of them afloat. Among his few painting sales during these years was a portrait of Elaine purchased by fellow painter Fairfield Porter.[36] More lucrative were Bill's various commercial projects. As if trying to be both the breadwinner and the homemaker, he would leave a plate of cheese, sliced apples, and chocolate for Elaine before he left for a job—a gesture she was temperamentally unequipped to reciprocate. Often, there was not enough money for both food and cigarettes, or food and paint.

Although Marjorie said that Elaine would pay several months of rent in advance when Bill sold a painting,[37] painter Janice Biala told a different story. When she asked Bill and Elaine about a check she had sent for a painting of his, he "looked at [her] in a very funny way, and Elaine said, 'Oh, there's a check?'" Bill hadn't wanted her to know about it, lest she use it for a shopping spree.[38] A certain willful lack of concern for her husband during the early years of their marriage surfaced in other ways. According to Joop Sanders, when Bill had a bad case of strep throat that sent him to the hospital, Elaine never visited him.[39] Friends clubbed together to cook for him, yet she still seemed indifferent. Biala, who had cooked a duck for Bill, recalled that Elaine stayed out until 3 A.M. that night and then ate the dish herself.[40] She also appeared unconcerned by the heart palpitations he experienced at periods of high anxiety about his work.[41]

Accustomed to eating out and oblivious to mess, Elaine had no interest in cooking or cleaning. Bill, who had traditional notions of wifely duties, joked, "You have a very nice life for a young man."[42] She did make at least one grand effort to cook dinner, purchasing all the spices listed in a recipe for beef stew that was supposed to serve eight people. Ingredients for the dish, which the two of them wolfed down in a few minutes, cost a budget-busting twenty dollars—money they could have dined out on for several days.

Hunger was an ever-present specter to the downtown artists; Elaine and Bill knew a Dutch painter, Jan Rollans, who was in desperate straits and too proud to ask for handouts; he wound up starving to death. Still, with the right attitude, you could go far. Alex Katz, who worked two or three days a week as a frame carver back then and lived with no source of heat, recalled: "I was poor, but as long as I had clean white shirts, ties, movies, bars, and cigarettes, I never felt impoverished."[43]

Ernestine Blumberg and Ibram Lassaw asked Bill and Elaine to be the witnesses for their wedding in 1944. Afterward, the couples went to a smorgasbord restaurant for a meal that Elaine remembered as costing two dollars apiece. They watched the parade of "incredible food" go by, but the portions were tiny and the meat was strangely compressed ("like black-hole meat"). Still, they were determined to sample everything because the price included "all you could eat."[44] In the same vein, artists eagerly took advantage of the cookies and tea served by two elderly women in the neighborhood and the "opulent layer cake" that accompanied glasses of Scotch at the baronial apartment of Alexander Bing. The real estate developer, art collector, and amateur painter would invite artists to look at his "fabulous collection" of art books.[45]

Another lifesaver was the lunch invitation extended to the de Koonings on Tuesdays by émigré friends of Edwin Denby. He was also helpful in more lasting ways. When Elaine railed against a de Kooning imitator who sold work on the installment plan to a counterman at Stewart's Cafeteria, Denby told her that attacking other artists was not the way to help Bill. "Don't be an 'artist's wife,'" he advised. "Talk only about the ones you like."[46] She took his words to heart, and his continuing mentorship would serve her well when she began reviewing art in 1948. (See chapter 4.)

Among the things the couple didn't budget for was the cost of sending their sheets to one of the commercial laundries run by Chinese families. (Coin-operated laundromats were scarce until the 1950s.) When Elaine's brother Conrad noticed how grimy the sheets were, he suggested, "Why not put them in the bathtub, let them soak in some soap, rinse them out, and take

them out on the roof to hang?" He strung a wire clothesline for her between the chimneys. As the story goes, he looked up at the roof about six months later and saw sheets hanging—very gray sheets. It seemed that Elaine had never taken them down.[47] From a practical point of view, it's unclear what they were sleeping on. Did they do without sheets? Did someone take pity on the couple and give them a new set?

Bill told Elaine that he thought she'd give up painting when they married. He suggested that if she admired him so much, she would get a job and support him. She asked him how he got that idea; after all, when they met, she was already a painter with her own studio. "I never ask you to get a job," she said. "Don't ask me. I want to paint just as much as you do, and I'm willing to starve along with you. Besides, something always happens."[48] Sure enough, serendipity—like Bill's teaching job at Black Mountain College (see chapter 3)— usually saved them from utter penury. He advised his students at the college to "look for the lowest possible standard of living and guard your time."[49]

Asked decades later if poverty had any benefits, Elaine explained how time-consuming it was. If there was no money for supper, "we'd have to go borrow money. Well, sometimes that meant spending the whole day…just finding someone to lend you five dollars. And also, you couldn't buy materials."[50] Because it was not easy to scrounge up enough money to buy canvas, Elaine would paint on a piece of cardboard. Primed with white lead or gesso, it could be transferred to canvas later on. (When Bill's paintings got larger, and a two dollar tube of cadmium red could disappear in one brushstroke, he started using house paints.) The main reason the couple painted on small canvases, like many of their peers, was that this was all they could afford. Joan Mitchell, who could afford to work on a large scale, told Elaine that after her first solo show in New York, in 1952, "artists came up to her and said, 'Joan, now that you're finished with those canvases, can we have one to work on?'"[51]

IN THE FALL of 1945, Elaine impulsively sailed to Provincetown with Bill Hardy—a handsome engineering student who hobnobbed with the down-town art crowd—to visit their mutual friend Edwin Denby, who spent summers there. A storm battered the boat that night, and she woke up on the leaky floor of the cabin. It turned out, she said in a late-life interview, that Hardy had never sailed before; as far as she was concerned, he was "a pain in the neck."[52] She would also claim that the Hardy episode was platonic. But Bill was furious, not least because she apparently didn't return until early December. (It's not clear whether she misremembered or misstated Hardy's prowess; Bill's biographers call him "an accomplished sailor."[53])

This was not Elaine's first episode of inappropriate behavior. Soon after the wedding, at a party the de Koonings gave in their loft, she said she'd had too much to drink and had to lie down. When Bill went to check on her, he discovered her in bed with Robert Jonas. Elaine and Bill also clashed in other ways. "Our endless conversations would turn into arguments," she said. "That was my whole [family] background."[54] (Years later, a minister she met on a lecture trip told Elaine, "Being married to you must be like being married to twenty women." She wondered whether that was a compliment.[55]) Yet she was unapologetic about the ferocity of her arguments, proudly telling one interviewer, "I seemed to have been born a revolutionary."[56] Bill's personality was more phlegmatic, and as a grateful immigrant, he didn't share Elaine's complaints about life in America. Despite these cracks in the marriage, the façade of a happy union was maintained whenever Bill wrote home. A letter to his father that November included a lipstick kiss imprint by Elaine and photographs of each of them.

In December 1945,[57] the 22nd Street studio that Bill had so lovingly refurbished was snatched away from them. There had been many months of unpaid rent, but the couple's eviction was due to the sale of the building.[58] Bill and Elaine's brother Conrad carried all the couple's possessions by hand (the rolled-up linoleum flooring was balanced on the men's shoulders) over more than twenty city blocks to their new home. It was a tiny cold-water flat, five flights up, at 63 Carmine Street—on the corner of Seventh Avenue in Greenwich Village—that rented for eighteen dollars a month. (Elaine later explained that "cold-water" was a misnomer "because the only thing hot in the flat was the water."[59]) There was no heat; the de Koonings made do with a hazardous kerosene stove that had to be cleaned frequently, lest the soot catch fire.

Now, they painted in opposite corners of a ten-by-fifteen-foot room. Small irritations—like Bill's habit of whistling themes from classical music, which got on Elaine's nerves—were magnified in such close quarters. And so were their different views of marriage. One night, Bill asked Elaine to make supper. She replied that she'd do it if he cooked the following night. A long silence ensued. Then Bill uttered his often-quoted line: "What we need is a wife."[60] The following year, Bill rented a second-floor studio—shared with Jack Tworkov, in order to afford the thirty-five dollars monthly rent—at 85 Fourth Avenue, between 10th and 11th Streets, across from Grace Church.[61] Elaine painted on her own in the Carmine Street flat, which the couple also used as a bedroom.

Around this time, she had the first of two abortions during her years with Bill, who was not happy about having to advertise the fact when he had to

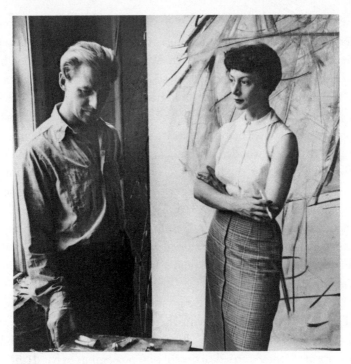

Willem and Elaine de Kooning, 1950.
Photo: Rudy Burckhardt. ©2016 Estate of Rudy Burckhardt/Artists Rights Society (ARS), New York. Photo courtesy of Tibor de Nagy Gallery, New York.

borrow money for the procedure. (She had been fitted for a diaphragm at the Margaret Sanger Clinic before her marriage, but it had apparently failed.) At this stage in his life, Bill had adamantly refused to be a father.[62] The experience of dealing with her mother's unsettling behavior may also have influenced Elaine's decision, as well as her own temperament. "She loved children, their energy, as long as it was tearing down the structure of parental authority," her nephew Clay Fried said, "but she didn't want to change diapers ... [or] wipe Cheerios off some kid's face."[63]

Toward the end of her life, Elaine told an interviewer that when she walked in Washington Square Park a year after her marriage—her memory of "my hair flying in the wind" serving as a stand-in for her feeling of freedom—she passed young mothers with baby carriages. "And I looked at them with *pity*! And they looked at me with envy."[64] She told her sister Marjorie that if she had had a child, she never would have become an artist, "because it is a full-time job."[65] Yet Elaine may have been deeply conflicted about becoming a mother. At one point—the year is not known—she experienced a false

pregnancy,[66] a rare condition (pseudocyesis) in which menstruation stops and the belly swells, among other symptoms. There is still no medical consensus on the causes of this curious malady, but factors are believed to include both the dread of and the desire for pregnancy.

Elaine's quandary must be understood in a broader context. "Women who were wives of painters didn't have children," said painter Emily Mason. "There was a real [unspoken] prohibition against that."[67] Even in the fifties, when artists' standard of living was improving, attitudes failed to change. When Mason was pregnant with her first child, she announced her happy news to Janice Biala, who asked how far along she was. Hearing that Mason was still in her second month, Biala said, "Oh, good. There's still time for an abortion."

SUNDAY NIGHTS AT HOME were devoted to Mayor Fiorello LaGuardia's radio talks; during the 1945 newspaper strike, he began reading the cartoons aloud on WNYC. On other nights, Elaine and Bill often read detective novels, a passion they shared with other artists, including Mark Rothko and William Baziotes ("the real expert," according to Elaine). At some parties, she said, "the discussion would not be about art. It would be about the comparative merits of Dashiell Hammett and Raymond Chandler."[68] The de Koonings' taste also ran to weightier books. Elaine read aloud to Bill from the works of nineteenth-century philosopher Søren Kierkegaard, which had been translated into English in the 1930s. His evocation of a life lived "authentically" underpinned the existentialist movement that had seeped into general awareness in the postwar era. It seems likely that Bill's interest in philosophical texts—"he liked to pick out a line which had meaning for him," Conrad said[69]—was sharpened by Elaine's wide reading and questing intelligence.

In 1949, when Bill was working on *Attic*, a vast canvas filled with the outlines of organic shapes, Elaine said that, despite the lack of treelike forms, the painting somehow reminded her of "[William] Faulkner's forest." (Forests have both a literal and a symbolic presence in his stories and novels.) As she told the story later, Bill "lifted a pile of papers, and underneath was a book by Faulkner."[70] Bill "loved Faulkner's endless sentences," she said. "He just was lost in admiration over how much would happen in one sentence." This was of a piece with his belief in the expansive aspect of painting—its capacity to hold many diverse influences—which would have a marked influence on Elaine's work.

SOCIALIZING TOOK DIFFERENT FORMS, from dinner at an artist's studio, followed by a viewing of his paintings, to chatting with friends encountered on the street. There were parties at the homes of artists who owned a record player and a stack of 78s of jazz musicians like Fats Waller or Louis Armstrong.

There were venues for live music and left-wing politics. "We'd meet at Café Society,[71] where we listened to boogie-woogie, and we'd meet at political rallies at the Artists Union[72] or at Madison Square Garden," Elaine recalled. "We could argue all night with as much energy as we expended on our dancing."[73] By 1943, the Waldorf Cafeteria, on Sixth Avenue[74] near West 8th Street, had replaced Stewart's Cafeteria as the artists' hangout. Beginning around 9 P.M., they would sit at the tables pushed against the wall, across from the windows fronting the road. Most of the artists who came to these sessions had formed their opinions about art on their own, and by talking with other artists.

"There was a tremendous amount of shoptalk that went on in the '30s, engendered by the WPA, and in the '40s it continued," Elaine recalled. "It was a constant mulling over of questions."[75] One night, the grandly philosophical painter Aristodemos Kaldis proposed remaking the neighborhood with Doric, Ionic, and Corinthian colonnades, each of which he believed to represent a different type of human influence. Elaine, who fearlessly jumped into these conversations, suggested that he "leave Eighth Street alone," because it was simply "an American marketplace."[76]

Cafeteria convocations left much to be desired, however, largely because the management frowned on customers who sat for hours while nursing a single cup of coffee. At one point, only four people were permitted to sit at a table, smoking was forbidden, and the door to the toilet was locked. Sculptor Philip Pavia came up with the idea of an artists' clubhouse, modeled on the social clubs formed by Italian and Greek émigrés, with rent paid by member dues. In 1948, he found a loft for rent at the top floor of a factory building at 39 East 8th Street, two doors up from The Subjects of the Artist, a school offering afternoon and evening sessions billed as "a spontaneous investigation into the subjects of the modern artist."[77] Subjects of the Artist was led by Robert Motherwell, in what others believed was a quixotic effort to shore up the reputation of the New York surrealist painters—considered hopelessly retrograde by the downtown artists who founded the Club. With a ratio of fewer than three students per teacher, the school was not financially viable; it folded in May 1949. The loft was taken over by Studio 35, led by three artists on the New York University faculty who continued the school's Friday night lectures, which were open to the general public.[78]

Bill was a charter member of the Club, as it was known, along with Pavia, Franz Kline, Ibram Lassaw, Conrad Marca-Relli, Ad Reinhardt, Milton Resnick, Joop Sanders, and others.[79] After the initial rule banning women was abolished, Elaine and Mercedes Matter were invited to join. (One early member recalled that "no one could keep [Elaine] out of anything she wanted

to be a part of."[80]) Artists would ascend the creaking wooden staircase worn down in the middle by decades of tromping feet. Dust balls and cigarette butts lingered in the corners of the stairs, fuzzily illuminated by a neon over-head light. Inside the loft, the atmosphere was a blend of cigarette smoke, the aroma of brewing coffee, and the aural assault of voices raised to stake out or defend a position.

Club furnishings were utilitarian: wooden folding chairs that were set against the walls for the Sunday night dances to phonograph records (when wives and girlfriends were invited). Wednesday nights, reserved for members only, were devoted to conversation and the occasional informal roundtable. But in Elaine's recollection, simply offering a room and a coffee pot was not sufficient to attract a crowd. In spring 1949, Pavia began organizing Friday night panel discussions and presentations by composers, philosophers, writers, and others.

As Thomas Hess recalled, the lecture would be "followed by...fiery denunciations from the floor" and then "beautiful women would pass around baskets and collect dollar bills from the audience."[81] The money was used to buy bottles of liquor, served in paper cups. "Everyone would have a tiny amount," Elaine said, "like half an inch in a paper cup. And they would have records of polkas, which Philip Pavia liked, so everyone would dance. And that would go on for hours. It was a great deal of fun.... It became very, very festive."[82] Who were the "beautiful women"? Perhaps Elaine was among them.

She was remembered for coming to Club events "more often than any other woman," often in the company of her close friend, Ernestine Lassaw.[83] Along with Mercedes Matter, Rose Slivka, Alice Yamin, May Tabak, and Grace Hartigan, Elaine was one of the women known as "floor panelists," who would interrupt the speakers. As Pavia observed, these women "came in sheepishly and bounced out as colt horses.... Where else could a woman...heckle a man on art?"[84] Elaine's moxie even extended to dealing with visits by the police; Pavia would "let Elaine de Kooning handle them—and she did."[85] Alex Katz recalled Elaine "putting a cigarette in her mouth and waiting for someone to light it"[86]—shades of her coquettish pose with Bill.

Relations between the Club and Studio 35 foundered after the Club's artists were increasingly invited to speak there. Club members were a contentious group, suspicious of being asked to serve a project they believed was allied with surrealist interests and the agenda of the uptown Museum of Non-Objective Painting. In 1950, when Bill was asked to be a speaker at Studio 35, he insisted that Motherwell—by then living in Boston—come down and deliver the talk, "The Renaissance and Order," which Elaine co-wrote. Yet Bill and Elaine, and

several other Club artists, couldn't resist dropping by to hear it. If this infighting among a beleaguered group of artists seems hard to fathom, we have to realize that postwar New York was riven by political factions hotly debating the merits of Stalin and Trotsky; the artists' insistence on taking sides was of a piece with the fiercely ideological positions staked out by intellectuals of the era.

At a members-only session of the Club on April 25, 1951, the conversation turned to distortion in art. Elaine said, "I believe more in van Gogh. A distorted look in a face or figure is an irrational quirk." Bill seemed to agree, voicing his dislike of distortion both "from the inside," in the work of German Expressionists, and "from the outside," in the paintings of Chaim Soutine and Francis Bacon. After other artists chimed in, Elaine reminded everyone of Maurice de Vlaminck's remark that a telephone line conveying an emotionally fraught conversation could be painted with a wiggly stroke. "To me, a telephone wire is not just a wire," she said. "A mere line doesn't do it."[87]

What matters from this temporal distance is not so much what Elaine said at these meetings as her utter fearlessness, as a thirty-three-year-old woman, speaking up during a heated discussion by *seventeen* male artists. Her Brooklyn-bred voice had a unique inflection and her pronunciation of certain words was idiosyncratic. Alfred Leslie later said that she had unconsciously picked up aspects of Bill's Dutch accent.[88]

Elaine was especially active at the Club in 1952, when she and Mercedes Matter became the only female members of the voting committee that determined Club policies. On January 25, Elaine was a member of the "Abstract Expressionism II" panel—convened after the publication of Thomas Hess's new book, *Abstract Painting*—along with fellow painters Adolf Gottlieb, Harry Holtzman, Burgoyne Diller, and Peter Busa.[89] She was also the only woman on two panels held in April: "Integration of Art and Architecture" (with Denby, Raymond Hendler, and Frederick Kiesler) and "Problems of the Engaged Artist" (with Barnett Newman, Emanuel Navaretta, Lionel Abel, and Hendler).[90] On May 14, Elaine "sponsored" (i.e., organized) the "New Poets" panel, introduced by Frank O'Hara, which featured John Ashbery, Barbara Guest, and James Schuyler, with Larry Rivers as moderator.

In November, in the giddy final moments of an all-night Club party for the painter known as Alcopley,[91] who was moving to Paris, people were digging into wallets and pocketbooks to give him old tickets and ID cards. Elaine upped the ante by removing her right shoe and stocking, and ceremoniously handed them over, "amidst great applause."[92] (This witty Dada gesture was apparently interpreted as a purely sexual come-on by Nancy Ward, Franz Kline's companion. In an effort to compete with it, she removed her bra and presented it as an additional offering.)

Elaine resurfaced as a panelist on January 28, 1955, when she served on "Nature and the New Painting II"—a response to an essay by Frank O'Hara in which he argued for a broader understanding of "nature" in art that encompassed abstraction, as well as realism.[93] O'Hara and artists Mike Goldberg, Grace Hartigan, Milton Resnick, and Joan Mitchell were the other panel members. In his essay, O'Hara had discussed Elaine's paintings of basketball players who "leap in excitement of paint...like the cheering of spectators." He praised her ability to capture movement and the perceptual basis of her paintings: "What she experiences seems to go straight to the canvas."

In addition to her keen participation in these discussions, Elaine played the role of an amused onlooker. Her satirical piece, "Participants in a Hearsay Panel,"[94] skewers the contentious atmosphere of the Club in the late fifties. ("Neo-Dada has become Neo-Mama," says one participant. Others chime in: "Neo-Mau Mau." "Neo-Meow Meow." And then Elaine says, "Well, according to a noted museum director, the only thing that sells right now is Neo-Me Me.") She was also unafraid of challenging the status quo. A couple of years later, she accosted the art writer Irving Sandler. "The Club has two hundred members and none of them is black. Why?"[95] Whether she ever received a satisfactory answer is not known—Sandler wrote that there were only a handful of black artists in the downtown art world in those days—but hers was surely one of the few voices to raise the question.

Wayne Thiebaud, who came to New York from California in 1956 and stayed for a year, offered the sharply focused view of an outsider surveying the scene: "You'd go to almost any opening, and [Bill] de Kooning would be there, Harold Rosenberg, Clement Greenberg, Barnett Newman...talking and arguing. They also all met at the Club very often on Friday nights."[96] Thiebaud was fascinated by the way Bill would join conversations "seemingly from left field." He recalled Bill's wry observation at the Club memorial for Jackson Pollock, who had died in a car crash in August: "Everybody said [Pollock] was very good...so I go to his studio, and to tell the truth, his work didn't look so goddamn good to me. But the trouble was, I got back to my own studio, and my work didn't look so goddamn good either."[97]

ELAINE ONCE LIKENED the downtown artists of the late forties and fifties to children who played only with the youngsters on their block. While she and Bill also knew artists who lived uptown, or who had left Manhattan (Gorky moved to Connecticut in 1945), the immediate neighborhood was a hive of creative activity. As many as forty artists had studios on 10th Street, including Pat Passlof, Mercedes Matter, Fay Lansner, Perle Fine, Joan Mitchell, Franz Kline, Milton Resnick, Ad Reinhardt, John Ferren, Philip Guston, Michael

Elaine at a gathering on the roof of the Tanager Gallery, 1956.
Photographer unknown. Joellen Bard, Ruth Fortel, and Helen Thomas exhibition record of "Tenth Street Days; the Co-ops of the '50s," 1953–1977. Archives of American Art, Smithsonian Institution, Washington, D.C.

Goldberg, Conrad Marca-Relli, Ludwig Sander, Esteban Vicente, and Nicolas Carone. In 1959, Harold Rosenberg would belatedly salute the 10th Street artists in an *ARTnews* feature illustrated with individual photos of artists—including Elaine and Bill—standing in a doorway or walking down the front steps of their lofts. Other shots offered views of studios and gallery openings,

and revealed the proletarian grubbiness of the street, with its shambling bums, pool hall, and a shop selling guns and fishing tackle.[98]

It was only natural that the artists developed close ties as they constantly encountered one another while walking down the street, waiting on line at the hardware store, or hanging out at the Cedar Tavern. Drab and smoke-filled, it had a bar up front where artists could greet colleagues as they entered, and booths in the back, occupied for hours by talkative groups huddled around a pitcher of beer. Because the Cedar was just around the corner from the Club, it soon "began to be crowded with artists who didn't want to attend the lectures at the Club and were waiting for the parties afterward," Elaine recalled. "Then the Cedar became a hangout every night of the week—a festive place to go after the day's work, knowing you'd always find some friends."[99] A great mystique grew up around this bar in subsequent decades, but as Elaine told an interviewer, its appeal was simply a matter of its convenient location: "8th Street at University Place was the center of the universe" for downtown artists. "There were years when you went to the Cedar and knew each and every person," she said. It was a place where "young could meet old," poverty occasioned funny stories, and the competitiveness that emerged later among artists "didn't exist," because the situation was hopeless—everyone was in the same leaky boat.[100]

One evening in 1950, Elaine was sitting in a booth with Bill at the Cedar when author and photographer John Gruen came over to tell her how much he liked her writing. "The thing you noticed about Elaine was her tremendous vitality and wonderful wit," he recalled. "Coming from an Irish background, she had a fast and funny comeback with just enough edge to it to put you on the alert." He was impressed that not only did Elaine keep up with the men when it came to drinking, but she also "could hold forth with greater verbal virtuosity than many of that crowd." It struck him that "Elaine loved art, but she seemed to love people even more." [101]

3

Black Mountain, Provincetown, and the *Woman* Paintings

BILL'S FIRST ONE-PERSON exhibition, at the Charles Egan Gallery, opened on April 12, 1948.[1] Elaine knew that it would not be easy to get him to let go of his eternally "unfinished" canvases before he painted over them, and to amass enough completed work for a show. So in fall 1946, she and Egan had hatched a plan: they set the opening date—a firm deadline to work toward—many months in the future. Intent on giving the show a unified focus, Bill eventually decided to exhibit ten of his black-and-white paintings and none of the figurative works.

It was far from a given that avant-garde American artists in those days would have their work shown in a New York gallery. Dealers hospitable to the new work could be counted on the fingers of one hand: Julian Levy, who showed Gorky; Betty Parsons (Jackson Pollock); Marian Willard (David Smith); Peggy Guggenheim (Robert Motherwell); Edith Halpert (Stuart Davis). Their galleries were all located uptown. In the early 1950s, a cluster of "shoestring" galleries opened downtown, near the artists' lofts, including Peridot and Tibor de Nagy—and artists began to form co-op galleries, beginning with Tanager and Hansa. Egan was a high school dropout who became friendly with the downtown New York artists at the Waldorf Cafeteria. He had begun his art-dealing career at Wanamaker's department store and moved on to a couple of galleries before launching his own space in 1946.

As opening day neared, Elaine, Charles, and Bill gathered in the Carmine Street apartment to name the paintings. They decided that three positive votes were needed to determine each title.[2] (The one exhibited as *Painting* must have eluded their attempts at agreement.[3]) There was no evening reception at the gallery, but Bill and Elaine didn't even bother to show up on opening day. Asked about this years later, she dismissed the idea: "Nobody went to openings in those days."[4] *ARTnews* critic Renée Arb published a glowing

review, and Clement Greenberg, writing in *The Nation*, called Bill "one of the four or five most important painters in the country," but the paintings did not appeal to the few collectors who saw them. (Most of the gallery visitors were artists who couldn't afford even $300 for a picture; playwright and screen-writer Clifford Odets was interested but said the prices were too high for an unknown artist.[5]) There were no sales by May 12, the final day of the show, so Egan kept it up until June 25—an extension that Elaine later called "an embar-rassment to Bill. It made things seem more hopeless."[6]

The couple's finances were as rocky as ever. They had no way of knowing that four months later, the Museum of Modern Art would buy *Painting*, for $750. Elaine had begun writing reviews for *ARTnews* (see chapter 4), but al-though she spent many hours on each one, the pay was just two dollars apiece. So, it was a great relief that Bill had a two-month teaching job at Black Mountain College, in the mountain hamlet of Asheville, North Carolina. Two round-trip train tickets were issued, room and board were free, and Bill would receive $200—enough for two months of rent for his studio ($70) and for the Carmine Street apartment-cum-studio ($36) while they were away. The remaining $94 would cover art supplies and sundries, including the ciga-rettes they both smoked constantly.

Founded in 1933, Black Mountain College was an experiment in progres-sive, arts-centric learning that was owned and operated by the full-time faculty. The painter Joseph Albers, a recent émigré from Germany after an illustrious career at the Bauhaus,[7] was the first teacher hired. He had offered Bill the summer position when painter Mark Tobey declined it, and after seeing reproductions of *Painting* and *Orestes* in the February issue of *Magazine of Art*.[8]

The train journey to Asheville began unpromisingly, at night, in a heavy downpour. Reluctant to spend one of their precious dollars on fifty-cent pillow rentals, and unable to find a comfortable sleeping position, they gave up and read mystery magazines. In the morning, as the train lumbered up a mountain, a bright green landscape beckoned through the window. But their first impression of the campus was dismal. "There were isolated students sun-ning themselves on the grass, looking, we thought, peculiarly listless and for-lorn."[9] It was a relief to be greeted by Albers, "embracing us like old friends."

The accommodations were basic: a cottage, minimally furnished with a table, two chairs, a bed, and a bureau. The dining hall's communal tables fostered engrossing conversations among the faculty—who included composer John Cage, choreographer Merce Cunningham, futuristic architect Buckminster Fuller, geometric weaver Anni Albers, and sculptor Richard Lippold—but the meals were barely edible. A "frankfurter-and-banana salad looked like

something Elaine would make," Bill joked."[10] Yet, whenever the dinner bell rang, students and faculty stampeded for the dining hall; top speed was necessary to avoid missing out on the limited quantities of food. Two summers later, well-heeled painter Helen Frankenthaler was appalled at the "depressing" atmosphere. She found the people "dingy," the food "terrible," and the housing situation "unspeakable." Snakes, which she assumed to be poisonous, slithered across the road at night.[11]

But Elaine and Bill were troupers, accustomed to making do. After viewing the Studies Building, with its tiers of tiny identical studios—just big enough for a desk, chair, and cot—Bill decided to paint in the cottage's living room. Elaine used one of the studios, resting her palette on the desk and reveling in a view of Lake Eden, visible through the window. She would paint on sheets of wrapping paper tacked to the wall.

Elaine was one of about thirty students in Albers's class in color theory. (As female student, Elaine was part of a tiny subgroup, along with sculptor Ruth Asawa, photographer Hazel Larsen, and painter Pat Passlof.) Albers's instruction was based on a simple principle, "to open eyes." She found his teaching style at once "authoritarian" and "hilarious," regaling Bill with imitations of his rebukes to wayward students. ("Ach so, Mr. Dublin. You are smiling. You are finding somesing I am saying funny.")[12] But she also gained a new appreciation for the optics of color as she worked on exercises designed to sharpen artists' ability to discern subtle aspects of the visual world.

One day, Albers held up several shades of green and challenged the students to identify the precise color of a Coca-Cola bottle. Some of his exercises—such as writing your name with your eyes closed and then switching to your nondominant hand and repeating the task with open eyes—emphasized kinetic awareness. Elaine's quick mind and impetuous spirit sometimes clashed with Albers's stress on working steadily toward a single goal. When she attempted to solve several of his visual problems in one composition, he tore it up, calling her approach "too extravagant." Decades later, she would contrast Albers's style of teaching with Bill's patient, one-on-one instruction.[13] His class consisted of having everyone work on just one drawing or painting of the still life he had set up. Pat Passlof would remember Bill's talk on "Cézanne and the Color of Veronese" as a reassuring corrective to the prevailing notion that an abstract artist was supposed to sever all ties with the past.[14]

Watching portly, fifty-three-year-old Buckminster Fuller make his way to the podium to give an evening lecture, Elaine whispered to Bill that he looked "stuffy." Then Fuller launched into a rapid-fire talk about ecology, engineering,

and technology, illustrated with geometric constructions made from clothes-pins and other everyday materials. Moving to the blackboard, he drew a square, connected two opposite corners with a diagonal line, and said, "Ah, here's our old friend, the hypotenuse." Charmed by this droll remark, Elaine decided to take his course. She was the lone woman—an ideal situation, from her perspective; the others were mostly architecture and engineering majors from Harvard.

Fuller led the class in the construction of the first full-scale geodesic dome, using six "great circles" constructed from aluminum Venetian blind strips—a make-do aspect typical of the Black Mountain spirit. The great circles' inter-sections would form the rigid triangular elements needed to distribute stress, enabling the twenty-two-foot-high[15] dome to remain standing with no inte-rior supports. After computing the dome's projected tensile strength, the class had determined that double strips would be needed, but the school had pro-vided only enough money for single strips. Fuller was undeterred.

On a rainy day, virtually everyone on campus who was not involved in the project stood and watched as the students bolted the aluminum strips to-gether and tried to make the structure stand up. "This isn't going to work," Fuller told Elaine just before the countdown, "but we'll try it anyway."[16] Sure enough, the dome rose only a few feet before collapsing. "All the Bauhaus types [who] came to watch…stood around and laughed like the laymen laughed at Robert Fulton when he first tried his steamboat," Elaine said. "And I just knew Bucky was right and they were all wrong."[17] Fuller dubbed the piece Supine Dome and later claimed that he actually wanted to show how safe a collapse would be. ("I only learn when I have failures,"[18] he said, a senti-ment Bill shared.) Fuller's emphasis on the way things worked rather than how they looked irritated the design-oriented Bauhaus people at Black Mountain. But Elaine adored him: "I thought, thank God I didn't meet him when I was eighteen, because if I had, it would have pulled me right off my track. I would have become an engineer, because he made it *so* fascinating; he was the pied piper of engineering."[19]

One day, Elaine, Bill, and student Ray Johnson[20] watched Fuller use the silverware on the table of a local restaurant to build increasingly complex three-dimensional constructions—with help from Elaine's bobby pins—while discussing their engineering properties. When the waitress came with Elaine's order, she didn't want to retrieve her knife and fork, so she reached into her purse for a pair of pliers to hold her hamburger. Observing this, Fuller quickly improvised: "Which brings us to the paradox of tensile strength!"[21]

Buckminster Fuller, Elaine, and Josef Albers, 1948.
Photo: Beaumont Newhall. ©1948 Beaumont Newhall. ©2012 The Estate of Nancy and Beaumont Newhall. Courtesy of Scheinbaum and Russek Ltd., Santa Fe, New Mexico. Image courtesy of North Carolina Museum of Art, Black Mountain Research Project.

At other times, Elaine—who treated Black Mountain as the college expe-rience she had missed out on—distanced herself from Bill. She told a friend who asked if she was staying in the couple's faculty cottage, "Oh no, we're separated."²² (Bill seems to have slept in a dormitory, where he complained about the students' noise.) At lunch, Elaine joined Cage and Cunningham for

conversations punctuated with bursts of laughter ("Bill...called us the gigglers"). She went swimming in Lake Eden with fellow students, a sandals-and-beards crowd whose bohemian style must have been especially appealing. "I made [Bill] feel even more like an outsider," she confessed years later to an interviewer. "I was totally inconsiderate."[23] But Cage valued her friendship. A decade later he dedicated his "Solo for Piano" to her—a work in which he consulted the I Ching so that chance would dictate the placement of notational techniques (which the pianist could play in any sequence) on the page. It is probably not coincidental that he chose this radical transmutation of standard musical notation into "an abstract visual language" as his homage to Elaine.[24]

A shocking event that temporarily brought the de Koonings together was Arshile Gorky's suicide on July 21. Egan had sent them a letter about it, enclosing a newspaper clipping.[25] The couple had last seen the painter at a party in late February celebrating his solo show at the Julian Levy Gallery. Gorky, whose melancholy temperament would surface at the best of times, had been depressed for many reasons. He had undergone a colostomy in 1946; his wife, Agnes ("Mougouch"), was having an affair with the painter Roberto Matta; and despite positive (if uncomprehending) reviews, his work was not selling well. Then, in June, Gorky was seriously injured in a car accident and had to wear a massive head brace. Mougouch had endured years of her husband's fierce possessiveness and frightening rages. After he confronted Matta, she left him, taking their two children. Despairing of any reversal of his misfortunes, Gorky walked into the shed on the family's Connecticut property and used the noose he had prepared weeks earlier. In Asheville, Elaine, Bill—who had "recoiled [at the news] as if struck"[26]—and Ray Johnson took a long walk to reminisce about him.

Bill had always revered Gorky's insights, developed while copying the work of artists past and present. His observation that all art, even the work of the great painters of past centuries, lives in the present—that you could freely borrow from it while finding your own way as a painter—made a lasting impression on the Bill. And because he was Elaine's ultimate tutor, she would allow her own knowledge of Old Master paintings to infuse her work with an extra dimension, as we shall see.

IN THE MORNINGS, Elaine took Cunningham's two-hour dance class, held six days a week in the dining room. At night, there were lectures by the faculty on subjects ranging from Tolstoy to industrial design, and concerts of the piano music of Erik Satie, played by John Cage. A champion of the French

composer, Cage also mounted a production of *The Ruse of Medusa* (Le Piège de Méduse), a one-act play with music by Satie.[27] (Cage played it on an out-of-tune piano.) He chose Elaine for the role of Frisette, daughter of Baron Medusa,[28] and asked Fuller to play the Baron. William Schrager, "the handsomest student on campus,"[29] played Frisette's suitor. Cunningham took the

William Schrager, Merce Cunningham, and Elaine in *The Ruse of Medusa,* 1948.
Photo: Clemens Kalischer (?). Jerome Robbins Dance Division, The New York Public Library for the Performing Arts, Astor, Lenox and Tilden Foundations.

role of a mechanical monkey that cavorted between the scenes in sixty-second dances he devised.[30] The director was Arthur Penn, years away from fame.

Elaine, who had only one line in the play, remembered the rehearsals as a lot of fun, with Fuller's remarks keeping everyone in stitches. Yet he initially worried about making a fool of himself as this pompous character in a tail-coat, and it took all Penn's skill—including deliberately silly exercises involving skipping and rolling on the floor—to get him to feel at ease onstage. In one photo of the production, Fuller looks much more relaxed than Elaine, who stands stiffly in her long flounced muslin dress, with the fingers of her downstage hand tensely curled. Penn had coached her in a "pert, mincing walk and fluttery gestures"[31]—totally different from her athletic, free spirited self. (Decades later, Pat Passlof remembered Elaine's performance as "hilarious."[32]) She was also put in charge of set design—she got Bill to use his crafts-man talents to create a faux marble veneer on a desk and two columns—and costumes, which were made by Mary Outten, one of Bill's students. The August 14 performance, in the dining hall (the college had no theater), was considered a highpoint of the summer session. There was talk of bringing the production to New York, but no one knew the sort of influential sponsors who could make that happen.

The sets and costumes did make their way to Manhattan; the following summer, Elaine wore her Frisette costume for her leading role in *The Dogwood Maiden*, a twenty-one-minute silent film by Rudy Burckhardt, with dialogue presented on title cards. She played the Sorceress in this comic fantasy, set in the "enchanted" forests of Wading River (a tiny town on the north shore of Long Island). This was a marvelous role for Elaine, who initially appears in a black wig and a long, artfully shredded black dress, flicking her fingers in a suitably magical way. "It's going to be snakes for supper," she says. "Snakes for dessert, too." This was probably an in-joke about her disdain for cooking, though the snakes may also have been meant to invoke the White Goddess myths, recently popularized by Robert Graves.[33] (Years later, Frank O'Hara called Elaine "the White Goddess" because "she knew everything, told little of it though she talked a lot, and we all adored [and adore] her."[34]) At one point in the film, Elaine performs a seductive dance to guitar music played by Burckhardt, luring him down to the ground where they begin to make love. When the spell is broken, she is transformed into "Clarissa, a glamorous belle of the village," demurely turning from side to side like a mechanical doll in her Frisette dress, with dogwood flowers in her hair.

IN ADDITION TO his teaching, Bill worked all summer on one painting, *Asheville*, a complex layering of abstract and quasi-figurative elements (an eye,

a window, a fat-cheeked face in profile), energized by swaths of pink and orange. He painted on a piece of cardboard; Elaine worked on wrapping paper. She had begun painting abstractly in 1947, at her Carmine Street studio, but now her style had become more distinctive, with rhythmic qualities that varied from languid to jazzy. Most of the seventeen abstractions she completed that summer contained small, rounded, irregularly shaped forms that jostle together or float separately on a milky backdrop. Some of the works are in high-key colors—pink and orange (the couple probably shared those pots of enamel) and turquoise. Others were painted in quiet neutrals. Elaine seems to have been experimenting with Hans Hofmann's push-pull theory, according to which the adroit management of warm colors (which appear to push forward), cool colors (which seem to recede), and overlapping shapes creates a sensation of motion—coaxing the eye to move around the canvas rather than resting in one spot.

Back in New York, she put away these paintings, still rolled up from their journey, as if a chapter in her life had closed. Thirty-five years later, she dismissed them as "a testimonial to the durability of paint, if nothing more." They didn't resurface until after her death, in shows at the Benton Gallery in Southampton and the Washburn Gallery in New York.[35] Writing in *Art in America*, critic Lawrence Campbell noted that "[e]ach painting has the all-conquering optimism of abstract art during the '40s."[36] He saw multiple influences in these works, including the paintings of Gorky and pre-Columbian and American Indian art. The *New York Times* reviewer admired the liveliness of these works; she particularly liked the smaller ones, but couldn't resist finding them "eerily similar" to Bill's paintings of the early 1990s.[37] This was a stretch, because Elaine's compositional structure was much tighter; her painterly freedom had not yet caught up to her impetuous personality. In 1992, when the Metropolitan Museum of Art acquired *Untitled, Number 15* (plate 5), the museum bulletin described its "quick, broad brushstrokes and bright, shiny colors...loosely organized around an architectural understructure"—a feature perhaps related to Fuller's influence—and opined that Elaine's "later representational styles never showed the same daring or intensity."[38]

ELAINE EXPERIENCED THE BEST of both worlds at Black Mountain, hanging out with students as well as faculty. She became part of the inner circle as Bill's wife but bonded with people by the sheer force of her personality. As a parting gesture, Elaine and a group of students took action against a local resident who had angrily accused them of ruining his expensive grass as they walked past his house. Retaliation consisted of ornamenting the lawn with dozens of gleaming pennies.[39] There were many parties that summer, social

events that allowed everyone to take a break from the contentious atmosphere of dueling ideas about art. The final celebration was a ball at which Elaine waltzed with Fuller, who told her she was "a terrific performer per ounce."[40] After the summer session ended, Elaine lingered at Black Mountain while Bill returned to New York with his student Pat Passlof.[41]

That fall, Bill painted *Woman*, a toothy figure with a giant eye, prominent nostrils, mismatched arms and breasts, and flowing blonde hair. On the left side of the canvas, a giant eleven-point yellow star nearly pokes into her upraised face. On the right side is the faint outline of a house. It's tempting to link those details to a walk Elaine and Bill took along a country road one night in Asheville, after Bill complained about the noise at a party they attended. The utter quiet and the canopy of stars proved too much for him. "Let's get back to the party," he said. "The universe gives me the creeps."[42]

Did the painting—the first in a parade of increasingly exaggerated figures of women—conflate this unsettling experience with his current feelings about Elaine? During these years, Elaine was impatient with Bill's need to spend nights painting. "She thought, you paint during the day and then you go out and have fun," her brother Conrad said. "And Charlie [Egan] was like a good-time Charlie."[43] Helen Frankenthaler later recalled that she and Clement Greenberg would "pick up Charlie Egan and Elaine, usually at the Egan Gallery," and their other friends—who included *Partisan Review* editor William Phillips and his wife Edna—and go out for drinks at the Cedar [Tavern]." She did not mention Bill.[44] Nights out on the town fueled an intimate relationship. Egan surprised Elaine by marrying a woman he had recently met, but the affair continued, with his wife's knowledge.[45] At a party Bill did attend, Egan's wife Betsy saw him banging on a locked bedroom door; inside were her husband and Elaine.[46] Around this time, Bill began an affair with the pretty and vivacious abstract painter Mary Abbott, who had separated from her husband two years earlier. He would have overlapping casual involvements in the next few years, giving each woman a special bell-ringing code for his studio.

Bill was constantly asked about the *Woman* painting. He would say that he was intrigued by the shapes of the women he saw passing by on the street—the top-heavy effect of large breasts, the amplitude of thighs and buttocks, the exaggerated effects created by thickly applied lipstick and eye makeup.[47] This observation, made by an artist accustomed to studying the shapes of things and veering in and out of abstraction, seems a plausible explanation of how he came to paint these images. The complex mutations of Bill's earlier paintings of women—from the abstracted image of Elaine in *Queen of Hearts* (1943–1946)

and the biomorphic voluptuousness of *Pink Angels* (1945) to the fantastic protuberances of *Warehouse Mannequins* (1949)—illustrate his sustained painterly fascination with the lushness of female anatomy, as glimpsed and imagined. He painted various versions of *Two Women* during summers that he and Elaine spent in East Hampton, where women in skimpy summer togs were everywhere to be seen. One influence he cited was Jane Bowles's experimental novel *Two Serious Ladies* (1943), about two proper Americans who embrace louche living in coastal settings.

Over the years, Bill supplied other supposed sources for these works, from the "greedy and nasty" faces of women picking over a sales table at S. Klein[48] to his own mother, whose rages and abuse had dominated his childhood. He even suggested that he was "painting the woman in me,"[49] a remark that has been linked to a "perceived crisis in American masculinity" at mid-century—an attempt by male artists and writers to purge their identification with their mothers in order to reify their masculine identities.[50] But it is overly deterministic to view a group of paintings simply as testimony to a prevailing mindset.

Bill once said, "Women irritate me sometimes. I painted that irritation in the *Woman* series."[51] Yet he is also on record as saying (though not specifically about these paintings), "I like the grotesque. It's more joyous."[52] One knowledgeable observer has proposed that "[t]here will never be a concrete answer" to questions about the identity and meaning of these painted figures, "because the Women are first and foremost part of a formal painterly evolution in de Kooning's work."[53] Ultimately, the sources of a great artist's work can never be fully known. Who can itemize with certainty all the impulses, memories, and influences (artistic and real-world) that produce any significant work of art? Parse it as you will, it will always kick over your neat little boxes and insist on its own peculiar strangeness. During Bill's two-year struggle with *Woman I* (1950–1952), images in his mind of Mesopotamian goddess figures and Picasso's paintings mingled with thoughts about his mother, about Elaine, and about women in general. For reasons that he himself may have only partially understood, when his painted creature assumed a form somewhere between demon and cartoon, he did not choose to wipe it out.

IN THE SUMMER of 1949,[54] Elaine traveled to Provincetown, Massachusetts, where Hans Hofmann ran his fabled school. She rented a studio and sat in on his classes, which were attended by a mix of elderly Sunday painters (whose work he invariably praised) and young male students (who received his unvarnished criticism). It was an odd move—Elaine had previously found little of value in a lecture he gave—but probably an attempt at not only distancing

herself from Bill for a while but also finding a new mentor. As she said later, "It wasn't so much what he said about any one [student's] painting, but what he said about painting in general."[55] Years later, she recalled his technical advice about always retaining the "ground"—the base color of a painting. When she got stuck, she would add more white paint before trying to make further changes.[56] Hofmann, whom Elaine described as "a kind of bull elephant," gave a party featuring an innocuous-seeming punch with a staggering alcohol content. "Everyone crawled out on their hands and knees," she said.

Elaine shared a rental at the ocean with artist Susie Mitchell, one of Clement Greenberg's girlfriends, and the son of the owner of Maeght Gallery. According to Edith Burckhardt, "when people had hangovers and made bad gossip about each other," Elaine "went on cheerfully painting and partying." At summer's end, her roommate finally got up the nerve to ask how she managed to keep her cool. "When does it ever hit you?" she wanted to know. "'Never,' [Elaine] replied. [She] would not let it."[57]

In a humorous letter addressed to her young godchild, Denise Elaine Lassaw—Ernestine and Ibram's daughter, named in Elaine's honor—she mentioned the swimming and boating, the "moonlight parties and picnics," and her belief that she was the only person in Provincetown who didn't have a car. She sketched the heads of four of the painters in town and a row of people holding ice cream cones. This summer paradise would end soon. "The days grow shorter," she wrote, adding musical notes to illustrate the slightly misquoted words from "September Song."[58]

Larry Rivers was one of the Hofmann School students that summer. Estranged from his wife, he and his married lover, a painter also taking classes at the school, had rented a one-room apartment near the beach.[59] Every week, there was a painting "crit," an event attended by a mob of artists (not necessarily Hofmann's students) tightly packed into the school's single room, warmed by sun pouring through the skylight. From Rivers's urban perspective, Provincetown was a strange place—the air "full of fish and salt" in town, an "odorless breeze" on the dunes. The bars—he had a saxophone gig at one— were all decorated with fishermen's nets and other nautical paraphernalia. In his memory, this was a summer all about sex, nude sunbathing on the beach, "getting happy" (either with alcohol or pot), and making art.

Social events made the artists feel "part of a happily beleaguered community," Rivers said. At one dinner party he hosted, the guests included Elaine, poet Delmore Schwartz, writer Milton Klonsky, and painters Fay Gold, John Grillo, Anne Tabachnick, and Jane Freilicher—who brought her husband, a stack of Count Basie records, and tomatoes from her garden. Grillo concocted

a dish that tasted like meat but (he confessed later) was made from locally caught whiting. Rivers recalled that Elaine, who wore heavy makeup and an unfashionably short skirt, talked rapidly "about everything from drawing to capital punishment," with her "customary verve and intelligence." She had arrived at the party with painter Perle Fine, "proving her fidelity to Mr. de Kooning as well as to Tom Hess and Harold Rosenberg," Rivers wrote, teasingly alluding to her sometime lovers.

Bill was intermittently part of the Provincetown scene. "He came to visit me now and then," Elaine said later, in a rare admission that she was not totally on her own that summer. Someone took a photograph of the two of them sitting back to back on the beach, Elaine wearing a pert expression and a sexy two-piece bathing suit.[60] Joop Sanders, who was visiting, recalled Elaine's worries that Biil would drown after getting drunk on sherry with an unidentified artist; the two of them had walked down to the beach despite hurricane warnings. When Sanders found them, the other man had passed out. To revive him, Sanders and Bill decided to move him into the water. Lacking bathing suits, they stripped off their clothes. Although the beach was deserted, they were arrested by a state trooper for indecent exposure, jailed briefly (until they sobered up), and fined five dollars.[61] Despite the couple's increasingly separate lives, Bill remained solicitous of Elaine. At one point, he wrote to Jack Tworkov asking for a loan of fifty dollars to pay for his return to New York "and also [to] leave Elaine some money."[62]

Overshadowing all summer activities was a double-page spread in the August 8th issue of *Life* magazine about Jackson Pollock. Arnold Newman's photograph of the thirty-seven-year-old painter showed him in paint-spattered work clothes with arms crossed, in front of his eighteen-foot-long painting, *Number 9*.[63] "Is he the greatest living painter in the United States?" the headline teased. Although the mass-market weekly seemed at best uncertain about Pollock's achievement, this was the first acknowledgment by the mainstream media that the tiny downtown art world had anything to crow about. Bill cracked that Pollock looked like a gas station attendant.[64]

Elaine and Bill were included in Artists: Man and Wife, an exhibition of work by ten artist couples—including Pollock and Lee Krasner[65]—that opened in September at the Sidney Janis Gallery. (Three years earlier, the de Koonings were part of a similar exhibition, Husbands and Wives, at the Laurel Gallery.[66]) Elaine showed her wide-eyed *Self Portrait* (ca. 1942); Bill's painting has not been identified. Stuart Preston, the *New York Times* critic, wrote that "on the whole the husbands are the more adventurous." He criticized the wives for basing their work merely on the "design or color" of their

Elaine, Lee Krasner, Dorothy Norman, Jackson Pollock, and Willem de Kooning, 1950.
Photo: Jack Calderwood. Jackson Pollock and Lee Krasner Papers, Archives of American Art, Smithsonian Institution, Washington, D.C.

husbands' styles. Preston singled out Bill and Elaine (as well as Pollock and Krasner) as exemplars of this perceived difference between the men and the women, an attitude echoed by the *ARTnews* reviewer.[67]

During the next decade, Elaine's increasing painterly freedom would help her break free of Bill's direct influence. Her idiosyncratic portraits and vivid images of sporting events would change the course of her creative life.

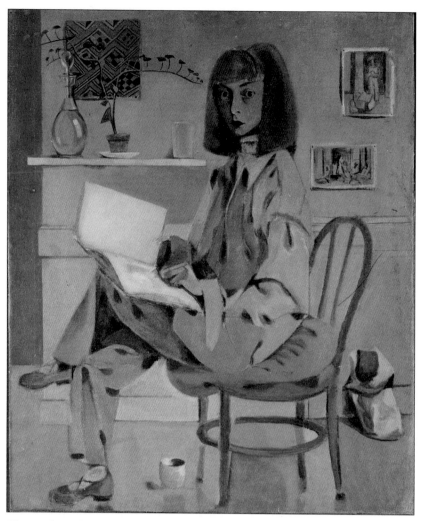

Plate 1. Elaine de Kooning, *Self-Portrait*, 1946.
Oil and charcoal on canvas, 23-3/4 x 19-3/4 inches; Metropolitan Museum of Art, New York; George A. Hearn Fund, 1994. Image ©The Metropolitan Museum of Art. Image source: Art Resource, NY. © Elaine de Kooning Trust.

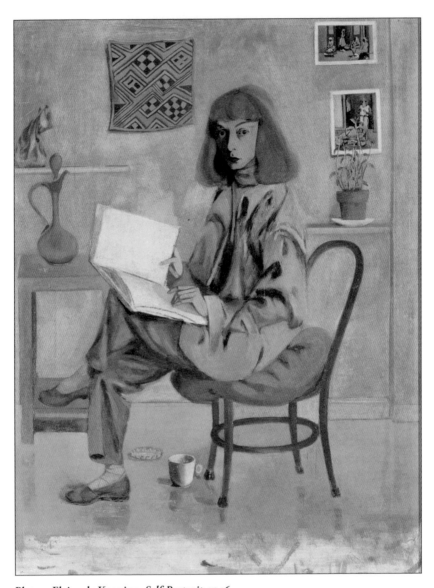

Plate 2. Elaine de Kooning, *Self-Portrait*, 1946.
Oil on Masonite, 29-3/4 x 22-1/2 inches; National Portrait Gallery, Smithsonian Institution.
Photo credit: National Portrait Gallery, Smithsonian Institution / Art Resource, NY. ©Elaine
de Kooning Trust.

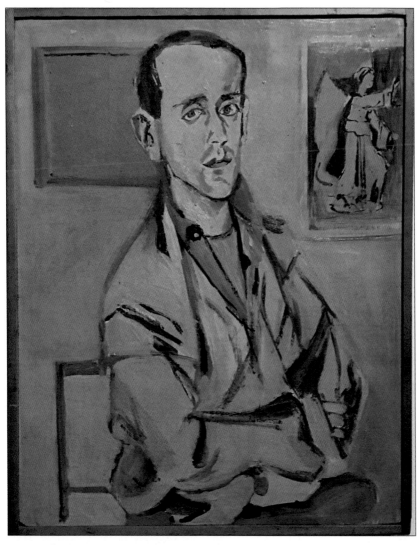

Plate 3. Elaine de Kooning, *Joop-Angel #3,* **1945.**
Oil on board, 17-3/4 x 13-3/4 inches; Collection of Timothy and Karin Greenfield-Sanders.
©Elaine de Kooning Trust.

**Plate 4.
Elaine de Kooning,
Charlie Egan, 1946.**
Oil on Masonite, 32.25
x 24.875 inches. Private
collection. Photo courtesy of
Levis Fine Art, Inc. ©Elaine
de Kooning Trust.

Plate 5. Elaine de Kooning, *Untitled, Number 15*, 1948.
Enamel on paper, mounted on canvas, 32 x 44 inches; Metropolitan Museum of Art, New
York; Iris Cantor Gift, 1992. Image ©The Metropolitan Museum of Art. Image source: Art
Resource, NY. ©Elaine de Kooning Trust.

Plate 6. Elaine de Kooning, *Chess Player (Portrait of Conrad)*, 1950.
Oil on canvas, 50 x 57 inches. Private collection. Photo courtesy of Levis Fine Art, Inc. ©Elaine de Kooning Trust.

Plate 7.
Elaine de Kooning,
Angry Man, **1950.**
Oil on canvas,
50 x 32 inches.
Private collection,
Florida. Photo
courtesy of Levis
Fine Art, Inc.
©Elaine de
Kooning Trust.

Plate 8. Elaine de Kooning, *Willem de Kooning*, ca. 1952.
Oil on panel, 38-5/8 x 25 inches; National Portrait Gallery, Smithsonian Institution. Photo
credit: National Portrait Gallery, Smithsonian Institution / Art Resource, NY. ©Elaine de
Kooning Trust.

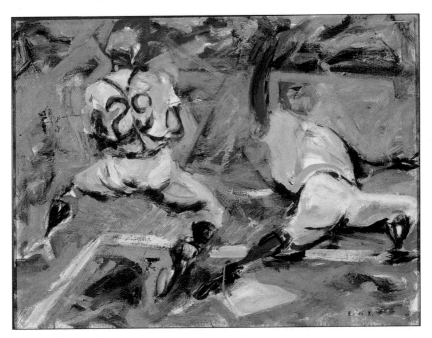

Plate 9. Elaine de Kooning, *Baseball Players*, 1953.
Oil on canvas, mounted on board, 17-5/8 x 23-9/16 inches, Savannah, Georgia. Gallery exchange, 1965.6. ©Elaine de Kooning Trust.

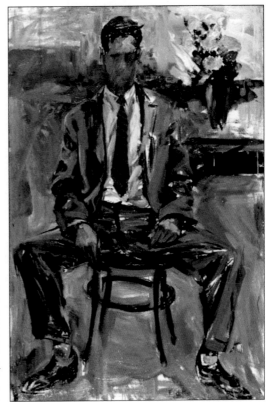

**Plate 10.
Elaine de Kooning,
Fairfield Porter, 1954.**
Oil on canvas, 48 x 31-7/8
inches; Bebe and Crosby Kemper
Collection; gift of the Enid and
Crosby Kemper Foundation,
1995.22. Kemper Museum of
Contemporary Art, Kansas City,
MO. ©Elaine de Kooning Trust.

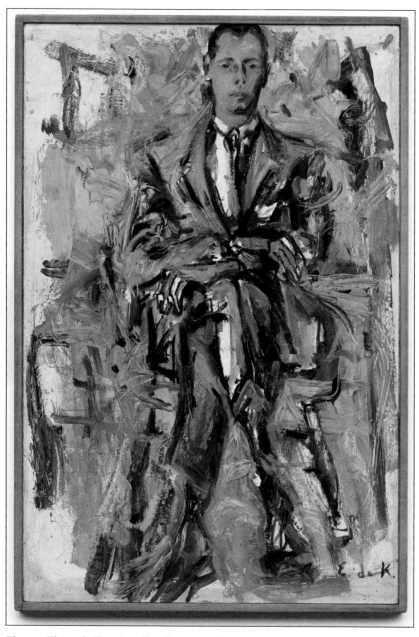

Plate 11. Elaine de Kooning, *Tom Hess #1*, 1956.
Oil on board, 22-7/8 x 15-3/4 inches; National Portrait Gallery, Smithsonian Institution. Photo credit: National Portrait Gallery, Smithsonian Institution / Art Resource, NY. ©Elaine de Kooning Trust.

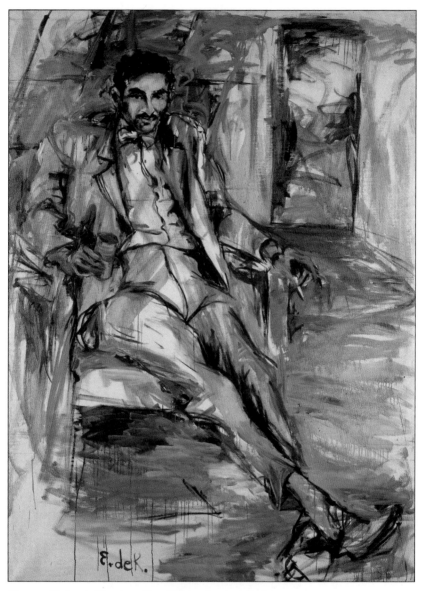

Plate 12. Elaine de Kooning, *Harold Rosenberg #3,* 1956.
Oil on canvas, 80 x 59 inches; National Portrait Gallery, Smithsonian Institution. Photo credit:
National Portrait Gallery, Smithsonian Institution / Art Resource, NY. ©Elaine de Kooning Trust.

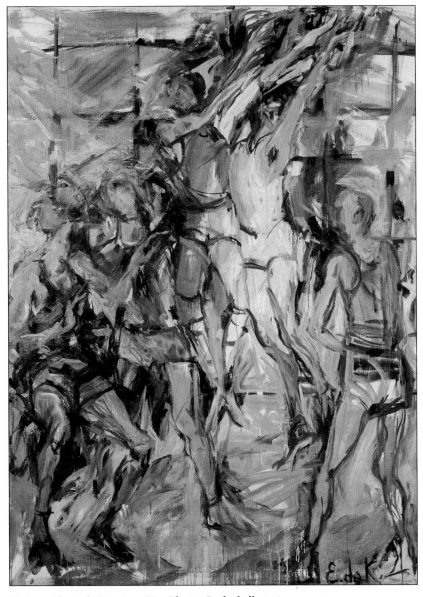

Plate 13. Elaine de Kooning, *Men Playing Basketball,* **1956.**
Oil on canvas, 80 x 66 inches. Photo credit: Geoffrey Clements/Corbis. ©Elaine de Kooning
Trust.

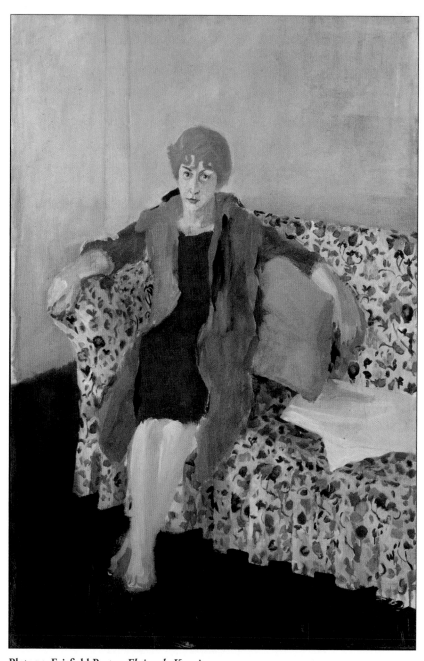

Plate 14. Fairfield Porter, *Elaine de Kooning*, 1957.
Oil on canvas, 62 x 41 inches; The Metropolitan Museum of Art, New York; gift of Mrs.
Fairfield Porter, 1978. Image ©The Metropolitan Museum of Art. Image source: Art Resource,
NY. ©2016 The Estate of Fairfield Porter / Artists Rights Society (ARS), New York.

Plate 15. Elaine de Kooning, *Tibor de Nagy exhibition poster,* **1957.**
Lithograph, 20 x 13 inches. Private collection, New York. Photo courtesy of Levis Fine Art, Inc. ©Elaine de Kooning Trust.

**Plate 16.
Elaine de Kooning,
Portrait of Robert Mallary,
ca. 1958.** Oil on canvas,
70-1/2 x 49-1/2 inches.
Charles & Mary Anne Fried
collection. Photo courtesy of
Levis Fine Art, Inc. ©Elaine
de Kooning Trust.

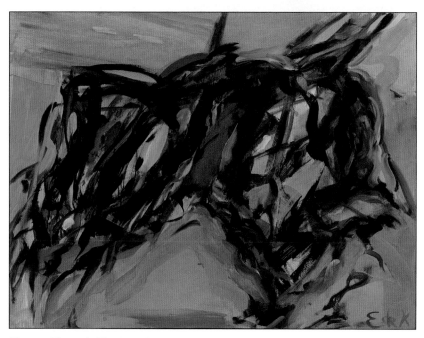

Plate 17. Elaine de Kooning, *Juarez*, 1958.
Oil on Masonite, 35-3/4 x 47-7/8 inches; The Solomon R. Guggenheim Museum, anonymous gift, 1983. Photo credit: The Solomon R. Guggenheim Foundation / Art Resource, NY. ©Elaine de Kooning Trust.

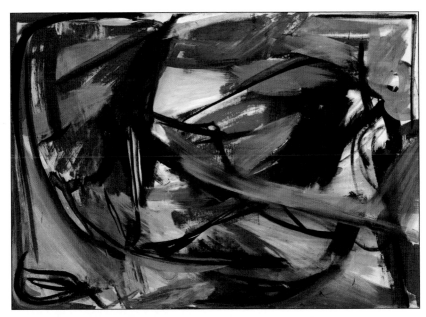

Plate 18. Elaine de Kooning, *Farol*, 1958.
Oil on canvas, 54 x 77 inches. Private collection, New York. Photo courtesy of Levis Fine Art, Inc. ©Elaine de Kooning Trust.

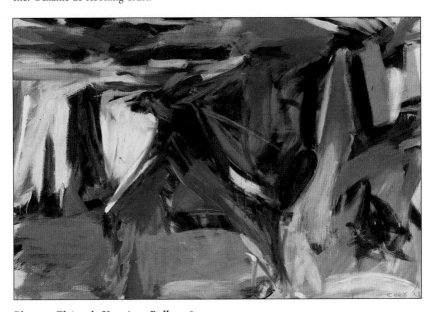

Plate 19. Elaine de Kooning, *Bull*, 1958.
Oil on canvas, 52-3/4 x 78-1/2 inches. Virginia Museum of Fine Arts, Richmond. Gift of Pamela K. and William A. Royall Jr. Photo: Travis Fullerton. Image ©Virginia Museum of Fine Arts. ©Elaine de Kooning Trust.

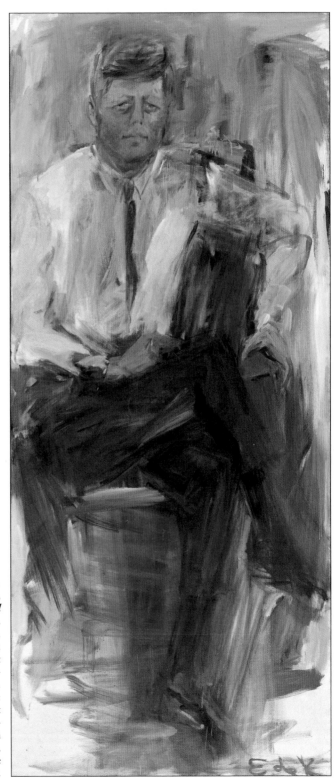

Plate 20.
Elaine de Kooning,
John Fitzgerald
Kennedy, **1963.**
Oil on canvas,
102-1/2 x 44 inches;
National Portrait
Gallery, Smith-
sonian Institution.
Photo credit:
National Portrait
Gallery, Smith-
sonian Institution
/ Art Resource,
NY. ©Elaine de
Kooning Trust.

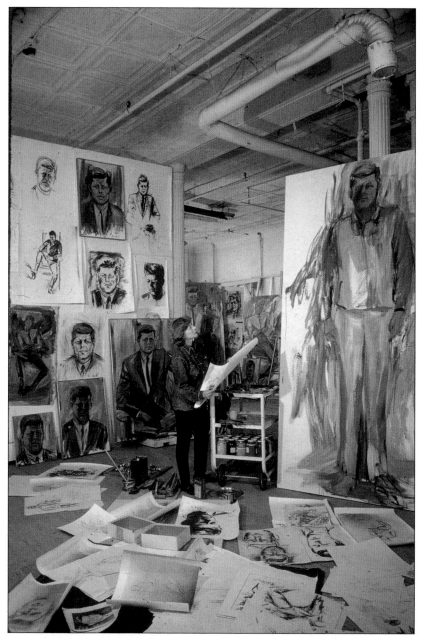

Plate 21. Elaine de Kooning with portraits of John F. Kennedy in her Manhattan studio, 1964. Photo: Alfred Eisenstadt. The LIFE Picture Collection, Getty Images.

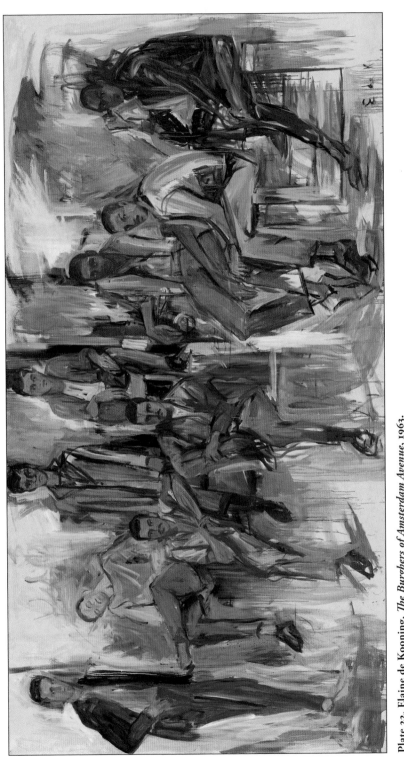

Plate 22. Elaine de Kooning, *The Burghers of Amsterdam Avenue,* **1963.**
Oil on canvas, 88 x 166 inches. Private collection, Philadelphia. Photo: Mark Gulezian, Smithsonian Institution. ©Elaine de Kooning Trust.

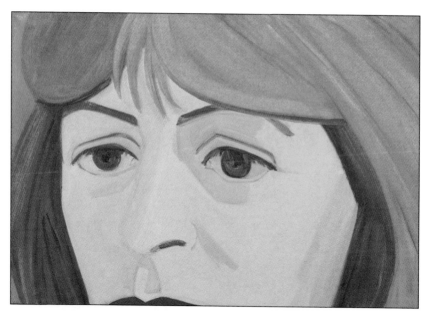

Plate 23. Alex Katz, *Portrait of Elaine de Kooning,* **1965.**
Oil on canvas, 79 x 62-3/4 inches. Art © Alex Katz / Licensed by VAGA, New York, NY. Photo courtesy of Leslie Hindman Auctioneers.

Plate 24.
Wolf Kahn,
Elaine de Kooning, **1968.**
Pastel on paper. Collection of Wolf Kahn.

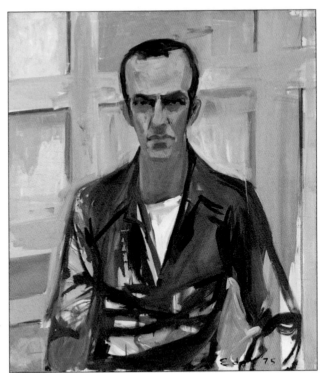

Plate 25.
Elaine de Kooning,
Portrait of Alex
Katz, **1975.**
Oil on Masonite,
34 x 30 inches.
Private collection.
Photo courtesy of
Levis Fine Art, Inc.
©Elaine de Kooning
Trust.

Plate 26.
Elaine de Kooning,
Portrait of Kaldis, **1977.**
Oil on canvas, 40 x 30 inches.
Collection of Barbara and
Barrett Silver. Photo courtesy
of Levis Fine Art, Inc.
©Elaine de Kooning Trust.

Plate 27. Elaine de Kooning, *Megan Boyd,* **1982.**
Oil on canvas, 30 x 20 inches. Collection of Barbara and Barrett Silver. Photo courtesy of Levis
Fine Art, Inc. ©Elaine de Kooning Trust.

**Plate 28.
Elaine de Kooning,
Bacchus #80, 1983.**
Acrylic on canvas, 84 x 66
inches. Private collection,
New York. Photo courtesy
of Levis Fine Art, Inc.
©Elaine de Kooning Trust.

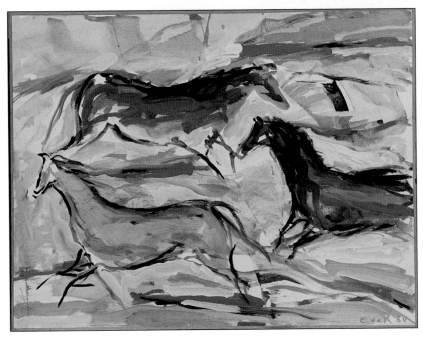

Plate 29. Elaine de Kooning, *Cave #49: Morning Horses*, 1984.
Acrylic on paper, mounted on canvas, 30 x 30 inches. Charles & Mary Anne Fried collection.
Photo courtesy of Levis Fine Art, Inc. ©Elaine de Kooning Trust.

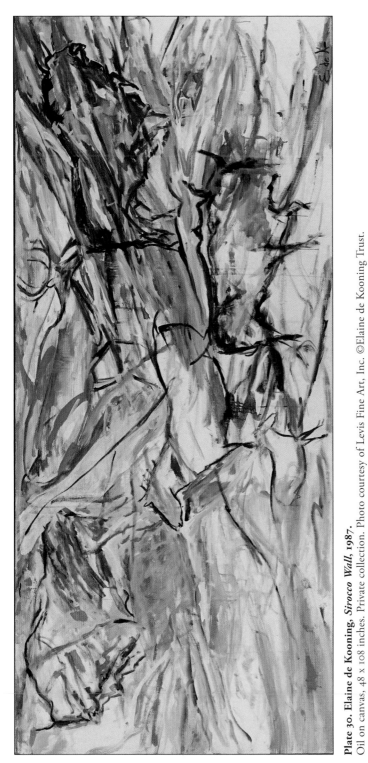

Plate 30. Elaine de Kooning, *Sirocco Wall*, 1987.
Oil on canvas, 48 x 108 inches. Private collection. Photo courtesy of Levis Fine Art, Inc. ©Elaine de Kooning Trust.

Plate 31. Elaine de Kooning, *Portrait of Aladar Marberger*, 1986.
Oil on canvas, 65.5 x 43.25 inches. Charles & Mary Anne Fried collection. Photo courtesy of Levis Fine Art, Inc. ©Elaine de Kooning Trust.

4

Illuminating Art

IN APRIL 1948, *ARTnews*, America's leading art magazine, hired Elaine as an "editorial associate," a fancy title for freelance reviewer. She got the job by complaining to Renée Arb—a young art historian who had published one of the few thoughtful reviews of Bill's 1948 show—that the magazine's other writers were graduate students who didn't seem to know anything about contemporary art. Arb mentioned this conversation to editorial assistant Thomas B. Hess, and he was sufficiently interested to invite Elaine to the office to talk about the problem.

The lanky son of a prominent New York attorney and his wife, Hess had graduated magna cum laude from Yale in 1942, with a major in French art, history, and literature. That year, he worked as what we would now call an intern with Alfred Barr Jr. and Dorothy Miller at the Museum of Modern Art. After his war service with the U.S. Army Air Force, he began his *ARTnews* career, becoming executive editor in 1949 and editor in 1965.[1] Elaine and Hess were involved in a long-running affair, which no doubt helped boost her influence at the magazine.[2] As someone who seemed to know practically everyone in the tiny downtown art world of the late '40s, Elaine served as an unofficial conduit with the leading art journal of the era, introducing Bill and Pollock (and many lesser-known artists) to Hess. He would return the favor in a rather tortuous 1960 essay about her work, celebrating her inclusiveness, her willingness "to invite chaos in."[3]

Despite Elaine's fondness for Hess, there were times when he rubbed her the wrong way. In an undated letter, she thanked him for sending "ravishing flowers" but railed at his oppressive and "unwarranted" outburst about several trivial-sounding matters—including her confusion of the affluent city of New Rochelle[4] with the village of Port Chester—and told him that if anyone told her to watch the clock, her impulse is "to look for the nearest exit."[5] Hess was married to Bennington College graduate Audrey Stern. A granddaughter of a founder of Sears, Roebuck, she used her wealth to support social causes.[6] Decades later, when she died at age fifty, Elaine mused in a letter that she

regretted how long it took her to appreciate Audrey, whom she called "a truly great lady" and—more hauntingly—a "tragic Henry James heroine."[7]

When Elaine began writing for the magazine, its editor was Alfred Frankfurter, a portly, commanding figure in his early forties who had turned a once-sleepy journal into the dominant voice of art criticism in America. Art writer Eleanor Munro, a staff editor who later married her boss, remembered how he "talked a steady streak in a style florid with jokes and visual descriptions, dropping names and names of places—palaces, villas, homes of the great, private collections, out-of-the-way historic monuments—and anecdotes about his past life," which included working with the art advisor Bernard Berenson in Italy. Frankfurter would gossip on the phone with wealthy clients "while we editors sat rocking back in our chairs, riveted and repelled."[8]

Although he didn't care for Abstract Expressionism, Frankfurter allowed Hess—who was passionately committed to it—to proceed at full steam, encouraging the work of emerging artists. Munro, who started working for *ARTnews* in 1951, remembered that he would stand at her elbow, "gaze thoughtfully" at her edit of a writer's copy, utter a swear word, "and tell me the [version] in my machine wasn't yet right."[9] A staff editor recalled how (in contrast to Frankfurther's large executive-style office) Hess's desk was "right by the entrance from the elevators"—perfectly positioned to chat with the artists, dealers, and writers who dropped by.[10]

Elaine seems to have written her reviews both at the office and at home. (She had purchased a used portable typewriter, finally replaced in 1960 by a new Smith-Corona electric model.) Philip Pavia could hear her typing from his apartment at 90 East 10th Street, because he and the de Koonings shared a fire escape.[11] She started with six "test reviews," one of which was about the sculptor Alberto Giacometti's exhibition at the Pierre Matisse Gallery. Giacometti was an unknown quantity in America in early 1948. Hess had written favorably about the show, but his review hadn't been published yet. Elaine's rave review (and her dismissive review of another artist—possibly the only negative piece she ever wrote) gave him confidence in her discernment.

REVIEWERS WERE INSTRUCTED to visit the artist's studio a month before the gallery opening—a means of ensuring more timely reviews. For the writer, this rule made the job more time-consuming, because the artists liked to talk, and they had to pull out their works one by one for viewing. Because artists' studios were also their homes, Elaine would be thrust in the midst of family life—"artists with four kids and something on the stove"—which helped her understand "all of the travail" involved in producing the work she was writing

about.[12] She took copious notes on these visits to support her claim of total visual recall: the ability to look at her scribblings and immediately visualize every work she had seen.

ARTnews had a two-hundred-word limit for reviews, "a painful discipline in the case of artists I thought were great," Elaine said.[13] Before she realized what would happen if she exceeded the word limit, one of her early rave reviews[14] was cut down in a way that displeased her to fit the allotted space. The two-dollar fee[15] meant that, at best, Elaine would earn one cent per word. Because every piece took her a long time to research and write, she made a fraction of the average $1.32 hourly wage in manufacturing industries.[16] Fellow painter Fairfield Porter, whom Elaine had recommended as a reviewer to Hess, grimly pegged the reviewers' earnings at a nickel an hour.[17]

Reviews in *ARTnews* had always been anonymous, a state of affairs that came to a boil after one reviewer wrote that Gorky was influenced by Bill. He was appalled at this error—so much so that he wrote a letter to the magazine in which he said he was "glad that it is about impossible to get away from [Gorky's] powerful influence."[18] Elaine was upset, too, because people thought she had written the review. She insisted to Hess that the reviewers had to be identified, and from then on, their initials were appended. Elaine was "E.K."

Her first signed review, in the May 1948 issue, was of paintings by Arnold Friedman, a post office clerk who had died two years earlier, after devoting his brief retirement to canvases inspired by the American Impressionists.[19] She wrote that in his late landscapes, he "gives us the topography of his imagination: swirling, segmented landscapes that look like enlarged sections of the human brain." With this brief review, a major voice for twentieth-century art was born.[20]

At first, she said later, Frankfurter was disinclined to hire an artist as a reviewer because of the danger she would favor her friends. Elaine's response was, "They were all my friends. I know everybody. So there's no possibility of favoritism." After three months he was still dubious, accusing her of writing only favorable reviews. "That's disgusting, isn't it," she said, and walked out of the office.[21] She believed that "the function of criticism is to open doors, not to sit in judgment."[22] What she offered was a close look at the work—"to cast some light on it" with observations that might not have occurred to the casual viewer. As she later pointed out, in those days—before the machinery of hype and celebrity culture that began with the *Life* magazine article about Jackson Pollock—"artists' reputations were made by other artists." (Elaine once told an interviewer that Bill was initially puzzled at her dual role. He said that being an artist who worked as a critic was like "Mickey Mantle going up to bat and then sitting down at the foul line to critique the other players."[23])

In February 1949, Elaine wrote about Albers for "5 Stars for February," a feature (by several writers), that briefly summed up the career of each artist "star," as well as mentioning his current show. Perhaps feeling somewhat daunted by having to write about the man whose student she had been months earlier, she filled about one-third of the piece with well-chosen quotes from Albers. Then, in the last line, she gracefully refuted one of his statements ("My work is study, not revelation"), declaring, "in the nature of revelation are the austere expressions of his spaces and colors." This issue of the magazine also contains an astonishing total of nineteen reviews by Elaine, nearly all of artists little known today. (She once claimed that her record was thirty-eight reviews in a month.) Among the polite murmurings of her reviewer colleagues, Elaine's review of a solo debut by Swiss artist Frederick Sommer stands out for noting his "almost sadistic concentration on the machine-like junction of forms."[24]

Of course, like all writers, she had to learn her craft. But she arrived at *ARTnews* already seasoned by her tutelage with Edwin Denby, a former dance critic for the *New York Herald Examiner* who freelanced for journals and magazines.[25] He began to take her under his wing after her remarks about the Modern's Mondrian retrospective and Stuart Davis show in 1945.[26] Intrigued by the "energy and aggressiveness [and] also a kind of lyrical inevitability"[27] of Davis's paintings, she returned to the exhibition several times to take notes. Elaine wrote a twenty-page essay about Davis, frugally typed on both sides of the page. Not intended for publication, the piece was her way of figuring out what she thought about this work. She was thrilled when both Bill and Denby praised it; composer Virgil Thomson was similarly impressed. A dozen years later, Elaine decided that only a few changes were needed to publish the piece in *ARTnews*,[28] and she was rewarded with a note of appreciation from the artist.

Denby sometimes invited her to accompany him when he reviewed a dance performance, a special treat. Elaine had a crush on him, even though he was gay; she later said that Bill furiously resented these evenings at the ballet.[29] While Denby filed his review at the newspaper office, she would write her own review, which he would critique.[30] He apparently allowed her to substitute for him a few times when he was out of town, and she once wrote a magazine article about ballet.[31] Elaine admired Denby's elliptical poems about his observations as an urban pedestrian, collected in 1948 in *In Public, In Private*, with photographs by Rudy Burckhardt and a frontispiece by Bill. (One poem, "A Postcard," includes Elaine's name in a roll call of friends sending Burckhardt birthday wishes.) As she began teaching herself her new craft, she would bring an art review—written on pieces of paper

with taped-together inserts resembling collages—to the Horn & Hardart Automat on 23rd Street, for him to critique.

In both her painting and her writing, Elaine was mercilessly self-critical. After spending an entire day with sculptor Reuben Nakian in his studio, she wrote a review for the May 1949 issue that didn't quite meet her high standards. As the 5 P.M. deadline neared, Elaine brought her other reviews for the issue to the *ARTnews* office, saying that she just needed to make a few changes in the Nakian piece. She hunkered down to work on it and suddenly realized that everyone else had gone home. "When Thomas Hess came in at nine in the morning just as I was leaving, he said suspiciously, 'You haven't been here all night, have you?' I laughed wanly at this preposterous suggestion and fled without an answer."[32]

Thirty-nine years later, Elaine sat down with a writer to critique a draft of an introduction to a catalogue of Elaine's paintings. Because the session was recorded, we can hear how judiciously Elaine weighed every sentence. "You don't want to get bogged down in [descriptive] detail," she said at one point. "Too much detail can be just as bad as too many generalizations."[33] She read several sentences aloud and praised them ("this whole thing is fine") and then casually remarked that the redundant parts could be crossed out later on. "You have to be willing to go for broke and then just lose it," she said—Elaine's approach to art, writing, and life in a nutshell. She insisted on precision, admitting that she herself often found it difficult to find the right word. "It's not that I *scraped* the paint in *Black and Gold Bison*; *swept* is the word, with a huge squeegee." Quotes would help make the piece "more vivid," she suggested, because "dialogue is more interesting than someone's monologue."

As the session continued, Elaine became increasingly critical, pointing out that the writer's ideas were deployed in a "helter-skelter" way and dismissing the "swamp of generalizations" in the opening sentences. "You're not writing about Paleolithic art; you're writing about my paintings," she said. "It would be like writing about my baseball painting and suddenly talking about the nature of baseball." Opinions were another matter: "When it comes to your own observations, that's your business. You can say what you want." To drive home her point that artists are not always aware of what their work communicates, Elaine recounted the story of Rothko's reaction to her 1958 *ARTnews* piece, "Two Americans in Action: Franz Kline & Mark Rothko."[34] She had written that his paintings suggested a feeling of luxury. "And he said, 'I don't intend that at all.' And I said, 'I don't care at all what you intend. . . . I'm an educated eye, and that's what I get out of your painting.'"

ELAINE REVIEWED LARRY RIVERS'S first one-person show, at the Jane Street Gallery, in 1949. Explaining that he "toured the country as a saxophone player with a jazz band for five years before he took up painting in 1945," and—unusually, as she notes—began working abstractly before copying Old Master paintings and switching to figuration, she described his "large interiors, peaceful and somewhat stiff in warm, shimmering tones…[with] windows opening on radiant blue skies."[35]

She and Rivers became good friends. A few years later, she wrote to him that she had suggested to his dealer that the couple who bought one of his paintings should donate it to the Met rather than to the Modern, because "the prestige is more penetrating" (a typically Elaine locution). She added that she had seen a painting by Poussin at the Wildenstein Gallery, located uptown on 64th Street. In a phrase redolent of the penny-counting economies of the time, she wrote that this "perfect picture," loaned by the Louvre, "is worth walking all the way for."[36]

Elaine would console Rivers when he worried that Bill's influence on his work was too great and would selectively praise his work. But, like most friendships, theirs was sometimes clouded with misunderstandings. In an undated letter from this period, Elaine apologized for missing a supper date with Rivers and his sometime lover, poet Frank O'Hara. She explained that she was at the Cedar and "got involved (over drinks, which always destroy my sense of time) in a business discussion" about Bill's paintings. Then she lashed out at Rivers for making such a fetish of frankness that he betrayed a secret she had told him. "Rather than face a fact that I don't like, I prefer to dodge it if possible," she wrote. Frankness was often unnecessary, she wrote, and "not so interesting even when necessary." In her view, "dodging saves feelings."[37] Yet, the feelings she was saving—or rather, burying—were sometimes her own. She had learned, as her mother's child, that unpleasantness was best papered over with gaiety. In a dark period years later, she would rely on alcohol to do the job.

Like many authors, Elaine sometimes warmed up by writing letters. In late November 1952, she began a letter to Rivers with a bit of Cole Porter-inspired mock-poetry ("the fru fru fru of tiny raindrops…"[38]) and then caricatured herself fussing with her pads and pencils, and dusting her typewriter as "preparation for writing a long, pertinent article," only to put off this task to write to him. Rivers, in the grip of a romantic crisis, had cut his wrists one afternoon. (He was painted by Fairfield Porter, in whose home he recuperated, with symmetrical bandages and a stunned look.) Breezily dismissing his claim of an impending nervous breakdown as a vitamin B deficiency—she later said

she thought of him as "such a vivacious person and so exhibitionist"[39]—Elaine changed the subject to her own experience a few days earlier.

She and Bill had traveled to the Philadelphia Museum of Art for a lecture he delivered in his self-effacing manner ("explaining in detail why he couldn't draw feet, use color, compose, or finish any painting he starts"), and they had to put up with the inane remarks of museum patrons who took the couple out for meals and drinks. In a remark she would later have reason to modify (see chapter 9), she wrote that Philadelphia has "as much to do with art as Harry Truman." What saved the trip was a twentieth-century sculpture show, and seventeenth-century paintings by Rubens, Ribera, and the Le Nain brothers in the museum's collection. The Le Nain picture sparked "a fairly violent argument" between her and Bill about whether the composition would have been equally compelling had the beggars worn finery instead of rags. She said it would, and he said it wouldn't. This was the kind of dispute she found invigorating.[40] Paintings by the Le Nain brothers—Louis, Mathieu, and Antoine—were particularly important to Bill; as Jed Perl has written, they were the chief sources of "the poses, the features, the color, the mood" of Bill's paintings of the late 1930s and early '40s.[41] Yet the curious thing about this anecdote is that the only Le Nain painting the museum owned at that time was Louis Le Nain's *The Reprimand,* in which there are no beggars.[42]

AFTER NEARLY A YEAR of writing capsule reviews, Elaine notified Albers in March 1949 that she was leaving *ARTnews* to travel to Tangiers with her sister Marjorie. ("I find the idea of doing nothing but painting on the brink of the Mediterranean very appealing," she wrote.[43]) That plan seems to have been a passing fancy. But she did stop reviewing because, as she said later, "a critic has to look at everything fairly" and she was afraid she was "losing the rough edges" that she needed as an artist.[44] Instead, she began writing feature pieces for the magazine. They would make her name as one of the most incisive art writers of her day—and pay her as much as seventy-five dollars apiece. The format for the "X Paints a Picture" series was already in place: the writer would ask the artist to start work on a painting and make repeated visits to record its progress. A photographer—usually Rudy Burckhardt—documented different stages of the picture. Most of the time, writers could choose the artist they wanted to spotlight.

Elaine's first piece in this series, "Edwin Dickinson Paints a Picture," appeared in the September 1949 issue. Then fifty-seven years old, Dickinson was "an astonishingly little known and unappreciated" artist, she wrote. He was a friend; a year earlier, she had painted *The Music Party,* in which he is seen playing the violin,

with Daniel Brustlein on cello. Elaine was feeling her way in this piece, carefully crediting the artist's interests, methods, and influences, and concluding with a detailed comparison of the three stages of *The Ruin*[45] that she had observed. Toward the end of the article, in the midst of an earnest discussion of the artist's use of perspective, she wrote, "*The Ruin* is seen more or less as if one were strolling past it." This is the sort of casual-sounding yet freshly minted observation that would soon color all of Elaine's *ARTnews* features.

In 1950, Elaine undertook an extended piece on Albers, telling him that she wanted to include his theories about color. "And he said, 'Well, I will do this series, *Homage to the Square*, and it will just be based on color.'"[46] Two weeks later, he had completed about one hundred paintings, all the same size. So Elaine was able to write about the works for which he is best remembered.[47] Their "aseptic, almost militant simplicity," she explains, is the result of a lengthy process involving multiple precise calculations worked out on graph paper and experiments with color relationships in oil paint sketches. Despite the gulf between Albers's rigidly impersonal approach to painting and her own, Elaine demonstrates an acute sensitivity to his work. Her brief article pinpoints not only the mind-boggling details of his approach but also the "unadmitted sensibility" (created by his "peculiarly gentle and tentative" ruled lines and the "delicate translucent atmosphere" of his matte colors) that distinguishes his paintings. When the artist was someone she knew personally, her warmth and enthusiasm shone through in every paragraph.

In "Gorky: Painter of His Own Legend," Elaine praised her late friend for "never entertain[ing] the provincial (but popular) concept that originality in art is measured in terms of rejection of tradition." Gorky, she wrote, looked to the compositional rhythms of Jacques Louis David's last painting, *Mars Disarmed by Venus* (1824), as an aid in composing *Diary of a Seducer* (1945)—a ghostly play of shapes in which, for example, "the sole of Venus's foot becomes an obscure little glow on a pale gray surface." Elaine daringly takes this line of thought one step further. After looking at Gorky's painting, she wrote, "the David begins to change…and we feel a new rhythm reverberating through it." This is the genius of her clear-sighted vision, critical mind, and flexible outlook. In her art world, there are no boundaries, no diktats. A painting completed yesterday can influence the way we see a work from a century ago: "Innovations don't destroy previous art; they amplify it."[48] Taking her cue from Bill, she saw no essential dichotomy between figurative and abstract paintings. In a 1962 interview, she remarked that *all* painting is both abstract ("its meaning is not in its physical attributes") and representational ("it represents the history of thoughts, impulses, emotions and decisions of the individual artist").[49]

Although much of her writing was about the art of her time, her sense of art as a continuum allowed her to write with probing intelligence about the paintings of Auguste Renoir.[50] She observed that, in common with other artists—from Michelangelo to Matisse—who had founded their own styles, he produced "an after-image larger than the work itself." Renoir's after-image is the "sugary translucence" that strikes many sophisticated viewers as "suffocating." Yet, in his individual paintings, he seduces the eye with his "caressing light." Sketching Renoir's blandly upbeat personality in a few deft phrases, she concluded that he is "an artist to be seen, not thought about."

OVER THE YEARS, Elaine recommended several art writers to Hess, including the poets Frank O'Hara and John Ashbery, painter Jack Tworkov, Harris Rosenstein (who became executive editor of *ARTnews* when Hess took over as editor), Kermit Lansner (married to painter Fay Lansner), and Jack Kroll. Elaine hadn't even read Kroll's writing at the time, but his "prodigiously witty" conversation convinced her that he would add to the magazine's luster.[51] An argument with Fairfield Porter at Gorky's Whitney Museum retrospective led her to mention his name to Hess. ("She talked to me about how good they were," Porter wrote to a friend. "And I talked to her about how bad they were."[52]) Musing about this turn of events years later, Porter—who would occupy Elaine's reviewer slot after she became a feature writer—figured that he got the job because "apparently I expressed myself so well."[53] In 1957, he would paint a gorgeous portrait of Elaine with outspread arms, sitting in one corner of a flowered sofa in his Southampton home. Her direct, slightly skeptical gaze illuminates one aspect of her personality; her slinky, fiery red dress captures another (plate 14).

IN LATE WINTER of 1954, Elaine wrote with evident relief to Larry Rivers that she was working on "my very very last technique piece"[54]—an article about painter Balcomb Greene.[55] It was time to move on from the "X Paints a Picture" series to larger themes.

"Subject: What, How, or Who?" an essay published in *ARTnews* in 1955,[56] demonstrated Elaine's high wattage of critical brilliance. Rallying to the cause of avant-garde artists who chose to paint non-abstractly, she illuminated the fallacies of "purity" and "authenticity" that had caused a rift between abstract and figurative painters. Elaine explained that any vital art style "is a mode of thinking" about a subject. She pointed out that even though an abstract artist "does not have to choose a subject...he always ends up with one." That's because even abstract painting has a subject: "all the debris of thought and opinion in previous styles." The style in which an artist chooses to

paint—whether it is Abstract Expressionism or Surrealism—"automatically becomes part of his subject." More broadly, Elaine noted that an artist's choice of subject is only partly a matter of personal volition; it is also governed by social, historical, and psychological factors.

Earlier that year, in his essay "American-Type Painting,"[57] critic Clement Greenberg observed that modern art is subject to a process of "self-purification," in which nonessential aspects are purged to "renew the vitality of art." He wrote disparagingly about how Bill was unable to "tear himself away from the figure," thus remaining "a Late Cubist" rather than a shining hero of modernism. After discussing several other artists, Greenberg hailed "[a] new kind of flatness" in paintings by Barnett Newman, Mark Rothko, and Clyfford Still—canvases "that exhale color with an enveloping effect."

Without addressing Greenberg directly—his name does not appear in her essay—Elaine insisted that "flatness is just as much an illusion as three-dimensional space." In a droll salute to practicality, she wrote that the quality of flatness is meaningful only in a practical sense: "to a person driving a car or setting a table." Artists were always pursuing the new, believing in "revolution—for its own sake." Yet, she cautioned, *no* style is innately revolutionary. "Shocks today are mock-shocks," she wrote. "Parody is king." She explained that parody is always a commentary on other art, created expressly for an audience sufficiently sophisticated to get the message. Elaine's parsing of the situation was ahead of its time, postmodern in its understanding of self-reflexive art.

This essay also contains Elaine's observation that many so-called Abstract Expressionists were actually "Abstract Impressionists" who have revived the "dead" style of Impressionism. These artists "keep the Impressionist manner of looking at a scene"—responding to its optical qualities with a flurry of brushstrokes—"but leave out the scene." (Joan Mitchell, Philip Guston, Milton Resnick, and Sam Francis were among the painters who employed this approach.) Instead of painting "the optical effects of nature," they were "interested in the optical effects of spiritual states." In a vivid summation of her point of view, Elaine wrote that the seventeenth-century painter El Greco, a painter to whom she felt particularly close, "loved his own brushstrokes as much as the tears in the eyes of his saints, or rather, tears for him *were* brushstrokes."

Although Greenberg's nemesis, Harold Rosenberg, was a friend and sometime lover of Elaine's, she viewed his criticism dispassionately. She thought him "very good in sociological terms" and astutely noted that, by talking to artists, "he understood art through words. He didn't have an eye; he had an ear."[58] Rosenberg and Bill had become good friends after seeing a lot of each other in the summer of 1952, their strong personalities well suited for spirited conversa-

tions. Rosenberg liked to play the provocateur, and Bill enjoyed making enig-
matic remarks that others would have to puzzle out. His long-mulled-over
paintings had little to do with action painting, and he privately dismissed
Rosenberg's theories, but the two men and their wives[59] bonded over a shared
antipathy to Lee Krasner, who was engaged in a furious and heartbreaking at-
tempt to promote her husband's work and crush any rivals to the throne.

BY 1957, ELAINE felt secure enough in her position at the magazine to write
a spoof of Ad Reinhardt in "Pure Paints a Picture," in which the painter ap-
pears as "Adolph M. Pure, noted Anti-Post-Abstract-Impressionist." Playfully
adopting the *ARTnews* "X Paints a Picture" format, she created an outlandish
character who painted with black fluid injected in foam rubber, and who
sanctimoniously opined that "the more pure your art is, the more you can give
less." Nonetheless, Elaine admired Reinhardt for his originality. Although
they never agreed about anything—he was famously opinionated—"we also
liked each other ... and we were able to argue with the greatest good humor."[60]

In 1958, Elaine wrote "Two Americans in Action: Franz Kline & Mark
Rothko." Nearly two decades later, she recalled that after she showed Rothko
what she felt was the final version, he told her he didn't agree with anything she
said about his work. "I said okay and tore up what I had written about him."
The piece was due the next morning, and she knew she would have to stay up
all night writing, but she told him they could talk for two hours. Rothko,
whose wit and flirtatious manner appealed to Elaine, asked if he could sit in
her studio while she rewrote the piece. No artist had ever asked for this privi-
lege, but she gamely agreed. "After a couple of hours, I said, 'Gee, Mark, I'm
getting hungry. Would you mind running out and getting me a hot pastrami
on rye?' So he went out and got sandwiches for us, and I gave him some books
to read." She handed him each page as she finished it, and he would single out
one word. They would argue about it until she understood his objection.
Despite her incredible patience during this long night, she believed that
Rothko's worry about what was said about his work to be "kind of a weak-
ness....He looked upon his paintings as children that had to be protected
from the cold, cruel world."[61]

Elaine's great gift as a writer was her extraordinary insightfulness.[62] Her ar-
ticles about art and artists are illuminated by a blithe disregard for received
wisdom, a lively dialogue with art of the past, and a luminous clarity of expres-
sion. She once wrote, "writing and painting use different parts of the brain and
I think they refresh each other."[63] But she agreed with an interviewer that being
known as an art writer may have stalled her recognition as a painter: she didn't

have a one-person show until 1954[64]—six years after her first review appeared in *ARTnews*. On the other hand, reviewing required her to analyze work she felt was subpar, a teaching experience in itself. And she gained the benefit of understanding "the way things were run...the relation between art galleries and museums and so on."[65]

DURING THE 1950S, galleries began to hold more evening openings, with the enticement of free liquor. The drinking continued at the after-parties. "There were a great many parties after the openings," Elaine said later. "Sometimes there'd be three parties in one night. We'd go from one to another and they were kind of arranged to synchronize."[66] Given her pinched finances, it made perfect sense that "a drink downed was fifty cents saved—a sound economical measure."[67] Grace Hartigan wrote in her journal that she was "pleased especially" to see the de Koonings among the throng at the opening for her one-person show at Tibor de Nagy Gallery, on March 31, 1953.[68] After finishing their drinks (Hartigan, feeling nervous, consumed a half-pint of Scotch), the artists moved on to a cocktail party hosted by collector Roland Pease.

As the fifties progressed, sales increased. With more money in their pockets, artists were swept up in the general sense of euphoria: the bleak days were over. Hard liquor replaced the poor man's glass of beer. By the early sixties, Elaine and many other artists were in thrall to the liberating but coruscating powers of alcohol.

East Hampton, Pro Sports, and the Separation

ELAINE HAD EXTENDED her summer visit to Provincetown into the fall, working without heat until a streptococcal infection caused her to return to New York. Now she had to scramble to find a new place to live and work, relying on friends who were temporarily out of town. At first, she borrowed Edwin Denby's West 21st Street flat. Then she moved to painter Bill Brown's studio on 100th Street, where she woke up every morning with "dirty ditties" running through her head—sung by youngsters sitting on the stoop outside. She later claimed to have moved into eight studios in 1950.

The highlight of her year was her presence in Talent 1950, which opened in April. She was one of twenty-three artists (including Franz Kline, Larry Rivers, Grace Hartigan, and Alfred Leslie) whose work was selected by Clement Greenberg and art historian Meyer Schapiro for this landmark show of up-and-coming artists at the Samuel Kootz Gallery.[1] Writing in *The Nation*, painter Weldon Kees—who noted that the participating artists had been ignored by the dominant 57th Street galleries—praised the show's "enormous spirit and optimism and love of paint."[2] Months later, whether out of loyalty to Bill or genuine skepticism, Elaine would disparage all but one of Pollock's paintings in his fourth solo show at the Betty Parsons Gallery. Within earshot were Greenberg and Lee Krasner, Pollock's most fervent supporters.[3]

THE ARSHILE GORKY MEMORIAL EXHIBITION opened at the Whitney Museum in January 1951. Elaine's clear-eyed tribute to the late painter ("Gorky: Painter of His Own Legend") was published that month in *ARTnews*.[4] "Tireless, fastidious and intolerant, Gorky reduced personal tragedy—his own or anyone else's—to the level of discomfort or irrelevancy," she wrote, describing his "long stride and dour face" and his fanciful accounts of his personal history. Turning to his great paintings from the mid-1940s (*The Liver Is the Cock's Comb, Diary of a Seducer*), she evoked the way an initial impression

of "light and witty loquacity" yields to "an overpowering flux of successive and simultaneous images...a cruel and opulent sexual imagery."

Paintings by both Elaine and Bill were included in the Ninth Street Show, an artist-selected exhibition that opened in on May 21 in a vacant storefront on East 9th Street: one work apiece by nearly seventy artists. As Alcopley said later, "There was no interest in our work [from dealers], so that's the reason why we did it."[5] *ARTnews* executive editor Thomas Hess, one of the show's few reviewers, praised the "authoritative statements" by Bill, Kline, Pollock, and others, but disparaged works by younger artists that struck him as "dainty and feminine, despite all the slappings and dashings."[6] He didn't mention Elaine by name, but she may have been included in his censure.[7]

In early November, during a record-breaking cold spell with heavy snow and sleet, Elaine slipped on the ice and broke her right leg on a visit to the Empire State Building.[8] While she rested at home—she had moved temporarily to 145 West 21st Street, taking over Denby's flat when he was in Italy[9]—Aristodemos Kaldis sketched her wearing a cast, her skirt rucked up to show how high it extended on her thigh. Her right foot rests on a pillow (Kaldis emphasized the nails on her hands and feet, as if to suggest bright nail polish), and she sits clutching another pillow, with a how-did-I-get-into-this-mess expression on her face. She hired a lawyer to pursue legal action, joking that he was writing speeches for Adlai Stevenson's presidential campaign instead of working on her case. (Stevenson inspired her as well; she wrote to a friend that she planned to vote for him—the first time she deigned to participate in an election.[10]) But despite spending weeks in a wheelchair and then hobbling on crutches, Elaine didn't let temporary incapacitation cramp her style.

A strong man—on one occasion, John Bernard Myers of the Tibor de Nagy Gallery—would be enlisted to carry her up flights of stairs for parties that "always seemed to be on the fifth floor."[11] Painter Gandy Brodie was tapped to accompany Elaine on cab rides to look at art.[12] As she fondly related at his memorial, he would "manage" her wheelchair while she struggled in and out of taxis. Navigating stairs (at a time when no accommodations were made in public places for wheelchair users) was a particular problem, but Brodie would gamely take charge while "pouring out a running commentary on Cézanne or Rembrandt while I was just trying to keep my balance." (Many years later, Elaine would paint a portrait of her intensely focused friend, who "never relaxed" and demanded that his listeners have an opinion on the smallest matters. He would ask, in all seriousness, "Is that or is that not a beautiful ashtray or sunset?" She found him "exhausting but . . . invigorating."[13]).

Elaine was listed as a dependent on Bill's Internal Revenue Service tax form for 1951.[14] The couple paid $1,750 in medical bills and related expenses for her broken leg, a significant portion of Bill's $7,610 income, which included the $4,000 first prize he won from the Sixtieth Annual of the Chicago Art Institute for *Excavation* (1950). He had joined the Sidney Janis Gallery, which began advancing him money for art supplies. (The previous summer, when *Excavation* was en route to the Venice Biennale, Elaine told Bill that it reminded her of Breughel's *Triumph of Death*. She was right, as usual; he showed her the magazine in his studio that had reproduced the painting on its cover.)

In the spring of 1952, while she was still recovering, Elaine gratefully accepted Fairfield Porter's invitation to spend time with his family in Southampton.[15] "I went for two days and stayed for two weeks," she wrote. "During which period I did nothing but paint, eat, talk, read and sleep."[16] Porter had articles to write, and Elaine "got malicious pleasure" from being able to work in his studio, helping herself to "great thick gobs" of his paint, which she normally couldn't afford.

A car trip to the Barnes Foundation art collection in Philadelphia with Mercedes Matter and her relatives inspired exuberant but tempered praise from Elaine. She found the subjects of Renoir's large paintings "vulgarly beautiful" and joked that "Barnes' very fine sense of humor" in selecting his Picassos "made the Spanish artist 'look like a reliable but slight second-string artist.'" She also observed: "The big Seurat and big Cézanne *Bathers*[17] looked like blown-up reproductions to me, such is the effect of getting too familiar with a painting you've never seen."[18] With this remark, Elaine presciently ventures into territory explored in Walter Benjamin's 1936 essay, "The Work of Art in an Age of Mechanical Reproduction," which would not be translated from German to English until 1968.

Elaine was involved in a memorable event in 1952, at the Flemington, New Jersey, farm of Fritz Hensler, a German-born intellectual.[19] Four cars were needed to transport all his guests—who also included Bill and his current girlfriend, Jean Steubing; Franz Kline and two women friends; Conrad Marca-Relli and his wife; Milton Resnick and his girlfriend; Mercedes Matter; Philip Guston; George Spaventa; and writer Lionel Abel.

Accustomed to the idea that a party was an occasion to get sloshed, some of the artists brought bottles of Scotch, gin, and vodka. Hensler, who had planned a special dinner, to be served with a German Moselle wine, proactively locked up his guests' liquor supply. This did not go down well with the artists. When their host stepped away to check on the food, Kline pried open

the cabinet and passed around the bottles. After drinking the hard stuff, the artists had no use for the Moselle—accounts differ as to whether the wine was poured into the potted plants or spilled on the floor—and the rack of lamb was consumed amid an atmosphere as raucous as that of the Cedar Tavern. Elaine recalled that Hensler "wanted to have this discussion of philosophical matters. But we were all drinking martinis.... The more pompous Fritz got, the more reckless we got."[20] Abel, who was disgusted at the artists' antics, wrote that his fellow guests "seemed to have gone all the way out to New Jersey just to prove they had never left Eighth Street and University Place."[21]

Told that there were not enough beds to accommodate everyone, the artists drunkenly tried to figure out who would get them. The party eventually moved outside, and when the bed issue remained unresolved at dawn, Elaine declared that she would walk back to New York. She began limping away in her cast, probably just to force Bill to come after her, which he did. The party broke up, and everyone returned to New York. As Elaine said later, artists' out-of-control drinking unleashed "extremes of emotion and also the whole exhibitionistic thing."[22] In retrospect, she admitted that she felt ashamed of the artists' behavior, though she also said that Hensler "was totally without a sense of humor."[23]

In the fifties, many of the downtown artists self-consciously adopted a "live fast, die young" credo compounded of equal parts of existentialism, postwar disillusionment, and youthful romanticism. Alcohol was central to this outlook, and a woman who wanted to fit in had to keep up. Elaine's friend Ernestine Lassaw believed that the heavy drinking began when artists availed themselves of the seemingly endless supply of free liquor at art gallery openings, which clustered on the same nights of the week.[24] "Everyone was hung over every single day," Elaine once claimed, exaggerating ever so slightly. "Everyone would have blackouts and repeat themselves and get so smashed they'd be staggering around. Everyone was a standup comic. It was like a ten-year party."[25] The next day, she said, "everyone ... would not remember how the evening ended.... Artists became alcoholic without realizing it."[26]

THE DE KOONINGS had first visited East Hampton in 1948, around the time of Bill's first show, spending a weekend with Pollock and Krasner in their tiny farmhouse.[27] In 1950, artist Mercedes Matter, who was renting a room for August in Amagansett, invited Elaine to come join her—an invitation that charmed her because the setting sounded "fantastically uncivilized" and there seemed to be ample potential for "start[ing] some trouble" with "certain raving harpies" (unidentified women Matter had complained about).[28]

In 1952 and 1953,[29] Elaine and Bill summered at the spacious East Hampton home of art dealer Leo Castelli and his wife Ileana, on Jericho Road. Castelli, who never represented either of the de Koonings (or any other Abstract Expressionist painter), nonetheless said later that his "real hero at that time was probably de Kooning."[30] The house was big enough so that Bill could set up a studio on the screened porch. Elaine was relegated to "an exposed porch," which—speaking decades later—she claimed to love. "On rainy days," she said, "I'd work in our big bedroom." She and Bill would paint all day and socialize at night—several young people in the arts[31] were spending the summer nearby—eliciting a vexed response from a visiting Englishman: "You Americans exhaust me!"[32]

Elaine was still in the grip of the "faceless men" series she had begun around 1950. She painted Castelli with a somber expression half-hidden by a splotch of brown shadow[33] and a nearly blank-faced portrait of John Bernard Myers.[34] He had to pass through Bill's studio to get to hers for the sittings. Why, he asked, was that painting of a woman always changing? Bill, who had covered parts of the canvas with pieces of masking paper and kept moving them around, was silent for a moment. Then he asked his visitor to shield his eyes so that only the doorknob in the room was visible; isolated like that, how could you tell what it was? Bill explained that he was trying to paint a woman "with no reference to anything" and yet make her "believable"—a difficult problem. (Myers, often an unreliable narrator, claimed that when he asked Elaine how the painting turned out, she said, "Oh, Bill wanted to destroy it. But I hid it.")[35]

In August 1952, Elaine wrote to Ernestine Lassaw in a light-hearted mood: "My hair hasn't been this light or my skin this brown in many a year." She was now in her "natural state—broke," after buying her mother a refrigerator to replace her icebox.[36] But there was plenty of inexpensive fun to be had; one night, Elaine and her artist friends "went nude bathing in the moonlight."[37] She was working, too—finishing an article about Buckminster Fuller. After an evening of drinking with Burgoyne Diller (when she was supposed to be looking at his paintings, for an *ARTnews* feature), Elaine was left "with nothing but feathers in my head, which I used to dust off Bucky."[38]

That fall, Bill began an affair with Joan Ward, an attractive and successful commercial artist he had met at the Cedar. He moved to the top floor of 88 East 10th Street, between Third and Fourth Avenues; she lived nearby.[39] Bill had dedicated this year to his *Woman* paintings. He completed *Woman I* (1952)—at the urging of Meyer Schapiro, who visited the studio—and worked on *Woman II* (1952–1953), *Woman IV* (1952–1953), *Woman V* (1952–1953),

and *Woman with Bicycle* (1952–1953). (Elaine once said that Bill used to think of her as one of the teenage girls on bicycles who infatuate the narrator of Proust's novel *Within a Budding Grove*.[40]) She later recalled his intensive "all day, every day" efforts, which he often erased. "I saw hundreds of images go by," she said. "I mean, paintings that were masterpieces. I would come in at night and find that they had been painted away."[41]

Bill's *Woman* paintings had become increasingly grotesque, and Elaine was tired of hearing about the likelihood that she was their inspiration. To dispel such notions, she asked the photographer Hans Namuth to shoot her in front of the latest canvas, on which Bill was still working. (He later destroyed it, and it was never exhibited.) When the photo was printed, she was surprised to see that she had virtually become "part of the painting, as though I were the *Woman*'s daughter, and she had her hand, protectively, on my shoulder."[42] Relating this story decades later, Elaine seemed amused by it. In another interview,[43] she admitted that the paintings "have a certain ferocity," but that watching them develop ("here, it's an abstraction; here, it's a figure") made her see them primarily in formal terms. On one occasion, she asserted that this figure "didn't come from living with me. It began when [Bill] was three years old," living with his volatile mother, after his parents divorced.[44] What with Elaine's tendency to put a bright face on troubling matters—and the absence of letters or journal entries by her on this subject—it is impossible to know how she really felt when the paintings were new. Yet there is one more piece of evidence: in another photo of the painting by Namuth that was probably taken at the same session—and includes both Bill and Elaine—she stands to one side, leaning away from the canvas with her arms folded, a strained expression on her face.

The new *Woman* paintings were the subject of Bill's third solo show, in March 1953, at the Sidney Janis Gallery.[45] At the opening, sculptor Herbert Ferber sadly informed Bill that he felt "sorry for Elaine." Fellow painter Grace Hartigan told her, "That one's you. That one's me. That one's Jane Freilicher." Art students insisted to a friend of Elaine's that the show was "conclusive proof that de Kooning is a homosexual." They rested their case on what appeared to be bullet holes on one of the *Women*. In a letter, Elaine explained that these were actually "very chic rubies" that could be stuck directly on the skin, which Bill had seen in an issue of *Harper's Bazaar*.[46]

The reviews were howlingly negative. *Time* magazine: "mighty ugly… mid-20th-century dames." James Fitzsimmons in *Arts and Architecture*: "the ugliest and most horridly revealing that I have seen…about the woman, the creature, the goddess they represent." Sidney Geist in *The Art Digest*: "In a

gesture that parallels a sexual act, he has vented himself with violence on the canvas."[47] Elaine bemusedly noted that "no one talked about the painting. They all talked about THE WOMAN." Seemingly inured to the controversy, she wrote that Bill was surprised at the extent of it and "quite pleased to discover that he had shocked the avant-garde."

Woman (now known as *Woman I*) has huge dark eyes, a sour, toothy grin, enormous, boulderlike breasts, and oddly shaped arms (one looks like a leg). Below the hem of her skirt, her pink feet are shod in espadrilles. In the March 1953 issue of *ARTnews*, Thomas Hess published "de Kooning Paints a Picture" an earnest piece that attempted to defuse the painting's shock value by calling the figure's smile "not fearful, aggressive," but "detached," giving it "a touching irony and humanity." Above all, he wrote—as a work made up of discontinuous passages (created in part by painting on attached pieces of paper that were subsequently removed)—*Woman* was *ambiguous*. Hess noted that de Kooning credited Elaine for verbalizing this "montage" effect.[48]

SINCE HER BLACK MOUNTAIN COLLEGE days, Elaine was intimately connected to the worlds of avant-garde theater, dance, and poetry. In the fifties, she said, the audience for these art forms was "like a huge family; you knew everyone." Before one of Merce Cunningham's early dance concerts, with music by John Cage, Harold Rosenberg looked around the theatre and announced loudly, "It's almost curtain time and the Lassaws aren't here yet." As the laughter died down, he added, "There's a stranger in the third row. Throw him out!"[49] Fellow artist Sherman Drexler recalled that Elaine told him about a party she attended at which there were about sixty people: "Suddenly everyone was looking at everyone, realizing that perhaps they had all slept with each other at some point. Because you only knew a certain amount of people. You were a subset of society, and you summered together, and you wintered together, and you talked the same talk."[50]

In the summer of 1952, Elaine traveled to Waltham, Massachusetts, with artist friends to see Merce Cunningham's choreography—for Igor Stravinsky's *Les Noces* and Pierre Schaffer's *Symphony pour un homme seul*—and Leonard Bernstein conducting Marc Blitzstein's adaptation of Brecht's *Threepenny Opera* (which she sometimes referred to in later years, puzzlingly, as an explanation for some of her mother's beliefs). These performances were part of the historic four-day Brandeis College Festival of the Creative Arts, led by Bernstein, who also conducted the premiere of his own opera, *Trouble in Tahiti*.[51]

Elaine designed the sets for *Presenting Jane*, a one-act play by James Schuyler that was part of an evening of poets' plays in February 1953 at the Theatre de

Lys, presented by John Bernard Myers and his companion, theater director Herbert Machiz.[52] Myers told Elaine that she had just three days to produce her sets, on a budget of seventeen dollars. ("I did the set for fourteen," she said, "and had a good meal with the extra three."[53]) The work of her poet friends was intensely meaningful to her. A quarter-century later, Elaine would be one of several artists who contributed to *Homage to Frank O'Hara*, after his untimely death.[54] Poet David Shapiro remembers that once, when he and Elaine were on an escalator, she turned to him and recited one of Edwin Denby's sonnets.[55]

When she returned to New York in 1953 after the summer in East Hampton, Elaine hopped from Edwin Denby's flat to Donald Droll's, at 132 East 28th Street.[56] She was now in her mid-thirties, and this was the first studio she rented completely on her own. The small walk-up was "much too expensive," she wrote, adding, in inimitable Elaine-style: "But how else is a girl to raise her standard of living but by acquiring new and larger debts."[57] Because there was no bed in the new place, she slept in her brother Peter's studio ("the spookiest any poor precocious artist has ever been subject to") while he was in Europe. Bill had told Elaine he would fund the services of a carpenter who could build her painting racks and an easel. What with her increasing demands on the carpenter, Bill's modest offer ballooned into financial support for the construction of two four-and-a-half-foot benches, a bedside table, a large table with metal legs, and swinging partitions "that look, when closed, as though Sarah Bernhardt is behind them ready to enter and deliver."[58] When Bill argued that the partitions were a luxury, she countered that they were "a practical extension of available wall space." (Her brother Conrad built her bed.) Even so, compared to Bill's new studio—with its skylight, waxed linoleum floor ("like a skating pond"), and a Murphy bed that reminded her of the drawbridge on which Douglas Fairbanks swashbuckled his way through the silent film *Robin Hood*—Elaine complained that her new digs were "not beautiful and much too small and cramped."

The de Koonings' 1953 income of $6,664.26 was almost entirely from sales of Bill's work at the Sidney Janis Gallery ($6,202.76). Elaine's modest contribution came from her magazine articles, a studio sale of her drawings, and an honorarium for jurying a painting show in Chicago. In a pattern she would repeat for much of her life, her expenses—including $350 for "travel in connection with lectures, serving on painting juries, interviews for articles"— exceeded her earnings. Among the couples' numerous charitable contributions (American Red Cross, March of Dimes, etc.), $100 went to "Catholic Church charities." It's noteworthy that Elaine's sympathies still extended to her family's faith despite her claim to have "stopped being Catholic" at age sixteen.[59]

IN APRIL 1954,[60] Elaine's first one-person show—paintings and drawings from the previous five years—opened at the year-old Stable Gallery on West 58th Street. Named for its original home in a former livery stable, it still smelled of horses. Earlier, Elaine had approached the art dealer Betty Parsons, who prided herself on "discovering" artists and had eclectic taste. But Parsons said nothing when she visited Elaine's studio, which she took as a lack of interest. (Many years later, painter Hedda Sterne—who showed at Parsons—told Elaine that the dealer had been interested in representing her but had expected her to follow up.) So Elaine asked her former teacher, Stable artist Conrad Marca-Relli, if gallery director Eleanor Ward might be interested in her work. And that's how Elaine finally got her show. She would always tell young artists to find an artist connected with a gallery to run interference for them.

Ward—who had returned to New York after working with the couturier Christian Dior in Paris—showed a diverse group of artists, including up-and-comers Marisol Escobar, Joan Mitchell, Alex Katz, Cy Twombly, Andy Warhol, Joseph Cornell, and Robert Rauschenberg. Lacking knowledge of avant-garde art, she was sufficiently open-minded to learn from her artists, who urged her to continue the legacy of the artist-run Ninth Street Show. Concurrently with the opening of her gallery in 1953, Ward inaugurated the Stable Annual, a large, influential exhibition selected by the participating artists that continued until 1957. Both de Koonings had work in every Annual.

A month before the opening of her show, Elaine wrote to Larry Rivers that every day she would get a new idea, "proving that every painting I ever made was all wrong" but that *now* she was finally on the right track. She ruefully called this state of mind "a charming picture of disorganized energy," but contrasted it to "organized energy," which she decried because "[a]ll it leads to is money, mainly thereby creating bigger and angrier problems." While it's not clear exactly what she was referring to, this remark was in line with her conflicted feelings about money—inappropriately connected to the intrinsic value of art, yet needed for the luxuries she favored, and most appreciated when it just seemed to fall from the sky. (At one point in 1955, when a potential teaching job fell through, she wrote to a friend that she was trying to think of "some other way of making money without spending any time at it."[61])

Her paintings in the show included an early still life, a portrait of Fairfield Porter, her recent images of basketball players, and several abstract works—at least some of them inspired by current events. *Event in a Warehouse* may have been prompted by a string of fatal warehouse explosions in Muncie, Indiana (January 1953), Plains, Texas (February 1953), Wilmington, North Carolina (March 1953), and Rosine and Houston, Texas (June 1953). *Sympathizer*, an

explosive abstraction, may refer to the communist witch-hunt led by Senator Joseph McCarthy, which ensnared many artists and writers who risked career-ending blacklisting if they refused to testify that their peers were communist sympathizers.

Prices ranged from $30 (for a drawing) to $700. *New York Times* critic Stuart Preston assailed her "pugnacious" brushstrokes—would he have said the same of a male artist?—but admired her draftsmanship and the pictures' "genuine vitality, marred only by 'consistently dismal color.'"[62] In *ARTnews*, Fairfield Porter praised Elaine's "incisive wit in the drawing and in the selection of details."[63] Her portraits, he wrote, were "both sympathetic and frighteningly acute." Porter leaned on his friendship with Elaine to deduce that the show "reveals a stubborn, clever personality."

BILL HAD AN AFFAIR with Marisol Escobar[64] in the spring of 1954, which the young artist found rather unsettling because of all the other women flitting in and out, and because of Bill's heavy drinking, which had escalated the previous year.[65] The de Koonings spent the summer in Bridgehampton at the Red House (a dilapidated eight-room Victorian dwelling named after its paint color). Joining them were Franz Kline, his girlfriend Nancy Ward, and Ludwig Sander. Bill painted in the garage. It was a madly social season, what with all the artists and other art-world people—including Harold Rosenberg and dealers Sam Kootz, Leo Castelli, and Sidney Janis—who were living in the Hamptons. Joan Mitchell and Mimi and Paul Brach rented a house on Fireplace Road, in the East Hampton hamlet known as The Springs. That long, twisting road was also home to Betsy and Wilfrid Zogbaum, and Jackson Pollock and Lee Krasner. Elaine and Bill had first visited the Pollocks in the spring of 1948. Months later, at a party at Clement Greenberg's home, Krasner told Elaine, "You have the heart of the tiger." She chose to take this enigmatic remark as a compliment, "but it was an attack."[66] Relations between the two women—married to the two rivals for the crown of American painting—were always edgy.

As Elaine said later, "It was a kind of pleasant but nightmarish summer.... There is such a thing as too many friends, too much talk, too much booze, too much of a good thing."[67] Early in June, Elaine's housemates left to pick up boxes of books owned by local bookstore owners Carol and Don Braider (who also showed paintings by the artists) for temporary storage in the Red House basement. Pollock, who had been drinking, drove over in his Model A Ford and downed a few more beers. Feeling nervous about being alone with him—in one account, he began chasing her around the house—she called

the store to speed the men's return. While carousing with them on a crumbling pathway outside the back door, Pollock tripped and Bill fell on top of him, causing Pollock's ankle to break. The rivalry between the two artists turned a relatively minor accident into a cause célèbre, one of three long-remembered events of a liquor-sloshed summer.

Another was the inauguration of the Artists & Writers Softball Game, in Zogbaum's front yard. As the story goes, for one game, Elaine, Bill, and Kline painted a coconut and two grapefruits to look like softballs—so convincingly that when Rosenberg pitched each of them to sculptor Philip Pavia, he slugged away, to gales of laughter. Elaine played in these games, too, along with Bill, Kline, James Brooks, Leo Castelli, Howard Kanovitz, John Little, Joan Mitchell, Charlotte Park, Larry Rivers, Harold Rosenberg, Barney Rosset (formerly married to Mitchell), Saul Steinberg, and Esteban Vicente. (Zogbaum was unable to join in because he had dropped a lighted match into his cabin's space heater, creating an explosion that gave him third-degree burns.) The annual event clearly meant a lot to Elaine. A few years later, in a letter to Philip Pavia,[68] she joked that she heard "some upstarts have taken over our baseball [*sic*] game" and needed to be put in their place when she came out to East Hampton.

The third event, in August, was a croquet party at the Red House for which Elaine gaily sprayed perfume on paper flowers she attached to the trees and Bill painted the three-hole toilet seat in the outhouse with a marble pattern. Two decades later, when the outhouse was transformed into a shed, the toilet seat migrated to someone's basement. In the 1980s, the house's owners hired an auctioneer to dispose of its contents. He contacted Elaine to see if his hunch about the authorship of the painted seat, which he had purchased for fifty dollars, was correct. Elaine vouched for it, but she was dismayed when the seat suddenly was claimed as a genuine work of art by de Kooning. "It was a joke," she said, not a painting. But appraisers determined that it could fetch anywhere from ten thousand to more than one million dollars.[69] As luck would have it, despite an estimate of fifty to sixty thousand dollars, the Guernsey's Auction House sale in New York on February 20, 1992—in the midst of a recession and art market slump—failed to attract a buyer.[70]

The summer of 1954 also featured a visit from Cornelia, Bill's seventy-seven-year-old mother, who hadn't seen her newly successful son for nearly two decades. Marjorie drove Elaine and Bill—who sold several paintings to pay for his mother's passage—to meet the ship in Hoboken, New Jersey. ("She never stopped talking," Marjorie said. "Blabbered away in Dutch.") At the Red House, Cornelia insisted on talking to everyone she encountered, despite

the language barrier. In the evenings, mother and dutiful son would stroll placidly down Main Street, like Dutch burghers. But Cornelia was a force to be reckoned with, from her mania for cleanliness (she awoke early to scrub the steps and regaled guests at one dinner with a long story—translated by Bill—about how she cleaned the garbage can) to her zest for high-decibel argument. She hated Bill's current paintings, criticized his drinking, and looked askance at his wayward marriage. Elaine, who said that Cornelia "could walk through a brick wall," likened her to the carved image of a woman on a ship's figurehead, "breaking gigantic ice floes."[71]

ELAINE'S PAINTING *BASKETBALL PLAYERS* (1954)—now known as *High Man*[72]—was included in Sport in Art from American Collections Assembled for an Olympic Year, a traveling exhibition that opened in November 1955 at the Museum of Fine Arts in Boston. The show was organized by the American Federation of Arts and sponsored by the newly launched magazine *Sports Illustrated*.[73] In the catalogue, Elaine is quoted as praising the "immensely important role [of sports] in American consciousness." She noted that they were "a means of communication"—implying that they transcend social and language barriers—and that they "indirectly involve passions that are anything but trivial."[74] Basketball was still a young professional sport; the National Basketball Association was established only six years before the show opened.[75] This may account for the fact that Elaine's was the only depiction of basketball players in this encyclopedic show. (Even Leroy Nieman, famous for his sports illustrations for *Playboy* magazine, didn't focus on basketball until the 1970s.)

Elaine had begun painting basketball players in 1948 or 1949[76] and continued the theme intermittently throughout the fifties; after picking it up again in the late seventies, she pursued it for a few more years. She explained that the game itself didn't particularly interest her; what captured her imagination was "the image of all these figures together—arms and legs, and you didn't know which arms belonged to which man. It was like a group figure with this many arms and legs."[77] The leaping players fit with the color-and-brushstroke-driven sense of movement she retained from Abstract Expressionism. After using energized brushstrokes in her paintings of seated men, she was intrigued by the opportunity to pursue this style with an active subject.[78] In her eyes, basketball offered "gesture and the nervous kaleidoscope of color."[79]

The impetus for these paintings, she often said, was her realization that the abstract compositions she admired from a distance on the front pages of newspapers in kiosks were actually sports photos. She liked the black-and-white

graininess of the newspaper shots because they left her free to invent her own color schemes. Elaine also attended basketball games at Madison Square Garden, which offered the opportunity to watch the athletes in motion, dribbling and passing, and elongating their bodies as they made a shot. Jump shots allowed her to incorporate an ethereal verticality in the composition. Her concerns were remote from those of the average sports spectator; her basketball paintings, she said, "always seemed kind of tragic to me."[80]

In *High Man*, a welter of brush strokes merges with the arms and seemingly weightless legs of two leaping players. The faces of these buoyant shooters are obscured. Although they are obviously on different teams (one wears a white jersey, the other, a green one), the mere sliver of space between their bodies and the way each man's bent knee mirrors the other give them a twin-like appearance. Because the setting in this huge painting is undefined—Elaine didn't even include the basket—the soaring figures with upraised arms have a curiously spiritual quality. This is not as odd at it may seem, because she was familiar with El Greco's *Vision of St. John* (1608–1614), from her visits to the Metropolitan Museum of Art. In a flowing blue robe, his arms upflung, and his face tilted to the heavens, St. John of Patmos is shown receiving one of his prophetic visions.[81] He is appealing to God on behalf of the souls of martyrs—the naked figures in the background of the painting. The martyr on the far right jumps up to receive his white robe from an angel, his right arm poised almost as though he is about to make a lay-up shot.

Like many skilled artists, Elaine drew upon multiple remembered images from Old Master paintings, melding her immediate perceptions with the formal inventions of centuries past. Perhaps it is not surprising that the art writer Leo Steinberg likened Elaine's equally large painting *Men Playing Basketball* (1956; plate 13) to "a crucifixion."[82] There are more figures in this version; three players jump for the ball, and the central one—facing forward, seemingly pinned in space, with his ankles joined—does resemble images of the crucified Christ. But the focal point of the scene is the sexy little detail Elaine gave the player on his left: a clump of underarm hair that registers dramatically against his pale arm and jersey.[83]

In a similar but much less dramatic manner, Elaine's baseball paintings from the fifties isolate moments when, as she explained, "all the men gathered together, when the catcher ran in, the pitcher ran in…where they all converged."[84] In her painting *Out!* a reviewer wrote, "the umpire becomes a smear of black and the confusion at base, an explosion of whites."[85] After acquiring a TV in the 1960s, Elaine would watch the games in her loft, but in the fifties, she attended Yankee and Brooklyn Dodger home games. On July 22, 1956, she

Elaine with *Men Playing Basketball*, ca. 1956.

Photo: Walter Silver. Gelatin silver print. ©Photography Collection, The New York Public Library.

sketched Yankee player Norm Siebern, who had made his Major League debut a month earlier (*Baseball #30-A–Siebern*), capturing his stance in profile but curiously miniaturizing his six-foot-two stature—perhaps to evoke the long-distance view from the bleacher seats. Similarly, while the title of her watercolor *Campy at the Plate* (ca. 1955) refers to Roy Campanella, the celebrated African American catcher for the Dodgers appears as an anonymous-looking figure standing next to the umpire. But maybe that is precisely the point. From the bleachers, the players in their baggy uniforms (in an era before the addition of names) were identifiable mostly by the way they slouched.

Many sources state that Elaine traveled with the Yankees and Baltimore Orioles in 1953 and 1954. The origin of this story is unclear—it may have surfaced in a *New York Times* article[86] about a show of her sports-themed paintings—but there seems to be no substance to it. It's more likely that Elaine attended part of the Orioles' inaugural season in 1954 while visiting her brother Conrad, who worked in Baltimore.

Baseball, with its long periods of inactivity, might not appear to be suited to her interest in the glimpsed moment. But Elaine's 1953 painting *Baseball Players* (plate 9) is a study in motion, with a player sliding safely across home plate, while the catcher next to him—caught in mid-jump—mirrors his wide-legged stance. The Yankees won the World Series that year, but whether this image is meant to portray a specific game is impossible to know, because the uniforms are so generalized. Elaine's figures have a marvelously kinesthetic quality, embodying the tension (of the catcher) and release (the player's triumphal slide) of a climactic moment.

In 1981, when several decades of Elaine's drawings and paintings of sports themes were shown at Spectrum Gallery in New York, Hilton Kramer judged her pastels of ball players to be among her best work.[87] He wrote that she seemed to aspire "to do for baseball something akin to what Degas achieved with horse racing." Many of Degas's paintings of this subject consist of seemingly casual groupings of jockeys and horses before the race has begun. His interest in the sport had little to do with portraying the suspense of a race; what captivated him were the formal qualities of an equestrian image.

Baseball legend Eddie Robinson (then the New York Yankees' first baseman) came to Elaine's studio at one point in the mid-fifties and asked to see her sports paintings. As she recalled decades later, he looked at her images of basketball and baseball games—apparently unfazed by her nontraditional approach—and said, "I'll take these six." No one had ever bought so many of her paintings at once. "I just liked his style," she joked.[88] For years, these paintings were a fixture in a restaurant Robinson opened in Baltimore.

Elaine once remarked that American football appealed to her as a subject because of "the groupings" (presumably, the offensive and defensive formations) and "the way the uniform distorted the body of the player."[89] But she told one of her assistants that the padding made the players less interesting to paint;[90] perhaps that's why no paintings by her of football games have surfaced to date. Tennis was a sport that initially held no appeal for Elaine. She changed her mind in the mid-sixties, when the chairman of the Dallas Davis Cup Committee invited her to paint the matches. "This is the first time I've seen tennis," she told a reporter for the *Dallas Morning News*. "Most civilized sports audience I've ever encountered." Referring to her painting of a young Arthur Ashe Jr., then ranked the number-three player in the United States, she called the reporter's attention to Ashe's "articulated limbs," marveling— with her abstractly focused artist's vision—that "he almost pulls apart at times."[91]

JOHN GRUEN HAD NOTICED that Elaine was no longer coming to the Cedar, now that Bill was keeping company with Joan Ward. She and her twin Nancy had become fixtures of the bar, seemingly "appear[ing] out of nowhere," with "no real connection to the art world."[92] On January 29, 1956, Joan gave birth to Johanna Lisbeth de Kooning, known as Lisa. Bill, who had spoken up at a panel discussion at the Club the day before, was no longer close to Ward. In any case, he assumed that a girlfriend's pregnancy would end in abortion. Visiting her in the hospital, he was in shock—though he soon became entranced with the baby, whose photograph he added to his studio wall. Elaine was shocked, too: she saw that Ward was registered as Joan de Kooning. "How wonderful," Elaine supposedly said, putting a bright face on a deeply troubling event. "Bill and I always wanted a baby." Exacerbating the emotional weight of this turning point in her life with Bill was the hysterectomy she had shortly before the child was born.[93]

THE CONTENT OF Elaine's spring 1956 show at the Stable Gallery[94] was similar to her earlier exhibition, with a handful of sports images and a sampling of portraits. Gallery owner Eleanor Ward (no relation to Joan and Nancy) increased the price of a drawing to $75 but pushed down the top painting price to $600. In *ARTnews*, Parker Tyler noted how Elaine's abstract brushstrokes in the seated portraits created "liveliness in passivity."[95] *Arts Magazine* reviewer James R. Mellow singled out her "strident color" and "bravura brushwork."[96] A *New York Herald Tribune* writer awkwardly suggested that in

Elaine's "essentially objective" portraits, "the feelings play their part [in] brushwork which is kept up at a lively pace."⁹⁷

Elaine's paintings would be included in an autumn exhibition at the Stable of work Tom Hess discussed in his *ARTnews Annual* article, "U.S. Painting: Some Recent Directions." He placed Elaine among those who believe that "there are almost no 'don'ts' to inhibit an artist from freely choosing" styles and subjects. Because the meaning of a painting is not identical with its subject, he wrote, it would be possible to paint the same one 100 times without necessarily repeating yourself.⁹⁸ (Little did he know that he was describing Elaine's later series of *Bacchus* pictures.) While Hess's article offered a broad survey of noteworthy younger artists, his essential argument had already been succinctly stated by Elaine the previous year in her essay, "Subject: What, How or Who?"

Before this show opened, Elaine wrote to Ward to sever connections with the gallery. Her letter is a model of judiciousness. She praised the Stable for its beauty and its atmosphere and lauded Ward for her "way of doing business." But she said that she didn't feel her work was properly represented "by the six minor pictures" Ward choose to retain in the gallery after the show. Ward's disinterest in Elaine's "big baseball picture on which I had worked for two years" and her portrait of her brother Peter ("which I consider to be one of my most successful pictures to date") were further indications that the artist–dealer relationship was a mismatch. Worst of all, Ward seemed to feel that Elaine had painted her pictures too quickly and was not ready to have a show. Insisting that she had "the friendliest feeling" toward the dealer, Elaine concluded in her inimitable fashion: "We can celebrate over a magnum of champaigne [*sic*] sometime and confuse the art world."

ELAINE'S MOVE FROM ABSTRACTION to figuration (often, as in the portraits, with elements of abstraction) was no doubt prompted by awareness of her relative strengths and weaknesses as an artist, as well as by her range of interests. Yet commentators have persisted in trying to find a deeper reason. One writer, who sees "a real lack of interiority" in Elaine's work, has suggested that the shift was "a ploy to deflect attention from her self [*sic*]."⁹⁹ This view is intriguing, in view of Elaine's resistance to introspection and the zestfully outgoing public persona she cultivated, no matter what troubles weighed on her mind. However, Elaine's shift from self-portraiture—cited by the writer as a case in point—was simply due to the increasing availability of other people to paint. How many artists besides Rembrandt have continued to produce self-portraits throughout their working lives?

Fairfield Porter's view is closer to the mark; he greatly admired her portraiture but believed that her abstractions "do not seem to liberate her talent." In an apt phrase, he likened her abstract paintings to "making conversation."[100] In other words, they are full of a sort of ingratiating energy that often fails to convey a deep engagement with abstraction as a personal statement. Grace Hartigan, who praised Elaine's "wonderful range and freedom" and her "beautiful touch," also zeroed in on this weakness: Elaine, she said, would "settle for gesture, rather than question it and deepen with it."[101] (Hartigan, who was mentored by Bill in her early days, included an abstracted image of Elaine riding a bicycle in her painting *City Life*, from 1956—a witty rejoinder to Bill's grinning *Woman and Bicycle*, and a recognition of Elaine's ubiquitous role in the "city life" of downtown artists.)

IN THE SUMMER of 1956, while Bill stayed on Martha's Vineyard with Joan Ward and Lisa,[102] there was at least one bright spot in Elaine's life: the start of her long working association with Dord Fitz. An artist, teacher, and gallery owner in Amarillo, Texas, he was visiting New York because he had arranged a show for his students at a gallery on 55th Street.[103] Mosaic artist Jeanne Reynal,[104] who lived nearby, dropped in and met Fitz. She encouraged him to knock on Milton Resnick's studio door. After convincing an initially hostile Resnick that he was the real deal, Fitz accompanied him to a party where he met Elaine, Kline, Louise Nevelson, and other artists.

On a return trip the following spring, Fitz held court with artists at the Cedar Tavern to work out the details for 7 Contemporary Painters, a fall group show of work by Elaine, Resnick, Kline, Pat Passlof, Joe Stefanelli, John Grillo, and Miles Forst.[105] To save shipping costs, the paintings were removed from their stretchers and rolled up so that they would fit in Fitz's station wagon for the trip back to the Dord Fitz Gallery, then located above a lumberyard in Amarillo.[106] Elaine flew out to see the show—her first experience of the Southwest, which seems to have included a trip to New Mexico.[107] Despite the low prices ($2,000 for the largest painting), the only buyer was Fitz himself. Undaunted, he mounted another show of adventurous work, mostly by New York painters, in 1959.[108]

Fitz's 1960 show The Women—an unusual exhibition concept at the time—featured nineteen artists, including Elaine, Biala, Nell Blaine, Perle Fine, Jane Freilicher, Helen Frankenthaler, Grace Hartigan, Louise Nevelson, Joan Mitchell, Pat Passlof, Jeanne Reynal, Hedda Sterne, Miriam Schapiro, Ethel Schwabacher, Jane Wilson, and California artist Claire Falkenstein.[109] As an indication of the weak market for art made by women, the *total* value of the fifty-seven works was determined to be $75,000 (about $600,000 in

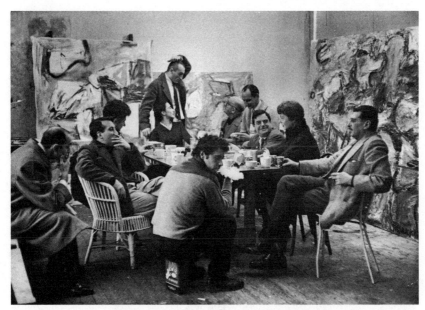

Milton Resnick's 10th Street studio, December 1, 1956. Clockwise, from far left: Irving Sandler, James Rosati, George Spaventa, Pat Passlof, Resnick (standing), Earl Kirkham, Angelo Ippolito, Ludwig Sander, Elaine, Al Kotin, (unidentified man).
Photo: James Burke. Getty Images.

today's money). Always up for a trip out of town, Elaine was one of the six artists who attended the March 19 opening. The festivities included a chuck-wagon cookout on a ranch, featuring cowboy coffee and a grilled mystery meat that turned out to be sweetbreads.

Fitz also gave Elaine a solo show in 1965.[110] His final tribute to her—in *Eight Modern Masters*, curated for the Amarillo Museum of Art—was a selection of paintings spanning nearly thirty years of her career.[111] While Fitz was famous for his diatribes against liquor and cigarettes—his daughter said that he put up with Elaine's chain smoking but "regulated her alcohol consumption"[112]—he and Elaine were on surer footing in their mutual dislike of religious and political conservatives. Their symbiotic relationship had a ritual quality. Every spring through the early eighties, Fitz would take his students and clients to her studio, where she was "her energetic, friendly self."[113] And when Elaine visited Amarillo, she would accompany Fitz as he traveled to his art classes across the plains of Texas and Oklahoma—combining instruction with sales of her paintings to his students.[114]

During these years—the mid-fifties and early sixties—Elaine's work was included in group shows at leading institutions, including the Walker Art

Elaine (left, in tweed coat) at chuck-wagon lunch, Durr Cattle Ranch, near Dumas, Texas, 1960.
Photo: Dord Fitz. Courtesy of Carolyn Fitz.

Center,[115] the Jewish Museum,[116] the Carnegie Institute,[117] the Whitney Museum of American Art,[118] and the Art Institute of Chicago.[119] She participated in a juried exhibition organized by the Museum of Modern Art's Junior Council[120] and another show organized by the Modern that traveled around the country but was never shown in New York.[121] She also had solo shows at New York galleries: Tibor de Nagy, Roland de Aenlle, James Graham & Sons.

In this respect, hers was an early career much like that of other promising young artists—unlikely to have been either boosted or marred by Bill's growing fame in the late fifties. But in succeeding decades, when her paintings were out of synch with the dominant styles, major museums no longer came courting. Although she had numerous solo exhibitions at galleries in the 1980s,[122] museums showed her work only in group exhibitions with a historical theme—notably, The Fifties: Aspects of Painting in New York;[123] The Figurative Fifties: New York Figurative Expressionism;[124] and In Memory of My Feelings: Frank O'Hara and American Art.[125]

ON THE NIGHT of August 11, 1956, Jackson Pollock drunkenly smashed his car in The Springs, killing himself and one of his two women passengers. "It was a tremendous shock," Elaine said later, because he had always bounced back after accidents. Alcohol was so central to many artists' everyday lives

that—when word got around that he was sober at the time (not true)—people remarked that perhaps the accident wouldn't have happened if he had been drinking. At the Cedar, his death was the topic that bound everyone together, reminding Elaine of the aftermath of President Roosevelt's death. Elaine met Pollock's eighty-one-year-old mother at the funeral. Her possessiveness reminded her of Bill's mother, whose personality, she said, created "a certain kind of rebelliousness…in their attitude toward women."[126] (In an effort to smooth over Bill's relationship with Cornelia, Elaine had begun answering her letters, making up messages from him.) Afterward, she joined Bill in Martha's Vineyard; sculptor David Slivka let the couple stay in his rented house. The proximity of Elaine and Joan Ward led to a string of confrontations, culminating in Elaine's accusation that Joan's wedding ring was fake. "It's no phonier than yours," she supposedly responded. Finally, Elaine left for Provincetown.[127]

ALTHOUGH ELAINE AND BILL had long lived apart and become involved with others, they separated for good—or so it seemed at the time—in 1957. Alcohol brought out the couple's "nasty arguments in public," her brother Conrad recalled. Despite Elaine's public show of good will, the birth of Joan Ward's child the previous year was the last straw. She moved to 80 St. Mark's Place; her friend Joan Mitchell had a studio at number 60. In the pre-hippie era, this shabby, crime-ridden neighborhood was populated mostly by immigrants from Eastern Europe.

Elaine's brothers piled her possessions on wheelbarrows and trundled them over the more than twenty blocks from her 28th Street studio. That night, Elaine said, "suddenly this tremendous blast of music came through the floor. And we all dropped everything, and my two brothers burst out laughing"—because the lease stipulated that she would not live on the premises. The "God awful" loud music—old popular songs, mostly—that played every night from 9 P.M. until 4 A.M. came from the nightclub downstairs. Elaine hadn't realized it was there until she moved in. As one of her brothers said, "This is a wonderful studio for an artist to go mad in."[128] Nearby was a Polish dance hall, which Elaine visited a few times—once, in the company of Andy Warhol. She liked the energy of the Saturday night folk dances and appreciated the convenience of a nearby liquor store where she stocked up for her parties. When she walked in holding a copy of *ARTnews*, the proprietor told her that he favored artists because they drank the hard stuff.

WHEN BILL DRANK, "he would often become very pugnacious, and I thought he was hostile toward me," Elaine said decades later, remarking that she now

realized "it was booze talking."[129] They had also different ways of dealing with disagreements, even different views of life in the United States. Elaine was accustomed to raging arguments ("No statement in my family ever went uncontested"[130]) and to freely disparaging aspects of American life. Bill's manner was more elliptical, and he was charmed by American abundance and entitlement. More fundamentally, Bill had come to the marriage with traditional ideas of a wife's role, apparently not realizing that Elaine would never agree to play it.

But her own behavior—her constant need for attention, youthful self-involvement, and spendthrift habits—must have been hard to live with. Elaine probably came closest to the problem when she was asked to opine on why another artist left his wife. "Nobody can ever presume to know what a break is due to," she said. "It can be anything, including the institution of matrimony."[131] The give-and-take of a successful marriage requires an ongoing level of empathy, thoughtfulness, and flexibility that she could not or would not muster in these years. She would remember the plate of apples and cheese that Bill put out for her when he left the studio to earn some money; a similar gesture would not have occurred to her. It was not an aspect of marriage she could have observed growing up with her troubled mother, who instead fed her daughter's self-confidence and independent outlook. Yet Marie's later life offered a template for coping with marital differences and reasserting one's independence. At a time when divorce was not considered respectable (and was unthinkable for Marie, as a Catholic), the Frieds had led increasingly divergent lives, spending more and more time apart. Marie had long threatened to leave home once the children were grown; no one believed her, Elaine said, until she carried out her plan.[132] She spent her last years in Manhattan, pursuing her various interests, including mathematics and languages.

FIDELITY, OF COURSE, was never a given in the de Koonings' union. When Thomas Hess was writing his seminal monograph about Bill's work (published in 1959), he told the art writer Irving Sandler that when he tried to find out when certain works were painted, Bill could only remember which woman he was sleeping with at the time.[133] A few months before her death, in an unintentionally revelatory remark, Elaine spelled out her view of the "till death do us part" aspect of their marriage: "You know, I'm doing what I damn please, and he's doing what he pleases."[134] What mattered to her was what they had in common—their sense of humor, their friends, their ideas about painting and writing, and their unwavering support for each other's work. Those things are important, but they are not the same as a willingness to "be

there" for the other person. It was not until her mid-fifties that she assumed that role, as we shall see.

Throughout their eighteen-year period of estrangement, Elaine remained sporadically in touch with her husband, who provided financial assistance from time to time. For his part, Bill—whose attachments to women were always short-lived—seems to have avoided a divorce to keep other women from trying to marry him.[135] Elaine and Bill were not the only artist couple in their circle to live apart without divorcing: married in 1944, painter Hedda Sterne and cartoonist Saul Steinberg separated in 1960, but remained close and never divorced.

Artist Mimi Gross was in her early twenties, newly married to multimedia artist Red Grooms, when she met Elaine in the early sixties. According to Gross, Elaine was "very angry" at Bill, "parading these other women"—his lovers—"in front of the whole world, because he was popular."[136] Gross said she was dropped by Grooms's friends after she and her husband separated in the mid-seventies and failed to receive her share of credit for collaborative work with him. Whatever Elaine's actual feelings may have been, she commiserated "about the similarities in our lives."

Snarky observers would note that she tended to speak of Bill "as if she had seen him the day before, even when years had elapsed between visits."[137] If the point of this criticism was to deride the couple's connection, it ignored the fact that Elaine lived daily with fond memories of his precepts, the "Bill always said" remarks that would pepper many of her interviews. Once, after she gave a lecture, someone quoted the saying, "Nothing can grow in the shade of tall trees." Wasn't it tough for her to make her own way? Elaine had a typically witty comeback: "You can lean on a tall tree. And you can climb it."[138]

She sometimes invoked the age difference between her and Bill to clinch her case for the lack of rivalry, pointing out that Lee Krasner and Jackson Pollock, in contrast, were close in age.[139] The fourteen-year gap between Elaine and Bill had become sixteen years in all her public statements (and probably in her mind, too, by now) because of her life-long fudging of her birth year.[140] In Elaine's view, Krasner had great confidence in her abilities but allowed herself to be dominated by Pollock. "Her ambition seemed to be for Jackson socially," Elaine said, referring to Krasner's efforts on his behalf with dealers.[141]

Elaine has been accused of sleeping with Hess and Rosenberg primarily to advance Bill's career. To believe this is to misunderstand both her personality and the spirit of the times. She was impetuous, free-spirited, and generous— the opposite of a plotter and conniver. Sexual connections between people

with flagrant conflicts of interest were commonplace at the time. Elaine knew men in the art world who fascinated her with their ideas and their authoritative presence, and she felt entirely free to get involved with them—just as they evidently felt entitled (despite their marriages) to maintain a fleeting or long-lived relationship with her. As Margaret Randall noted, "Those were safe men for her. The fact that they were married was very convenient."[142] In choosing these men, Elaine may have been compensating for having a father who was so colorless and ineffectual.

Elaine had a large and loving circle of friends, and a solo act was a lifestyle she was well equipped to handle. She reveled in her freedom to live the life she wanted and to paint to please herself. Even as a child, she said, she never concerned herself with other people's responses to her art. For her, painting was an intellectual activity; she likened herself to a scientist who never worried about interest from the corporate world.[143] After Bill became famous, she would remind interviewers that he worked in obscurity until the mid-fifties. "In terms of our own circle," she said—the slender ranks of artists who shared her and Bill's sense of what was important in painting—"nobody's famous.... So that never was any kind of issue personally."[144]

But she did admit that his paintings had an "overpowering" influence on her. "And so, to keep a sense of myself, I always hung on to some kind of subject"—a succession of themes that she would paint repeatedly.[145] The paintings in her November 1957 show at Tibor de Nagy Gallery included portraits of Bill, Tom Hess, Harold Rosenberg, and Frank O'Hara, and the abstract paintings *Sympathizer*, *Protestant*, and *Herzog*—a stick figure with a triangular torso overlaid on a bright yellow and orange abstract background. It probably represents Maurice Herzog, who had written a bestselling book about his role in the first Western expedition to reach the peak of the Himalayan mountain Annapurna I. Among the grimmer painting titles (*Suicide, Vestibule Killing, The Death of Johnny A.*), at least one reflects a local police blotter item—Johnny Acropolis, president of Teamsters Local 456 in Yonkers, New York, was killed by an unknown assailant in 1952.

The reviewer for *Arts Magazine* praised the "astringently colorful" canvases in the show for their "masterly" execution.[146] But poet and critic James Schuyler—who knew Elaine and would have been aware that Bill was now involved with Pollock's former girlfriend Ruth Kligman—noted the "rawness" and "psychological insight" of Elaine's work (a curious thing to say about abstract paintings). "If anxiety is not absent," he wrote, "neither is beauty."[147]

Despite her rift with Bill, there was reason to doubt that the split was permanent. During the summer of 1958—when Kligman went to Europe by

Herman Cherry and Elaine, at the home of Ernestine and Ibram Lassaw in The Springs, East Hampton, 1957.

Photo: Ibram Lassaw. ©Ibram Lassaw 1957/ Denise Lassaw 2016.

herself, unable to persuade Bill to accompany her—he invited Elaine to stay with him at a friend's cottage in The Springs. In public, at least, Elaine retained a buoyant outlook. That summer, she went to a party given by Grove Press publisher Barney Rosset, who was developing land at Three Mile Harbor.[148] The temporary bridge to the island that he had built for partygoers collapsed under their collective weight, plunging many of the smartly attired men and women into the water. Elaine and Ernestine Lassaw found the whole thing hilarious; they peeled off their clothes and jumped in.

6

Enchantment

WHEN ELAINE ARRIVED in Albuquerque in the fall of 1958[1] as a visiting artist at the University of New Mexico, it was love at first sight. She was dazzled by the way "the cottonwood trees and aspens had turned an overwhelming gold."[2] After the urban density and gray verticality of New York, the brilliant hues of the Sandia Mountains and the big sky stretching across the Rio Grande Valley were a revelation. Her fascination with the southwestern landscape was uniquely kinesthetic: "New England mountains are so well-planted," she remarked, "but the New Mexico mountains seem to move toward you."[3] Her paintings began to expand horizontally and echo the vivid colors of the Southwest.

Elaine rented a five-room adobe house in Old Town[4] for seventy-five dollars a month, a significant chunk of her $700 salary.[5] In early November, she presented a collage of impressions in a letter to a friend, including the way the Sandia Mountains turned "deep red at twilight—fantastic," the "enormous" 350-year-old adobe that housed the restaurant where she dined, and the "adorable" students she had, "all seventy of them." She had recently purchased a car so that she could look at the scenery while en route to local towns rather than having to converse with whomever was driving her. But her wheels would not be parked in her adobe garage—she had converted it into a studio where she had just finished "three good paintings."[6] Earlier in the fall, Elaine traveled to Roswell and Santa Fe, spreading the word about Philip Pavia's new art magazine, *It Is*, as she judged an art show and investigated local museums. In Taos, she visited Georgia O'Keeffe, a few weeks from her seventy-first birthday. In a letter to Pavia, Elaine described this "grand old gal" who "looks like a monk (not a nun)" and was "very witty in a 'dry' sort of way." Amazed that O'Keeffe owned "an adobe castle…with servants, gardens," Elaine observed, "when artists out here make it, they Make It." It suddenly struck her, she wrote, that artists "pay for living in New York with blood."[7]

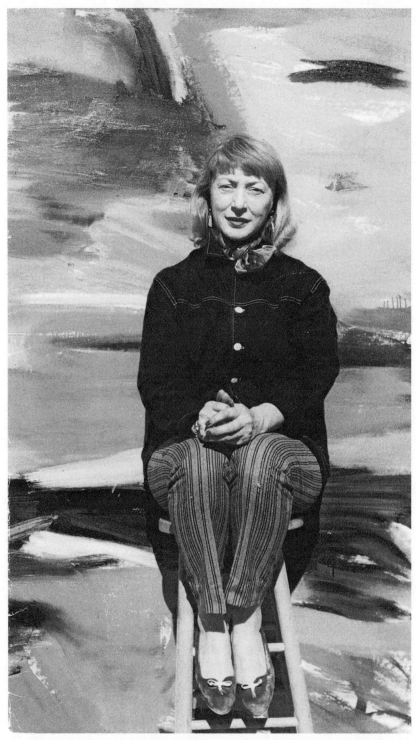

Elaine with one of her paintings inspired by the southwestern landscape, ca. 1958.
Photographer unknown.

Elaine's enchantment with New Mexico did not include Albuquerque, which she viewed as "bleak, impersonal, uningratiating, a big-city-in-the-making with little time for art." This was the type of environment that usually bred artist-eccentrics, she wrote, "doggedly working away in blind alleys." Yet she found a new reason to rejoice after discovering a dozen young abstract artists with "communal energy and sense of purpose, and a totally high level of awareness of current avant-garde trends in painting."[8] An interview with Elaine in the *Albuquerque Journal* was peppered with her upbeat quotes. She said she was "charmed with the cultural atmosphere of the area" and surprised "at finding so little 'provincialism'" in Southwest art.[9]

In an article published in *Art in America*,[10] Elaine explained that the landscape she was so smitten with ("the flayed pink earth, the jagged stampeding mountains, the reverberating sunsets") was too intense to play a role in local artists' abstract paintings. She described them as "strongly introspective...stubbornly original and personal, yet not eccentric." Elaine marveled at how the artists maintained such a "buoyant resistance to neglect." Yet she also saw parallels with the downtown artists of New York a decade earlier, noting how "a glorious, tough originality blooms in isolation."

One reason for the unusually large group of serious artists in the area was the presence of the university; most were either faculty members or graduates. They had learned about the new directions in art from national art magazines and from the example of Richard Diebenkorn, who came to the university in 1950 as a graduate student familiar with the work of innovative New York and California artists.[11] But what made Albuquerque a unique art center was a sixty-six-year-old abstract painter influenced by Kandinsky. In addition to his teaching at the university, Raymond Jonson ran an on-campus gallery in an experimental structure that also contained his living and working spaces. One painter told Elaine, "The brush would have dropped from my hand if it hadn't been for Raymond Jonson."[12] Even though nearly all the visitors to the gallery were struggling fellow artists, not collectors who could write a check, the prospect of having this beloved faculty member decide that your work was worthy of a show was encouragement enough.

Inspiring though he was, Jonson could not compete with the intoxicating presence of forty-year-old Elaine, recalled by artist William Conger as "very sensual and very forthright." On the first day of class, she showed up in a leather skirt and boots, a far cry from the way women normally dressed in 1958. "I hadn't seen any women in leather skirts," Conger said. "The way she moved, every part of her body glistened in this leather. I was smitten. And then she put one leg up on a stool. I'm telling you, as a twenty-year-old guy, I was a goner."[13]

Elaine and Conger became good friends. As he points out, "she didn't know or care about the usual barriers that would exist between faculty and students, which were much looser in those days. She would routinely call up a few students—'meet me at this bar.' Sometimes we were old enough; sometimes we weren't. She would hold court. Other artists would show up, as if on cue." It was her way of bringing the Cedar Tavern to Albuquerque. "She did a lot of drinking, and the more she drank, the more talkative and interesting she became.... She just had a way of talking about art that was extremely engaging and made you feel like you were a member of this secret club."

As a teacher, Conger said, Elaine liked to tell stories that gave her students an insider's view of the art world. Once, she mentioned how Franz Kline had trouble with titles. In her telling, he would gather several people for drinks before pulling out the paintings. Fueled by a bottle of Scotch, "people would come up with all kinds of ridiculous names." (This eight-hour session occurred before Kline's first solo show, at the Charles Egan Gallery in October 1950.)[14] Other stories she told were actually lessons in disguise. Gorky, she said, would put tracing paper over reproductions of Old Master paintings and outline the "negative" spaces—the empty places between the figures, and between each figure's arms and legs. He used these odd-looking shapes to create the startling forms he used in his paintings—the images resembling bizarre plants, imbued with a sexual suggestiveness. The lesson was that you could use art of the past to make enormous leaps in the present, if you know how to harness that resource.

"She had a way of emphasizing the act of painting a lot," Conger said. What mattered was the thing you did without a plan or an idea. Bigger was usually better: "She would insist that people go to the hardware store and get big brushes." Elaine was pragmatic, too, telling students not to waste time with gesso (used to prime the canvas surface), because a gallon of Elmer's glue would do just fine. Her approach must have seemed particularly appropriate in an art department that was woefully underfunded, with "broken-down tables, war surplus chairs...broken easels."[15]

Elaine gave all her students A's, which prompted the chairman to call her into his office. "Mrs. de Kooning," he said, "you have to grade on a curve." When she demurred, he called in another teacher, saying, "Look at his grades: A's, B's, and C's." Elaine replied, "Well, I guess my students are better than his."[16] Yet in class, Conger remembered her being harshly critical at times, particularly to the sorority girls, who tended to be rather timid painters. Pointing out a weak aspect of their work, she would say, "I don't want to see this anymore!" She was not particularly sympathetic to their problems. When a young woman asked her about being a "woman artist," Elaine bristled. "I am an artist,

period," she said. Asked if she were the subject of Bill's *Woman* paintings, she snapped, "Absolutely not."

If Elaine's directness alienated some students, Conger was enthralled. Her influence on him "had to do with the energy and guts of being an artist...that an artist's ability came from uninhibited action." She was also an intellectual mentor ("One had to...be smart around Elaine"[17]) and an early booster of his career, including his work in a New York gallery show of Albuquerque artists when he was still an undergraduate.[18] At the end of her year at the university, Elaine urged him to come to New York and become her assistant while working on his paintings. "You can get jobs," she insisted. But he decided that New York was unaffordable, and he didn't want to work as a handyman.

Another student did take her up on her offer. Eddie Johnson was a quiet young man devoted to photography, not one of the guys who hung out at the local bar. When Elaine first encountered him, he was painting "small, gray still lifes."[19] She suggested that he get some large brushes and a large canvas "and use slashing strokes and be reckless." He immediately began working in a totally different style, and Elaine was pleased at "this closeness of rapport" between them. His oil pastel portrait of an artist friend, Robert Corless, is rendered with vibrant colors and an assured touch.[20] After graduating in 1960, Johnson went to New York to join Elaine. In a 1964 self-portrait serigraph, he seems to shrink into one side of the print, his mouth small and tense, his eyes cast downward. Portraits of him by others during this period also show a haunted man. Elaine tried to bring Johnson out of his shell by introducing him to Steve Poleskie, owner of Chiron Press; the two of them collaborated on an experimental film for which she served as associate producer.[21]

Johnson eventually returned to New Mexico, to work in his family's house-painting business.[22] Decades later, when Conger gave at talk at the university—on the occasion of a show of paintings by local artists from the period when Elaine was teaching there[23]—he saw his fellow student again. "He was stooped over, with a long white beard and a couple front teeth missing. All I could think of was Rip Van Winkle. I thought, Oh boy, that's what would have happened if I became Elaine's assistant."[24]

By the mid-1970s, Elaine would alter her advice to art students, suggesting that they "stay put." Her reasoning was that artists in New York "can get involved in some kind of careerism," to the detriment of their work. "Artists do not survive in terms of sales," she said. "The whole idea of being an artist is to follow your own direction."[25] (Of course, her rationale assumed an artist much like herself, with strong self-esteem and some outside income.) She told her students that they had to have "confidence amounting to arrogance, because,

Elaine de Kooning, *Eddie Johnson*, 1962.
Charcoal on paper, 26 x 19-7/8 inches. Private collection. Photo courtesy of Levis Fine Art, Inc.
©Elaine de Kooning Trust.

particularly at the beginning, you're making something that nobody asked you to make."[26] Also crucial, she once said, quoting the Bible to make her point— "Iron sharpens iron; so a man sharpens the countenance of his friend"[27]—was the importance of seeing and discussing the work of fellow artists.

IN ALBUQUERQUE, ELAINE noticed that artists often used acrylic paints, which had not yet caught on in New York. Experimenting with the new

medium, she liked the way it could be used to cover large areas quickly. She was also struck by the unusually large proportion of woman among the local artists. "Most impressive," she wrote, were Joan Oppenheimer, who had graduated from the university eight years earlier, and Connie Fox, "a magnificent draughtsman and colorist," who was finishing her master's degree at the university when Elaine arrived. "She was like a fresh wild breeze," Fox recalled. "The personality who came and brought excitement with her. She was a lot of fun, really witty, and a really good talker."[28]

The two women became close friends "almost immediately," Fox said. "It was amazing how much we understood each other although we came from totally, totally different backgrounds. I had never seen a museum until 1950, when I went to Europe."[29] Fox was living with her husband and young daughter in an old, partly modernized adobe in the village of Tijeras.[30] The original back bedroom had a mud floor; a huge fireplace heated the entire house. "We would have parties with artists from the area," she said, "and Elaine was the real life of the party.... She just fit right in."

Margaret Randall, a petite twenty-one-year-old whose unhappy youthful marriage had recently ended, would also become a good friend. She worked as a model for one of Elaine's studio classes, "fumbling my way toward poetry."[31] When Randall said she would have loved to draw instead of posing, Elaine immediately gave her paper and put a piece of charcoal in her hand. (Years later, in New York, Elaine gave her an expensive brush, explaining—in her typically counterintuitive style—that beginners were the ones who needed the best equipment.) "Elaine believed in freedom," Randall wrote later. "Freedom of gesture, risk in everything she touched. She showed me that abandon long practiced becomes skill."[32] Her drawings for Randall's 1961 poem collection *Ecstasy Is a Number*[33] include a rare religious figure—St. Margaret with her black cross, accompanying the poem, "St. Margaret Stepping from the Belly of the Dragon"—and several images of jazz pianist and composer Thelonious Monk, three of which illustrate how he "played with his hat on," as Randall wrote in "Thelonious."

"From the moment I met her, I felt like we had known each other forever," Randall said. "We were together almost every day from then on, while she was out here." The traditional notions Randall had grown up with about a woman's place in the world had cramped her horizons. She was used to "the intense hypocrisy of middle-class America"—including the need to pretend that shattering personal experiences, like sexual assault or cancer, had never taken place.[34] At a time when women struggled in isolation against many odds, Elaine "represented one of the first examples of a woman who could do whatever she wanted, who could be creative and make her life into a statement that mattered,"

Randall said. "She was absolutely unbound by convention. She taught me that there shouldn't be a difference between discourse and actions." With Elaine, "anything was possible." If you were trying to decide which of two possible directions was best, she "laughed and asked, 'Why choose?' "[35]

Randall had told Elaine about the Shalako, an all-night ceremony that takes place on the ninth day of the winter solstice to reenact the Zuni creation story, offer prayers for continued prosperity, and honor the dead. Six dancers who sing and shake rattles wear huge masks that combine the features of birds and animals; other performers from the village take the roles of sacred clowns. Because the Zuni Pueblo governor was an admirer of Bill's work, he and his wife invited the women to spend the night in sleeping bags on their porch, a welcome shelter against the cold. (Elaine later had Bill send the governor a small painting.) This intimate experience of ancient ritual may have whetted her interest, decades later, in Paleolithic cave paintings.

During the fifties, Randall was an aficionada of the Sunday bullfights at the Plaza Monumental in Ciudad Juárez, Mexico, and Elaine would accompany her on the six-hour drive. She would spend the entire afternoon sketching the drama of the *corrida* in oil-based pastels. "Afterwards, we always tried to make friends with the bullfighter," Randall recalled, "and he was quite entranced with Elaine. Several times, we went out for drinks and fought off his advances."[36] According to her financial records for 1958, Elaine made a dozen trips to Juarez—her biggest single cash expense of the year, other than "entertainment." (She paid cash rather than writing a check because, as she noted, "expenses preceded income." Many of her checks had bounced, and she was obliged to borrow money to finance her travel and other costs.[37]) Elaine wrote to a friend in New York that she was "on the side of the bulls, so far," observing that they "look so happy when they come rushing out." She was charmed at how they seemed "fantastically light on their feet."[38]

The bullfights loomed so large in Elaine's imagination that the Sandia Mountains in Albuquerque came to remind her of "the muscles and bristled hides of stampeding bulls,"[39] a confluence that is visible in some of her paintings. With her portrait painter's acuity, Elaine would compare Jackson Pollock's eyes to those of a bull running a charge.[40] She was viscerally aware of the animal's anguished ferocity: once, a bull whose profile she was sketching turned around "and suddenly his horns came charging toward me."[41] The bulls were enormous animals, sometimes weighing more than a thousand pounds; for a spectator seated in the stands, the threat seemed real.

"Even in my abstractions, I have to have a theme," Elaine said later. "This image of the bull, this swirling image ... could be more realistic or more

abstract."[42] Her bullfight paintings from this period, which usually have simple, descriptive titles (*Bull, Standing Bull*), translate the colorful, animated aspects of the event (the matador's costume, the airborne red or fuchsia cape, the blur of spectators in the stands) into Abstract Expressionist slashes of paint. She used Liquitex, an acrylic paint that came in brilliant hues and dried rapidly. "Right now," she wrote, "I want pageantry, splendor, panoramas, clamorous color—trumpeting reds and shrieking yellows—the phony glitter of tough bordertown facades, the heraldic colors of the corrida."[43] The bull itself—whether outlined in black or a built from a prismatic reflection of its colorful surroundings—is the focal point in this visual cacophony. Elaine captures the animal both as a hulking mass and as a lunging blur. In some of the paintings, the bull is clearly identifiable; in others, if you didn't know the title, you'd be hard pressed to identify what the picture was about.

In *Death in the Afternoon*, Ernest Hemingway wrote that "the formal bull-fight is a tragedy, not a sport,"[44] because the bull is always destined to be killed. From the ceremonial opening parade of all participants to the final moments of the dying bull, the event is governed by strict adherence to ritual. It begins with the matador manipulating the large, brightly colored cape (*capote*) he holds in two hands, to test the bull's responses. This prologue is followed by the entrance of two *picadors* mounted on horses swathed in protective padding who provoke the bull to attack the horses. The picadors use their lances to stab the bull's neck. These actions, usually repeated several times, serve as a sort of warm-up, showing how the bull will react under attack. The wounds also force the bull to lower its head so that its charges will be less dangerous to the matador. (Elaine wrote to a friend that she "hated the picadors."[45])

The matador's pass with his *capote* in this first stage of the bullfight—he slowly swings it away as the bull charges—is called the Veronica. The name is taken from St. Veronica (who is said to have wiped Jesus's brow on his way to Calvary) because the matador begins with his hands holding the cape's top corners—the same way the saint is depicted holding the cloth imprinted with Jesus's face. Elaine's painting *Veronica* (1960) is an abstract image of the *capote*, an irregular shape of crimson and fuchsia with strokes of black paint that blazes against the yellowish color of the sandy arena.

A trumpet fanfare marks the next phase of the event. The *banderillos* enter; their mission is to wound the bull with barbed wooden sticks—an occasion to demonstrate the men's skill and courage, as well as yet another means of determining how the bull will ultimately behave.

The final ten minutes belong to the matador, who makes series of one-handed passes with a red *muleta* (a smaller cape, attached to a stick), in an effort

to maneuver the bull into the best position to make the kill. This is the ultimate test of his skill—ideally, a set of four or five passes that cause the bull to repeatedly curve around the matador's body while spectators admire his ability to anticipate and react to the bull's movements. When he feels that the "moment of truth" is at hand, he exchanges the fake sword he started with for a real one and plunges it into the bull's aorta. (Elaine noted, with her Wordsworthian sense of the way the natural world appears to echo human awareness, that it was always twilight at the moment of truth.) After a great performance, the crowd will stand, waving handkerchiefs, to encourage the awarding of a grisly trophy, usually one or both of the bull's ears, to the matador. A typical *corrida* can last well over two hours, with two reprises of the entire scenario, showcasing new bulls and men.[46]

Even if you didn't know that the title of *Faena* (1960)[47] refers to the matador's final movements of his *muleta* before making the kill, the thick red and orange brushstrokes that whip around to enclose a small wedge of space suggest both speed and force. The matador is a stick figure, barely indicated by swipes of black paint; the bull is reduced to a vaguely outlined head.

Why did bulls—which also populate her late works based on prehistoric cave paintings—captivate Elaine? And why, we may wonder, was she not outraged at what many see today as a needlessly brutal event? Her nephew Charles Fried said, "I always attributed that to her liking of masculine things."[48] Animals had intrigued her since childhood, when she drew cows on the family farm in upstate New York. But cows lacked the "rippling contours" of bulls, she said. "The fighting bull...may be the most beautiful animal on the fact of the earth. Its contour is always moving. It's like music."[49] It was completely in character for Elaine to react this way, not only as an animal lover but also as an artist fascinated by bodies in motion. She seems to have had a deeply kinesthetic relationship with the animal—a feeling so palpable that she once claimed to "identify with...the image of the bull."[50] Years later, she wrote, "I was squeamish, but if I was [painting], then blood wasn't blood, it was simply red."[51]

The postwar popularity of existentialism, which stressed the importance of individual responsibility for living a meaningful life, had revived arguments for the ethos of bullfighting put forward decades earlier by Hemingway. Elaine had read some of Søren Kierkegaard's writings about the need to live purposefully.[52] Of course, she was also familiar with Harold Rosenberg's description of the birth of what he called "action painting"—when the canvas became "an arena in which to act" and "what was to go on the canvas was not a picture but an event."[53]

Unlike Hemingway,[54] Elaine focused on the bull, not the matador—
"I always [painted] as if the matador didn't exist; he is the killer," she said.[55]
Her pictures are about the movements of an animal and a piece of cloth, not
those of humans. (Though, with typical curiosity, she wrote to a friend that
she was about to meet a "toreador" to get his side of the story.[56]) She was
haunted by the way, "in the center of the spectacle...the bull is confronting
death," while the matadors seem to "fade away."[57] Elaine had seen matadors
before a bullfight who "looked as though they were practicing how to become
invisible. Their faces seemed veiled with fear. And their eyes were like the eyes
of prizefighters after the first few rounds."[58] The human players in the ritual
are usually absent or unrecognizable in her work. Despite its title, *Matador*[59]
seems to be showing the bull from the matador's point of view. In *Bull/
Matador*,[60] the latter is reduced to a streak of green and pink with a small
yellow, featureless face topped with black cap. (Richard Wright made the
same choice—focusing on the bull—in his travel book *Pagan Spain*, pub-
lished the year before Elaine came to New Mexico.[61]) When Elaine returned
to the bullfight theme in 1974, after a trip to Spain, she worked in a more rec-
ognizably figurative style that gave the matador more prominence.

BACK IN NEW YORK in 1960, as she worked on her paintings of bulls and
abstract southwestern landscapes, they became larger and larger. She used a
long-handled brush attached to a six-foot-long aluminum pole to reach the
top of the canvas. An interviewer watched her manipulate this tool to make a
"light-handed swish" that "imbed[ded] a banderilla in the bull's shoulder."[62]
With her feet in a fourth-position ballet stance, she would throw her head
back and lunge at the canvas, as if simulating a matador making a kill. "Now
my colors...want to burst the boundaries, to expand, radiate, explode," she
wrote in a statement for the Graham Gallery exhibition of her new work."[63]
In a review of the show,[64] the *New York Times* critic wrote that she was skilled
at "preserving both the emotion and the actual character of a contest" while
working semi-abstractly.[65]

Getting the paintings to the gallery was a struggle in itself. Because the larg-
est one—an immense ten by twenty feet—wouldn't fit through her studio
door, she resorted to removing the canvas from its stretcher and rolling it
around a cardboard cylinder used to move carpets. Afterward, intrigued by the
way brush strokes looked on a curved surface, she decided to stretch more can-
vases on cylinders and paint "vertical landscapes" on them. Elaine worked long
hours every day for months on the cylinder paintings. She glued the canvases
to the cylinders before starting to paint, which made the task much harder

than working on a flat surface. ("It was a very unsettling experience to work on a surface that was constantly receding," she recalled.[66])

The Graham Gallery exhibited the fourteen cylinder paintings in April 1961 with a four-panel abstract mural by Norman Bluhm, cannily marketing the two artists' work as "portable paintings" for public buildings, "usable by architects on an experimental basis."[67] Ranging from three to eleven feet tall, the cylinders were suspended between the gallery ceiling and floor—an installation that created an inadvertent "happening"[68] at the opening. The combined weight of all the gallery visitors made the floor sink slightly, and the cylinders toppled amid shouts of "Timber!"[69] (Because they were made of cardboard, no one was hurt.) An *ARTnews* reviewer wrote that despite the problem of "avoiding a barber-pole as a concept," Elaine's painting was "luscious."[70] But she ultimately decided that these works were a failure, adding, "I keep them around to torment myself with."[71] Elaine was ahead of her time with the cylinder concept—other artists' painting-sculpture hybrids of the sixties were still on the horizon—but although she returned to painting on flat canvases, the idea of extreme verticality still intrigued her. Her next portrait series would consist of "very tall men on very tall canvases."[72]

DURING HER MONTHS in New Mexico, Elaine became involved with Robert Mallary, a ruggedly handsome fellow instructor.[73] As a young man with a fervent belief in socialism, he traveled to Mexico City to study with muralists David Alfaro Siqueiros and José Clemente Orozco. Siqueiros's interest in the potential of technology in art led Mallary to begin experimenting with plastics in the late 1930s. In the early fifties, while working at an advertising agency in Los Angeles, Mallary inspired a young Wayne Thiebaud, who learned from him "how hard you had to work [as a fine artist], because you were dealing with...an extraordinary community of excellence."[74] With his "sense of inquiry and terrific analytic skills,"[75] Mallary gave Thiebaud his first awareness of the life of the mind. By the mid-1950s, when Mallary arrived in Albuquerque, his groundbreaking luminescent sculptures had been featured in solo shows at two museums in California and were featured in *Time* magazine. Now he began making relief sculptures incorporating painted sand and gravel coated with polyester and mounted on plywood.

Though known as a womanizer, Mallary was said to have had eyes for no one else after Elaine arrived on campus. But his high seriousness sometimes clashed with her high spirits. Elaine was "always interested in what's interesting and what's fun to do," Conger said. On one occasion, she tried to perform a trick that involved getting a card to stand on edge while Mallary fumed at

wasting time with such a frivolous activity. When the couple's differences came to a boil, Elaine said to Randall, "I'm quite bored with him; you can have him." The shy young poet was quite in awe of Mallary, admiring his "sense of adventure."[76] They had a yearlong relationship, journeying together to Berkeley to visit Richard Diebenkorn. Afterward, Mallary and Elaine resumed their close connection.

When he saw one of Elaine's portraits of himself (plate 16), he told her that he wanted to add one more brushstroke in blue, "right there at the knee."[77] It is a testament to Elaine's trust that she let him do this—apparently the only time she ever permitted another artist to touch up her paintings. She may have been impatient with his gloomy demeanor, but she respected his intellect and inventiveness—demonstrated at the 1964 New York World's Fair in *The Cliffhangers*, a group of men's tuxedos, stiffened with plastic into flailing postures, which he suspended on the side of a building.[78] Elaine's influence may be visible in two of the abstract relief sculptures Mallary showed in 1959 exhibitions[79] at the Museum of Modern Art: *Head of a Bull* and *Bull*.

BY ALL ACCOUNTS, Elaine was a gifted art teacher. Her enthusiasm and upbeat personality made her insistence on hard work more palatable. Of course, she was too savvy to reveal her awareness of the odds—that out of a class of twenty students, at most one would still be painting two decades later. (Many art students, she remarked to an interviewer, are actually training themselves to be art collectors.[80]) Although she would have preferred to do her own work without interruption, she discovered that "teaching would give you ideas which you would not otherwise have had." As she liked to say, "It's the obstacle"—in this case, the need for money—"helping you." Realizing that her students also needed to earn a living, she would tell them to look for day jobs with a high hourly rate, like plumbing, and to live as cheaply as possible so that they could spend more time in the studio. "Working two days a week or three to support yourself... makes you respect the time you have left."[81]

After Albuquerque, Elaine would spend much of the next two decades as visiting faculty, for a semester or several years, at universities and art schools in the New York region and around the country.[82] Studio art departments were expanding, and artists with connections to the avant-garde were increasingly in demand. In addition to providing a small income, these teaching stints gave her the freedom to sketch and paint in a new location while devoting just a day a week to working with students, with no faculty meetings or other administrative chores. Teaching, she said, was "shop talk," the equivalent of the time she used to spend "chewing the fat with other artists."[83] That's

why she worked only with graduate students, who already knew they wanted to be artists. At Carnegie-Mellon University in Pittsburgh, her students included Barbara Schwartz, who said that studying with Elaine "changed my life,"[84] and Aladar Marberger, future director of the Fischbach Gallery in New York. When he confessed that he hated to be alone—not a state of mind conducive to the artist's life—Elaine suggested that he become an art dealer, a métier that suited him perfectly.

In the 1980s, she mused about the "interplay between the different generations" that marks an artist's life.[85] In her twenties, most of the artists she knew were older. In her thirties, her friends were mostly her age. By the time she turned fifty, their ranks included students and assistants. The university had become the new patron of art in the 1950s, when "suddenly, artists who did not have degrees"—like herself—"were asked to teach on the college level," creating "a population explosion in the art world."[86] One unfortunate sign of the times was students' attempts to conform to the latest trends reported in the art magazines: "As Bill de Kooning once said, 'If you can see the bandwagon, it's already left.'"[87]

The perks of Elaine's teaching positions would eventually include travel abroad—for three years, beginning in 1974, with the New York Studio School Summer Program in Paris. Her friend Mercedes Matter had founded the school in Manhattan a decade earlier. The two women were rivals in the early fifties, when Harold Rosenberg was involved with both of them simultaneously,[88] but they had become close in recent years. Elaine counseled Matter about her own work, urging her to get rid of "the critic in you saying it's not good enough before you've done anything."[89] The New York Studio School was intended as a corrective to the anything-goes atmosphere that had begun to permeate art schools in the sixties, which Matter had criticized in an *ARTnews* article.[90] Like Bill, she believed in the importance of the time-honored practice of learning to draw from life (by looking closely at an arrangement of inanimate objects) and of spending long hours in the studio; the school placed equal weight on painting, sculpture, and drawing.

In Paris, Elaine and fellow faculty member Wayne Thiebaud—who had met her when he was living in New York in 1956—sometimes combined their classes so that they could both talk about "how a work could be taken apart and discussed."[91] Thiebaud remembered that Elaine was "a big favorite" with the students. "I don't think she thought of herself so much as a classroom teacher but as an advisor, confidante, supporter," he said. "She loved to hold forth and beguile people." Happily for her, there was just one day of teaching, plus a half-day of leading her students through a museum. It was, as she said, "a dream job."

To Matter, Elaine described her students as "mostly quite inexperienced but very responsive and intelligent."[92] Elaine's nephew Clay Fried, who came with her to Paris, recalled that her favorite students were "the good ones, but also the flamboyant ones, the fun ones. If you were struggling with some little drawing and you were very rigid in your interpretation of…the color, or the light, or something, she would shy away. She's not going to give you a whole new religion on the spot and tell you what to do. She'd be like, pizzazz! *That's* got it! And she would immediately latch onto those who had the laughter and the looseness and the hilarity…they were her posse."

Like other notable artists during a period of fine arts degree expansion, Elaine would also be invited to jury student art shows, critique student work, direct workshops, and give talks at colleges and other venues throughout the United States. The people who showed up at the workshops were usually amateurs, so Elaine's strategy was to have them start a different painting each day, to jolt them out of their preconceptions about art and achieve "a new state of mind."[93] (One year, a student offered to pay her thirty dollars an hour just to talk to him about art. Elaine joked that this arrangement was "beginning to ruin my social life…as I have begun to feel that I should be paid every hour on the hour when I talk."[94])

Never one to discriminate between A-list and lesser events, she traveled to a shopping mall in Kansas City in the middle of a February cold spell in 1966 to receive a "Gold Palette Award" on opening day of the city's Mid-Winter Art Fair. In April of that year, Elaine was in Amarillo—working on one of the portrait commissions that began to multiply after she painted President Kennedy—when she came to the rescue of Dord Fitz's three-day workshop. Learning that Fitz was ill and Larry Rivers was suddenly unable to fly out for his guest teaching stint, she called Alex Katz and persuaded him to fill in. His plane was delayed, so she taught his first class herself.[95]

When Elaine spent an extended period of time away from home on a teaching assignment, her suitcase would contain "some fragment" of past work, to maintain continuity with her art practice.[96] In 1976, when she was appointed Lamar Dodd Visiting Professor of Art at the University of Georgia in Athens,[97] the fragment was a charcoal drawing of Aristodemos Kaldis; she wound up making an entire series of paintings based on it. Elaine was remembered fondly at the university as an engaging teacher who gathered all kinds of people at her studio—"waitresses, literature students, Sunday painters," as well as students.[98] It seemed apropos that the furniture in her rented apartment, which she occupied only to sleep, consisted of one red sofa. If budding artists seemed sincere, even if they were copying images from a magazine,

"she'd find something good to say to encourage them," said faculty member
Ed Lambert. (His recollection is at odds with Elaine's remark, "if I have stu-
dents who are not talented . . . I don't find I have anything to say to them."[99])
Comparative literature professor Betty Jean Craig singled out Elaine's "sense
of humor like Lucille Ball's," as well as her wide reading, revealed when she
spoke to Craig's class about links between painting and literature.

When Elaine, in her working uniform of polyester pantsuit and white
blouse, first visited the campus to show slides of her work, her attention was
riveted by the brightly patched hip-hugger bellbottoms worn by a male grad-
uate student in the audience. "She kept looking at me with those big round
kitty-cat eyes," Jim Touchton recalled.[100] At the end of her presentation, she
was introduced to Touchton, laughed at his outfit, and launched their lifelong
symbiotic friendship. "The whole time I was in grad school, I was her personal
car driver," Touchton said, recalling what a boon it was to have her faculty-
parking sticker on his Pontiac Grand Prix. He would later work as Elaine's
studio assistant in East Hampton and travel with her when she returned to
the New York Studio School in Paris. Elaine, Touchton said, "gave me confi-
dence in myself as a painter. . . . I became alive when I met this woman. . . . She
just convinced me that the world is bigger than the canvas."[101] She also became
his "closest friend, confidant, and true partner in mischief."[102] In her mind, he
seemed to be frozen in time; years after he left school, she always introduced
him as "my student from Georgia."

Elaine had begun working on a major painting series[103] while taking advan-
tage of Athens' peaceful atmosphere, so she was sincere in her praise of the
town: "It's wonderful here; there are no distractions."[104] The university returned
the favor; Elaine's first retrospective exhibition opened at the Georgia Museum
of Art in March 1992.[105] Sadly, she was no longer alive to enjoy the honor.

Loft Life, Speaking Out, and European Vistas

WHEN ELAINE RETURNED to New York from Albuquerque in late spring of 1959,[1] she felt like Rip van Winkle. Downtown streets were almost unrecognizable, what with the influx of new cafes and shops. She observed that the increasing crowdedness of gallery openings and parties had led artists to "pull away from the clutter of communal life, back to small gatherings and quiet, intense conversations."[2] Even Harold Rosenberg's 1959 ode to the artists of 10th Street mirrored the new reality in its final paragraph. A block-long apartment house was rising on the northeast corner, at Fourth Avenue, representing "the seizure of about one-eighth of Tenth Street's potential studio territory." Referring to the street's legions of passed-out winos, he wrote sardonically, "By the time you read this, there will be doormen to clear the sidewalks of daytime sleepers."[3] (The artists tended to feel protective about "their" bums; Elaine saw them as "lost souls...but gentle and marvelous sad people."[4])

A few years later, when Elaine was walking on University Place, home of the Cedar Tavern[5]—now a magnet for hangers-on—she glimpsed Hans Hofmann, in "an expensive gray suit." He walked past her, apparently lost in thought, but she caught up with him when he stopped to look at a display of fruit and vegetables in a grocery store window. "Where is everybody?" he asked forlornly. "Where do the artists go to meet nowadays?" The answer, she said, was "nowhere."[6]

Yet even if the downtown artists' we're-all-in-this-together ethos was on its last legs, Elaine staunchly maintained its viability. "We disagree a lot. We can say, 'I saw your last show and didn't like any of the paintings in it,' but we stay friends," she told an interviewer from Texas. "In New York, if some artist gets sick we take up a collection and take over soup."[7] And when artists finally started selling their work, she said, they began "hiring younger artists to do carpentry, plumbing, and house painting, with, of course, plenty of time off

to talk shop."[8] Elaine's accounts show a cascade of small sums paid to young artists for help with the loft, as well as for stretching canvases and photography. Other helpers were repaid in ways that meant more than money.

Denise Lassaw, daughter of Elaine's friends Ernestine and Ibram Lassaw, was put to work making tuna sandwiches for lunch, cleaning brushes, sorting mail (she would read the bills and gallery notices to Elaine), filing a multitude of newspaper clippings, and posing for portraits. In return, Elaine took Denise's opinions seriously and offered a sympathetic ear.[9] Elaine's generosity also extended to older artists. One day in spring 1959, she visited a gallery showing work by a friend, Emily Mason, who was going through a difficult period after the deaths of her mother and brother. The dealer was engrossed in a phone conversation, so Elaine quietly selected a print she liked, wrote a check for it, left it on the counter, and waved good-bye.[10]

Before her teaching stint in Albuquerque, she had moved to a loft above an orthopedic appliance store at 791 Broadway, which was recently vacated by her friend Mercedes Matter. Across the street was Grace Church, housed in an elegant Gothic Revival building that later would be granted landmark status. "It gives me a feeling of dodging time," she said of the Episcopal parish church. "A feeling of England and the nineteenth century."[11] She soon met assistant minister Stephen Chinlund who taught a Bible class on Tuesdays that she attended ("I just loved to argue about biblical matters"[12]).

Elaine's building was a former clothing sweatshop serviced by a small, shaky elevator. She pointed out to a visitor the "small, medium and large signs" on the walls of her fourth-floor studio.[13] On the two "painting walls"— one, eight by eleven feet, the other, twelve by twenty—she would tack up the canvases that she worked on simultaneously. Another visitor remarked on the "incredible litter of press clippings, unanswered letters, sketches...notes to herself on the back of envelopes...tables with...buckets of paint, all kinds of odd things pinned to the wall, and...stacked in all kinds of directions, enormous paintings which made corridors out of the long room."[14]

In 1959, Elaine gave her official address as 51 Raynor Street in Freeport, New York, home of her sister Marjorie Luyckx, who was handling her business affairs. Eighty-five percent of her $5,850 income came from the sale of her own and an unspecified number of Bill's paintings.[15] Her paychecks from the University of New Mexico and small fees for jurying art shows and giving lectures made up the rest. That year, she racked up $8,993 in expenses, what with four cross-country trips, the purchase of a car, studio rent in New York and Albuquerque, carpentry labor (to build stretchers and frames), studio cleaners, and art book purchases. Elaine spent nearly $1,000 on taxis "to and

from openings, lectures, museums, exhibitions, etc."—she apparently didn't inherit her mother's subway habit—and a whopping $1,930 on entertainment ("cocktail parties, dinner parties, restaurants, etc."). As she liked to say, "Take care of the luxuries and the necessities will take care of themselves."

The following year, an interviewer described Elaine as a "small, wiry woman with red hair and brown eyes and an intensity" that paralleled the effect of her paintings.[16] She was now juggling a visiting professorship at Pennsylvania State University with trips to Cleveland, Chicago, and several cities in Texas for openings of her exhibitions,[17] as well as brief art jurying stints. Her continuing fascination with bullfights and her affair with Mallary also took her back to Juarez and Albuquerque on a regular basis.

That fall, Frank O'Hara and Joe LeSueur invited Bill and Ruth Kligman for dinner, hoping Elaine wouldn't find out. Playing the innocent, she asked O'Hara if she could come for a drink, and made a point of lingering until the dinner guests arrived. LeSueur—who called Elaine "adorable, improvident," and impossible to fault—watched her pull off what he called "a *coup d'éclat*" (great feat). After reducing the much-younger Kligman to insecure babbling, Elaine made a "leading-lady exit" with O'Hara, who helped her flag down a cab.[18] She had honed this above-the-fray behavior back in the 1930s and must have enjoyed the opportunity to deliver a repeat performance.

IN THE DECEMBER 1960 issue of *ARTnews*, it was Elaine's turn to be profiled (by Lawrence Campbell[19]) in the "X Paints a Picture," series, with photos by Rudy Burckhardt—most dramatically of Elaine as a small silhouetted figure reaching up to make a brushstroke on a huge canvas. Campbell wrote that, "like a figure out of Baroque history," she "does not have a sense of her own boundaries" and is "torn apart and held together at the same time." This hyperbolic description was apparently intended to suggest Elaine's breadth of interests. And there's more: although she is "calm, poised," he wrote, "[s]omething urgent is always happening" in her studio. Campbell is vamping here, as if waiting for writerly inspiration to strike. If only Elaine could have given him a critique. (In fact, as Campbell wrote later,[20] she rewrote his final paragraph—but only because she found it too flattering.) Fortunately, her own comments pepper this article.

"Drawing for me was always keeping myself under control," she said. But in Albuquerque, she got "caught up" in intense colors, a feeling like being "let out of prison." She talked about her personal experience of color ("you feel color with your muscles or your skin") and the need to rein in its power with the defining action of brushstrokes. Intrigued by the quality of color even in

dim light, Elaine said that in her bedroom, which was never completely dark, she liked to keep a painting to look at if she awoke during the night. Speaking about the role of size in painting, she noted the "challenge" of working on a small scale and cautioned that an artist "must constantly be on guard" against the "falsely impressive aspects" of a large canvas.

In the same issue of the magazine, Campbell also reviewed her show of bullfight images at the Graham Gallery. Painted in the horizontal format that was the legacy of her time in Albuquerque, several of these works are more than thirteen feet long; the largest, *Arena*, is a majestic ten by twenty feet. Campbell praised the paintings' "fantastic scale and energy"—his urban sensibility led him to compare her newly vivid colors to "the neon flash from a street light"—and recognized that "for her, the bull is the hero."[21]

Earlier that year, from February to May, she had splurged on the $500 monthly rent for a fourth-floor space at 537 Broadway that occupied the entire city block between Spring and Prince Streets. This vast studio, which had elevators at each end, allowed her to see all her paintings side by side. "I had some money for a trip," she said, "And I decided to take a trip around myself."[22] It was "an opportunity to see what my idiosyncrasies are." The space was so large that "visitors would walk in the door, take one look, and double up laughing." She had to put her palette on a dolly to roll it from painting to painting; a wheeled table from a restaurant supply house served to transport her brushes, paints, and other equipment. An angled brush attached to a long aluminum tube enabled her to paint canvases taller than ten feet without having to step back to survey the results.

ELAINE'S PENN STATE INCOME in 1960 was only $702, a sum that didn't even cover her taxi fares ($980), never mind the expenses of cross-country travel, day-to-day living, painting supplies, and hired helpers. The thousand-dollar Hallmark Award she received in April for *Veronica* and $7,500 in painting sales were not enough to keep her from seeking multiple loans—from Bill, Mallary, collector Al Lazar, Ibram Lassaw, and others—only some of which she was able to repay that year.[23] Bill sent her $4,000; an additional $1,200 from Mallary may have been his payment for her painting *Standing Bull*.[24]

Other paintings from the late fifties also reflect her Southwest and bull-fight interests: *Albuquerque*, *Farol* (plate 18), *Bull* (plate 19), and *Juarez* (plate 17)— selected for the prestigious Whitney Annual in 1961.[25] In this painting, the bull's sinuous, black-outlined silhouette is overlaid with multi-colored paint strokes that evoke the ceremonial trappings of the *corrida*.

Lawrence Campbell described *Juarez* as "darkly violent...a hymn to electrically charged movement." Elaine was one of "the best of the newcomers to this Whitney," he wrote in his review of the show, remarking that "it is surprising to find her here in the role of a neophyte," because of her familiarity as a writer to readers of the magazine.[26]

In June 1960, while teaching a two-week summer painting course at the Contemporary Arts Museum in Houston, Elaine met the author Donald Barthelme, who was just beginning to publish his short stories, and his then-wife Helen. He had been organizing events at the museum and would be appointed part-time director the following year. Elaine was enchanted by Barthelme's spontaneity; at a cocktail party at someone else's house, he dived into the pool fully dressed "and then pulled in the host who then pulled in a couple of guests."[27] Barthelme admired Harold Rosenberg's essays, and he was one of the first speakers the *New Yorker* writer signed up for his new lecture series at the museum. When Rosenberg recommended Elaine to teach the painting course, Barthelme responded that the idea "sounds fine," but wanted him to suggest a man as an alternative.[28] (It's unclear whether his concern was the reaction of the museum's board of directors or whether he thought Elaine—or any woman artist—lacked a sufficiently high profile.)

Rosenberg was intent on luring Barthelme to New York to serve as managing editor of *Location*, a new literary magazine. In the summer of 1962, when he and his wife visited New York to discuss this plan, Elaine invited them to her studio and showed them her "faceless" portraits. Helen, an English professor, found the blank faces unsettling, although she "easily recognized" the subjects. Elaine, she wrote, was "cheerful and generous, but...a little intense as a hostess."[29] Donald began working on the magazine in October. He was soon caught up in Elaine's alcohol-fueled social orbit. Later that month, Helen flew out from Houston to try to patch up their troubled marriage. The couple went to a party at Elaine's studio, where Helen met Bill, whom she found "[g]ray haired and very handsome...easy to talk to." Bill apparently told her (untruthfully) that he had stopped drinking, and Helen noted approvingly that "[h]e seemed not to fit into the frantic atmosphere of the studio."

No doubt longing for the spaciousness of the temporary studio she had rented, Elaine moved to a 3,600-square-foot L-shaped loft at 827 Broadway, between 12th and 13th Streets, a former bakery she found with Bill's help. (He lived in the same building, at its other address: 831 Broadway. There were separate doorways and lobbies for 827 and 831, but they shared a service elevator.) The bakery had left an unwelcome legacy. Guests at a big party she gave before

moving in "made a point of telling me that I had rats," she told an interviewer, "and they weren't referring to any of the other guests."[30] Occupying the entire third floor, the loft was painted white to maximize the feeling of open space. Elaine's landlord had offered her a deal if she fixed up the place herself, which meant depending on the skills and physical labor of her young assistants. She had three telephones installed, one at either end of the loft and one in the middle—testimony, in an era before answering machines were in wide use, to her passion for keeping in touch with friends. (Her first phone was installed in 1944 in the loft she shared with Bill; he found the constant ringing so annoying that he ripped the instrument off the wall.) Bookshelves, moveable walls, and painting racks on wheels demarcated the interior space she used as an office. A green rug with seating grouped around it served as a living room. Helen Barthelme noted that "paintings, books, clippings, and other things [were] hanging or pasted on the walls around the entire floor."[31] The bedroom was in the rear. A former student of hers who stayed there when Elaine was out of town was amazed at how uncomfortable her bed was, with its foam rubber mattress. But she insisted that she liked it that way. "Her deal," said a friend, "was not to be comfortable."[32] When her young nephews visited, they used the room as their anarchic retreat. "She would come in and laugh at how we'd be throwing bottles of paint out the window and watching them explode on the parking lot sidewalk," Clay Fried said.[33]

Having separate areas for painting, writing, and sleeping suited Elaine's need for constant stimulation. "I find writing and painting give me a chance to break up too much routine," she said. When she was working on a painting and couldn't figure out how to proceed, switching to writing seemed to use a different part of the brain. A painting might involve "any one of 100 different directions," while writing was a matter of laying out her thoughts "logically until I make my point."[34]

Every other month she held a Tuesday-night party ("We call them brawls," she joked) for as many as forty guests. She chose the day, she said, because artists liked to work on weekends, and openings were held on Mondays and Tuesdays. "We're addicted to getting together after an opening to talk things over," she told a woman's page writer from the *Provincetown Advocate*.[35] "I love big cocktail parties. Even when I give a 9 o'clock party, it's likely to be a cocktail type of thing with people standing around. And since the Twist [the new dance craze] has come in, you know, we've been doing that. It's good for you, because you can't drink so much if you're going to get out on the floor and cavort around." (Elaine was indulging in wishful thinking here.) Other parties had a special focus. When Edwin Denby published his *Collected*

Poems, Elaine orchestrated an affectionate tribute, with excerpts from films by Rudy Burckhardt in which Denby appeared, readings of his poetry by John Ashbery and others, and a dance performance. Then Taylor Mead stood up. Wearing a Boy Scout shirt and holding a tiny booklet, the slightly built poet and performer turned a few pages in silence and sat down, to appreciative laughter from the crowd.[36] Elaine championed inclusivity of all kinds at social events. Twenty-one-year-old poet Bill Berkson was surprised to find so many people his own age who were interested in art."[37] Guests included people from different walks of life, like boxer-turned-cop George "Baby Dutch" Culbertson and former heavyweight champion Ezzard Mack Charles. One night, painter Herman Cherry tried to demonstrate the similarities between boxing and action painting to Charles by punching the air like a boxer. Charles said that he thought he understood what Cherry was getting at, "but the canvas doesn't hit back, does it?"[38]

Elaine told the *Provincetown Advocate* writer that she usually served spaghetti with meatballs at her parties or "a very spicy Spanish dish stretched with rice or macaroni to feed as many people as arrive." She didn't care for sweets, she said, but she would buy four or five varieties of cheese at a specialty store on First Avenue and serve them to her guests with fruit. Elaine eventually became an ardent, if idiosyncratic, health food devotee. Her entry in the Museum of Modern Art's *Artists' Cookbook* describes her as possibly "the only person who brings wheat germ and brewer's yeast to Paris."[39] She explains that she became "a vitamin nut" after reading "that each cigarette you smoke devours the vitamin C in the juice of one orange." Not that there was any question of giving up smoking.

Adjusting her diet according to foods she believed were "good" or "bad" for her, Elaine told the cookbook authors that she breakfasted on yogurt, wheat germ, bran, oats, and raisins. Her other nourishment, she said, consisted of fruit, cheese, and raw vegetables. ("Three meals a day is preposterous.") She also remarked puckishly that "artists are hungrier" than other people. The recipes she shared include Desert Soup (a cold concoction of buttermilk, tomato juice, and chives), Elaine's Coleslaw (in which bacon grease augments the mayonnaise), and Yogurt Soup (with the unlikely ingredient of cooked oatmeal).

"Her idea of cooking was to give you a dry salad," Ernestine Lassaw recalled.[40] Indeed, Elaine's contribution to another artists' cookbook, illustrated with one of her drawings of a bull, was a Fruit and Grain Salad.[41] One summer in the 1970s, her nephew Charles Fried discovered that the eggs in her refrigerator were so old they had dried out. When he brought a package of rancid

Elaine de Kooning, *Dutch Culbertson*, 1962.

Charcoal on paper, 40 x 26 inches. Charles & Mary Anne Fried Collection. Photo courtesy of Levis Fine Art, Inc. ©Elaine de Kooning Trust.

ground beef to her attention, she said, "My mother always said, if in doubt, throw it out." And she blithely tossed it out the window, to land on the Broadway sidewalk. Years later, when Charles and his wife visited Elaine, she made the couple a smoothie that had some odd crunchy things, which turned out to be uncooked rice.

Charles also remembers going on a grocery store run with her when she bought two hundred fifty dollars' worth of food (the equivalent of well over one thousand dollars today), including several jars of caviar. Such extravagance was typical, especially when it came to gifts. "If you were scandalized by the cost of [something], that made it even more attractive" to Elaine. Her accountant would come over and tell her that she had to stop spending so much, Charles said, "And she would say, 'I'll make more!' "[42] So it comes as no surprise that despite cash deposits totaling $4,700 between March and September 1969, her checking account had eighteen overdrawn notices between March and November of that year.[43] Clay Fried, who received generous checks from Elaine for his birthday bearing her scribbled directive, "no necessities," remembered that she was "constantly out of money" even though she tried to make ends meet by "painting Texas oil millionaires and their mistresses and wives or…giv[ing] lectures that she didn't really want to do." Her outlook "was always, 'Something will happen. I'll figure something out.' "

A painter himself, Clay adored her "fantastic energy and intelligence and laughter." He was sixteen when she took him to see the 1971 van Gogh exhibition at the Brooklyn Museum. "I wanted to look at every drawing for at least a minute or two," he said, "and she was like, 'Oh, yes, *this* period.' She was pretty brisk in her appreciation." But the two of them would meet up again over coffee to talk about "which ones were important" and then return to the gallery to look at them together. Elaine also took him to other artists' lofts, to show him the everyday reality of an artist's life. "She'd say, 'Let me show you this guy, who, after fifty years of work hasn't sold a single painting in twenty years, and look at the dust and clutter all around him.'" When he came to a lecture she gave at a college in western New York State, she made a point of telling him how dreary it would be to teach art in the middle of nowhere. "You'll have your bills paid," she said, "but you won't have a life."

Elaine firmly believed that nothing, including the lure of a good paycheck, could be as compelling as the path she had chosen. She would call Charles Fried from time to time and urge him to reconsider his career as a geologist: "What are you doing wasting your life in that job? You should quit and become an artist." Yet, when her nephew Guy Fried was admitted to Yale Medical School in the early 1980s, she cheered him on, saying that the family

would need "someone to interpret what the doctors are saying." By then, with symptoms that would soon be diagnosed as lung cancer, she probably realized that he could be a great help to her.

In Elaine's view, there was an inherent clash between being a mother and being an artist, because both are full-time commitments. (Her touchstone was her own childless life, in which "I just never have time to do what I want to do.") But she played her permissive-aunt role to the hilt. At family gatherings, Elaine would leave the adults' table to sit with the children, whom she fondly called "the cavemen," alluding to their love of eating with their hands. "She had no superego, and much more id than our mothers," Guy Fried said.[44] "As a child, you could do no wrong." Her zest for living in the moment also delighted other people's children. Painters Emily Mason and Wolf Kahn have happy memories of Elaine's frequent visits to their 15th Street apartment in the early 1970s. She would come to dinner and then play Masterpiece[45]—a board game in which players compete to bid on paintings that may be forgeries—with the couple's children, Cecily and Melany. "There were a bunch of cards with paintings on them," Mason said, "and Elaine would give a running commentary: 'I knew I didn't like that one!' 'This is terrible!' 'This is wonderful!' The kids adored her; she was part of our family life. She was such fun to be with, always laughing—she had a throaty smoker's cough-laugh. Her favorite word was 'hilarious.'"[46]

ONE EVENING IN the summer of 1960, trailed by a reporter from the *Milwaukee Journal*, Elaine told friends at the Cedar Tavern that she was thinking of doing a series of paintings "on the Chessman case."[47] Caryl Whittier Chessman's face was on the cover of *Time* magazine's March 31 issue. He was the longest resident of Death Row, and his case had attracted the attention and sympathy of such luminaries as Billy Graham, Eleanor Roosevelt, Albert Schweitzer, Robert Frost, Norman Mailer, Ray Bradbury, Dwight MacDonald, and Aldous Huxley.

In January 1948, in Southern California, a man popularly known as the "red light bandit" committed a series of robberies at gunpoint from couples in parked cars; in two instances, a woman was sexually assaulted. Chessman, a parolee from Folsom Prison, was charged with eighteen counts of robbery, kidnapping, and rape. Convicted of all but one count after a three-week trial in which he served as his own defense counsel, he was sentenced to death. This was the punishment mandated under California law for crimes involving kidnapping with bodily harm. ("Kidnapping" was deemed the appropriate charge because Chessman took the women to his car, parked more than

twenty feet away. The legal definition was based on the distance between two bedrooms in a house.)

During his years on death row, Chessman presented his side of the story in four books, including a bestselling autobiography, *Cell 2455, Death Row*, that was the basis for an eponymous 1955 film. (More than two decades later, Alan Alda played a swaggering Chessman in the NBC TV movie, *Kill Me If You Can*.[48]) The only child of devout Baptist parents whose lives went off the rails—his father attempted suicide after business failures; a car accident left his mother paralyzed—Chessman spent his adolescent and teenage years committing petty crimes, beginning with car thefts and escalating to robbery after he joined a gang whose members he met in prison. But it wasn't his troubled past that caused members of the intelligentsia to pursue a stay of execution. Rather, it was the combination of his unswerving declarations of innocence, his accusations of a forced confession during his initial police interrogation, and what his supporters believed was a misapplication of the death penalty.

Elaine once said, "The word 'crime' to me doesn't exist," comparing her refusal to countenance the meaning of the word to cultures that have no words for familiar concepts.[49] Granted, she said this in response to a question about Mark Rothko's suicide in 1970, but her remarks seemed sufficiently sweeping to include any type of crime. One of the often-told anecdotes about Elaine was her reaction after her loft was burglarized. Realizing that it had to have been an inside job (the locks were still in place), she tracked down the perpetrator, invited him back to the studio, and gave him some money. She did not turn him in to the police. According to another story that made the rounds, Elaine was once accosted by a mugger with a knife in the dim hallway of her building. Miming laryngitis, to reassure him that she wouldn't call out for help, she handed over her wallet—and ushered him up to her loft for coffee. Apocryphal or not, Elaine's response seemed plausible to anyone who knew her. In a 1969 interview, she said that Bill once told her, "You're always on the side of guys behind bars." Laughing, she agreed with his assessment, adding, "The guys behind bars were more amusing and charming than the guys who were running the country."[50]

After reading Chessman's autobiography, she began following news about his case, annotating and selectively underlining the dozens of clippings that she kept in a photo album with a red cover on which she pasted a newspaper headline: The Real Story of Caryl Chessman. Next to an article quoting the original police description of the "red light bandit," provided by his victims ("swarthy complexion...five feet six to five feet ten...") she wrote, "nobody

makes a mistake on the height of an average man—a tall man, yes." (Chessman was six feet tall.) She underlined the words, "for 11 years Caryl Chessman asked for a lie detector test for him and the police involved." With her check for a two-year subscription to *The Nation*, she enclosed a note explaining that her interest in receiving the magazine was due specifically to its "reporting and position-taking on the Chessman case."[51]

Drafts of letters she wrote include statements such as: "I think he is a valuable and terrific man and he must be saved" and "Everyone seems to feel that's the law answers the question, but the fact is[,] there are a great many stupid[,] vicious and unequitable [*sic*] laws." In a note dated February 22, 1960, she mused, "Ever since I said my ridiculous prayer...and put myself in Chessman's shoes, life seems suddenly to have become very bleak." She was conscience-stricken about the huge extra loft space she rented when Chessman was living in a cell four and a half by seven and a half feet. With pacifists Robin Prising and David McReynolds, Elaine co-organized a march on Fifth Avenue in New York on April 30, 1960, to support Chessman and protest capital punishment;[52] she rode in a rolling mock-up of a prison cell, carrying a photo enlargement of Chessman's face printed on a giant canvas.[53]

He was executed two days later, after eleven years and ten months on Death Row. Elaine had never seen him in person, so she had to rely solely on media images for her portrait. In a 1963 photo of her studio wall, a Chessman photo is tacked above a board with a group of images of President Kennedy.[54] Reviewing Elaine's spring show at the Graham Gallery, the *ARTnews* writer described the portrait as "remarkable in...its unmistakable likeness," as well as in "its eloquence [and] its despair."[55] The previous summer, Elaine had traveled to California expressly to visit Rosalie Asher, Chessman's legal counsel during most of his time on Death Row, whom he named executor of his estate. "We wept on each other's shoulders as though we'd known each other a lifetime," Elaine wrote to a friend.[56] The two women continued to correspond about aspects of the case. Invited by Elaine, who offered to pay her way, Asher came to New York for the opening of the show; back in Sacramento, she wrote to Elaine: "The chance to know you better...is one of THE highlights of my life."

In the mid-seventies, during an art workshop Elaine held for prisoners at California Medical Facility, a state prison in Vacaville, she wrote to Tom Hess about her students, who ranged from "a Homeric giant...who likes to paint ballet dancers 'from imagination'" to a man up for parole whose large abstractions in oil and plaster she rated as "very good." Elaine was enchanted by the wooden pendant he made for her that said, "I could understand a lot if only

they wouldn't explain." While sketching Governor Jerry Brown in his office during this trip, he had conversations with Republican businessmen who fulminated against labor unions. She appreciated the way he refuted the men's arguments while retaining a courtly demeanor.[57]

ELAINE CONTINUED TO speak up on behalf of causes that moved her. ("I'm always in favor of action, you know."[58]) In 1961, she was the only artist to sign a Declaration of Conscience supporting the Cuban Revolution that was published in the left-wing journal *Monthly Review*.[59] "She was political in a way that a lot of artists weren't," said Margaret Randall (another signer, along with Norman Mailer and Lawrence Ferlinghetti). "It was unusual at the time because the chill of McCarthyism was very much with us."[60]

But Elaine was not one to follow in lockstep when she believed that the means were poorly aligned with the goal. Back in the 1940s, Elaine and Bill were among the artists who had colonized New York lofts abandoned by manufacturers, creating ingenious ways of remedying the lack of heat, electricity, and running water. By the early sixties, between five and six thousand artists lived in lofts they had fixed up, clearing out trash, fallen plaster, and broken shards of skylights.[61] Yet living in a loft was still illegal. In 1961, the Artist Tenants Association was founded to stop artists' evictions. A strike petition—signed that summer by five hundred people, including Bill, Helen Frankenthaler, Fairfield Porter, and Jasper Johns—threatened to withhold work from galleries and museums unless the city stopped enforcing the law. Elaine thought this was a foolish idea. In a letter published in the *Village Voice* she wrote, "It is not necessary to harass our allies"—galleries and museums—"by a withdrawal that would not harass City Hall in the slightest." As she well knew, "The New York art world has seen harder times than this."[62] (The strike was ultimately suspended, and the city agreed that artists would no longer be evicted if their lofts met certain safety conditions.)

Elaine also took a counterintuitive position on resale royalties for artists. Rather than lobby for legislation, she said that the best way to help young artists would be "to give rich people a tax deduction to buy art."[63] She told a story about Adlai Stevenson's second attempt to capture the presidency in 1956, when he ran against incumbent Dwight D. Eisenhower. During a meeting with other artists who were wondering what to do to support him, painter Grace Hartigan said that a Republican would actually be more helpful to artists, "because if a Democrat gets in, rich people are going to be very depressed."

Although Elaine would participate in the Peace Tower of 1966—hundreds of two-foot-square works of anti-war art mounted on fifty-eight-foot-tall

steel scaffolding erected in an empty lot on the Sunset Strip in West Hollywood[64]—she did not really believe in art as a viable means of protest. Picasso's *Guernica* was seen only by "the super-sophisticates," she said. "And it didn't change anyone's opinion one bit about stopping war."[65] In her view, art was more effective in a pragmatic role, to help raise money for a worthy cause. Elaine had been interested in the rights of Native Americans ever since her travels in New Mexico. Less than three months before her death, she would contribute work to an art auction in Boston to support legal aid for a First Amendment lawsuit by Hopi and Navajo tribes against the U.S. government for forcibly removing them from their ancestral homelands.[66]

Conspicuously absent in this catalogue of causes is the women's movement. A few months before her death, she said, "Women's lib and feminism never seemed an issue to me, because as far as I was concerned, my mother ruled the universe. We had to be liberated from *her*."[67] Elaine was disinclined to make a fuss about the situation of women artists, and she didn't like to be lumped with them.[68] According to an often-told story, Elaine was talking to Joan Mitchell at a party when a man asked, "What do you women artists think—." He didn't get to finish his sentence because Mitchell grabbed Elaine's arm and said, "Elaine, let's get the hell out of here." In common with Mitchell, Grace Hartigan, Helen Frankenthaler, and other women of the Abstract Expressionist era, Elaine's view was that artists of either gender should "believe in what you're doing and just do it."[69] She maintained that women who are artists meet with art-world rejection, but not because they are women. "All the good women artists I know eventually got galleries," she said.

Discussing what is now called "the male gaze," Elaine was an astute and open-minded commentator, yet one whose own perspective was not specifically feminist. In 1953, she reviewed two books about the female nude for *ARTnews*.[70] One was *Nus d'Autrefois 1850–1900*, a compendium of vintage pornographic photographs, including such classics as a woman whose bare breasts rest on the tray of apples she holds. The other book, *The Female Form in Painting*, thinly disguised as an art historical treatise, contained reproductions of nudes painted by artists of eras past.

Elaine wrote that the photographers—freed from the artists' need to represent a nude in the guise of a mythological or biblical figure like Venus or Eve—presented each woman as a specific individual, "absent-mindedly erotic… droll, domestic, and not at all remote." She viewed these "dainty, naughty and sentimental images" as "extravagantly unmistakable specimens of the Second Sex." Her use of that term indicates her familiarity with Simone de Beauvoir's groundbreaking book of that title. (The English translation was published

earlier that year.) Yet, considered in tandem with her gently satirical treatment of *The Female Form*'s authors' lofty claims, her benign remarks about the photographs do not present a recognizably feminist point of view. They might just as well have been written by a man.[71]

In 1962—startlingly early for such a pronouncement—Elaine remarked that "the American woman has definitely arrived as a painter. There are no doors closed to her now."[72] Perhaps she was coasting on the burst of publicity created a few months earlier by a *Cosmopolitan*[73] magazine feature, "The Amazing Inventiveness of Women Painters."[74] Elaine merited a full page, along with Helen Frankenthaler, Ethel Schwabacher, and Lee Bontecou, while the other women (Grace Hartigan, Sonia Gechtoff, Louise Nevelson, Nell Blaine, Ethel Magafan, and Joan Brown) had to share their space. "This generation of women artists is not competing with men," authors Jean Lipman and Cleve Gray wrote. "It is simply saying, 'Look at my work, this is what I, a woman, feel.'" Elaine's write-up noted that she had married "one of the most prominent and controversial painters in America"—possibly a reason that she received such prominent coverage—yet had "preserved her own personality in her work." The de Koonings' separation was not mentioned.

Together with a friend, painter Rosalyn Drexler, Elaine responded to Linda Nochlin's much-debated 1971 article in *ARTnews*, "Why Have There Been No Great Women Artists?"[75] Elaine wrote that she resisted "being put in any category not defined by one's work." Being a woman was no more relevant to being an artist than being tall or hot-tempered, and nowadays, "women have exactly the same chance that men do." While she agreed that women artists were not sufficiently exhibited in museums, sought after by collectors, or hired at universities, "any artist, no matter what his gifts, faces neglect." In the 1940s, she suggested, the title of Nochlin's piece could have been, "Where Are the Great American Artists?" Elaine was not in favor of Nochlin's proposal that women create new, open-minded institutions. She didn't want to be part of *any* institution. What she believed in was "the free enterprise conception of individual achievement."

In her 1977 interview with Eleanor Munro, Elaine contended that women are "tougher," better able to work "in isolation," and accustomed to "a lack of response" from the art world.[76] But as late as 1981, during an interview before a talk in Los Angeles about women artists, she made a point of saying that she was not a crusading feminist and that "hostility to men ... is where feminists lose me."[77] Hungry for male attention all her life, Elaine was unable to grasp why a woman would prefer a female partner. When her longtime friend Margaret Randall told her that she was a lesbian, Elaine's response was,

"I absolutely understand, because there's not a lot of good men around." Randall was astonished at Elaine's obtuseness but kept her feelings to herself. As she said later, life with another woman "was sort of a second-class choice for Elaine. We were very good friends and we shared all kinds of things, but she had that chemistry with male bodies, painting them and appreciating them."[78]

As time went on, Elaine occasionally threw a bone to the women's movement. In 1974, she said that she "wasn't a Woman's Libber at first, but every year I tend to realize that there are enough obstacles to being an artist without the discrimination."[79] In the late '70s, she allowed her work to be included in at least two feminist-themed shows.[80] As a supporter of the campaign to pass the Equal Rights Amendment (ERA), Elaine designed a banner for the ERA parade in East Hampton in 1980. The N.Y. Feminist Art Institute honored her in 1984.[81] And in 1986, she sounded resigned to the imminent opening of the National Museum of Women in the Arts in Washington, D.C., an institution disparaged by some of her peers. Twenty-five years earlier, she said, such a museum would have seemed patronizing. "But now it does make a certain sense in that museums have neglected women artists."[82]

IN APRIL 1962, Elaine attended the crowded opening of Wayne Thiebaud's solo show of his paintings of cafeteria-counter pies and cakes at the new Alan Stone Gallery. Discovering that *ARTnews* had sent a young reviewer who hated the show, she called Thomas Hess and urged him to come to the gallery. The upshot was that he canceled the negative review and wrote a positive one. Thiebaud, who was in his early forties but just beginning to show his work, viewed this intercession as "an amazing piece of luck," made possible by "the generosity and thoughtfulness of Elaine," who "understood how hard it was to persevere."[83]

Despite his painterly style, Thiebaud was sometimes claimed as a Pop artist because of his subject matter. Pop Art was anathema to Elaine.[84] Always conflicted about the commercial aspect of art, Elaine disapproved of the "young artists who are working in the Pop Art mode because it's a way of making money."[85] While she maintained that the artist must be "a rebel," she couldn't wrap her mind around rebellion that rejected the high seriousness of Abstract Expressionism. Like many of her peers, she never abandoned the Abstract Expressionist credo that any valid style must be driven by "inner necessity." The highest goal of art was self-discovery—the transformative activity of *making*.

Searching for an apt comparison, Elaine suggested that an "authentic" artist, who "can never take orders," was like a priest—conveniently overlooking his subservience to the hierarchy of the Catholic Church. Extending the

Catholic analogy, she called artists whom she believed were concerned only with pleasing collectors and critics "genuflectors." In her view, fine art must always be based on previous fine art ("the artist finds something new by constantly looking back"[86]) and must never concern itself with pleasing the public. Hollywood filmmakers "always think an artist works toward fame," she once said. "They can't imagine the thrill of the actual work; it doesn't occur to them... [that] fame is a by-product."[87]

A MONTH AFTER THIEBAUD'S OPENING, Elaine and Robert Mallary attended a concert by the modernist composer Lucia Dlugoszewski. With a mysterious prescience, she suddenly leaned over to Mallary and said, "Franz just died." At intermission, she left in search of a telephone booth to call the hospital where Kline had been admitted with rheumatic heart disease. "Mr. Kline expired seven minutes ago," she was told.[88] He was a few days short of his fifty-second birthday.

In "Franz Kline: Painter of His Own Life"[89]—the most personal and heartfelt art essay Elaine ever wrote—she paid tribute to his black-and-white canvases, which "often loomed with an uneasy contemporary sense of the tragic," while simultaneously celebrating the man himself. "Everything he said, the wisecracks, the miscellaneous bits of lore, the hilarious reminiscences are pertinent to his creation and our understanding," she wrote. Invoking his "panoramic enthusiasm," she traced the way his conversation ranged zestfully over myriad topics—comedians, sports, old movies, English and German graphic art, Wagner, jazz trumpet player Bunk Johnson. Elaine praised Kline's "extraordinary memory for essential gesture" as she traced his development from representation to abstraction. She told of the "hundreds of tiny sketches" that "became the key to his self-discovery" and the "fanatic care" he took to position the rectangle he would draw around each one. She invoked his struggles with materials (working on a large scale, he initially could afford only cheap house painters' enamel) and approvingly noted his lack of interest in trying to explain what his art meant. She likened his signature works to "different versions of one immense, complicated machine seen from different angles." In her final paragraph, she returned to the "inclusiveness" of his art; lurking between the lines is the inclusiveness of his personality, which mirrored her own. Toward the end of her own life, she would offer another reminiscence: "When you were with Franz, you laughed a good deal. He was irresistibly comical and tender."[90]

IN THE SUMMER of 1962, Elaine went to see The Controversial Century: 1850–1950, a show at the Provincetown Art Association and Museum of

Frank O'Hara, Elaine, and Franz Kline at the Cedar Tavern, ca. 1957.
Photo: Attributed to Arthur Swoger. National Portrait Gallery, Smithsonian Institution, Washington, D.C.

works supposedly by van Gogh, Matisse, and other masters, from the collection of auto company heir Walter P. Chrysler Jr. It was obvious to her that these were fakes. But it wasn't obvious to John Canaday, the *New York Times* art critic, who wrote a rave review.[91]

Elaine took her artist friends to see the exhibition, which, she said, "became the laughingstock of Provincetown." New York attorney Ralph F. Colin, legal counsel of the Art Dealers of America, already had his suspicions about Chrysler after two of his Picassos had been labeled fakes by the artist. Colin tipped off *Life* magazine, which wrote an exposé.[92] In the meantime, Canaday published a mea culpa, "High and Low in the Chrysler Show,"[93] in which he lamely pointed to the opening of his initial review—a playful report

of being "drugged" by the sunshine, salt air, and a seafood lunch—as the reason for his lapse of judgment. It isn't clear whether he knew that Elaine had anything to do with the unmasking of the fakes. But the art world was small in those days, Canaday had a sour personality, and his scorched-earth review of her portrait show at the Graham Gallery the following year may have been a payback.

In the fall, Elaine traveled to Washington, D.C., with Marisol and Ruth Kligman for the opening of the Washington Gallery of Modern Art, which had mounted the first retrospective of work by Franz Kline. Elaine had written the introduction to the catalogue. At the dinner, Kligman—who had been to Rome with Bill in 1959 during their affair[94]—said, "This would never happen in Italy." Elaine wondered what "this" was. It turned out Kligman was upset that no men had come by to speak to them.[95] In a letter reporting this exchange, Edwin Denby noted, "there is a rumor Elaine is going to Palm Beach for Christmas to paint Kennedy." The rumor was true. (See chapter 9.)

ELAINE HADN'T BEEN to Italy yet; she would take her first trip to Europe in June 1973. Her nineteen-year-old niece Maud Fried was planning to spend the summer in Greece, but Elaine convinced her to change her plans. A plane ticket sweetened the deal. "We had fun trying to really *be* there," Maud said. "Elaine does not do things as a bystander."[96] In Florence, they walked nearly everywhere—to the outskirts of the city on one occasion, to hear an organ concert—and tried out their newly acquired Berlitz Italian on shopkeepers and waiters. In addition to day trips in the region, the two women took a "very, very rigorous" art tour of the city. "Every museum, every grotto, every church," Maud recalled. "We got up at seven every morning and were out of the pension by eight.... She would not prejudice me by giving me her thoughts and opinions before I had a chance to look or be moved by the art. We spent time looking... trying to understand the perspective of the artist." To see the stone Michelangelo used in his sculptures known as the *Prisoners*, Elaine took her niece to marble quarries. Maud said that Elaine secured permission to visit galleries that were closed in the aftermath of the 1966 Arno River flood, to observe specialists conserving the artwork.[97]

The following year marked Elaine's first trip to Paris, teaching in the New York Studio School Summer Program. In letters to Mercedes Matter, Elaine raved about the "reserve and politesse" of Parisians, even in the Métro at rush hour. She also inquired about a possible tuition reduction for her nephew Clay Fried, a budding artist who had just graduated from high school and was serving as her studio assistant. Elaine, who took him with her to museums and

galleries, wrote to Matter that he was learning what it was like "to be involved with art around the clock."[98] After fortifying themselves with coffee and omelets, Elaine and Clay would walk around the city with their Winsor & Newton traveling watercolor sets, stopping to perch on a stone wall to capture a view.

It was serendipity that they noticed Jules Dalou's massive bronze statue, *Le Triomphe de Silène*,[99] on an afternoon visit to the Jardin de Luxembourg. The nude, big-bellied figure of Silenus—the perpetually drunk elderly companion of the wine god, Bacchus—lies on the back of a donkey. Nude male and female followers holding his legs struggle to keep him from slipping off. Another male figure holds Silenus's shoulders. Other figures, including a woman and a baby, look like they're in imminent danger of being trampled underfoot. The tableau is low comedy, co-opted by the strictures of formal composition.

Elaine always thought the sculpture was of Bacchus himself, and titled her extensive series of paintings with his name. (The current, freestanding name plaque at the edge of a flowerbed bordering the statue looks like a recent addition; on a return trip years later, Clay noticed that the sculpture also occupies a more prominent place in the park.) Despite her experience with alcoholism, Elaine usually said that the subject of the sculpture was of no particular interest to her.[100] What fascinated her was the frozen movement of the figures against the breeze-blown foliage, with the dappled light adding its own rhythms. "Everything was in motion," she said. "This static image just shimmered." She liked the "ambiguity" of the forms ("you don't know where one starts out and leaves off") and their "turbulent energy."[101] In her eyes, "the shadow and light were small flying pieces of color." Did her nearsightedness play a role in her preference for the blurred view? (plate 28).

Although Elaine initially sketched the sculpture from several angles, she ultimately decided to make multiple images from one vantage point "to see where [they] would take me."[102] This decision was of a piece with her preference for employing the same pose for multiple portrait images of the same person. Color was particularly important to her in the Bacchus paintings— "gray and green and yellow and blue, and the variances occurring within these colors."[103] After working on this series for six years, she joked that she could paint the statue with her eyes closed. But she often used an early charcoal-on-canvas sketch as a touchstone, to remind herself of "the kind of activity I want from this image."[104]

Writing in *Art in America*, Lawrence Campbell found her *Bacchus* painting show at Gruenebaum Gallery in fall of 1982[105] to be "the strongest and most lyrical" work by Elaine that he had ever seen. He praised her "Baroque

rhythms of color" and compared the series to Claude Monet's multiple views of Rouen Cathedral, in the sense that "each [painting] is made unique by the way it is painted." Campbell aptly intuited Elaine's perception of the sculpture—not as "art" but "as much a part of nature" as the park itself.[106] (Did the serial work of other artists influence Elaine to work in this manner? It seems more likely that the impetus was simply her need to focus on a single theme, even while she worked on multiple canvases.)

During her 1976 summer teaching sojourn in Paris, Elaine was accompanied by Jim Touchton, one of her graduate students at the University of Georgia. ("I began to wonder if she asked me to come along just to carry her suitcase and canvases," he said, only half joking.[107] Elaine's youthful expectation that a man should jump to do her bidding had never altered.) Before her teaching duties began, the two of them made the rounds of museums ("She would walk up to a Monet: 'Look at that little square right there—that's a Bill de Kooning'") and visit the Ménagerie (zoo) at the Jardin des Plantes.

There was an adjacent café where Elaine liked to order an omelet in her Brooklyn-accented French.[108] "She would cut off two-thirds for her plate and give me the rest," Touchton recalled with a laugh. One day, Elaine purchased a flour sack emblazoned with a red medallion to hold her watercolor supplies. After she and Touchton finished their café meal, they stopped at the zoo's gorilla in his tiny cage: "And Elaine's eyes and his eyes met like [a moment from the movie] *King Kong*." The gorilla banged his chest, ran around, and made loud sounds. "I think he likes me," Elaine said. Obeying some errant impulse, she swung her flour sack at him, and he promptly put his head down and threw up.[109] It must have been the most visceral response to her quicksilver personality that she ever received. (The next day, she mischievously swung her bag again, and the gorilla encored his performance.)

IN 1958, WHEN Elaine interviewed Mark Rothko for her *ARTnews* article, he offered her a drink—at 10 a.m. "No thanks," she said. "I don't drink during the day."[110] But in the 1960s, her drinking escalated. Like Rothko, she became what he called a "tippler," using alcohol to cope with daily life. This kind of drinking is not about fitting into a cool lifestyle; it is driven by gnawing anxiety or depression. Her anguish is visible in a searing charcoal self-portrait from 1968. The mid-sixties were unsettled years for Elaine, with momentous events in the lives of the two people with whom she had the most formative and turbulent relationships. Her mother died on May 26, 1964, and was buried next to her husband in the upstate New York village of Roscoe. Bill's response to Elaine's invitation to the funeral was chilly. "I'll tink about

it," he said."[111] His drinking had escalated more precipitously, feeding angry outbursts about Elaine. The following year, he drew up a will that left the bulk of his estate to his daughter Lisa and tried to divorce Elaine. In an unsuccessful attempt to persuade her to agree, he gave her a large group of his drawings. (Another version of this story has Elaine simply helping herself to these works.)

It is not surprising that underneath Elaine's "immediacy and vivacity," John Ashbery perceived "some secret that she couldn't impart."[112] Elaine's hyperactive socializing, her need to constantly keep busy with art and writing projects, and her many years of heavy drinking were all ways of avoiding a confrontation—not only with the scars of her early childhood and her fraught relationship with Bill but also with the frightening possibility that her mother's unbalanced personality might have been passed down to her in some form.[113]

Alex Katz painted his sharply observed portrait of Elaine in 1966 (plate 23). Poet and critic Bill Berkson has described this portrait as "Elaine as a liberal-era Joan of Arc."[114] It captures both her intelligent gaze and her arched-eyebrow glamour at age forty-eight. Katz was working with cropped images at the time; his painting is a close-up of her face that stops just below the bow of her upper lip. Her worried-looking, slightly droopy-lidded brown eyes are the focal points of the image, framed by brown hair that morphs into a brassy red. Katz remembers her hair as "very styled; it wasn't natural." Like virtually everyone else in her orbit, he described her as "brilliant" and "a lot of fun to be with," as well as "one of the top writers of her time."

Elaine had bought Katz's cutout painting of Frank O'Hara (it stands, like a sculpture, on a wood base) from his 1963 Tanager Gallery show, paying three hundred dollars—his biggest sale to date. She told him that she put it next to her bed. "I'd wake up and find a man there," she joked.[115] When O'Hara was killed in a freak accident in the summer of 1966—a dune buggy ran into him on the beach—Elaine, like all his friends, was devastated. She and Bill had driven to the hospital where O'Hara had been taken and heard the grim prognosis from his doctors. While a healthy man might have pulled through, heavy drinking and smoking had weakened his constitution. "When I walked into his room, he said: 'Oh, Elaine, how nice.' I said, 'Get better.' He said: 'All right.'"[116] He died seven hours later.

IN THE AUTUMN OF 1966, Elaine bought a two-bedroom shotgun[117] cottage with a small yard on Shelter Island's tiny Locust Lane. The island, at the eastern end of Long Island, is accessible only by ferry. She wrote to John Cage that the island was "heavenly" and "only a two and a half hour drive from the city."

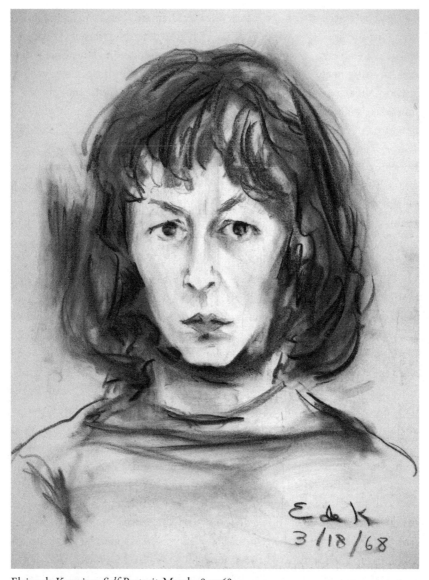

Elaine de Kooning, *Self-Portrait*, March 18, 1968.

Charcoal on paper, 23-11/16 x 18-1/8 inches. National Portrait Gallery, Smithsonian Institution; Ruth Bowman and Harry Kahn Twentieth-Century American Self-Portrait Collection. ©Elaine de Kooning Trust.

The low mortgage rates were "much cheaper than rent," and she had fallen in love with the flowers in window boxes.[118] Elaine described herself as "happily isolated" in a New Year's card to an artist friend noted for her landscape paintings, inviting her to visit with the lure of "beautiful landscapes everywhere you look in all seasons."[119] Maud Fried, who visited as a child, remembers the house as "charming," with "petunias at every windowsill which [Elaine] taught us to pick following their bloom." But on another occasion, an adult visitor was shocked at the derelict condition of the cottage. "It was like a Booth cartoon,"[120] Robert Dash said, noting the low ceiling, a dying plant, and a broken light bulb. He described Elaine "with this bottle of Scotch saying, 'Oh I *love* this place.' "[121] She was spending much of her time teaching at colleges around the country, so the cottage was more of a pied-à-terre than a home. Still, this was no way to live. Bill's biographers linked her neglected living space to her "troubled inner life, which she concealed from others."[122]

She had a happier experience with real estate when she bought the Fried family's ancestral farm. When Charles Fried's grandfather, Konrad Fried, had arrived in the United States as an indentured servant, he received in exchange a seventy-five-acre parcel of land in the hamlet of Callicoon, in Sullivan County, New York.[123] The natural spring that provided water was prone to washouts, which made farming a constant struggle. In the 1870 U.S. Census, Konrad reported the value of his land as only $2,500 (about $47,000 in today's money). It's no wonder that his eldest son, Conrad—Charles's father—abandoned farming and turned to carpentry. Charles's sister Louisa, who taught at the schoolhouse two miles down the road, eventually moved to California; at some point after that, the farm was sold.[124]

Now the farmhouse and its long, rocky drive were badly in need of repair. "Let's all fix it up and enjoy it," Elaine told her family.[125] Her brother Peter installed a new floor in the great room, and she spent part of one summer painting the exterior of the two-story dwelling. "Heavy manual labor but exhilarating too," she wrote to her former student William Conger. "Wonderful fresh water lake swimming, etc. I reluctantly come to the city for a couple days each week."[126] Elaine had a small foundry built on the property where she worked on a series of bull bronzes shown at the Graham Gallery in 1973.

At the farm, Elaine made the most of visits from her family. Her niece Maud treasures the memory of a stone-jumping trip up the creek with her cousins, a fanciful experience that "helped us learn about ourselves and the magic of the woods and creek."[127] Elaine had asked each child to choose a favorite spot that would henceforth be considered their own property—a rock, a cliff, an eddy. On another occasion, she challenged everyone to a race. Elaine

Elaine de Kooning, *Charging Bull*, 1964.
Bronze, 8 x 5 x 14 inches. Charles & Mary Anne Fried Collection. Photo courtesy of Levis Fine Art, Inc. ®Elaine de Kooning Trust.

came in last, winded and drained, possibly not even noticing that someone had set out a line of cigarettes across the finish line.

While the farmhouse was still a work in progress, Elaine invited artist Jim Bohary and his wife and son to come up and live there. She offered him two hundred dollars to install plumbing and make other improvements. The arrangement worked out well, and the Bohary family returned many times. Bohary had met Elaine in 1971, when he was looking for a studio in New York. She sweet-talked the owner of her building into renting Bohary a small space with a skylight that had been used for storage. When she was out of town, she let him use her own studio. Through Elaine, he met leading painters and art writers, including Thomas Hess and Harold Rosenberg. "I consider her a very democratic Gertrude Stein," he said, comparing Elaine to the experimental writer whose salon in Paris attracted leading artists and writers in the early twentieth century. Two years later, when she was asked to give a portrait demonstration in conjunction with her show at the Montclair Museum, Bohary agreed to pose. He and his wife Sandy piled painting equipment into his van and drove to New Jersey for the forty-five-minute sitting. "She captured a certain thing," he recalled. "A young man, a little jumpy at the time."[128]

ENSCONCED IN HER spacious loft, Elaine would normally look out the window to make sure that anyone ringing the street-level bell was someone she expected. But when she gave a party at night, her guard was down; people wandered in off the street. A poet friend asked Elaine how she insured everything. "They take the TV," she replied. "They leave the art alone."[129] Liquor flowed freely at these parties. As Elaine once said, "Surrounded by drinks, drinking seemed the natural thing to do."[130] On February 6, 1968, she wrote a check for $106.80—about $727 in today's money—to the Union Square Liquor Store. This may have been the Tuesday-night party she gave at which a friend recalled that young male guests "kept bringing her checkbook to her, saying they needed more booze."[131]

During three days in May, she spent nearly one hundred dollars at another liquor store for "entertainment." That fall, she would write the names of visiting friends alongside records of checks to liquor stores, perhaps as a way of rationalizing her purchases for personal use. Painter Richard Rappaport and Elaine's former student Barbara Schwartz were the last people to leave after a typically alcohol-drenched party Elaine gave to celebrate her loft renovation. Lying on her bed in a semi-stupor, oblivious to Rappaport's presence, she pleaded with Schwartz to tell her "that she was still beautiful." Then, realizing that Rappaport was taking this all in, she was furious at being observed at such a vulnerable moment.[132]

As youngsters, Elaine's nephew Luke Luyckx[133] and his cousins witnessed artists' alcohol-sodden scenes at openings and parties at Elaine's loft, including her own heavy drinking. "It was sad to see Elaine struggle with it," he said. "I can't tell you how many times she would end up on our couch in Freeport after a party."[134] He would make her a ham sandwich or an egg on an English muffin; she would eat it and drink a glass of orange juice, and then fall asleep again for a couple hours. "She would deny that she had a problem," Charles Fried said. "She would say 'I'm not drinking,' which meant she was not drinking hard liquor but wine—she would drink a couple of bottles of wine a night; that was 'not drinking.'"[135] When it came to alcohol, she made her own rules. "She would never have said she had too much to drink." said Clay Fried. "According to her, it was the right amount, whether she was slurring [her words] or insulting people. She was having a good time, and she would deny being drunk. It was a good time up until she passed out."[136]

One of the more memorable insults occurred in late 1970, when Elaine was a guest at a party for Irving Sandler to celebrate the publication of his book about Abstract Expressionism, *The Triumph of American Painting*. After downing a few drinks, she walked up to Dorothy Pearlstein and said she

recognized her from Alice Neel's portrait. (Considering that Neel was no flat-
terer, this may have been something less than a compliment.) Then Elaine
asked her to point out her husband, Philip, the painter. Sighting him un-
leashed a bizarre string of remarks from Elaine, who insisted repeatedly that
there were two Philip Pearlsteins, the "good" one she knew and the one at the
party, "the Philip I've hated all these years." Taking pity on her, the Pearlsteins
drove her home. "As she got out of the car," Dorothy wrote to a friend three
weeks later, "Elaine's final words were, 'I feel as if I've lost something. I'll have
to find someone new to hate!'"[137]

And then there were the car accidents. "It's amazing that I did not go the
way David Smith went [or] Jackson Pollock," she told an interviewer in 1969,
alluding to the artists' fatal car crashes.[138] During her year in New Mexico, she
had bought a used car, and her friend Margaret Randall instructed her in the
mysteries of gear shifting. Elaine failed her first two driver's tests and had to
turn on her charm to convince the Irish American who administered the third
test that it was only proper to pass a woman whose forebears came from the
auld country. Her shaky driving skills didn't mix well with alcohol. One night
in Albuquerque when she was drunk, she drove into her own living room.[139]

In January 1963, on her return to Manhattan from sketching President
Kennedy in Palm Beach, she was convicted of drunk driving for a previous
incident and fined one hundred dollars.[140] After another accident, in August
1969—on her way home from a dinner party in the Hamptons, her car
swerved off Main Street in Amagansett and struck a parked car, setting off a
chain reaction that damaged four other parked cars—she was hospitalized for
several days with head injuries. (Her head had broken the windshield.)
Refusing to take a blood test at the scene, she was charged with felony drunk
driving at the arraignment the following February, because of her prior con-
viction. Elaine pleaded innocent through her attorney.[141] "It was a tiny bit of
self-destruction," she said later that year. "No matter how I want to rewrite the
story or rationalize the story."[142] A third car accident occurred when she
veered off a dead-end coastal road on a foggy night in the Hamptons, landed
in the water, and didn't realize it until she tried to open the door.[143]

Elaine was in therapy at this time with a Dr. Harkavy.[144] She told an inter-
viewer that the experience was "extremely interesting." Robert F. Kennedy
was appearing in her dreams, and she "spooked [her] shrink" when the sena-
tor was assassinated the night after she related her obsession with him. Elaine
confessed, "I'm preoccupied with suicides, etcetera and so forth, which is
always a tipoff."[145] She didn't explain further, but she was obviously aware of
the self-destructive aspect of her drinking.

Elaine and Joan Mitchell in Vétheuil, France, June 1975.
Photographer unknown. Courtesy of the Joan Mitchell Foundation, New York.

One version of Elaine's how-I-got-sober story describes her visit to Bill, when she urged him to quit—with a martini in her hand. When he pointed this out, she said she would have no problem giving up drinking. He dared her to do it, and she did.[146] Another version features Marjorie's constant criticism of Elaine's habit of repeating herself when drunk. (Marjorie had recorded her sister, to let her hear how incoherent she was under the influence.[147]) It's not clear what the decisive factor was—psychotherapy or her membership in Alcoholics Anonymous—but in the mid-seventies, she finally stopped for good. "When she wanted to do something, she'd do it," Charles Fried said.[148] A few years after Elaine quit, she wrote to an alcoholic friend, quoting Edwin Denby ("booze makes us inferior to ourselves") and urging the man to remember that, "For our immoderate souls, there is no such thing as moderation."[149]

Toward the end of her life, she mused that the ferocity of the dialogue between George and Martha in Edward Albee's play *Who's Afraid of Virginia Woolf* was really "two glasses of liquor conversing with each other...a good deal of that emotion was alcoholic."[150]

By the time of her 1974 trip to Paris, Elaine had given up hard liquor, but she hadn't quite ended her long romance with alcohol. "In France, she could get pretty dosed on a bottle of wine by herself," her nephew Clay said. "Part Two was giving up the wine, which happened a year or two later. But she was wrestling with that thought."[151] The following summer, Elaine visited painter Joan Mitchell. She had been living in the village of Vétheuil, northwest of Paris, for the past decade; staying with her now was a young painter, Phyllis Hailey. Elaine was accompanied by Hollis Jeffcoat, the twenty-four-year-old painter who administered the Paris program at the Studio School. After chatting about various things, she got to her point: Mitchell, who was virtually living on cigarettes and alcohol, was on the road to ruin. She pooh-poohed Elaine's concern, saying that she had stopped drinking for three days (on her fiftieth birthday), and it didn't do anything for her. But Elaine's real gift to Mitchell—who never gave up alcohol—was Jeffcoat, a tall, slender woman with a soft voice. While befriending Hailey, she became Mitchell's close companion, and eventually her lover.[152] Did Elaine know that the two of them would want to spend time together? She had almost a sixth sense for making connections between her friends.

8

Portraits as Moments and Memory

"SINCE LAST SUMMER," Elaine wrote to a friend in February 1963, "I've been totally involved with portraits."[1] That spring, a solo show of her recent work in this genre opened at the Graham Gallery in New York, heralded by Elaine's appearance with eleven other artists—all male—on a CBS-TV program.[2] Years later, she would call portrait painting "an addiction"[3] and compare her compulsion to paint images of other people to her smoking habit.[4] She claimed that the low status of portraits in contemporary art made her "even more involved with them, if anything."[5]

Although many of her sitters were friends, portrait commissions supplied much-needed income. Elaine's level of engagement with this work varied over the years,[6] but in an *Art in America* interview, she insisted that "anyone can be interesting," regretting only that the commissions were all "hidden away" in private collections. She explained that it is actually easier to paint someone you've never met before, because you're basing the image on an immediate reaction to the sitter's appearance.[7] (Once, when a man complained that she made her look "like a brute," she confessed that she saw "a little" of that aspect in him.[8])

Elaine typically advertised her availability to paint "a limited number of commissioned portraits" while giving a series of classes in a city. For five days in July 1972, she presented an afternoon workshop in portrait painting at the Tyler Museum of Art in Tyler, Texas. While she was in town, the Collins family—descendants of an insurance company founder and philanthropist—was one of several that took her up on her offer. In her paintings of the parents and their grown children, the women sit demurely in stylish dresses, while the men sprawl with the casual entitlement of local landed gentry. (In a letter, Elaine described the ranchers and oilmen as "gay and friendly," though she wondered how the local artists managed to keep painting "in this [cultural] vacuum."[9])

"My Texas millionaires have a nickname for me, The Dutchess," she told an interviewer. Asked why, they said, "When you have a few drinks, you begin to order us around." When she informed one family that her portrait needed to hang on a particular wall of the house, which would involve moving the chandelier, they asked, "'Where should we put it, Dutchess? Should we send it to you in New York so you can put it in your bathroom?' So they sent it. It was charming. They just thought I was too impossible."[10] Being "impossible" was in keeping with her sense of herself as delightfully willful.

According to the Graham Gallery, Elaine's portrait prices during this period—from which the gallery took a one-third commission—ranged from $1,500 (head and shoulders) to $4,500 (full figure).[11] A potential client who wanted a group painting of her three sons was quoted $4,500.[12] Before a *Life* magazine story about Elaine's portraits of President Kennedy elevated her stature (see chapter 9), her prices were lower.[13] But she did not command the prices of gallery artist William Draper, who had a studio on Park Avenue; his traditional portraits cost $6,000 to $12,000. The discrepancy was likely due to Elaine's lower status as a woman artist, her lack of Draper's establishment trappings, and her unconventional painting style.

Elaine said that she never painted anyone smiling "because smiles are a response to another human being," while a portrait is "a response to someone's solitude."[14] (She could have added a practical reason: a sitter's smile would soon harden into a grimace.) What she wanted was something beyond role-playing—"Most people hide behind their daily occupations and trivial pursuits," she said—and distinctly different from an image caught by a camera. "A photograph is just that one moment that's caught," she said, "whereas a portrait...should have intimations of how that person looked ten years before and will look ten years from then."[15]

Portraiture enabled her to blend the precise observation of her exquisitely detailed early drawings and her Abstract Expressionist brushstroke into a personal style. She sought an image that was "simultaneously still and in motion like a flag in the wind...uneasy, yet exuberant."[16] Her self-imposed requirements were complex: a portrait should be sufficiently true to life so that "the grocery man could come in and say, 'Oh, that's him,' but it also has to satisfy my requirements for abstract space."[17] Elaine once told an interviewer that "the painting must be economical and free, but the resemblance must be breathtaking."[18] (When she showed three dissimilar drawings of Harold Rosenberg at the Roland de Aenlle Gallery, the *ARTnews* reviewer wrote that one emphasized "his gargantuan features," while another was "covered with deep scribbled shadows," yet they all were clearly recognizable as "this New York personage."[19])

Elaine's process varied. "Sometimes I begin with color washes to set up areas," she said. "I may start with an outline or work from a pencil drawing. Sometimes I simply start with a feature—an eye, perhaps—and work the whole portrait from that."[20] The key to painting a facial feature, she said, "is to forget what you know about it and just reduce it to paint strokes, or other kinds of shapes."[21] As she worked, she balanced her attention to formal aspects of the composition with alertness to the emotional atmosphere. "I identify totally with the sitter," she said. "It's as though the sitter is painting the portrait and I'm responding." Her brother Conrad, who sat for Elaine and watched her paint on many occasions, wrote that she "seemed to have, or...deliberately develop, a psychological relationship" with her sitter."[22] Elaine's friend Connie Fox discerned the same aspect. "[S]he delved far beneath the *look* of the sitter into something near his or her spirit," Fox wrote. "There was a living investigative feel to her work, which was reinforced by her frequent habit of working in series or picking up on the same person at different stages in his or her life."[23]

Elaine's intense awareness of color and fanciful imagination once led her to remark that each of her subjects carried with him a specific sort of light—"a silvery light" or "a kind of lavender light."[24] Years later, sounding more practical, she said that the dominant colors in her portraits tended to reflect whatever colors she was working with at the time on other types of paintings.[25] Although portraits became less central to her practice in later years, she continued to paint them, just as she kept up her watercolor landscapes. "Often, you make discoveries," she would say, "with the painting that you do on the side." Up until the last decade of Elaine's life—when her sitters often posed against the landscape behind the deck of her studio in East Hampton—her portraits were not anchored in a specific setting. Instead, an abstract interplay of brushstrokes sets up what a critic called an atmospheric "charge" suggesting the "the energy...just beneath the surface."[26]

One reviewer ventured the opinion that Elaine used action painting to "bring down" the sitter, "like a gladiator whipping a net over his opponent."[27] But this is hyperbole. Contrasting her portraits to the famously unsparing canvases of Alice Neel—also represented by the Graham Gallery[28]—Elaine said, "[M]y whole idea of any person is sympathetic....I put myself in that person's shoes."[29] Neel, who briefly worked in Elaine's studio in the early sixties, at her invitation, claimed that the younger artist "stole my technique."[30] This accusation seems driven by pique, not fact. For her part, Elaine praised Neel as a "superb" portrait painter.[31] (Though when Neel asked if she would sit for a portrait, Elaine supposedly retorted, "Yes, with easels at twenty

paces."[32]) Elaine and Neel once went head to head in a two-person exhibition at the Phoenix Gallery in New York; the *ARTnews* reviewer praised work by both artists but declared that "[q]uietly, but with her usual dash and vigor, Elaine de Kooning stole the show."[33]

In 1956, Elaine completed a painting of Harold Rosenberg, *Rosenberg # 3* (plate 12), in one day, working from a charcoal drawing.[34] ("The idea of doing a painting from a drawing," she once said, "is that you're completely free in terms of color."[35]) Sweeping the canvas with orange, turquoise, and green brushstrokes, she found that the portrait—which, contrary to her usual practice, she placed on the floor to paint—came easily to her. With his stiff right leg stretched out fully (as a young man, he had osteomyelitis, a bone-marrow disease), his head sunken in his neck, the fifty-year-old writer commands the space in a lordly way, cigarette in one hand, glass[36] in the other.

The angle at which Elaine painted him emphasizes the triangular creases of his crotch and the wavy line of his fly—following the contours of his stomach to disappear between his thighs. Together with the effect of his bushy eyebrows and thick moustache, and the commanding size of the painting, which is nearly seven feet high, he comes across as a potent, even somewhat menacing figure. Yet in her eyes he was "full of a joyful quality." The gap between her perception and the appearance of the finished painting suggests that her feelings about him as a friend and intimate were more complicated than she may have realized. (Rosenberg disliked the painting, Elaine said, because he thought it made him look like a Miami hotel proprietor.)

Whether or not Elaine was consciously aware of it, her colors also brightened in her 1956 portrait of her other lover, Tom Hess[37] (plate 11). A reviewer pointed out how the paint "wedges and squeezes the figure" but allows his face to look out "like a proud tower."[38] When a group of her portraits (and landscape and bullfight sketches) were shown at the Graham Gallery in 1975, Hess would devote a long review in *New York* magazine to singing her praises. Elaine "presents the creative personality as an ultimate aristocracy," he wrote. Attempting to analyze how she established a likeness, he located it in the way details fuse in the overall structure, "even when the artist pushes them to the verge of romantic incoherence." He also suggested that her portraits shift from being purely pictorial to becoming a psychological likeness—of Elaine herself. Quoting her on the subject of portrait painting as an invasion of privacy, Hess proposed that "the privacy she invades most rigorously is her own."[39] Had another reviewer not made the same point about one of Elaine's portraits of Fairfield Porter ("almost a self-portrait, the only self-portrait of somebody else on record"[40]), it would be easy to dismiss Hess's words as a

product of his intimate relationship with her. Still, these remarks don't really make sense. Any skillful portrait painter who knows her subject will—consciously or not—infuse the image with her own sense of, and reaction to, the person's psychology. But this is not the same as presenting another person's inner self as one's own.

In July 1978, five months after having been hired as the head of the Department of Twentieth-Century Art at the Metropolitan Museum of Art, Hess died of a heart attack at age fifty-seven; Rosenberg had died of a stroke two days earlier, at seventy-two. A reproduction of one of Elaine's portraits of Hess accompanied Hilton Kramer's Sunday piece in the *New York Times*, "An Era Comes to an End."[41]

WHEN HER SITTERS were people she knew well, Elaine's portraits had a notable psychological aspect. In 1954, she painted her thirty-three-year-old brother Conrad, seated with his eyes closed, as if meditating, fingers interlaced. Two years later, her portrait of her brother Peter reveals a highly charged personality, conveyed in his tense pose and alert head, seemingly about to turn to one side. Elaine's portraits of Bill are particularly revealing. She captured the fleeting expressions on his face and the contours of his naked body while he slept. She sketched him holding a drink, with a wary expression on his face.[42] She even imagined him as *Bill Bird* (1951), in a semi-crouch, like the angel of the Annunciation in a Renaissance painting, and sprouting a pair of wings.

Elaine's portraits of her husband culminated in 1956—a year before the couple separated—in a drawing in which she erased his facial features and in a ferociously dehumanized painting, *Bill at St. Marks*.[43] Bill, she said, "had become an angry man; it was oppressive." (A painting from 1950, *Angry Man* [plate 7]—probably an under-the-radar portrait of Bill—dematerializes his figure into a black glyph on a colorful, brushy background.) Elaine struggled with *Bill at St. Marks*, "changing the color, changing the shoulders."[44] In the final version, Bill sits in a severely frontal pose, with his open thighs and bent knees forming an acute-angled triangle and one arm practically vaporized by the painterly blue mist hovering above his shoulders. A slab of blue paint obscures his face.

With a sensibility honed by working abstractly, and at a time when a suit was the customary outfit of a middle- and upper-class man, Elaine was intrigued by the way the buttoned shirt, necktie, jacket, and trousers divided men in half vertically. Her portraits in this series are all strictly frontal views; all the "action" is in the paint—a flurry of short strokes. She never asked her

sitters to sit in a particular way; what she wanted to see was their natural posture: "What I generally do is just talk to [the person] about other things, and I would say, 'That's it; hold that pose.'"[45] It became obvious that men had a limited repertoire of seated positions—with legs fully opened, or crossed at the ankles, or crossed at the thigh, or with one ankle resting on the opposite knee.

At one point, she began referring to these portraits as her "gyroscope" men, but failed to explain clearly what she meant. In a late-life interview, she mentioned that her inspiration was a book by the psychologist Rollo May.[46] In *Man's Search for Himself* (1953), May borrowed a term from the sociologist David Riesman to describe "gyroscope men" as individuals with a powerful, stable center (like a gyroscope's spin axis), who lived according to "rigid rules," repressed their feelings, and were unable "to learn and to change." (May's point was that these men were nineteenth-century types; a young American man at mid-century had the opposite problem—a passive disposition "with no effective center of motivation of his own."[47]) Elaine may have viewed men like Hess, Rosenberg, and Bill in this light—in terms of a certain inflexibility in their personalities—however modern their outlook on art.[48] The term became, as Elaine said, "an imaginative trigger" for portraits in which the man is the still center, with abstract bursts of color behind him. ("Tiny bits of color that kind of fly on [the canvas] can absolutely affect the entire composition," she said.[49])

Donald Barthelme, on the other hand, represented a new generation. In 1965, Elaine painted two portraits of him, after he had divorced Helen and remarried. One has a sketchy quality, more fully worked in the face (he wears his trademark horn-rimmed glasses), but with a doodle-like torso and legs. The other portrait is truly strange. Under the crook of Barthelme's right arm sits a faceless doll-like creature—a toddler-age projection of his daughter Anne, born on November 4 of that year. ("I painted her out, because she kind of turned into a midget," Elaine said later. "I just couldn't get the scale."[50]) A few years earlier, while working on her "tall men" series, Elaine had tried to reinvent the clichéd woman-with-child theme with a "male Madonna"—poet Myron Jones, standing with his arm around his son Christopher. But the style of the Barthelme painting is completely different. Elaine was going out on a limb, as was Barthelme, in his short stories. With this enigmatic portrait, she captured something of the amorphous, provisional aspect of his fiction. She and Barthelme remained on good terms. He would later say that his conversations with her lessened his anxiety about devoting his life to writing, though he told her, rather unfairly, that she "only seemed to be able to help

young people if they want to...do something creative."[51] Elaine would be the dedicatee of Barthelme's novel *Paradise* (1986), about a fifty-three-year-old architect separated from his wife who plays out a male fantasy with three lingerie models.

AFTER HER EXPERIMENT with the cylinder paintings in 1961, Elaine began a series of "tall men" on vertically oriented canvases. The results were uneven. Her portrait of Merce Cunningham obscures part of his face and neck with splotches of green paint, a mystifying tactic that leaches the viewer's attention from the tensile grace of his stance. In her portrait of Edwin Denby, she "wanted the sense of the figure kind of flowing past the canvas."[52] Dark brows shield his preternaturally staring eyes (possibly emphasized to suggest his visual acuity[53]), which vie for attention with his askew tie, suavely erect posture, long legs, and big feet. His entire figure is silhouetted in a nimbus of violet shadow, indicating the "moonlight" that Elaine believed accompanied him, even in broad daylight.[54]

Elaine was intrigued with the affinities between poets and artists. She believed that "poets are much more involved with intuition and wild flights of fancy" than critics or novelists. "So poets can look at a painting and understand it without having it spelled out."[55] In 1962, Frank O'Hara posed for her in Wolf Kahn's studio, which had better light than Elaine's loft but was so cold that Kahn had to loan O'Hara an overcoat (not seen in the painting).[56] At one point, impelled by some errant impulse, she wiped out his facial features. Now, she said, "it was more Frank than when the face was there."[57] When O'Hara's brother walked into the Graham Gallery, where the painting was shown, he immediately recognized his brother.[58] The giveaways were the distinctive widow's peak above his wide forehead and his slim physique (Elaine called him "hipless as a snake") with its familiar posture—left hand on hip, weight on the right leg. A faceless portrait seems particularly apropos for O'Hara, whom Grace Hartigan had painted as *The Masker*, in part as a reference to his double life as a gay man in a straight world.[59] O'Hara saw himself as composed of multiple identities, taking on aspects of whomever he was with at the time. In one poem, he wrote, "my eyes, like millions of / glossy squares, merely reflect."[60]

In Elaine's 1950 portrait of her brother Conrad playing chess (plate 6), his facial features are blotted out by the oppressive, dull green atmosphere of the room. It's as if the material facts of man and chair and chessboard are secondary to his inner life of intense concentration. Bill received Elaine's "faceless men" treatment in a 1952 portrait showing him with his left hand

clenched and a featureless expanse where the lower part of his face should
be (plate 8).[61] A few years later, Elaine painted a brighter, more detailed
portrait of Bill in a similar pose, also with his mouth blanked out.[62] In 1954,
Elaine's portraits of Fairfield Porter show him with either a scrubbed-out
face or just a gauzy glimpse of eyes, nose, and mouth (plate 10). That year,
Frank O'Hara described two of her portraits (of Conrad and Bill) as
"present[ing] a composed, contemplative man in the surcharged violence of
his days."[63] Another critic was less complimentary. Leo Steinberg dismissed
the "black smudge" obscuring Conrad's face in another portrait by Elaine as
"an impatient gesture of frustration"—apparently without considering its
psychological import.[64]

Elaine employed her "faceless" style only when painting someone she
knew well. One thing is certain: she didn't omit facial features because she
was unable to paint them convincingly. A quick look at her other portraits
will dispel that notion. So what was her rationale for this approach?
Because the "faceless" sitters *were* known to her, and they were apparently
all men, some have wondered whether her impetus was feminist anger.
This seems unlikely. Elaine's quarrel with feminism was its tendency to
view men as oppressors. By all accounts, she loved the company of men,
and the men in these paintings were people she admired—whatever argu-
ments she may have had with them from time to time. (She once said that
Porter "always treated [his wife] Anne like a slave...he was Mr. Macho
really."[65]) Yet the arguments may be a clue. Intriguingly, Elaine's brother
Conrad wrote that she was liable to paint out a sitter's facial features "if her
mood was not quite right."[66] Painting a faceless sitter may have been her
way of dealing with troubled aspects of her relationship to him.[67] She once
told an interviewer that in her portraits, she "wanted the figure to seem
alone in the world," which raises the question of why this was important to
her. Whether or not she realized it, this goal resonates with the feelings of
anguish and despair that her effervescent personality sealed off from public
inspection.

Beginning in the mid-seventies,[68] commentators suggested that Elaine's
goal in the faceless images was to stimulate the imagination of the viewer to
fill in the missing features, so that artist, sitter, and viewer would jointly
"create" a portrait. In this scenario, each viewer's perception of the portrait
would necessarily be quite different. This plausible approach to her work is
not supported by any surviving remarks she made. Yet she once likened the
faceless portraits to her fascination with the amount of content she could
glean while watching a film in a language she didn't understand.

ELAINE WAS OFTEN ASKED why so many of her portrait subjects are men. Her response was that, throughout history, women were painted by men, and she was simply turning the tables: "I tend to regard the male in general as a sex object." But she did paint women, revealing personalities ranging from introverted to dramatic. Margaret Randall was a young poet searching for her place in the world when Elaine knew her in Albuquerque. In an ink and gouache portrait from 1960, when the twenty-four-year-old Randall was pregnant with her son, Elaine captured her shy, engagingly awkward presence by emphasizing her large eyes, abstracting and shadowing her nose, and drawing her mouth slightly askew.[69] Other young women Elaine painted included Connie Fox's daughter, Megan Boyd; Patia Rosenberg, daughter of Harold Rosenberg and May Tabak; and Denise Lassaw, daughter of Ernestine and Ibram.

Megan, who posed outside the studio in 1983 with an autumnal backdrop of trees, has a wide-eyed, vulnerable look under a furry hat reminiscent of Lara's in the film *Doctor Zhivago* (plate 27). Elaine said that Megan was "like the queen of this forest...I think you would know she's a poet."[70] Connie recalled that because the light was fading, Elaine announced that she would devote five minutes apiece to each facial feature (eye, eye, nose, mouth), and completed the painting in the next twenty minutes. (Years later, Megan watched Elaine paint a portrait of her husband, Scott: building up the volume of his face and then—leaning her painting arm on the other one to steady it—very precisely creating the pupils of his eyes. In a final touch, she added swipes of the brush to render the brown-leafed oak trees in the background a bit more abstractly.)

Elaine's 1967 portrait of Patia presents the young woman in a strikingly serene pose, with fingers interlaced over a book in her lap and unblinking eyes in a self-contained, almost statue-like face. Decades later, Patia recalled that despite the turmoil she felt at the time, Elaine "found the order and peace that were hiding in my innermost soul."[71] Yet the dark shadows on her face subtly reveal the disquiet within.

Denise was in her late twenties, unhappy in her marriage, when Elaine painted her as a large-featured, stubborn-looking young woman in a headscarf and a vividly colored blouse. To Denise, her godmother had always been a beloved mischief-maker who offered liberating off-the-wall advice. As a teenager, Denise had dreamed of running away to Tangiers. Elaine subscribed to a weekly paper of shipping news, updating her goddaughter on vessels leaving for her destination. "She made it so easy," Denise joked, "that I never left."[72] Once, when Elaine confessed that she was broke (the cash she had on hand wasn't enough to pay the bills), and Denise was about to go on a trip,

Elaine gave her one hundred dollars. She said, "[W]hen you're down to your last [dollar], you should…empty your purse; then more will come to fill it up."[73] Denise also recalled Elaine's belief that "it was important to spontaneously celebrate any event of great beauty or opportunity for fun." (When Megan and Scott had their first child, Elaine whirled the baby in an impromptu dance that became part of cherished family lore.)

Bernice Sobel, who was in her late thirties when Elaine painted her in 1967, was a different sort of sitter. A soprano who sang with several regional opera companies and orchestras before settling into a career as a TWA stewardess in 1972, she had graduated from the Academy of Vocal Arts in Philadelphia in 1961.[74] Elaine's larger portrait shows her rather unflatteringly, with one eyebrow higher than the other, giving her a squinting look. She reclines on a sofa, swathed in an untidy heap of green evening dress. (As alert to the metaphoric possibilities of women's clothes as she was to the structure of men's suits, Elaine remarked to an interviewer that she viewed one of her female sitters "like the landscape, lying on the couch in a green dress."[75]) In the other painting, Sobel's peaked eyebrows lend her face a spunky quality, and she is seen in close-up—just her face, one partially painted outspread arm, and her décolletage. Although Sobel told an interviewer years later that her favorite role was Mimi in *La Bohème*, based on these portraits you could more easily picture her as Tosca or Minnie in *La Fanciulla del West*.[76]

WHILE TEMPERAMENTALLY DRIVEN to paint a single theme—gyroscope men, tall men, faceless men, bullfight imagery, a statue in the Jardin de Luxembourg—for months and years at a time, Elaine worked quickly on each canvas. What she sought in all her work was a gestural quality, the visible traces of brushstrokes that she found in the work of Rubens, El Greco, Rembrandt—and Bill, her touchstone in all matters artistic. The brushstrokes were her way of creating "some kind of little explosion or action or activity" on the canvas.[77]

Observers have criticized Elaine's quickly brushed portraits on the grounds that they appear to lack psychological insight, compared to the work of artists who focus minutely on facial expression as a window to the sitter's psyche. But Elaine was not interested in producing that type of portraiture. We have to remember her trust in the "glimpse," a word Bill liked to use to explain his translation of the visible world to the canvas. For Elaine, the glimpse was a gestalt—an overall impression, not a collection of individual attributes. She was also constantly weighing her intuitive perception of her sitters' inner selves against her desire—as someone who wanted to see the best in people—

to present them in a favorable light. The intimate specificity of the painter–sitter relationship led Elaine to compare portrait painting to falling in love: "Your beauty becomes your uniqueness."[78] Her brother Conrad wrote that her portraits demonstrated "the beauty of individuality."[79] Yet Elaine also revealed the personality-shaping forces of turmoil and discontent.

Dord Fitz, an artist, teacher, and art dealer in Amarillo, Texas, who became a good friend of hers (see chapter 5), wrote that in Elaine's portraits, "the image of the person's character is ... open for scrutiny and discovery by the beholder." As a family man with a dark secret—in 1951, he was arrested on a "morals charge" and fired from his position at the University of Kentucky because of a gay encounter[80]—he may have had some trepidation about just what Elaine's portrait of him would reveal. Reproduced on the cover of a 2008 exhibition catalogue about his influence,[81] her *Portrait of Dord Fitz*[82] obscures his eyes and mouth, perhaps alluding to his own masked self—the side of him that was closed off from public view. Fitz believed in paranormal phenomena and was convinced that he had extrasensory perception, so Elaine also may have wanted to convey his communion with the spirit world.

Elaine in her East Hampton studio with portrait of her nephew Jempy, 1982.
Photo: Gerald McCarthy. From his documentary, *Elaine de Kooning: A Portrait*, 1982.

BEST KNOWN IN the work of Old Master painters (Rembrandt van Rijn's *Syndics of the Drapers' Guild*; Francisco Goya's *Charles IV of Spain and His Family*), group portraits involve unique challenges. How do you arrange your sitters so that they relate plausibly to one another without allowing any one person to hog the spotlight? How do you create a balanced yet lively composition with so many separate points of interest? Elaine's most challenging portrait was the seven-foot-high, nearly fourteen-foot-long *Burghers of Amsterdam Avenue* (1963, plate 22), which presents nine young men standing or sitting in an undefined space splashed with gestural sweeps and drips of color. Most of the men were members of an art class taught by Elaine's friend Sherman Drexler at an experimental treatment center at Riverside Hospital for youths with drug addiction and psychological problems. Elaine asked the students to pose for her when she visited the hospital, on North Brother Island in the East River.[83]

She already knew two of the other men in the portrait—Eddie Johnson and Robert Corless, who worked as assistants for Elaine and other artists. Twenty-four-year-old Robert Corless had been exhibiting his work in gallery group shows, but he struggled with drug addiction.[84] (Elaine later described him as dying heroically after running into a burning building to save a baby; in fact, he died a junkie's death in a flophouse.) She told her friend Margaret Randall that she had "terrible fights" with Corless because he stole jewelry from her. Yet she held an unshakable belief in encouraging human potential. When Randall needed a babysitter, Elaine told her that if she trusted him with her "dearest possession," it would "give him a sense of self-worth."[85] Randall bravely agreed, and Corless turned out to be an ideal sitter.

In 1961, Elaine painted the two young men in casual poses—Johnson in a striped vest, Corless in a dark jacket—as *The Loft Dwellers*. Their faces are softly blurred except for their bright eyes. The picture was included in Elaine's Roland de Aenlle Gallery show that year, convincing Fairfield Porter that "these young men look exactly the way she has abstracted them, so strong is the impact." He praised both the "inspired looseness" of the contours of the figures (the "abstracted" aspect) and the "inspired specificity" of the shapes of their heads and bodies.[86] Coming from an artist who grappled with the same issues in his own work, this was high praise.

The men in *The Burghers* have wary or impassive faces. Two of them slouch on a packing crate; most of the five others sit with legs tucked up or crossed, on loosely rendered seats. The two standing figures may have been added separately. One sends a mixed message of cockiness (thumb hooked in his jeans) and tension (tightly crossed legs); the other (who has been identified as

Corless) stares straight ahead, his arms plastered to his sides. In front, at the center of the composition, sits twenty-four-year-old poet Frank Lima. Drexler knew him from the art class he taught for young addicts (Lima had asked to be excused from having to paint). The artist "urged him to 'write like you talk'" and introduced him to poets Frank O'Hara and Kenneth Koch.[87] When Lima married, Elaine would host the reception at the Fried family farm. (She also hosted Corless's wedding, at her loft.)

The title of the painting hints at the Dutch painting tradition by leaning on the Dutch origin of "Amsterdam Avenue." At the same time, the word *burghers*—meaning citizens, typically members of the bourgeoisie—lends the men gravitas. Auguste Rodin's bronze sculpture group, *The Burghers of Calais* (1884–1895) has been suggested as another reference point. But those six figures were truly burghers—leading citizens of the French city during the Hundred Years' War—who were corralled, with a rope around their necks, and brought before the English king (Edward III) to be beheaded. The only relevance to Elaine's painting is that at a time when large-scale figure sculpture normally celebrated a political leader or other luminary, Rodin created a monument to people who were not individually renowned by birth or achievement.

Elaine regarded *The Burghers of Amsterdam Avenue* as a political act, using a monumentalizing format to call attention to a class of young people whose lives were invisible to gallery goers. "I wanted the paint to sweep through as feelings sweep through," she said.[88] The early sixties were a period of increased attention to the city's growing numbers of youthful narcotics users, including a call for chemical substitutes for heroin. (Methadone, introduced to the United States in 1947, was first systematically studied as a therapy in the early sixties, when drug addiction was beginning to be treated as a disorder rather than a character flaw.)[89] A 1959 report[90] had noted that even youngsters living in Harlem slums who were "more sensitive, more persuasive with words, more intelligent than their friends" became addicts. Indeed, as we've seen, at least two of the men in the painting were in the process of finding their artistic footing. Elaine succeeded in creating a soberly confrontational portrait that burns itself into a viewer's consciousness by virtue of its sheer size and the accusatory force of staring eyes.

The Burghers was shown in spring 1963 at the Graham Gallery in New York with other portraits by Elaine.[91] The unusual subject produced a flurry of reviews in the popular press. *Newsweek*'s anonymous art writer—probably Jack Kroll, a friend of Elaine's who had begun working at the magazine that year—called it "a salvo from the quiet ones" and pointed out the ethnic

backgrounds of the sitters ("Irish, Puerto Rican, Negro"). The painting, he wrote, was the heir to the social realism of the 1930s. Lauding her ability to capture "the casual 'throwaway' ceremony of the modern face," he called her style neither realism nor abstraction, but "pure apprehension plus intelligence."[92] *Time* magazine's reviewer, who filled out his cautiously positive review with quotes from Elaine, saluted her portraits as "instant summaries" of individuals and tacitly praised her artistic independence, noting that she painted "only people who interest her."[93]

The *Herald Tribune* reviewer took a different tack, comparing her portraits to the bravura styles of nineteenth-century society painters John Singer Sargent and Giovanni Boldini. Elaine—who rejected such resemblances—was said to share their "extreme facility [and] complete self-assurance."[94] In the *New York Times*, chief critic John Canaday was too busy raging at what he saw as Elaine's utter ineptitude to bother mentioning the titles of her paintings.[95] Decades later, Hilton Kramer, who guardedly admired Elaine's portraits, dismissed *The Burghers* as "a cataract of painterly gestures," a social document lacking the personal connection that marked her portraits of friends.[96] It may not have occurred to him that Elaine's friends came from many walks of life.

It was one thing to paint a group of disaffected young men; another to corral a group of restless children long enough to capture their likeness. A woman in Pittsburgh asked Elaine if she could paint a group portrait of six children. She said it would be impossible, but she would try. "I came down into the playroom and they were all sitting on the floor," Elaine recalled "I said, 'Sit that way; don't move.'" The five-by-ten-foot canvas took her four weekends to complete. She described the experience as "send[ing] an artist to purgatory."[97]

ALADAR MARBERGER, WHOM Elaine described as "one of my most vivid students,"[98] was one of the young people whom she had urged to move to New York after graduation. After briefly serving as assistant dean of the New York Studio School, he was in his mid-twenties in the early 1970s when Marilyn Fischbach hired him to direct her gallery. (A fellow student later described him as "sharp, ambitious" and acting much older than his years.[99] In poet James Schuyler's view, Marberger "obviously doesn't care what one thinks of him, providing one *is* thinking about him, as exclusively as possible."[100])

Marberger shifted the Fischbach Gallery's focus from abstract art to contemporary realism; Elaine was one of the artists he represented. In 1986, when she made five portraits of him (two in charcoal, three in oil paint), he had

known for a year that he was under a death sentence: he had Kaposi sarcoma, the skin lesions that indicate an HIV infection. AIDS had been clinically observed only five years earlier, and it was still a little-known disease. In a video made by Muriel Wiener, Elaine—with cigarette in hand—is shown talking about her portraits of Marberger, in which he sits bolt upright in a throne-like chair.[101] Behind him is the sliding glass door leading to her deck, with a view of the vast, wooded W. R. Grace Estate[102] next door (plate 31). Elaine had become highly conscious of the role of light—preferably natural light—in her portraits. Using a foliage background created "a kind of nervous light that goes through everything," she said[103]—a quality she had incorporated in her *Bacchus* paintings. In her eccentric view, landscape was a mutable element of a portrait: "different people affect the landscape in different ways."

For the Marberger portrait, she chose a spot where light from both sides created "a line down the center of his face," especially visible in her charcoal sketch, *Aladar Marberger, Aladar #1*. (He sits in the same pose for all five portraits, which was her preferred approach. "Different things happen," she once said, when a painter employs "the exact same structure, over and over."[104]) She began with his black trousers, blue socks, and other details, and "suddenly his face was there... an image that... crystalized itself." This was the mysterious fatefulness she often invoked when speaking of her work. She claimed that she felt as if another power were guiding her brushstrokes, "and then afterward you see what you've done."[105] While the leafy surroundings—including plants that improbably trail beside Marberger—give the painted portraits a bright and airy atmosphere, his long, thin, staring face appears frighteningly intense. Yet in the video, Elaine declared that she was painting "Aladar before he had AIDS—a pure memory portrait, not what I was looking at." In another interview, she enlarged on this theme: "When we're looking at another human being, we don't just see what we're seeing; we see them through memory."[106] Critic Lawrence Campbell described what he saw as her ability to incorporate memories of a person "walking, standing, scratching, yawning, thinking, sitting... summed up into a pose."[107]

Painter Gandy Brodie was another strong personality in Elaine's painting gallery. At his memorial, she said, "His way of thinking affected my way of painting.... Even Gandy's clothes seemed to have opinions—his jacket, the blue hat he was wearing" in her 1973 portrait.[108] Writing about how Elaine's sitters expressed their individuality, poet Bill Berkson singled out Brodie's "isometrically flexing fingers."[109] Elaine deftly created that sense of locked-in movement with a zigzagging yellow brushstroke that runs along one thigh and outlines the joined fingers of his hands.

In her 1973 portrait of the painter Robert De Niro (father of the actor[110]), he looks down at something we can't see, an unsettling focus that gives him a troubled air. Normally, Elaine never let her portrait subjects do anything but sit still. But, as she later explained, De Niro was so restless that she parked a TV in front of him, and he was irritated by the program.[111] This strategy allowed her to reveal his unguarded, melancholy self. Because he was a fellow artist, she was also engaged in an artistic dialogue with him, using rags to apply paint and frequently wiping it off, as he did in his own paintings.

Although they were painted in the same year (1978), Elaine saw her two portraits of painter Jim Touchton, a student of hers at the University of Georgia, as radically different: an "innocent" image and a "brutal" image, even though both showed "exactly the same features."[112] Each one involved ten sittings. Touchton, who posed on a table in the studio they shared at the university, remembers how she would constantly wipe his face off and repaint it. "It was an emotional time for her," he said, "because she was flying back and forth from Athens [Georgia] and dealing with Bill."[113] (He was in the midst of the alcoholic benders from which Elaine would ultimately rescue him; see chapter 10.)

ELAINE'S MOST FAMOUS SITTER, apart from President Kennedy, was the Brazilian football[114] star Pelé (Edson Arantes do Nascimento), who arrived at the house in a Cadillac with his girlfriend and Portuguese-speaking entourage in early September 1982, and posed for two portraits. The sitting was arranged through Elaine's new friend, communications mogul Steven J. Ross, who had co-founded the New York Cosmos team in 1971; Pelé was one of its imported superstars. Elaine liked to have people around when she painted a portrait; their conversations kept the sitter looking animated.[115] So she told Pelé that it was fine if his friends chatted, but she needed him to remain silent. (Elaine knew from personal experience how boring it was to sit still. To amuse herself at a sitting, she would study the painter's finished pictures, imagining how she would improve them.[116] Among the artists who painted or drew her portrait were Fairfield Porter [plate 14], Alex Katz [plate 23], and Wolf Kahn [plate 24].)

The forty-one-year-old retired athlete spoke little English, according to Elaine's assistant. But at the beginning of the first four-hour sitting—with Pelé perched on a bar stool—he was sufficiently fluent to answer her teasing greeting about having come all the way from Brazil (he was then living nearby in Three Mile Harbor) and to express his pleasure at being painted by her. The six-foot-high canvas was only the second portrait she had ever painted in

acrylic, which suited her fast brush because it dried quickly.[117] To the assembled media—which included a local writer and a *Paris Match* photographer—Elaine made one of her odd color-related statements: "Black [skin] is not black…[but] actually orange, more or less."[118]

When Pelé returned to pose for a portrait in oil paint, "he sat absolutely immobile," Elaine said later, noting that this was a skill only a trained athlete or dancer possessed.[119] She painted out his Omega watch because, she said, it was "too distracting" and "looked too much like a commercial." Showing the assembled throng the day's results, she said that she would listen to comments and "consider" suggested changes—apparently breaking her no-alterations rule. (Normally, if a sitter was displeased with a commission, she would paint another one rather than make corrections.[120]) Pelé said he was not happy with the eyebrows and lashes; Elaine, agreeing that they were both too heavy, reworked them slightly.

In this painting,[121] the garden's rain-washed landscaping fancifully invades even the step of the deck Pelé is sitting on, covered in squiggles of bright green. Elaine explained that "in the treatment of the foliage, I wanted to get the quality of Pelé as a human being. He's a very spontaneous person."[122] Yet, at first glance, the portrait seems mute, revealing nothing in particular about the impassive-looking man in the gray suede tracksuit other than his casual pose with hands dangling between his legs. But that pose—which Elaine said she conceived even before she met him—is the key. An early reviewer of Elaine's portraits wrote that they represent "a bold synthesis of the abstract expressionist excitement and the simplicity of gesture peculiar to her subjects.…Vanity is shown the way the body is held, carried, hidden, denied."[123] Pelé sits with the casual grace of the athlete he had been, yet his dangling hands suggest his current status as a man of leisure, living off the fruits of a great career.

IN 1962, ELAINE was one of seventy-four artists selected by Alfred Barr Jr. for Recent Painting U.S.A.: The Figure, at the Museum of Modern Art.[124] When the show opened, art writer Irving Sandler took the opportunity to ask her about the current status of portraiture. Elaine disparaged most of it as "the mediocre art of officialdom." Yet, citing artists with styles as disparate as Modigliani, Neel, Porter, Rivers, and Katz, she prophesized that "the revival is at hand."[125]

Years later, when Elaine painted an intense-looking Katz, she found that "the structure of his jacket and the structure of his face—they all seemed of a piece to me." He told her, "You made me look urban"[126] (plate 25). In a similar

vein, a reviewer wrote that the gray crosshatching in Elaine's lithograph of poet John Ashbery—her contribution to a deluxe edition of his award-winning book, *Self-Portrait in a Convex Mirror*—seemed to be connected to his "concern with the fluid borders of persons and their environments."[127] Poet and essayist Charles North has written that although Elaine had been criticized for flattering her subjects, she really seems to be deliberately trying "*not* to demythologize" them.[128] This is a provocative thought. Elaine was aware that artists who paint portraits had to contend not only with the way they see a sitter but also with the sitter's self-image. As someone who had to a large extent "mythologized" herself, perhaps she saw the need to allow her sitters to retain some aspect of their self-constructed identity—their private sense of themselves—as a necessary psychological defense.

North's level of thoughtful analysis was largely lacking in reviews of Elaine's later portrait shows. Several years after her death, when the Brooklyn College Art Gallery and Washburn Gallery mounted shows of her portraits,[129] the art world paid scant, even slighting, attention. The *New York Times*'s backhanded verdict was that Elaine's images of artists and writers revealed her "at the height of her limited powers as a painter." Even in this brief review, Elaine's famous husband cast a long shadow: her brushy style in the 1956 portrait of Hess was viewed as "a response" to Bill's *Woman* paintings and, irrelevantly, as evocative of his *Clam Digger* paintings from the following decade.[130] In a review of the Washburn show,[131] Lawrence Campbell—who had written an enthusiastic piece about Elaine's portraits three decades earlier—observed, oddly, that her paintings looked as if "she searched for souls" that she could "fit into bodies."

A major exhibition at the National Portrait Gallery in 2015 brought the portraits back into focus. Elaine was praised as a "minor master" of "considerable talent and originality"[132] and as an artist whose style is "as much about the rhythms and processes of human recognition as it is about the diverse characters who were her subjects."[133]

ELAINE'S MOST-PAINTED SUBJECT was fellow artist Aristodemos Kaldis.[134] After his death in 1979, she estimated that she had done forty portraits of him, beginning in the early fifties.[135] Producing multiple images of the same person appealed to her "because, while I'm looking at a person and seeing one aspect, I also see them in other aspects."[136] She liked to work on several of these portraits at the same time, "to get a dialogue going," as she did most memorably with her paintings of John F. Kennedy (see chapter 9). Kaldis had a huge nose with a prominent wart, which suited her preference for faces that have some

"exaggerated" features, "something you can grab onto." (She likened him to Rodin's sculpture of Balzac.) In her view, "the ideal subject for a portrait would be the ideal subject for a caricature."[137] He fit the bill, as a shambling figure with long, uncombed hair, a rumpled jacket, and an ever-present long red scarf. Hilton Kramer described him as "large, noisy, histrionic, outrageous and irrepressible."[138]

In a memorable phrase, Elaine said that Kaldis "swooped through the art world like a festive zipper, bringing strangers, friends and enemies together"[139] so that he could regale them with his pronouncements on subjects ranging from art history to etymology and politics. Comparing painting his portrait to "painting an unmade bed,"[140] she liked the way his clothing constituted "a kind of self-image that's very powerful."[141] She sometimes chose to paint Kaldis in the chaotic environment of his studio, "with clothes and canvases on top of one another"[142] (plate 26). Always hard up and plagued with diabetes in his later years, he was discharged from a hospital at one point with nowhere to live. In a characteristic gesture, Elaine allowed him to sleep for a few days on a sofa in her loft. Days stretched into weeks, and finally Elaine told the famously long-winded artist that he would have to be silent if he expected to stay. The next day, when he greeted her with a "good morning," Elaine couldn't resist saying, "There you go again!"[143]

Kaldis once brought artist Irving Marantz[144] to Elaine's studio and demanded that she paint his portrait. There was nothing about the man's face that particularly interested her, but she was fond of Kaldis, so she agreed. Marantz sat down in front of a vase of tulips, visible behind his head in the picture. Although flowers are traditionally "feminine" accessories, Elaine saw them simply as abstract visual elements. As she worked on her canvas, she felt that "every stroke just fell into place, and it became a very interesting portrait." Those tulips may have been the catalyst. Around the same time, Elaine painted the superintendent of her building, who used to drop by her studio. She liked his "very contained way of holding himself" and the way "his whole personality is expressed in the folds of his clothing and the silhouette of his head."[145] In this portrait, she said, the flower in a pot behind the superintendent contained "all of the action of the painting."[146] It's intriguing that she believed she could create a painted world in which a potted plant conveyed more energy than her sitter.

9

Painting the President

LIKE MOST AMERICANS, Elaine had previously seen President Kennedy only in black and white—in newspaper photos and on TV. Now she was commissioned to paint his portrait. From her first glimpse of Kennedy— emerging in the late-morning sun at his family's Palm Beach estate—she was star-struck. Wearing an open-collared sports shirt,[1] white slacks, and sneakers, he appeared to her as a kind of god, "incandescent, golden."[2] His six-foot stature somehow seemed larger than life; it was as if he existed "in a different dimension."[3]

Kennedy and his family were spending the holiday season at this Florida property, known as the Winter White House. With eleven bedrooms, twelve baths, a swimming pool, a tennis court, and a carpet of immaculately manicured lawn fronting the ocean, the estate was a sybaritic refuge from the real White House, although the world's problems were never far away.

On December 28, 1962,[4] the first day of the sittings, Kennedy sat with one foot up, exposing his crotch, and flirted with Elaine. "Is this pose all right?" he teased. She felt obligated to remind him of the reason for her assignment, but he just smiled and didn't budge. "I determined to grab whatever I could," she said later. "If he sits this way, this is the way he sits!"[5] Kennedy was a veteran of many sexual encounters, a compulsive habit that continued after his marriage. But this seduction was purely visual, conducted via smiles and body language. The dowdy jumper and blouse Elaine wears in photographs of the sittings suggest that she was intent on blending into the background.

She drew the president in pen and ink, pencil, and charcoal (a medium that allowed her to sketch with the greatest speed). "When he changed position, I'd switch drawings," she told an interviewer. "I kept jumping back and forth."[6] Knowing that "getting a likeness means being ready to pounce upon accidents,"[7] she realized that she would need to memorize his gestures and expressions, because they changed so rapidly. She became familiar with the duality of "the built-in frown and the compassionate eye,"[8] as well as "the sharp, appraising glance."[9] Allotted a temporary studio, Elaine worked there during

the afternoons and into the night, trying to sort through details she had captured in person. She drew Kennedy seated and standing, and made studies of his head from different angles and in varied lighting.

Three days later, she returned to the estate for the second sitting. Ushered into a room adjacent to the patio, she had just finished organizing her art materials on a table when Pierre Salinger, the president's burly press secretary, rushed in. He eyed her setup with distaste. "What's all this?" he asked. When she explained, he told her to whisk it away and hide in the shrubbery with it.[10] His peculiar request made more sense a few moments later, when Kennedy appeared and a pack of reporters began thronging around him for the 10 A.M. press conference.

IN AN ARRANGEMENT that Elaine said she never fully understood, her dealer Robert Graham—who had been a prep school classmate of Kennedy's brother Joseph Jr.—had offered to donate a portrait of the president by Elaine to the Harry S. Truman Library, in Independence, Missouri, the former president's hometown.[11] In October, Graham had visited Truman in Kansas City and toured the library with him and their mutual friends, painter Thomas Hart Benton and his wife, Rita. (Benton had met his fellow Missourian in 1960 while working on a mural commission for the library.[12]). On this trip, Graham learned that the former president admired Kennedy and wanted his portrait to hang there.[13] Benton unsuccessfully angled for a friend of his, an Oklahoma artist[14] who had recently painted his portrait. Ultimately, the choice of a painter was left up to Graham, pending approval from Truman and the library.[15] David Lloyd, administrative assistant to Truman, mentioned to Philip C. Brooks, the library's executive director, that Graham's wife had money, so he would surely be able to donate the painting. Although Rita Benton worried that the dealer likely had "some young artist he's promoting, who might not really be first class," Lloyd and Benton had agreed that Graham would be unlikely to take that risk.[16]

During a visit to the Graham Gallery, Lloyd learned that Elaine was the painter Graham had in mind. After viewing a few examples of her work, he declared her to be "a competent draftsman and painter," Kennedy had already approved the commission, apparently because Elaine was said to be "a rapid worker."[17] On December 10, Lloyd wrote to Graham to assure him that Truman was "delighted" with the plan. If he liked the portrait, it would be hung in a prominent area of the library.[18] Graham told Brooks that Elaine was preparing to sketch the president in Palm Beach "for a period of three to five days."[19]

In mid-December, as Elaine wrote to a friend, the commission "dropped into my astonished lap"[20] when she was visited by LeMoyne Billings, Kennedy's prep school roommate and lifelong friend.[21] Elaine usually mentioned to interviewers that the White House emissary had brought with him the scathing review by *New York Times* critic John Canaday of her Graham Gallery show of six-foot-tall portraits of standing men.[22] Canaday was no friend of Abstract Expressionism, always quick with a putdown. In his review, the critic compared her output to that of a more conventional painter, Lennart Anderson (also showing at the gallery), and declared Anderson the better artist.[23] Elaine's "so-called figures are empty sacks of clothing surmounted by faces," the critic wrote. As a portrait painter, she had traded the "esoteric banality" of abstraction for "simple ineptitude."[24]

According to Elaine, Billings pointed to the reproduction of one of Elaine's portraits alongside the review and said, "We'd like you to do a portrait of President Kennedy in this style. Can you go down to Palm Beach next month?"[25] It's a good story, but Canaday's wounding remarks were published on Sunday, April 28, 1963, nearly four months after Elaine had left Palm Beach. Why she persisted in linking the review and the commission is a mystery, perhaps her way of pointing out how little damage this devastating review had done to her psyche. (Or maybe she was thinking of Canaday's 1961 review of the Whitney Annual, in which he had inserted another putdown: "While de Kooning shows how good Abstract Expressionism can be in the right hands, Mrs. de Kooning [demonstrates] how bad it can be in the wrong ones."[26])

In any case, buoyant self-confidence would color her account of the two columns Canaday devoted to her work in 1963: he had evidently thought her sufficiently important as an artist to be the recipient of so much of his venom. "I felt that I'm on the right track," she told one interviewer. "If a critic whose opinion I do not respect praises me, I would get very worried."[27] Canaday may have been paying her back for helping undermine his rave review of the Controversial Century exhibition in Provincetown the previous year, the show that was stocked with fakes.[28] Decades later, Elaine recalled that when the review of the Graham show was published, a friend asked if Canaday were an old boyfriend. "That's not the way my old boyfriends talk," she retorted.[29] Other friends "called up to congratulate me and said they read it with a ruler," she said. "They were impressed by the length of the attack."[30]

ELAINE'S FREELY BRUSHED STYLE must have seemed an ideal way to reflect the essence of The New Frontier—the forward-looking, aspirational leitmotif of Kennedy's presidency. In a practical sense, her reputation for rapidly

completing a portrait made her the ideal artist to paint a famously restless head of state. Normally, with someone new to her, she would request two or three preliminary sittings to gain a feel for the person and decide on a pose before the final two-hour painting session.[31] Because she had to fit herself into stray moments in Kennedy's busy schedule, she estimated that the entire process would take about two weeks.

Elaine hadn't reckoned on the fact that, unlike people she had painted before, who were capable of sitting fairly still, Kennedy was constantly in motion—reading newspapers or briefing papers, speaking on the phone, jotting notes. In an effort to ease his constant back pain, he was always changing the position of his legs as he worked and shifting from side to side in his chair. His restlessness "drove me insane," she confided to one interviewer.[32] Yet on some level, she also empathized; restlessness was her driving force, too.

She was not the only portraitist flummoxed by a restive U.S. president. When John Singer Sargent came to the White House in February 1903 to paint forty-four-year-old Theodore Roosevelt, he discovered that his famously energetic subject had no taste for sitting. Roosevelt's best pose came as he grumpily headed upstairs after Sargent rejected potential ground-floor locations. With one hand on the newel post at the landing, the President swung around to confront the painter. This pose, capturing Roosevelt's pugnacious vigor, was perfect. But he constantly turned away to issue orders during the half-hour sittings, and he was usually surrounded by people, including his young children. Unable to concentrate fully on the president's face, Sargent was not happy with the portrait. Years later, in a letter to a friend, he wrote that he "felt like a rabbit in the presence of a boa constrictor."[33]

ELAINE HAD WATCHED Russian high-jumper Valery Brumel defeat his American rival John Thomas at Madison Square Garden in 1961. Now, she compared Kennedy to Brumel, "who seemed to vibrate with energy, ready to spring."[34] According to a longtime family intimate, this quality permeated the entire Kennedy clan. "They were...mentally restless, physically restless— never sat anywhere for long." Kennedy also possessed what this observer called an "exploring mind," unusually open to new ideas, however extreme.[35] These traits may have contributed to Elaine's feeling of awed kinship with the president.

Another thing she worried about was the casualness of his outfit and his pose. Although she "adored" his off-duty style,[36] she was certain that the Truman Library wanted him to be memorialized in more statesman-like attire. Still, how could she argue with the president?

Elaine drew Kennedy in many positions, sometimes squinting into the sun, sometimes inscrutable in dark glasses. (He had asked her if they bothered her, and she replied, "The eyes are the key to a portrait." But he kept his sunglasses on.[37]) In the beginning, she focused on details: his eyes, his hair, his characteristic gestures. Puzzled at why her first attempts at painting him looked too stern, she realized that she hadn't paid enough attention to his unusual eyes. The violet color of his large irises was so vivid that it seemed to infuse the whites with a faint blue haze, an effect amplified by his overhanging brow bone.[38] As she worked, she noticed his "extraordinary variety of expressions," heightened by sunlight on the patio where he often sat.[39] Even the volume of his face seemed to change—"thin, almost boyish" on one day, inexplicably broader on another.[40]

Members of the president's cabinet and other officials had convened at the estate after Christmas to discuss the defense budget, foreign aid, and other pressing matters. Income tax reduction and other domestic issues were at stake as well; Medicare, then considered a radical program, had met with crushing defeat in Congress months earlier.

A few days before Elaine arrived in Palm Beach, Kennedy and British ambassador David Ormsby-Gore were sitting near the pool, discussing the fragile state of relations with the U.K., when the phone rang. The president suddenly veered from civilized conversation to loudly curse the caller—the deputy secretary of defense, who announced that the costly and unreliable Skybolt ballistic missile had been successfully fired. Kennedy intended to cancel this project, which had prompted fraught conversations with the British prime minister at a meeting in the Bahamas a few days earlier.[41] During his blow-up, the president's manicurist kept trimming his nails, and his unflappably devoted press secretary, Evelyn Lincoln, remained poised to take more dictation, as if playing roles in an absurdist drama.

ELAINE BROUGHT CASEIN PAINTS, which dry quickly, to her January 3 session with Kennedy. He wore a dress shirt and tie on this occasion, probably because he was meeting with agriculture secretary Orville Freeman.[42] At one point, Caroline Kennedy wandered in and began sketching on one of Elaine's pads with her pastels. Focused on filling in the sketched areas with color, Elaine was startled when the five-year-old wondered aloud, "How much paint is in these tubes?" She had squeezed out nearly all the cadmium yellow. Caroline also was part of the scene at another sitting. Stationing herself and her easel alongside Elaine, she tried to sketch her father. (Elaine later told an interviewer that she had a collection of "four Caroline Kennedy originals."[43])

As he often did when his children played nearby, Kennedy stopped working for a moment to acknowledge Caroline's presence. He walked over and drew a cat on her pad in crayon.[44]

One day (Elaine remembered it as day 2 of the sittings), Jacqueline Kennedy dropped by on her way to the beach. "It must be awfully hard to draw a man who never sits still," she observed.[45] She returned the following day to see how the work was progressing. As the women kneeled on the floor to shuffle through the sketches, she picked one out. "Oh, I love this one," she said. It was a small casein painting showing Kennedy with his feet propped up on a chair.

Elaine arrived by 9:30 A.M. on January 5, when Kennedy held what she recalled as a meeting about Medicare—a conference with Anthony J. Celebreeze, secretary of the Department of Health, Education, and Welfare (HEW); Wilbur Cohen, HEW undersecretary; and Francis O. Keppel, commissioner of education. Anxious to get a good view of her subject, she spied a metal ladder left behind by workmen and climbed up with her sketchbook. When she needed a new piece of charcoal or a pencil, she would call down ("like a surgeon") to her assistant, former student Eddie Johnson, who had accompanied her to Florida.

Glimpsing Elaine, one of the men stopped in the middle of a sentence, astonished to see a woman perched on the ladder, presumably taking notes.[46] No one explained what she was doing there, and Kennedy—accustomed to ignoring staff people working around him—just flashed his telegenic smile. Elaine admired the way the lines etched at the corners of his mouth and eyes revealed his "quick sense of humor."[47] It was a useful personality trait that enabled him, as one observer remarked, to diffuse the tension in stressful meetings with "a little phrase" that lightened the mood.[48] His warmth was of a special kind, Elaine said later, "a kind of impersonal friendliness for just about everybody."[49]

Exactly how many portrait sittings Kennedy gave Elaine remains a mystery. With typical overstatement, she told one reporter that there were "about ten informal sketching periods…over the space of a month."[50] Considering that Elaine sketched only in the mornings, and that the president—who was out of town or otherwise away from the estate on several mornings—returned to Washington on January 8, even the seven sessions mentioned in a *Life* magazine story seem to be an exaggeration.[51]

At one point—Elaine said it was a week into the project—she made a charcoal sketch of a jacketless Kennedy propped up on one arm of his chair, his habitual way of sitting. She kept it as a touchstone while working on piles of sketches that showed him in other positions. Sometimes, she focused only on his face, trying to capture one of his fleeting expressions. As the days passed,

"he seemed to grow older," Elaine said. She realized that she was beginning to see "the wear and tear of his office"[52] underneath the magnetic glow.

BACK IN HER NEW YORK STUDIO, Elaine worked furiously on several paintings based on her sketch of Kennedy's casual pose on day 1. Years later, she claimed to have worked on the eyes in one portrait for an entire week, spending six hours a day painting, wiping down, and repainting in an effort to capture the image in her mind. A month after her return to New York, when one of Kennedy's representatives came to view her progress, he was unpleasantly surprised. "That's not a presidential pose," he told her. "He'd never allow anyone to see that. Jackie, maybe. But he'd have to keep it in the bedroom."[53] Elaine went back to her charcoal sketch showing him supporting his body on one arm of the chair. Realizing that she would have to paint him wearing a jacket, she made drawings of him in a suit when she saw him on TV and collected photographs of him from newspapers and magazines. She struggled to deal with "the structure of the jacket [and] the sense of color," as well as "the structure of the pose," while also "getting patterns out of shadows and [determining] the shapes of the planes."[54]

Always attracted to the distinctive elements that make it possible to identify a person from a distance, Elaine said she was partial to "tiny shots [of the president] where the features were indistinct yet unmistakable."[55] She was also intrigued by a group of photographs by Kennedy's official photographer, Jacques Lowe, in which he looked anxious—images that he insisted never be published, for that very reason.[56] Portraits she really cared about, she once said, were those "that penetrate, that expose."[57] Now, her mission was not only to capture a likeness but also to convey what it meant to carry the burdens of the chief executive of the United States. She was "determined to convey the experience of a one-to-one contact with Kennedy, to communicate his warmth, sharp wit, appraising glance, and something of the outdoor figure I saw in the brilliant Florida sunshine."[58] It was an almost impossibly ambitious aim.

In February, as she wrote to a friend, "the whole Florida episode was like a fairy tale—or rather, I felt like twelve-year-old Elaine having a far-fetched daydream."[59] At Harold Rosenberg's birthday party that month, people kept asking her about the session with Kennedy. (Back in December, when Rosenberg saw how much equipment she had packed for the journey to what she viewed as an art-supply wilderness, he joked, "You're invading Florida!"[60]) Elaine wrote to a friend that constantly being asked about her experience got so boring that she avoided social events—a rare move for her.[61]

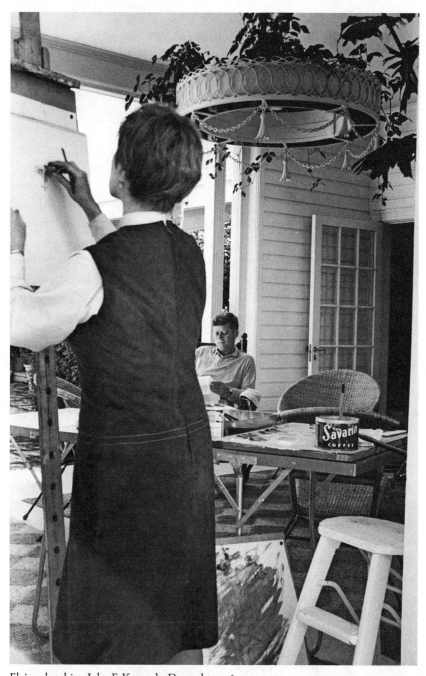

Elaine sketching John F. Kennedy, December 1962.

Photo: Eddie Johnson. James Graham & Sons Gallery Records, Archives of American Art, Smithsonian Institution, Washington. D.C.

As the months went by, assimilating her fragmentary impressions of the president into a single image began to seem almost impossible. Constantly rejecting various poses, she realized what Ingres must have gone through when he painted Louis-François Bertin. The French painter depicted the wealthy sixty-six-year-old art collector, journalist, and political heavyweight in a famous portrait (*Monsieur Bertin*, 1832). He glares out at the viewer, a fierce, bulky personage with unruly gray hair, seated in a chair with his stubby fingers clamped on his thighs. Because the painting looks almost like a photograph, it's hard to believe that Ingres could have pictured him any other way, yet he had a terrible time determining the best pose. Months passed, during which his attempts to portray Bertin constantly fell short. According to one account, Ingres finally decided to copy the way a painter friend of his sat at a café table.[62] Observers have noted that the visible tension in the painting may have stemmed more from Ingres's state of mind than Bertin's normally even-tempered personality.

DURING THE SUMMER of 1963, Elaine began to feel that her paintings of the president had become too rigid. Whenever she thought she was close to capturing the right image, it would "freeze." To rid herself of this block, she took a leaf from Ingres's book by painting friends who had a build similar to Kennedy's and even a "tall policeman"—probably retired heavyweight champion George "Baby Dutch" Culbertson, who had sat for Elaine's charcoal portrait a year earlier. One of these paintings was of Tom Hess, who obligingly posed in Kennedy's typical seated position, "leaning on his left hand with his shoulder twisted forward."[63]

The Kennedy portraits began to clutter her studio. "At one point I had thirty-six canvases going at once, all different stages," she told an interviewer.[64] Toward the end of her life, she mused that the multiple images really *were* the portrait.[65] Suffusing her paintings with orange and yellow tonalities, she sought to evoke what she saw as the orange cast of Kennedy's skin in the Florida sun. Had she had seen him in Washington, D.C., she acknowledged, "the coloring would have been entirely different."[66]

By September, she had painted a portrait that finally captured the spontaneity she had pursued over the past eight months. Yet the painting she still liked best was a different one—an image of the president standing, wearing the casual outfit he wore when she first saw him, and "squinting in the sunlight." Like Bill de Kooning, she believed in the primacy of "the glimpse"—the corner-of-the-eye awareness of a person that distinguishes him from everyone else. This was especially true in painting Kennedy, because she believed

that the portrait should express how he was viewed by the public, who saw him only as he was passing by.[67]

ON JUNE 5, Philip C. Brooks wrote to Elaine to suggest where her portrait might be hung in the Truman Library and to caution her that it would need to fit in with the paintings currently on view there. In addition to portraits of Eisenhower and Truman, this motley collection included Norman Rockwell's *Family Squabble* (a husband and wife arguing about the 1948 presidential election that put Truman in office) and *The Big Three at Potsdam* (a group portrait of Joseph Stalin, Winston Churchill, and Truman negotiating terms for the end of World War II).[68] Elaine's doubts about the setting were confirmed after her visit to the library. "All the other portraits are...sedate, not to say stuffy." she said.[69] Her exuberant over-life-size painting would be distinctly out of place there.

The same day Brooks wrote to Elaine he also wrote to Graham, telling him that Elaine "understands our situation very well"—alluding to the conservative nature of the library's other paintings and of Truman's own taste—and would produce a painting "of real artistic and historical interest."[70] Brooks obviously didn't realize that Elaine's awareness of the library's aesthetic conservatism would not convince her to alter her style.

Jean Kennedy Smith, the president's sister, and William Walton visited her studio in early October. Walton was an urbane journalist-turned-painter close to the Kennedy couple; a Graham Gallery artist, he had given painting lessons to the president. When he saw the staggering array of paintings, sketches, and lithographs covering virtually every inch of available space—including the kitchen and bathroom—Walton "doubled up laughing," Elaine said. He told her that the president would love them, and Smith sounded equally enthusiastic. "Now, if only I could have him sit still for just two hours," Elaine told her visitors, "I think I now could finish the portrait." She said that Smith promised her this could happen "if I have to hold him down myself."[71] (Elaine later claimed that she had gone to Washington, D.C., for one final sitting "just to freshen my image,"[72] but no information has surfaced about this encounter.)

In early November—after Elaine experimented with differently proportioned canvases in increasingly larger sizes—Brooks wrote to Robert Graham to ask if he could "confidentially" let him know whether the painting would be ready in the next couple of months, so that the dedication could be combined with another event.[73] Graham replied on November 20 that Elaine had completed "three acceptable portraits."[74] He wrote that a committee consisting of LeMoyne Billings; Mary Woodward Lasker, an art collector and former gallery

employee; and Jean Kennedy Smith would come to Elaine's studio to choose one or two paintings. They would be sent to the president for his approval.

TWO DAYS AFTER Graham wrote his letter, Kennedy was assassinated in Dallas. Rosalyn Drexler phoned to tell her. Stunned and grief-stricken, Elaine turned on her TV to watch the live coverage. Artist friends joined her, overwhelmed as they entered her studio by the crowded ranks of Kennedy portraits. "We all sat mesmerized by that little box…in a state of shock," Elaine recalled. Men she thought would never cry were in tears.[75] During the days that followed, she did the one thing she could do on autopilot: make charcoal drawings of the images flickering on the tube. "Even after they announced he was dead, I drew and drew," she said. On every drawing, she obsessively wrote "Nov. 22, 1963."

Willem de Kooning, who was watching TV at his home, painted his own image of the deceased president: *Reclining Man (John F. Kennedy)*. Working from memory, he attached a doll-like, boyish head vaguely resembling Kennedy's to a supine body whose contours were lost in ribbons of whitened brown and red paint—the painterly equivalent of the eradication of wholeness, the leaching out of life.[76]

After the assassination, Elaine found herself unable to pick up a paintbrush, unable to add anything to the unfinished canvases arrayed on the walls and floor of her studio. When the *Saturday Evening Post* requested one of the portraits for the magazine's cover, she declined because she couldn't face the idea of making money from this work. Although she continued to entertain guests, her bleak mood cast a pall over her loft parties. Elaine's friend Donald Barthelme was unable to soothe her; he felt that Bill's move to East Hampton several years earlier had left her "unsupported."[77] Robert Mallary—now at the University of California, Davis—had previously invited her for a two-month guest teaching stint that was supposed to start in January 1964. Now she wrote to say that she could not join him. He replied that he couldn't fill in for her; she had to come. Arriving at the campus with her paints, she was unable to open them. "Painting had become completely identified with painting Kennedy. For an entire year, I had painted nothing else."[78]

Mallary suggested that she try sculpture instead. "I wandered into the foundry [at the university] one day when they were pouring bronzes," Elaine recalled. "It was magic." The sculptor in residence explained the lost-wax bronze casting process, which involves heating a wax-filled ceramic mold from the original sculpture to "lose" the wax (it melts out), so that molten metal can be poured into the hollow shell. Elaine said she began to work in "a painterly

way" with the sheets of wax, making what she called "three-dimensional collages" with pieces of wood." The vague image she had in mind of a bird flying became a flying crucifix. Other pieces were bull images. She said that she loved being able to be involved in the entire process, instead of sending the piece to a foundry, as many New York artists were doing in the sixties. The presence of people around her as she worked was also ideal.

But after casting what she intended as an abstract bronze sculpture of Kennedy, she was shocked to see that it looked as though his head had been blasted by gunfire. She melted it down and tried again, this time avoiding any depiction of his face. The resulting piece suggests his characteristic way of hunching his shoulders, "as though he had just turned away"—the final view the world had of him in the Lincoln Continental convertible, when he was still alive. It was, she said, "a figure of grief."[79] Working intuitively, driven (as she later realized) to convey the contradictory qualities of "armor and… someone shattered," Elaine completed fourteen bronzes. "I…felt as though my whole life had been leading toward that sculpture," she said, marveling at how "an obstacle"—her sorrowful inability to paint—had channeled her energy into a type of work she otherwise would never have pursued.[80] She also began to resurface as the fun-loving Elaine her friends knew. When Wayne Thiebaud and his wife Betty Jean ran into her while shopping in Sausalito, she had just bought a pair of eye-catching red boots. "They're very wicked and I love them!" she exclaimed.[81]

THE FATE OF the Truman Library portrait remained uncertain. On November 27, 1963, Philip Brooks, the library's director, wrote to Graham that the "unbelievable events of the past few days" had made the portrait especially important, though he realized there might be a delay in selecting it.[82] Graham responded that LeMoyne Billings and William Walton had looked at the paintings but wanted to leave the final selection to Jacqueline Kennedy. Graham assured Brooks that, although Elaine would be teaching on the West Coast for several months, the portrait would be available "no later than April."[83] But in mid-November of 1964, Elaine told a reporter that Jackie still hadn't seen her paintings, because she could not yet face dealing with anything that reminded her of her late husband.[84]

At the Graham Gallery, the price list of Kennedy works for sale included fifteen of the oil portraits and twenty-three sketches, ranging from $1,500 for a charcoal "head" to $20,000 for a large oil painting. Graham had arranged for several exhibitions of the images. In February 1964, thirty-eight of Elaine's portraits and charcoal sketches of the president—including the four drawings

owned by Jacqueline Kennedy,[85] and works in the collections of Jean Kennedy and Stephen Smith—were shown at the Kansas City Art Institute School of Design.[86] In March, Graham received a check for $25,000 for one of the paintings from William van den Heuvel, a donor to the as-yet unbuilt John F. Kennedy Presidential Library. He wrote that he had conferred with Jackie about showing it while the library was under construction. Three of Elaine's portraits were displayed in the Massachusetts Pavilion at the World's Fair in New York, which opened in April.

A story about the portrait in the May 8, 1964, issue of *Life* magazine included several uncredited photographs of Elaine sketching the president, taken by Eddie Johnson.[87] (Not published in the magazine was his intimate photograph of Elaine kneeling at the water's edge in her sleek bathing suit and gazing at the image of Kennedy's face that she had sculpted in the sand.) In addition to serving as her assistant, Johnson had been a welcome companion. In a letter, Elaine wrote that the two of them "take a break in the middle of the day and go bike riding—the ocean drives here are gorgeous and everything looks so damned prosperous. We've been hunting high and low for the slums and so far have not uncovered them." The "junky art" in local galleries, she noted, "sells for very high prices."[88] Ever the sports fan, Elaine scoped out the town's dog races and the gambling sport of jai alai.[89] She rued that "both of us so unerringly chose losers that we lost all interest...I hate gambling if I don't win and I never do."

The *Life* story also includes a photograph of Elaine's studio by Alfred Eisenstaedt. Images of Kennedy are everywhere, tacked up on a partition, leaning on a wall, and scattered on the floor. Elaine looks up at the nine-foot-high standing portrait she made of him as if it represented some powerful deity (plate 21). In a sense, it did; she had pledged all her energy and ability and insight to his glorification. But there was trouble ahead.

Elaine had written to Evelyn Lincoln in December 1962 to assure her that "if any paintings and sketches are not completely satisfactory to the president, they will be turned over to you."[90] In early April 1965, Lincoln wrote to Elaine, reminding her of her pledge and chiding her for not sending paintings and sketches requested by an "irritated" Jean Kennedy Smith.[91] Six days later, Elaine fired back a letter. She was "amazed" at the tone Lincoln took with her and noted that it was far from clear exactly who was responsible for representing Kennedy's wishes. Vowing that she would view Jackie's word as "an absolute command," she complained that Lincoln failed to mention what the president's widow wanted. Elaine explained that she had "long ago" decided to keep the works Jackie didn't wish to exhibit as references for the other paintings—a

"limited, personal, temporary, and private use." And by the way, what became of the small painting Billings took with him in the summer of 1963?[92]

Graham quickly attempted to smooth Lincoln's ruffled feathers, explaining in a letter copied to Smith and Billings that "the creative mind" has a way of "see[ing] things in a different light from laymen like ourselves." Evidently struggling to find a resonant analogy for Elaine's insistence on having all her Kennedy images around her in the studio, he wrote that banishing these pieces would be like "sending your own children to dark dungeons."[93] (She did keep the nine-foot-tall canvas of Kennedy in his sweatshirt and sailing pants and sneakers. Bill had seen it and urged her to reserve it for herself.)

Meanwhile, the Truman Library had finally chosen one of the portraits. Brooks—who had the tough job of convincing the former president that Elaine's work was not too modern—made sure Truman knew that one of the paintings had been selected for the JFK Library. Benton helped, too, asserting in a backhanded way that "there was really nothing wrong" with Elaine's portrait. (The one he saw—in reproduction, on the cover of the Summer 1964 issue of *ARTnews*—is the version that now hangs in the National Portrait Gallery, in Washington, D.C.)[94] But Elaine was irritated that Graham wanted her to donate her portrait to the Truman Library. In a long letter citing several grievances, she pointed out that she didn't earn enough to make such a tax deduction worthwhile. She was also irate to discover that the $300 she received from the gallery—half of what it paid for the *ARTnews* reproduction—was supposed to constitute payment in full for her Palm Beach expenses. Not only was Elaine "never required to be involved in [a cover art] transaction," but her expenses were "easily $5,000."[95]

By the time of the formal Truman Library presentation on February 12, 1965, these issues apparently had been ironed out. Elaine's speech—leavened with a beguiling deprecation of her painting style: "I'm afraid that [the portrait] may take a bit of getting used to"—emphasized the unique aspects of public portraiture and the overwhelming impact of visual data in the twentieth century.[96] "Much of what we know of people, we know through our eyes," she said. Because Kennedy was the subject of countless photographs, the world discerned "his high intelligence, humor and compassion" based mostly on the way he looked in newspaper photos. When we look at someone, she said, "we take notes in shorthand." That's why we immediately recognize the subject of a skillful caricature. But while "caricature is always irreverent," a portrait "is full of reverence for the uniqueness of the man being portrayed." When the subject

is the president of the United States, likeness isn't enough; the image must also convey "the dignity of the person, the sense of his office."

After relating the saga of her work on the portrait, Elaine explained that her aim was "not to convey a realistic sense of a gray flannel suit worn by a man with a tan—but rather to attempt to communicate the brightness and high color of John F. Kennedy as I saw him." She also sought "to capture his quality of readiness as though he was about to spring from his chair, and to try to get the frown and the smile at once—the sharp, appraising glance." Because Kennedy was constantly in motion, "he slipped past us," she said. "And so, President Truman, I offer you not a portrait of John F. Kennedy, but a glimpse."

Truman was said to have "expressed pleasure" at the painting. Columnist Dorothy Kilgallen was probably closer to the mark; announcing the commission, she added, "Ole Harry really digs calendar art."[97] But he did seem to fall under Elaine's spell at the unveiling: in one of the official photographs that show them standing at either side of the portrait, they seem to be sharing a joke.

Elaine once said that her ideal portrait would never "settle quietly and politely on a wall." Instead, it would be "uneasy, yet exuberant."[98] In the Truman

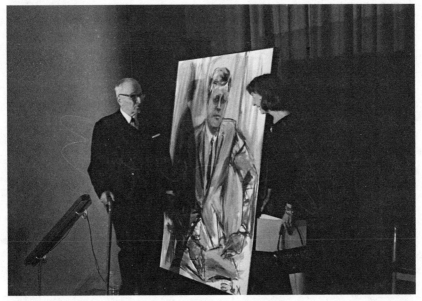

Harry S. Truman and Elaine share a joke at the unveiling of her painting of John F. Kennedy on February 12, 1965 at the Harry S. Truman Library.

Photo: Harry S. Truman Library and Museum, Independence, Missouri.

Library portrait,[99] dark yellow vertical brushstrokes energize the empty space behind the seated president. They invade the grayish white of his jacket and seem to be reflected in the oddly brassy color of his hair and his tanned complexion. (Elaine said later that she used "kind of a gold paint and worked the image into it."[100]) Because its size and vividness would have clashed with the library's other presidential portraits, Elaine's painting was hung in a separate part of the building. Yet this image of Kennedy seems tame compared with the portrait that actually does evoke both unease and exuberance—the one in the collection of the National Portrait Gallery.[101]

Visiting the museum's second-floor galleries, you walk past dignified, traditional images of the thirty-four presidents who preceded Kennedy. And then, you suddenly come face to face with a blaze of light and energy—slashing brushstrokes in bright yellow, blue, and green (plate 20). Kennedy's left hand grasps the arm of his chair awkwardly, his upper arm curiously raised as if he is about to leap up. The pronounced slant of his brow bones is almost a caricature—acute and grave accent marks above the intense blue of his eyes. His legs are crossed. His gaze is serious, yet somehow unrevealing. He is the man Elaine saw and intuited him to be—a man of action, ready to shift course at a moment's notice, who never allowed anyone to penetrate his private self. A man uncannily like herself.

10

Caretaking and Cave Paintings

IN 1969, ELAINE SOLD her Shelter Island house and bought a two-bedroom, two-bath cottage at 14 Sandra Road in The Springs neighborhood of East Hampton, with a loan from Bill,[1] who lived nearby on Woodbine Drive. Bill was now in thrall to alcohol. He would stay away from it for a while and then go on a bender, drinking around the clock, until he was hospitalized. After his release, he would generally manage to remain sober for several months, and then the cycle would repeat. When he was drinking, he wasn't painting. That winter, a visitor to his home was asked to bring a shot of whiskey, which Bill, unshaven and looking poorly, immediately gulped down. During her own visits, Elaine had become increasingly aware of Bill's deteriorating condition. His assistant, also a heavy drinker, had gotten in fights that landed him in the hospital.

She finally decided that the situation required her full-time presence in East Hampton. In late 1975, she bought a modest house on Alewive[2] Brook Road, a five-mile drive from Bill's home along the southern rim of Three Mile Harbor. Moving the contents of both her New York studio—she gave up her loft after a major rent increase—and the Sandra Road house[3] required four twenty-four-foot trucks filled with her paintings, books, bookcases, and other household goods. She joked in a note to a friend that the "huge, dry basement" was the lure: "In short, I bought a basement with nice, brand new house on top."[4] To another acquaintance, she wrote that it was "wonderful to breathe air again."[5] Even the foliage was special, she said—identical to the kind surrounding a statue in the Jardin de Luxembourg in Paris, the inspiration for her new painting series.[6]

The real reason for her move was that Bill had asked her to come back.[7] He realized that he was losing control of his life, surrounded in his studio by alcoholic hangers-on. It's not clear whether Elaine knew that in 1975 Bill had asked his lover Emilie Kilgore to marry him. (He discovered he could divorce Elaine without her agreement because of their long separation.) Kilgore had turned him down.[8]

But Elaine was not anchored year-round to her new home. One summer in the mid-seventies,[9] she taught at the University of Georgia Studies Abroad Program in Cortona, Italy. Traveling north to Florence, she marveled at the way it had "kept hold of the past," so that "you feel [the presence of] Michelangelo, and Raphael, and Galileo."[10] She even loved the touristic Leaning Tower of Pisa, delighting in its "incredibly beautiful" proportions. Elaine would return to Italy in the mid-1980s to explore the Amalfi coast with her sister Marjorie. Enchanted by Ravello and the neighboring villages, she drew precisely delineated hill towns in pen-and-ink, reminiscent of her New York cityscapes. Her watercolors—some made on the spot, others based on memories recharged in the studio—ranged from recognizable views to abstracted images of color and light, sometimes intercut with collaged paper.

In July 1977, Elaine and her brother Conrad traveled to Paris, with plans to move on to Italy, Holland, and Belgium "for some museum hopping" in August.[11] Her fifth-floor studio had a view of the just-completed Centre Pompidou; when she visited, the exposed pipes and "claustrophobic" feel made her think of life in a submarine. An evening of ballets by Balanchine and Béjart at the Opéra elicited a favorable review in a letter to Tom Hess, especially for the "most expensive seats" in an enclosed balcony outfitted with a "discrete little couch"—an oh-so-French touch for lovers that Elaine adored. She gave a thumbs-down on shows of contemporary French art and paintings by Robert Motherwell—who, she reported, claimed in an interview to be "the only survivor of the Abstract Expressionist movement."

That fall, Elaine joked to John Cage that because she was going back and forth every week between her Mellon Chair at Cooper Union in New York and her Lamar Dodd Chair at the University of Georgia, she "never ha[d] time to sit down."[12] Less than a year later, in May 1978, she gave up her position at the university, unswayed by the offer of a $5,000 raise and tenure—which she characteristically saw as "a trap." (Elaine had been earning an annual salary of $40,000, the equivalent of about $145,000 today, while spending just two days a week in Athens, Georgia.) According to Conrad, she was irritated that Philip Guston had been offered $2,000 for a single lecture,[13] but this hardly can have been her real motivation.

It seems more likely that Elaine's decision was due to Bill's ill health—he was still drinking, despite her efforts, plagued with a failing memory, and sinking into a depression that would result in two years of complete withdrawal from painting. When her former student Jim Touchton met Bill ("It's like me meeting God"), the celebrated painter was descending the staircase in his underwear. He walked over to his sofa without speaking and started

watching TV. Elaine initially talked her nephews Christopher Jean Pierre (Jempy) Luyckx and Clay Fried into serving as Bill-minders during the fall and winter of 1977–78. Then she leaned on Conrad—whose wife had recently died, leaving him at loose ends—to keep Bill from drinking and monitor his diet. This was no easy job, what with his violent episodes.

Elaine also may have wanted to spend more time in her Alewive Brook Road home. With Conrad's help, she had added a thirty-by-fifty-six-foot studio with a seventeen-foot-high glass wall at the north end. The studio floor was painted "flesh pink," to the amusement of her friends. Jim Touchton lived in the Springs house while it was under construction. When he asked her about the floor, she joked, "I like looking at flesh."

Elaine's decision to leave the University of Georgia did not spell the end of her teaching career. She would have one more appointment, at Bard College,

Exterior of Elaine's studio in East Hampton, 2016.
Photo: Amy Pilkington.

which honored her with the Milton and Sally Avery Chair in 1982.[14] But her life was now on a new financial footing. Bill's attorney Lee Eastman had drawn up a formal agreement, according to which she would now receive substantial regular payments from Bill. The deal obliged her to cede control over his estate, however, which understandably angered her.

In April 1978, after returning from a trip to Poland, Elaine had presented a slide show about Bill's current work at a gallery. She answered questions about the kind of brushes he used ("ratty old hardware store brushes"), the scale of his paintings (usually seven-by-eight feet), whether he was currently exchanging ideas with other artists (no), even whether he was influenced by Zen Buddhism (no, but she thought he worked in a "very Zen way").[15] "He seems with every year to work harder and harder and harder," she said at one point, ever her husband's supporter. Apart from her salesmanship—no doubt, second nature to her by now—she offered a gem: "Memory is where art comes from, even if you remember something that happened five minutes ago."

Tom Ferrara, a young artist who had worked with Conrad Fried at the data-processing equipment plant in Maryland where Fried was a leading engineer,[16] met Elaine when she came to visit. In the autumn of 1979, Ferrara took over Bill-minding duties, on Conrad's recommendation. "I was versatile and a good cook," he said. "Elaine said she really needed help with Bill. Someone needed to go there every evening and see that he eats." She was persuasive—"a dynamo, full of energy," Ferrara said. "She could walk into a room and start to crackle with ideas and conversation."[17]

But in her dealings with Bill, she now had to shift into a lower gear. It was during this period that she finally sat down with him for The Talk. She pointed out that he came from a long-lived family. (His mother died at 82, his father, at 89, and a grandfather, at 95.) "So your body's going to last," she said, "but your brain is going to go." According to Elaine, this line of reasoning eventually convinced him to go to Alcoholics Anonymous.[18]

Bill had started going to A.A. meetings in the early seventies, when he spent four weeks at a treatment center, but he didn't stick with the sessions afterward. A subsequent attempt, with an A.A. member Elaine thought Bill would find simpatico, also faltered. Now, Elaine took him to A.A. meetings herself, gave him doses of Antabuse, oversaw his meals, and made sure he had sufficient painting materials and stretched canvases to continue working. She took charge of his studio, firing his previous helpers and bringing in new ones, keeping tabs on his finances, and monitoring his visitors.[19] Although Elaine's new role was "wifely" in its caring involvement in every aspect of his life, she and Bill would never again be sexually involved, and he was still in love with Kilgore.

Around this time, Elaine and Bill were invited for dinner at the home of Bill Berkson and his then-wife, Lynne O'Hare. The de Koonings had just stepped inside when she started to ask the usual hostess's question about what they would like to drink. Elaine didn't let her finish. "Mineral water!" she cried. As she chatted with Berkson, Bill overheard something about a painter and looked inquiringly at Elaine. "We're talking about Phil Guston, Bill," she said loudly, as if he were hard of hearing. But even though Bill could appear out of touch—at another dinner, held thirteen years after Frank O'Hara's death, he asked how the poet was—he was still liable to come up with a thoughtful or curiously apt rejoinder. When asked if he still walked his dogs, he replied, "No, I'm a man. My dogs walk with me."[20]

CONNIE FOX, ELAINE'S friend from her Albuquerque days, was now living in a small town near Pittsburgh, Pennsylvania. Whenever she came to visit, Elaine would try to get her to move to East Hampton. In 1979, the two women spied a house for sale on nearby Saddle Lane. Connie liked it but wondered where she could put a studio. "Don't worry about it," said Elaine, with her characteristic cocked-wrist gesture of dismissiveness. "The whole house will be your studio." The owners, a divorcing couple, were eager to sell, and Connie was able to assume the mortgage. After the moving truck with all her artwork and possessions was stolen by thieves who set it on fire when they couldn't pick the padlock, Elaine and Ernestine Lassaw pitched in to help. One of Connie's cherished gifts from this period is a pair of wooden chairs, painted in what she calls "'Elaine yellow'—not a bright canary yellow but a really strong concentrated yellow." Serendipitously, Connie received $50,000 from her insurance policy,[21] enough to build a studio. Elaine's, she said with a laugh—amused at her friend's sense of competition—"is a little bit bigger than mine and the ceiling is a little taller."[22]

The two friends took t'ai chi classes together. "We eventually ended up doing the sword form together," Connie remembered, "where you use a sword and you go through a ritual of fighting."[23] Elaine's painting stance strongly resembles this position (left arm upraised and right arm thrusting the sword); put a cigarette in her left hand, and exchange one of her long-handled paint brushes for the ritual sword, and you've got her characteristic "attack." Fellow artist Herman Cherry fondly recalled "the eternal, infamous cigarette piercing the sky like the Statue of Liberty."[24]

Elaine and Connie would roam Sammy's Beach with their dogs. Elaine's were mostly white Akitas, but she always had a tender spot for a stray. As if duplicating her wide range of acquaintances in canine form, her pets ranged

from a giant dog described by a friend as a "wolf" to a tiny lap dog. The women also drove to Manhattan to see the art shows. "We had this whole routine," Connie said, "so that we could see more shows. She'd double-park, and I'd go in to see the show, and I'd come out, and we'd move down the street. I'd be in the driver's seat, and she'd go in. It was a lot of fun." Elaine's cleverness and sense of humor allowed her to be "very incisive and even damaging in a kind of not-offensive way," Connie said. "If you're smart and funny, you can really get to the heart of some matters without being grave and pretentious and por-tentous, which a lot of the men were."[25]

Connie, who taught a painting class at Southampton College,[26] had a stu-dent, Lawrence Castagna, who became her assistant. He made his living as a sous chef at a French restaurant in Bridgehampton. When the de Koonings came in for dinner, the owner urged Castagna to ask Bill to sign a menu. Afterward, Castagna flipped it over and saw that Elaine had written her name and mail-ing address (P.O. Box 1347) on the back, instead of 182 Woodbine Drive, Bill's studio address. It was a tacit message that she was in charge.

One night, Connie invited him to cook for a dinner party at her house. The guests included the de Koonings and Ernestine and Ibram Lassaw. "They were trying to see how Bill would react to me," Castagna recalled. "I didn't know this; I was just a kid. And then I get this call one day. It's Elaine; I knew her voice. She says, 'How would you like to come and work for me?' I says, 'Well, I'm still at this restaurant.' She says, 'Come to my house and take a look.'"[27] Elaine initially hired Castagna in 1982 "to be a sort of spy," he said, helping Ferrara keep Bill from drinking and maintain his day-to-day routine. Cooking was a big part of the job, and Bill's home had been outfitted with a restaurant-quality stove and refrigerators.

Then Elaine decided that she wanted Castagna, who was living in a room in her home, to be her own assistant. The first order of business was to replace the stove ("two of the burners weren't even working—you turn them on and the place would blow up"). After an elaborate French dinner he prepared for guests, Elaine said, "Everyone loved it. But you know what, that's the last one. No more of that food. We've got to go healthy." She became interested in mac-robiotics, hiring two Japanese people to teach Castagna how to cook the dishes. Eventually, she decided that was too extreme, so he would make a salad for her regular Monday lunches with artists, dealers, and art writers.

Working for Elaine inevitably meant pitching in with odd jobs. Castagna also helped in the studio, ordering stretchers and preparing the different-sized canvases she used. When Elaine traveled, she would ask him to keep an eye on things. (Even when she was home, one of his jobs was to secure the doors,

which she had a habit of leaving open.) For a while, Castagna helped Marjorie catalogue Elaine's paintings on index cards, a painstaking job that was often interrupted by her other requests. (Her nephew Luke remembers Elaine's habit of bossing his mother around: *Marjorieeee!*) Finally, Elaine's friend Edvard Lieber,[28] a painter and composer, was hired to come in one day a week and take over the cataloguing, using a computer. Learning that Herman Cherry was building a studio in East Hampton, Elaine enlisted Lieber to wrestle a box containing a refrigerator through the weeds to the new building. (Typically, she had purchased two fridges, planning to give one away.) Years later, Cherry remembered watching her lead the way, wearing one of her "filmy, loose silk dresses, much as her mother had worn."[29]

Elaine was always helping people, Castagna said, whether by making a phone call ("This guy's work is really good; I want you to look at it") or by hiring someone "who needed a hand," like Bill Sturgis, a recovering alcoholic who built the home's sunroom and helped redo the kitchen, with a wooden bowling alley ingeniously repurposed as a kitchen counter. In the mid-1970s, when the painter Marcia Marcus called to ask if she could borrow an easel for the summer, Elaine said, "Oh, come over. We're looking at coats." Puzzled, Marcus arrived at the studio to find racks of a visiting designer's coats and jackets, and fellow artists trying them on. She craved a reversible jacket that she couldn't afford and asked if she could trade artwork instead. But the clothing designer said she really needed the money. "And Elaine walks over and says, 'That looks wonderful on you. Surely you must have a drawing about that price.' And I said, 'Yes, but…' And she said, 'Well, then it's yours.' She gave me a cup of tea and I borrowed an easel besides."[30]

One day in April 1979, when Elaine and Bill were both in Manhattan, she suggested that he visit Aristodemos Kaldis, who was gravely ill, and offer to exchange paintings with him. An artist friend later reported that Kaldis was thrilled that his famous colleague had remembered him in this way; he called all his friends to brag about it.[31] It was an upbeat finale for the seventy-nine-year-old artist, who died a few days later. That year, Elaine sent $2,000 to sixty-six-year-old Mercedes Matter, who was dealing with financial problems, as well as poor health. "Your recovery is a matter of profoundest import to me," Elaine wrote to accompany one of the checks. "I think of you constantly and insist you get well immediately!" (As things turned out, Matter would outlive Elaine by a dozen years.)

In December 1980, at a luncheon in Baltimore—where a show of her Bacchus paintings had opened at a gallery—someone joked: "[T]he three questions not to ask Elaine de Kooning are, 'How's Bill?' 'What did JFK say?'

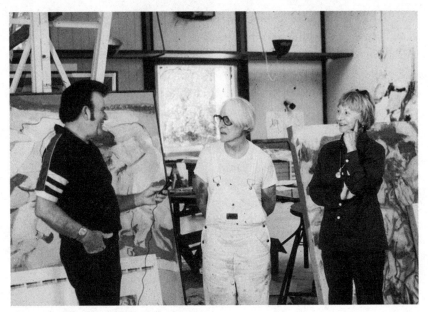

Dord Fitz, Bill, and Elaine in Bill's studio, 1981.
Photographer unknown. Dord Fitz Collection, Western History Collections, University of
Oklahoma Libraries. Courtesy of Carolyn Fitz.

[and] 'Why are you showing in Baltimore[32] and not in New York?'" To the
first query, Elaine gamely replied, "Bill's doing beautifully. What's he like? He
doesn't like anchovies."[33]

The following spring, Bill returned to painting, with airy, ribbon-like com-
positions evoking the coastal atmosphere of East Hampton. But he was a
changed man. He had a habit of staring into space and not responding to
people around him. Elaine was told by one doctor that, beyond the short-term
memory loss caused by binge-drinking, early signs of dementia or Alzheimer's
had begun to surface. Publicly, she insisted that Bill's behavior was a natural
result of aging. Her attention to his needs now far outweighed his interest in
her life and work. Yet he continued to praise her portraits. "I could never do
that," he would say.[34]

Bill was living and working in a 10,000-square-foot structure that he built
without consulting an architect; it reminded Elaine of a bus terminal. The
couple was photographed there for *Architectural Digest*'s "AD Visits" feature,
published in the January 1982 issue. Dressed in a purple shirt and rose-colored
slacks, Elaine posed with her ever-present cigarette next to Bill, in his rocking
chair. Between them on the floor sat the humble aluminum bucket she was

using as an ashtray. In the accompanying story, Elaine was allotted just one, quite possibly tongue-in-cheek quote, about the studio's combination of vast space and utilitarian details: "The décor is artless."[35]

That month, a group of Elaine's Italian landscape drawings and watercolors were shown at the Phoenix II Gallery in Washington, D.C. For some reason, she insisted that the gallery display only her "E de K" initials in the window. Worried that no one would know who this was, gallery director Arlene Bujese quietly posted a press release with Elaine's full name. Even so, people came in expecting to see work by Bill.[36] A reviewer for the *Washington Post* described range of work in the show as "extraordinary—from highly detailed classical pen drawings of Italian hill towns to joyfully colored abstractions."[37] The review quoted Elaine as saying that she aimed for "that sweet moment when the scene becomes the brushstroke."

In late August, the Elaine Benson Gallery in Bridgehampton presented a show aptly titled Elaine de Kooning and Her Inadvertent Collection. She had thought she owned about forty works by other artists, purchased over the years, but she actually had accumulated many times that amount. When she sold a painting, she would buy one by someone else. "I don't ever acquire the work of an artist who doesn't need money," she explained. "It's got to be merit and need."[38]

WHEN INTERVIEWERS VISITED BILL, Elaine was always on hand, steering the conversation to areas that highlighted Bill's strengths, animating dead spots, and rescuing him from non sequiturs. ("She…dominated [a] conversation as if she were the Queen of England," Touchton said.[39]) She told Emilie Kilgore that any misstep by Bill should be greeted by laughter "as if it's an inside joke that only we get."[40] Elaine was likely Bill's uncredited co-author for a statement published in a book about New York artists.[41] His familiar mantra, "You have to change to say the same," became the last sentence in a text that begins with a typically Elaine thought: "If you write down a sentence and you don't like it, but that's what you wanted to say, you say it again in another way. Once you start doing it and you find how difficult it is, you get interested."

Elaine, who believed that "art is always *now*" and that the notion of progress in art is a delusion, liked to quote Bill's words about prehistoric cave painting: "We [artists] never got better. We only got different."[42] In the summer of 1983, Elaine visited the Dordogne region of France, site of the Lascaux cave paintings. They are believed to have been made 17,000 years ago, during the Upper Paleolithic era. Nearly all the figures are animals—horses with small

heads, deer with elaborate antlers, bull-like aurochs (creatures that became extinct in the Middle Ages), male bison, cats, and a never-identified two-horned animal. Discovered in 1940, the caves were opened to the public eight years later. Droves of visitors exhaling carbon dioxide led to the growth of lichens and crystals on the walls, and lighting caused the once-vivid colors[43] of the paintings to fade. As a result, the caves were officially closed in 1963.[44]

Margaret Randall credits Elaine's "creative chutzpah" for finding a way around the rules.[45] A number of her cave images are titled "Les Eyzes," after Les Eyzies-de-Tayac-Sireuil, the commune (township) in the Dordogne *département* in southwest France where the Lascaux caves are located. But other prehistoric caves in this area *are* open to the public, so it isn't clear that she actually managed to wangle permission to visit Lascaux.[46] Elaine was one of twenty members of a tour group that viewed as many as three prehistoric caves a day, beginning with those in Niaux ("like a cathedral, these vast, awesome spaces") and Bédeilhac.[47] All her trips abroad involved collecting visual impressions and taking notes for her next body of work, and she had thought she might paint some watercolors of the caves. But she hadn't counted on the overwhelming effect of the cave imagery.

Her first response was to "the fantastic courage it must have taken for those first artists to go *into* the caves."[48] Visitors held lanterns to illuminate their path past huge columns formed by stalactites and stalagmites. "The great revelation to me," she said, "was how the artwork was hidden. It was secret. You had to go way in, and then if you…held the lantern in a certain way, a horse would appear, or a bison, or a bull." She linked this hidden aspect to New York artists' work in the 1930s—when it was rarely shown in galleries, visible only when the artists visited each other's studios.

"I felt a tremendous identification with those Paleolithic artists," she said.[49] "I found myself deep in the caves imagining that I was one of [the artists], looking for surfaces smooth enough to paint on." When she saw her first cave drawing, "a crude and powerful bison," she was struck by "its unexpected immediacy." Elaine was entranced with the artists' "high-handed way with scale, juxtaposing huge and tiny creatures." She noticed "the way [naturally occurring] colors would float down the walls," a phenomenon the cave artists might incorporate or not, as they saw fit. "That kind of helter-skelter mix enthralled me."[50] Every day, in her hotel room, she would sketch and paint (in watercolors) what she saw—not copying the imagery, but offering "my response to it."[51]

In October, Elaine returned to Paris with her sister Marjorie. "We walk all day, every day," she wrote to a friend. "Never take a taxi, bus or subway—the streets are so varied and exhilarating." At the Jeu de Paume, she found her

"admiration for Monet increas[ing] with every painting I see of his.... Every little landscape is a different idea." She included Monet in a group of artists she called "the Magic Ones": Bill, Gorky, van Gogh, Giotto, Giacometti, Matisse—and herself. In her view, they shared "a quality of grace—as though they can do nothing wrong—a quality little children have." It was a curious statement to make about her own work, an aspect of the wishful thinking that was her ballast against depression.

At the Parc Zoologique de Paris, she drew bison for her next painting series. It would be "based on the prehistoric cave art—not only the art but the caves themselves—the fabulous surfaces—yellow ochre and grey—undulating—mysterious crevices, etc."[52] As she contemplated the prehistoric past, Elaine worried about the future. On this trip, she was reading Jonathan Schell's new book about the planet in the aftermath of a nuclear holocaust, *The Fate of the Earth*.[53] She was haunted by "a sense that we're now at a turning point—either we're going to go past all of this...or we're going to blow ourselves into 'kingdom come,' or we're going to drown in our own garbage."

In 1984, shortly before her sixty-sixth birthday, Elaine and two of her nephews traveled to the village of Mousehole in Cornwall, England, to visit Connie's daughter and son-in-law Megan and Scott Chaskey. Arriving on the train from London, she cut a dramatic figure at the Penzance rail station, in her long purple down-filled coat and purple beret. Elaine was a zestful traveler, always keen for an outing. She joined the young people on walks along the cliff path to the coves and meadowland, toting her oil sticks and drawing paper. The prehistoric cave paintings still had such a grip on her imagination that she sketched their remembered images rather than the Cornish scenery—though she also painted watercolors of Megan, pregnant with her first child. Elaine's cigarettes were always at hand; her standing smoking posture, with one foot up on a stone, reminded Megan of a sea captain. Told that she couldn't smoke in the couple's home, Elaine would obligingly lean out the bay window, unaware of the plume of smoke that drifted inside.

That year, her friend Margaret Randall had returned to Albuquerque after years of living in Cuba[54] and Nicaragua, only to be greeted by an order of deportation. The U.S. government declared that the opinions she had expressed in some of her books ran counter to the McCarran-Walter Act, a Cold War vestige that denied immigration to a long list of undesirables, including political radicals. Elaine responded by reproducing her 1960 portrait of Randall as a poster; sales would benefit her legal defense.[55] ("If you came to Elaine with a problem," Randall wrote, "before you finished telling her about it she was actively involved in its solution."[56])

During the summer of 1984, Elaine pursued her interest in prehistoric cave imagery with a visit to Altamira in Spain. This involved joining another tour group, but she assembled some of her favorite people—Marjorie, Ernestine Lassaw, her nephew Jempy, and a young artist, Toni Ross—to come with her. "The cave painters took tremendous liberties with proportions," Elaine told an interviewer. "That's what fascinated me—to make a horse in as many ways as possible. And I loved the jumps in scale. Some animals were tiny, others huge." Once again, she praised the "tremendous immediacy" of the cave paintings, as well as "the interplay between the contours of the animals and the action of the walls—the bulges and cracks and fissures that the cave artists either incorporated or ignored."[57] (In France, when Elaine noticed a shape in the rocks "that looked like the back of a bison," she was fascinated to see that an artist had mirrored it in a wall painting.[58])

To Elaine, the cave paintings looked contemporary and exciting. They shared that elusive quality of "passion" that attracted her in art, and they represented "the beginning of human thought…before words, and before writing."[59] The bull images also connected with her paintings from the late fifties and the sketches she had made in zoos over the years. One writer has suggested that Elaine may also have been captivated by the Abstract Expressionist–style space of the cave paintings, "with no center or edge, no beginning or end."[60] (In 1953, when Helen Frankenthaler visited the caves, she wrote to her then-lover, critic Clement Greenberg, "It all looks like one huge painting on unsized canvas, in fact it all reminded me of a lot of my pictures."[61])

Rather than trying to keep up with current styles, Elaine believed that an artist should work passionately in whatever mode seemed right at that moment. In their late work, she said, artists "get rid of all the conflict that they worked with…and let it flow," using "the part of the brain that dreams."[62] Although dreaming is actually a function of the entire cerebral cortex, Elaine often invoked this image, clearly fascinated with the memory consolidation process that occurs during sleep. Perhaps it is no coincidence that she was a sound sleeper.

When she talked about her series of paintings based on the cave images, begun in June 1983, she sounded as though her canvases had sprung to life by forces outside her control. Her sixteen-and-a-half-foot-long triptych *Morning Wall* (1985–1986)—with outlines of full or partial forms of horses and bulls extending over three attached canvases—evolved over a period of about eight months. The rhythmic repetition of horizontal brushstrokes in the background "seemed to emanate," she said, from the looming form of the charging bull in the lower left corner.[63] The sweeping brushstrokes animate the painting visually while suggesting the animals' stored-up energy, both real and

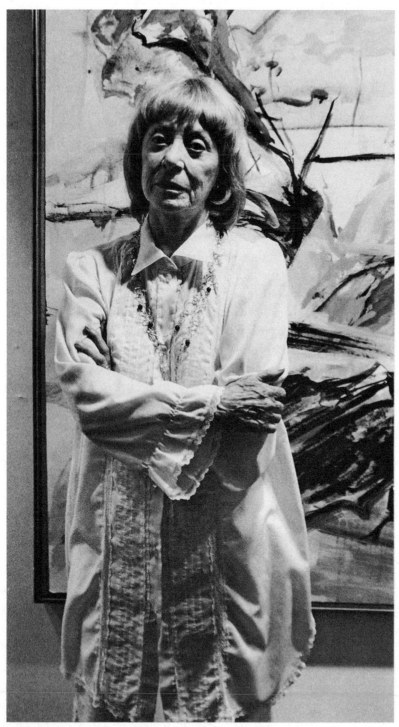

Elaine at her Cave Paintings exhibition at the Vered Gallery, East Hampton, August 1984.
Photo: Walter Weissman. ©1984 Walter Weissman.

mythic. In contrast, *Purple Wall* (1985) contains a transparent curtain of vertical "sweeps" intended, Elaine said, to evoke the verticality of the stalactites and "the movement of dampness on the [cave] walls."

Occasionally, "the very first gesture" she made on the canvas—in *Black and Gold Bison* (1986), the animal's zigzagging hind legs—would be the key to the rest of the image. She pointed out that leaving the minuscule area of the bison's eye unpainted created a powerful effect. "When I work on a painting," she said, "every tiny thing...is considered as important as a huge contour." Some of those contours were troublesome; during the four months it took to complete the nine-foot-long *Gold Grotto* (1985–1985), "all the animals would appear and disappear" until she settled on the final composition, with its delicate scattering of small bison and a horse that offsets the bulky contours of two rhinoceros. The colors in the cave paintings were arbitrary; she had started by imitating the ochers of the cave walls but ultimately allowed her "inner response" to the imagery to lighten her palette (plates 29 and 30).

After Elaine had completed many works on this theme, she was finally able to work "in one sweep, practically in an hour," to paint *Blue Bison* (1986), a five-foot-long canvas. It is dominated by two hulking, yet dreamlike (because they are transparent) animals with rhythmically contrasting outlines on a streaked and dripped ochre background. Since the late 1950s, Elaine had used oil and acrylic paint interchangeably, claiming that no one could tell by looking which medium she had employed. A manufacturer in Colorado had developed a new kind of acrylic that flowed almost as smoothly as watercolor—perfect for a "Zen" painting like *Blue Bison*, which was all about "grab[bing] something that happens very quickly...where every stroke seems to be right."

Gruenebaum Gallery, a strong supporter of Elaine's late career, showed the cave paintings in May 1986.[64] In an *ARTnews* review, artist Miriam Brumer described the essence of these works as "a dialogue between stimulus and response," in which Elaine was applying her Abstract Expressionist brushwork and colors of her own choosing, "rather than attempting to pay homage."[65] The lukewarm *New York Times* review tartly noted that the prehistoric artists lacked Elaine's energy, "but then they had to kill the animals as well as paint them."[66]

ELAINE ONCE SAID that one of the reasons she worked in series was that by making more than one version, "I could prove to myself that they were no accident. The idea of an artist is very much involved with proving things to yourself."[67] Quoting a wry statement of Bill's, she claimed never to have had a fallow period, because "you have to prove you're a failure, so you have to work

hard."[68] She also said that picking a theme was "liberating…because you find the variety possible within it."[69] When the interviewer tried to probe further into her obsessive approach to art making, Elaine dodged the question. But on another occasion, she mentioned in passing that her work was a way of coping with the jumble of thoughts constantly churning through her mind. "Painting," she said, "is constantly an act of having to pull myself together.… I always feel grateful to the person who presents me with my subject." The built-in structure of working in series had a mentally quieting effect that allowed her to focus on the task at hand.

IN MARCH 1985, Elaine wrote to a friend in jaunty orange ink that she had finally given up smoking seven weeks earlier, and she was no longer coughing. But she was having a hard time. "I identified smoking with painting and writing both," she explained. "I seem to work in short sprints now. I have to jump up and take a walk or eat or make a phone call!!"[70] In a matter of weeks, she went back to her beloved cigarettes. Smokers often believe that nicotine helps ease their anxieties and stress, but the nicotine withdrawal that makes a smoker reach for another cigarette is itself a cause of stress. Elaine tried plastic lookalike cigarettes, hypnotism, and Smokenders meetings, all to no avail. Despite her inability to beat this addiction, her victory over alcohol impelled her to confront heavy drinkers. At one party, she was overheard lecturing an artist friend: "Bob Dash, you should put that drink down right now!" Not to be dissuaded, he made fake coughing sounds and gestured to the cigarette she held in her hand.[71]

CROWN POINT PRESS—originally based in Oakland, California[72]—has welcomed many well-known painters who wanted to exploring etching techniques. Founder Kathan Brown is known for her knowledgeable guidance, staff of expert printers, and ability to sell the finished etchings. Elaine was recommended by Wayne Thiebaud for a two-week residency at the press, and John Cage[73] concurred that she would be a good choice. Elaine had worked with master printer Floriano Vecchi in 1957 to produce a screen print with an abstract motif that served as the exhibition poster for her Tibor de Nagy show (plate 15). But it wasn't until 1973, when she was invited to spend a six-week residency at the Tamarind Institute in Albuquerque,[74] that she took up printmaking in earnest. She based her lithographs—*Taurus, Arena, Picador, Juarez*, and an image she called *Experiment*—on her bullfight sketches. Elaine said later that she liked the way "something about the printing process seems to impose a kind of authority on the drawing," especially the deep, velvety

blacks.[75] She would return to the Tamarind Institute in 1977 to make four lithographs based on her *Bacchus* series for *Suite Fifteen*, a compilation of prints by fifteen artists[76] selected by Tamarind's advisory board to mark the institute's fifteenth anniversary.[77]

Arriving at Crown Point in early May 1985,[78] Elaine produced eight aquatint etchings of cave imagery, published as *Torchlight Cave Drawings*, as well as two sugar-lift[79] aquatints named after caves in France (*Peche-Merle*, with a horse and rhinoceros, and *Les Eyzies*, a grouping of five animals.) "We showed her this [aquatint] process—with finely ground rosin, the kind used on violin bows, that is very acid resistant," Brown said. "You dust it onto the copper plate and heat it slightly so the grains will adhere to the plate. There are all these little white dots, but if done properly, you don't see the dots [in the print] because the acid bites down around all of them."[80]

Elaine—whose technical aptitude had made her a quick study when she cast her first bronzes—immediately latched on to this process, which allows for tonal variations in the print. At the table set up for aquatints, "she plumped on a big bunch more [rosin] and then took her finger and started moving it around," Brown said. "She would just jump in and do something—she was very sure with a brush and with her handling of materials." In an interview, Elaine likened her finger painting style to prehistoric artists' finger-traced images in the dirt. (She also drew with a matchstick.) Working quickly, she compared her speed to "the sweep of the surface" she saw on the cave walls. The tricky part was keeping in mind that the composition on the plate would print in reverse. "Because direction is very important to me," she told an interviewer, "I always have a mirror around."[81]

Elaine was accustomed to keeping several paintings going at once, but while working with the Crown Point printers—who had to wait for her to complete her preliminary work on a plate—she began to appreciate the discipline of focusing on just one piece at a time. Printer Hidekatsu Takada remembered her as "so vigorous, so interested in other people."[82] Brown recalled that Elaine invited "everyone she knew in the area to visit the studio when she was there. She didn't mind letting them talk to each other" while she worked.

During the weekend that marked the halfway point of her time at Crown Point, Elaine visited her friends Marguerite (Meme) and Paul Harris in the picturesque coastal enclave of Bolinas, California. On Monday morning she returned to the press with exciting news: "I bought a house! It's right on the beach and has a gorgeous view." Perched above Ocean Parkway, the funky little cinderblock house looked out on Bolinas Reef, with a view of the Golden Gate Bridge. (Eleven years earlier, she had fantasized buying a "dream house"

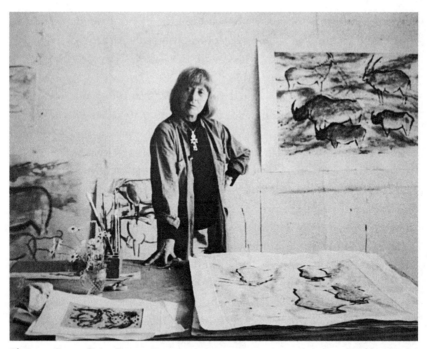

Elaine at Crown Point Press, 1985.
Photographer unknown. Courtesy of Crown Point Press.

in Vézelay, France, writing excitedly to an artist friend that "three artists could chip in" to come up with the $9,000 asking price.[83]) Thrilled to have bought property so cheaply in a town that was "like a little secret," Elaine didn't bother to inquire about details like square footage and taxes.[84] She immediately hired Roger Peacock, a local designer and builder, to convert the garage to a studio. There was no point in interviewing anyone else, she explained, because "he is so good looking!"[85] Yet despite this show of impulsiveness, the Bolinas house was connected to a long-range plan. Accompanying Meme Harris on a visit to her mother at a nursing home in nearby Mill Valley, Elaine realized that this would be the perfect place for Bill when he could no longer take care of himself, and she asked Meme probing questions about the quality of care.[86]

In addition to its dazzling vista, the Bolinas house embodied another kind of long view: Elaine's trust that she would still be around to enjoy it. Her familiar hacking cough—at the Crown Point studio, she had been "coughing like crazy," Brown said—was caused by chronic smoker's bronchitis.[87] But she also had a far more serious condition: lung cancer. In an effort to keep the cancer from spreading, she had recently undergone a partial lobectomy (removal of a portion of one lung) in a Manhattan hospital. Only her family and

closest friends knew about the operation. One of her confidantes was art dealer Aladar Marberger, her former student, who would learn in late October that he was infected with the virus that causes AIDS. "I'm just dying a little faster than you're dying," he told her.[88]

In California, Elaine also visited the homes of (unnamed) collectors whom she disparaged for their adherence to the modern art canon: "You saw the lineup. It got so ludicrous—the Rothko, the Newman, the Rivers, the Diebenkorn, the Warhol, the Johns, the Rauschenberg—that you could say, Where's your Twombly?"[89] In a similar vein, Elaine called Irving Sandler's book *The Triumph of American Painting* a "myopic view," because its focus was limited to a small group of Abstract Expressionists, discouraging museum directors from seeking out other worthy artists.

That summer, Elaine was one of several artists who drew an image on an Etch-a-Sketch[90] for a contest at the Parasol Gallery in Sag Harbor, marking the toy's twenty-fifth anniversary. Her sketch of two elephants under a tree evoked an experience in Kenya earlier that year, watching "whole families of elephants and other animals...lumbering in at night. They moved so majestically."[91] Her trip had also included days in Luxor, Egypt, where she was captivated by the tomb paintings in the Valley of the Kings. The images, she wrote to a friend, were "full of a sense of daily life," with "a tremendous joie de vivre." She was bowled over by scale of the Temple of Karnak, which "made the Empire State Building look as though it were made of toothpicks."[92]

In December, Elaine accepted Bill's Lifetime Achievement Award in the Arts, presented by the Guild Hall, the venerable East Hampton cultural center. The star-studded audience included the other award winners Alan Alda and Kurt Vonnegut, as well as socialite Lee Radziwell, news anchor Peter Jennings, and restaurant impresario Werner LeRoy. "Bill has gotten very testy about this sort of thing," Elaine told a reporter. "But he said, Guild Hall is different— that's family."[93]

DURING THESE YEARS, Elaine sometimes referred to the memoir she was planning to write.[94] In 1983, it was still just "fragments here and there and thousands of notes," she wrote to a friend.[95] One chapter would be on the summer she and Bill spent at Black Mountain. *Vogue* magazine had asked her for two thousand words about that experience, and she wound up writing a piece that was twice as long ("thereby cutting my rate per word in half—isn't that just like an artist?"). Even so, she wrote, "I had to leave out all sorts of incidents, characters, observations, etc." Although she was about to start the cave painting series, she planned to "begin each day with writing and not pick

Elaine in her office.
Photo: Gerald McCarthy. From his documentary video, *Elaine de Kooning: A Portrait*, 1982.
Courtesy of Gerald McCarthy.

up a brush until noon."[96] She told a friend that the book would be titled, Always In Love with Bill.[97] "Most of the stories are funny, you know," she remarked to an interviewer. "Which is what poverty is in retrospect from a position of affluence."[98] To another interviewer, she said that the book would also be "a history of the period."[99]

Elaine had a contract with Knopf for the memoir,[100] but it seems that she never submitted any drafts to the publisher. Less than eight months before her death, she claimed to have written "a great many chapters" of a book that would be "at least four hundred pages." This sounds like magical thinking, because she was still unsure of the book's scope. Perhaps, she told an interviewer, it could cover just the period from 1937 to her wedding: "I could easily do a whole chapter on John Graham...on Arshile Gorky...on Franz Kline." Elaine wondered aloud about whether to write an entire chapter on Bill's various jobs during their early days together or just to summarize them in a couple of paragraphs. She told the magazine publishing baron Samuel ("Si") Newhouse— whose empire includes *Vanity Fair*—that she could "practically" write a book just about the parties she and Bill attended. Or, what about her childhood, surely "a book in itself"? As she pondered the form her book would take, Elaine drew up specific subject categories, including "walks" (the conversations she and Bill and Edwin had while walking around Manhattan), "museum people," and "eccentrics."

An unresolved issue was, "How personal do I get?" Unwilling to forgo intimate dramatic and funny details that she knew readers would enjoy, she even considered framing this material as fiction.[101] Meanwhile, she dispensed advice to someone thinking of writing her own art-world memoir: "Don't, for heaven's sake, ramble. And, if possible, avoid evaluations [because] they are bound to get you into a peck of trouble."[102]

BY THE 1980S, Elaine's life in East Hampton had settled into a comfortable routine. One visitor found her "trim and buoyant at sixty-three"—actually, sixty-five—"enjoying a full life of her own while staying as close as possible to her husband."[103] A hundred miles from the cultural distractions of Manhattan, where, as she said, "you can spend all your time being a spectator of wonderful things,"[104] Elaine was free to focus on her work. She leavened her time in the studio ("work is the thing I most enjoy doing") with yoga and t'ai chi ("a very physical way of meditating"), and walks with the dogs. One day a week was devoted to business matters, including check writing and supervising a work crew. Marjorie would come in to help her with scheduling.[105]

Every evening, at about 6 P.M., Elaine would drive to Bill's studio, where his helpers would put dinner on the table. An artist friend, Art Schade, remembers watching Elaine slowly slicing Bill's meat. "She was affectionate and caring toward him," Schade recalled.[106] He and his then-wife Barbara Schwartz, Elaine's former student, often went to Bill's house for dinner in the mid-eighties. To pass the time before his bedtime, the de Koonings would watch TV—mostly PBS and game shows ("Bill liked the color and the excitement," said his assistant Tom Ferrara), and classic movies from the 1950s.[107] Although she sometimes gave the impression in interviews that she left the following morning for her studio, she rarely stayed overnight.

WHEN ELAINE MET Time Warner CEO Steve Ross and his second wife, Courtney, she was delighted to be introduced to their world. "She had never known anyone who showed a movie after dinner," art dealer Elaine Benson recalled.[108] In 1982, Courtney Ross produced a documentary about Bill, *Strokes of Genius: de Kooning on de Kooning,*[109] inaugurating an artist series introduced by Dustin Hoffman. Elaine, whose remarks dominate the film, recounted her initial meeting with Bill. She explained how important Gorky was to him, and how, in the 1940s, she and Bill never had enough money to last more than three days ("often just one dollar"). After Bill piped up to say that "We all became kind of drunks" after the Cedar Tavern became the gathering place, she corrected him: "Not drunks, Bill: drinkers." When the camera came to rest on a photo of Bill, his mother, and Nini, Elaine quickly chimed in to point out a flattering photo of herself and Bill on the beach in 1949. While noting the "shock and dismay and hostility" of the response to his *Woman* paintings, she added, "Bill, of course, felt they were cute." Elaine admitted that the paintings "do have a certain ferocity," but at the time, she said, she saw them "in terms of painting, not [as] an image of woman."

In March, Elaine accompanied Bill to the premiere of *Strokes of Genius* at the Kennedy Center in Washington, D.C., and to a White House ceremony where he received a replacement for the Presidential Medal of Freedom he was awarded by President Lyndon Johnson in 1964. (The original medal was lost; the de Koonings believed that Grace Hartigan's eccentric husband, Winston Price, had stolen it when he and Hartigan were Bill's houseguests.[110]) "Bill and [his daughter] Lisa sat on the terrace of the Kennedy Center while Elaine entertained people," a friend recalled. "It was Elaine who carried the celebration."[111] The couple's public life continued in April, with a White House dinner in honor of Queen Beatrix of the Netherlands. The *Washington Post* story about the royal visit included a guest list for the dinner in which

Elaine, like the other wives, was listed merely as an appendage of her husband, "Willem de Kooning, artist."[112]

Away from the social whirl, Elaine worked on a seven-foot-tall "word" painting—texts floating within a mixed-media abstraction. *Denkoraku* was named for a group of Zen Buddhist koans and commentaries compiled in 1300 by Keizan Jokin Zenji, based on talks he had given to monks. The koan form was a natural fit with Elaine's love of wit and subtle indirection, and the painting represented both her fascination with intuitive knowledge and a further reach of her involvement with the poets of her time that had begun with Edwin Denby, Frank O'Hara, and Margaret Randall.[113] A reproduction of *Denkoraku* was published in 1983 on the cover of *Sounds of the River Narajana & The Tablets I–XXIV*, by poet Arnold Schwerner.[114]

Through her friendship with Steve Ross, Elaine had met his daughter Toni. Elaine praised her drawings and paintings, and suggested that she come out to the Hamptons. As usual, friendly encouragement was accompanied by hands-on assistance; Elaine found her a house and a studio. Toni became part of Elaine's all-woman drawing circle—sketching from a model once a week—and sometimes worked alongside Elaine when she was painting a portrait. Elaine would drop by Toni's studio when she wasn't there, "and leave me little notes on the backs of envelopes—mostly encouragement," the younger artist said. "At the time, I thought my work was no good. She allowed me to take myself seriously."[115] (Jim Touchton also remembers the upbeat tone of the notes she left at his Springs studio—"You are on a roll indeed"—years after he was no longer her student.)

At the December 1983 opening of Bill's sixty-year retrospective exhibition at the Whitney Museum,[116] Warner Communications, which partially underwrote the show, hosted an elaborate dinner. A photograph shows Elaine in a lamé dress, her painted nails gleaming, but her expression is troubled as she protectively grasps Bill's upper arm. He smiles lopsidedly. Lisa stands at his other side, looking away at something we can't see. Although obviously posed, this is a portrait of an extended family under stress. Elaine came by herself to the black-tie opening party at museum director Tom Armstrong's home, explaining that Bill was "a little hard of hearing, and big crowds put him off."[117]

BILL HAD BEGUN to exhibit signs of Alzheimer's disease. Elaine was said to urge his assistants to mix his unvarying red, yellow, and blue paints—the de Stijl color triad so important to Mondrian—to create more shades for him to work with.[118] During visits from his dealer, Xavier Fourcade, she would help determine which of Bill's paintings could be considered finished.[119] Fourcade

died of AIDS in April 1987, but she decided not to tell Bill for fear of upsetting him.[120] At that point, Elaine was trying to cope with her own ill health while keeping up her work and travels, and she was no longer visiting Bill on a daily basis. Perhaps her innate sense of independence had also kicked in; Elaine was not temperamentally suited to being anyone's keeper. She was apparently unaware that Bill's condition had deteriorated to the point where he needed someone to bathe and dress him. Of course, his remaining assistants (Tom Ferrera left that year to pursue his own work) had not signed on to serve as nurses. When Lisa came to visit and saw her father's condition, she notified his accountant, who called Elaine. She hired a nurse's aide for him.

Courtney Ross and Elaine traveled to China and Japan for two and a half weeks in the autumn of that year. Elaine kept a daily log—sixty pages of notes, which she hoped to turn into a book.[121] Intrigued by sumi ink drawings, she returned with soft-tipped sumi wash brushes, her only purchases on the trip. "The brushes themselves are an inspiration," she said. In a departure from her earlier work, she planned to use sumi ink to illustrate the Book of Genesis.[122] In December, Elaine also spent two weeks working with students in Bulgaria under the auspices of the U.S. State Department, her final trip abroad.

Toward the end of her life, Elaine reveled in presenting whatever version of herself seemed appropriate at the moment. In early 1988, she went to the opening of Joan Mitchell's retrospective at the Corcoran Gallery in Washington, D.C. After chatting with her, Elaine passed on a piece of art gossip to an interviewer. According to Mitchell, critic Clement Greenberg had told Larry Rubin—the powerful Knoedler Gallery director, who also ran Galerie Lawrence in Paris—to dump her. Elaine suggested to an interviewer that the two men would likely deny the story. But, she added wickedly, "the thing about Joan [is] that every now and then she does tell the truth."[123]

In March, she celebrated her birthday by hiring a stretch limousine to drive her from Manhattan to Bill's house. During the three-hour drive, she worked on her memoir. When the car stopped on Woodbine Drive, she emerged in a cloud of Joy perfume. Bill and Conrad were agog. Then, having made the impression she hoped for, Elaine burst out laughing.

She put on her public face in May, when Lisa de Kooning married a French-Canadian landscaper. Despite her chilly relationship with Lisa, Elaine would tell people that she was very fond of Bill's child. Now, she gushed to a friend about Lisa's "beautiful young man" and the couple's baby ("Bill's first grandchild").[124] In late August, she drove to a party in Southampton hosted by Bill's old flame Mary Abbott; three days later, she was part of the poets-and-artists crowd at Jane Freilicher and Joe Hazan's Labor Day weekend party.

Although Elaine worked hard at being her usual upbeat and engaged self, her health was failing. "She was in denial," her nephew Charles said. "'I can quit [smoking] anytime,' and so on. She was in denial that she was mortal. To some extent, she didn't want to let that show—that she was in bad shape. Earlier, she wore tracksuits to show how fit she was, not that she would do any jogging."[125] According to Tom Ferrara, only Marjorie and Elaine's bookkeeper Frances Shilowich knew how ill she was. "She didn't really want to be taken care of, didn't want any sympathy," Ferrara said. He thinks her close-lipped attitude was related to her rivalry with Joan Ward, who was liable to "move in or take Elaine's place."[126] Elaine's father had also been a heavy smoker. According to his namesake, Elaine's nephew, "If he had a cup of coffee, he had a cigarette."[127] He had died—"suddenly," according to his obituary, signaling a heart attack—at age sixty-four, in 1951.[128]

BILL'S 1981 WILL (a new version, written after Elaine reentered his life) stipulated that his estate would be divided equally between Elaine and his daughter Lisa. However, if Elaine predeceased him, Lisa would inherit everything, and Elaine's family would receive nothing. Understandably, this did not sit well with Elaine. In 1988, she hired a legal firm[129] that wrote a codicil stipulating that if Elaine predeceased Bill, his attorney[130]—whose firm was hostile to Elaine's financial requests—would be replaced as executor of the estate by Lisa and her attorney. Bill's scrawled signature on the codicil was witnessed by Elaine, Lisa, and a studio assistant, but Eastman declared it invalid because of his mental state.[131] (At one point this year, Bill saw a woman drinking a cup of coffee in his kitchen, and wondered who she was. "That's Elaine, your wife," Conrad said. "Ah yes," Bill replied. "I used to love her.")[132]

All of Bill's assistants agreed that, "as much as Elaine enjoyed the social and economic rewards" of Bill's late work, "she was scrupulous in not pressing him to make pictures for the market."[133] On the other hand, she was never known for her business acumen, and now she was seriously ill. Leaving the search for a new dealer for Bill in limbo, she authorized two series of his work that became mired in difficulties. Based on his drawings from 1966 for *In Memory of My Feelings*—a tribute to poet Frank O'Hara—the seventeen new prints were not signed by Bill, thus making them far less valuable. (After a kerfuffle featuring the mysterious appearance of his signature on the prints, Bill's attorney had it removed.) Elaine had also asked sculptor Philip Pavia, whom Bill had turned to for guidance in the late sixties, to cast several of his recent sculptures. No doubt because Pavia was a longtime friend of both de Koonings, there was no written contract. While Elaine was alive, Pavia

received a steady stream of checks, but the payments stopped after her death, the authenticity of a couple of the clay pieces was deemed uncertain, and in a bizarre twist, Lisa de Kooning claimed they were made by her.[134]

IN MID-AUGUST 1988, Alcopley visited Bill's studio with Elaine. During the short drive from her house, she coughed so hard that she had to stop the car several times. Worried about this "ominous kind of cough," he begged her to stop smoking; she explained that it just didn't seem possible.[135] That month, an exhibition of her final series, the sumi ink paintings, opened at the Benton Gallery in Southampton.

Elaine believed that her constellation of aches and pains were the result of Lyme disease, which is caused by the bite of an infected blacklegged tick, common in rural areas of Long Island. She had frequent appointments with a doctor specializing in Lyme and anaplasmosis, another tick-borne illness, and believed that she contracted the disease from a rescue dog that was part wolf.[136] But her nephew and godson Dr. Guy Fried, who practices at Thomas Jefferson University Hospital in Philadelphia, doubted that Lyme disease was the cause of her ailments. Elaine agreed to have her symptoms checked out that autumn, and Steve Ross offered to fly her to the hospital in his corporate helicopter. The diagnosis was grim: Elaine's earlier lung cancer had metastasized.

Yet Elaine remained her vivacious and willful self. When Fried—obliged to deliver shattering news to the woman he had adored since childhood—told her the cancer had spread to her shoulder, she said, "The interesting thing about this cancer is, there's never a dull moment!" Elaine refused chemotherapy: "Chemicals that will take away my hair and make me sick? No thank you. I'd rather die looking good and having my wits about me." When Fried sent a doctor to talk to her about pain medication, she climbed out of her bed and demonstrated her t'ai chi exercises. Fried visited her at Thanksgiving, bearing a holiday meal, and friends gathered around her bed. "Elaine set her own rules and had her own priorities in life," he said. "Now that it was proven that she had a deadly condition, she wanted to go home. She wanted to see that Bill was properly cared for. She wanted to finish paintings and work on her autobiography."[137]

Elaine's cave painting show opened at the Fischbach Gallery on November 5. She went to the opening, looking frail—Alcopley was shocked at the deterioration in her health in just twelve weeks—and briefly attended the party Jim Touchton held in her honor at his loft on West 26th Street. "I said, let me throw a party for you," Touchton recalled. He told her she could invite as many people as she wanted. Beginning with twenty names, her list grew to 176

people, including John Cage, Merce Cunningham, John Ashbery—"people who would never [otherwise] come to my loft," Touchton joked. On the day of the party, one of the portraits she had painted of Touchton was delivered to him. On the back of the canvas, she had written, "I love you." Before she left, she told him that they would speak later. But there was to be no "later."

The next day, Elaine checked into Memorial Sloan-Kettering Hospital, in New York. Marjorie remained quietly in charge, greeting visitors. One day, Elaine called her friends Rudy and Yvonne Burckhardt and invited them to drop by. They were shaken to see how ill she looked, but she refused to discuss it. "Let's go on a vacation together," she suggested. "Where would you like to go? How about Machu Picchu?" Rudy said he had already been there. "OK," she replied. "How about some other place?" Yvonne realized that "this was her way of not burdening anybody with her illness."[138]

When blood transfusions failed to improve her condition, she was moved to Southampton Hospital. Now she finally wrote a will.[139] She left the family farm to Marjorie.[140] The Bolinas house would be sold. Her brother Conrad would serve as co-executor of her estate, with Edvard Lieber. Complicating matters was the money Elaine had borrowed from Bill after he was no longer mentally competent (about $500,000, according to his biographers[141]). A friend remembered Elaine's last phone call: "How jolly and chipper she was. How just the same as always."[142] She died on February 1, 1989, eleven days before her seventy-first birthday. Her brother Peter recalled her spirited personality in an emotional letter to friends ("she made us angry…she gave us joy"). In a riff about how her kind of hell-raising moved hell into heaven's sphere, he added, "Heaven might no longer be as safe a place to walk about in as it once was, with Elaine there."[143]

Three days later, a tearful Rev. Stephen Chinlund—her old friend from Grace Church —led the service at Elaine's funeral. As if heeding her positive outlook, sunny spring weather defied forecasts of rain and sleet.[144] The wake was held at Joan Ward's house, an ironic twist that, as Bill's biographers note, would have amused Elaine.[145] Then came a memorial service in August at the East Hampton Guild Hall. The following year, on the night of March 12, Elaine's birthday, several hundred people attended her nearly three-hour memorial service in the Great Hall at Cooper Union in Manhattan. "I think artists' funerals are very much like gangsters' funerals," she once said, alluding to the way so many fellow artists show up, "to pay homage."[146] She would have loved this event; some years earlier, prompted by a TV news broadcast about a family's request that a deceased congressman not be memorialized, she told Edvard Lieber, "When I die, I want tons of eulogies."[147]

Slides of her work from the late forties onward were shown, as well as Hans Namuth's photographs of her and Bill. Art dealer Joan Washburn—who would mount several posthumous exhibitions[148]—read excerpts from her reviews and feature pieces. Among the speakers were Alcopley, Rudy Burckhardt, Herman Cherry, Rosalyn and Sherman Drexler, Connie Fox, Grace Hartigan, Joop Sanders, Barbara Schwartz, and Esteban Vicente.[149] Jim Touchton recalled how he met Elaine, became deeply involved in her life in New York, and accompanied her on far-flung teaching stints. "Elaine always made me feel good," he concluded. "I think that is true for all of us who knew her."[150] Other friends who eulogized Elaine included art dealers Leo Castelli and Tibor de Nagy; poet John Ashbery; art writers Lawrence Campbell, Helen Harrison, Lee Hall, and Rose Slivka; actor and director Tazewell Thompson; Elaine's assistant, Edvard Lieber; her brother Peter Fried; and her goddaughters Denise Lassaw and Patia Rosenberg, who sang a Japanese song.

Hartigan had met Elaine on a visit to Bill's studio in 1948, impressed that "here was a woman…as pretty as I was, married to a great artist and flirting with him." Never one to worry about decorum, she startled the crowd by telling the story about Elaine visiting Joan Ward in the hospital after she had Bill's baby. Praising Elaine as a gifted teacher and brilliant lecturer, Hartigan recalled that, "unbelievable as it may seem," she was once a shy young woman who asked Frank O'Hara to read her talk for her at the Club. "She was fearless and honest," Hartigan said, with "a gift for portraiture like perfect pitch."[151] Hartigan heard from someone who visited Elaine in the hospital that she had dreamed of Aladar saying, "Hurry up Elaine. I've got a lot of clout up here."

Among the statements by friends on the printed program[152] was Slivka's declaration that in Elaine's company, "you got more ideas about whatever you saw and did. And you laughed more." For her, "everything was always new." Ernestine Lassaw wryly summed up the general sentiment: "[Elaine] never disappointed me except when she died."

Bill, who was never told about Elaine's death, was not present at the memorials. He died on March 19, 1997.

WORKS FROM ELAINE'S art collection were auctioned by Christie's New York in November 1989.[153] They included an abstract landscape Bill painted in the late 1920s, his *Portrait of a Woman* (ca. 1940; a figure with Elaine's hair and eyes, and a family resemblance to other de Kooning portraits of her), and his *Woman in Landscape #10* (1968). Also offered for sale were Alex Katz's three-dimensional portrait of Frank O'Hara and an untitled painting from 1956 by Joan Mitchell. While the seven cousins each received some of Elaine's

own work, Conrad stored "hundreds and hundreds" of other pieces in a warehouse in upstate New York, near his Sullivan County home.[154] In 1999, Jennifer McLauchlen, a young friend of Elaine's who had opened a gallery, took collectors to the warehouse to see these works.

And then there was the matter of the journals. For decades, Elaine had a stash of small notebooks—estimates of their number range from one hundred to three hundred—in which she kept a running record of events in her life, dreams she had, places she visited, and observations about people she knew in the art world. Planning to publish the journals, Marjorie had started transcribing the entries written in Elaine's distinctive script.[155]

Charles Fried, who read "bits and pieces" of the notebooks, said that they were "scandalously gossipy about her art friends and enemies." Marjorie's son Luke remembers the journals as "full of…saucy kinds of stuff that people would love to read about. Who slept with whom…[not] under-the-radar secrets, but those things people didn't talk about."[156] His mother once read a passage aloud about a well-known artist whose wife was mentally ill; the artist had given permission for her to receive electroshock treatments and a lobotomy. "My mom said, 'Jeez, do you think it's something I should include in the book? He's still alive,'" Luke recalled. "I said, 'By the time the book comes out, he probably won't be.'" But there would be no book. Elaine's death was too emotionally wrenching for the project to continue, and Marjorie's own health had begun to fail.

After Marjorie's death from ovarian cancer in April 1998,[157] Conrad Fried stored the journals in the warehouse that held the paintings. Then, during the summer of 2002—according to a curiously vague news story in *Art & Auction*[158]—an unnamed "Long Island-based art critic, a one-time intimate of the de Kooning family" discovered that the journals were missing.[159] According to the article, the Getty Museum was said to have entered into negotiations with Elaine's family to acquire the notebooks "for a high six-figure sum."[160] An anonymous source was quoted as saying that the family claimed they had been stolen. Yet months later, the article noted, no complaint had been filed with local police. Conrad moved to an assisted-living facility in Texas in 2006 and died in November 2009;[161] what happened to the journals is anyone's guess.[162]

The next generation of Elaine's family consists of Peter's children, Maud Fried-Goodnight, Clay Fried, and Guy Fried; Conrad's son, Charles Fried; and Marjorie's children: Luke, Michael, and Christopher Jean Pierre (Jempy) Luyckx. Michael Luyckx and Clay Fried became co-trustees of the estate after Edvard Lieber declined this role. Michael was closest to Marjorie, according

to Charles, and he was the one who packed up the contents of her house. Charles has devoted some time to searching for the journals, but their existence remains "a mystery," he said. Luke also said that he has no idea where they might be. "Did one of my brothers take them? I don't know…neither would ever tell me they had them."

The journals would surely make fascinating, gossipy reading. But let's not forget that we have Elaine's deeply considered *published* writings about the art of her time, which represent her most significant and lasting legacy. Perhaps someday they will be reissued in a new edition with the original photographs, introducing more readers to her broadly empathetic understanding of what it means to be an artist. A dozen years before she died, Elaine said, "I don't think artists are creative…it's more in the area of rearranging. You can be influenced by something and make something unique out of it."[163]

AS A PORTRAIT PAINTER, Elaine surely ranks with the best of her generation. Her emphasis on a glimpsed awareness of her sitters' habitual posture is unique to her paintings, and her ability to locate their inner disquiet puts her on the same footing as Alex Katz or Alice Neel. On the other hand, although Abstract Expressionism gave Elaine a painterly freedom, she did not create a distinctive body of work in that style, unlike other members of the so-called second generation of Abstract Expressionists (which includes Norman Bluhm, Michael Goldberg, Grace Hartigan, Alfred Leslie, and Joan Mitchell).

Elaine's serial pursuit of different subjects and stylistic approaches has made her work hard to pigeonhole. (She liked to call herself an "escape artist," impossible to relegate to a category, because "the whole idea of being an artist for me is to investigate and explore."[164]) Yet—from her Black Mountain abstractions of 1948, with their coloristic suavity and puzzle-like shapes, to the radiant hues and fluid draftsmanship of her cave paintings of the 1980s—one element stands out: her ability to infuse abstract and figurative forms with a sense of motion.[165] Capturing movement was the key to her work, whether she was painting basketball players, bulls, or sunlight flickering on a statue in the Jardin de Luxembourg.

She also left a vital legacy of another kind, related to her writing yet on a more universal level. Elaine stood apart from the cruelly competitive world of art. Her insights, nudges, praise, and support touched many lives, building confidence and providing connections. By her example, she encouraged others to see the world freshly and revel in its possibilities, as a bulwark against injustice and despair.

ELAINE ONCE TOOK Jim Touchton on a tour of the Green River Cemetery in The Springs, joking that "all the artists here are just dying to get into this cemetery." She is buried there, along with a roll call of celebrated twentieth-century artists and writers, including Jackson Pollock, Ibram Lassaw, Stuart Davis, Ad Reinhardt, James Brooks, Lee Krasner, Alfonso Ossorio, Frank O'Hara, Harold Rosenberg—but not Bill, who was cremated. "I know what I want," Elaine once said. "If I have my own way, I'm fine."[166] Even in death, she went her own way.

Acknowledgments

I AM BEHOLDEN to many people whose kind assistance has made my book possible. My heartfelt thanks go to those whose information, advice, and memories of Elaine helped smooth my path early on: Brandon Brame Fortune, chief curator, National Portrait Gallery; Helen Harrison, director, Pollock-Krasner House & Study Center; Jim Levis, director, Levis Fine Art, Inc.; artist Connie Fox; poet Margaret Randall; Elaine de Kooning's niece, Maud Fried-Goodnight; and her nephews Charles Fried, Clay Fried, Dr. Guy Fried, and Luke Luyckx.

I am deeply grateful to my perceptive and unflappable agent, Emily Forland, at Brandt & Hochman, and to the terrific team at Oxford University Press, particularly my steadfastly supportive editor, Norm Hirschy; Joellyn Ausanka, senior production editor; Lauralee Yeary, editorial assistant; and Carole Berglie, copyeditor.

As is so often the case in biography, I frequently relied on the prodigious research displayed in an earlier volume: *de Kooning: An American Master*, by Mark Stevens and Annalyn Swan, winner of the 2004 National Book Critics Circle Award and 2005 Pulitzer Prize. With great generosity, Annalyn allowed me to read transcripts of crucial interviews with two people who are no longer living.

Other individuals who have provided crucial information (including photographs) include, in alphabetical order: Patricia Albers, Jacob Burckhardt, Yvonne Burckhardt, Bill Berkson, Kathan Brown, Arlene Bujese, Jim Bohary, Chris Byrne, Lawrence Castagna, Megan and Scott Chaskey, William Conger, Tom Ferrara, Brewster E. Fitz, Carolyn Fitz, Paul W. Frets, Mary Gabriel, Mimi Gross, Marguerite and Paul Harris, Dr. Gerry Jacquette, Guy Kaldis, Rita Katz, Tim Keane, Alex Kline, Denise Lassaw, Emily Mason, Jennifer

McLauchlen, Maureen O'Hara, Roger Peacock, Amy Pilkington, Toni Ross, Joop Sanders, Art Schade, David Shapiro, Patterson Sims, Celia Stahr, Judith Stein, Jim Touchton, Walter Weissman, Wayne Thiebaud, Wolf Kahn, and Athos Zacharias.

I owe a great debt to libraries and archives, and the staff members whose patient and knowledgeable assistance have made my research a pleasure: Anne Bremer Memorial Library, San Francisco Art Institute: Lauren MacDonald, head librarian; Archives of American Art: Marisa Bourgoin, Richard Manoogian Chief of References Services; Beinecke Library, Yale University: Mary Ellen Budney, public services assistant; Brooklyn Historical Society, Katie Bednark, public services intern; Center for Southwest Research & Special Collections, Zimmerman Library, University of New Mexico: Mary Alice Tsosie, program manager, and Dina Barajas, research fellow; East Hampton (New York) Public Library: Gina Piastuck, department head, Long Island Collection; Emory University Manuscript, Archives, and Rare Book Library: Kathy Schoemaker, reference coordinator, research services; Fales Library, New York University: Emily King and Laurainne Ojo-Okikuare, reference librarians; Glendale (California) Public Library: Bryan Griest and Keith Kesler, librarians; Dobkin Family Collection of Feminism, Glenn Horowitz Bookseller Inc.; Harry S. Truman Library & Museum, Jim Armistead, archives specialist; Joan Mitchell Foundation, Laura Morris, archivist; The Josef and Anni Albers Foundation: Anne Sisco, office manager; LTV, East Hampton: Genie Henderson, archivist; New York Library for the Performing Arts; Northwestern University Music Library: Alan Akers, research services assistant; Philadelphia Museum of Art: Susan K. Anderson, Martha Hamilton Morris Archivist; Thomas J. Watson and Nolen libraries, Metropolitan Museum of Art; State Archives of North Carolina: Heather South, lead archivist; Western History Collection, University of Oklahoma; and the Willem de Kooning Foundation.

I also want to thank some special people for support of many kinds: Judith Stein, Patricia Albers, Deirdre A. David, John Richetti, Will Swift, Brian Jay Jones, Marc Leepson, Linda Leavell, Heath Hardage Lee, Svetlana Alpers, Rachel Gibson, Peter Anthony and Fred Schwartz, Alexandra Lightning, Pamela Lindberg, Meredith and Michael Shedd-Driskel, Katie Mills, Rick Bolton, Jim Leeke, Charlie Gray, Janice Page, Joan Fantazia, and Janelle Hernandez.

Please note: Reasonable efforts have been made to contact copyright owners of photographs; if additional acknowledgments are needed, they will be made in future editions.

Notes

FRONTMATTER

1. I call Elaine by her first name throughout this book to differentiate her from her husband, Willem de Kooning, who was known to friends as "Bill."
2. A book published several decades ago that purports to chronicle the de Kooning marriage is heavy on unsubstantiated gossip, thin on documented facts.

CHAPTER I

1. Elaine de Kooning interview with Minna Daniel. Editor of *Modern Music*, the quarterly journal of the League of Composers, Daniel was married to painter Mell Daniel.
2. Elaine de Kooning interview with Charles Hayes.
3. Elaine de Kooning interview with Molly Barnes (radio broadcast).
4. Elaine de Kooning interview with Charles Hayes.
5. *The Horse Fair* (1852–1855).
6. *Mother and Daughter* (1799), a self-portrait, showing Vigeé-Lebrun embracing her young daughter Jeanne Lucie Louise.
7. *The Creation of Adam.* Sometimes, Elaine mentioned Rembrandt (without specifying the painting) in addition to, or instead of, Michelangelo.
8. Elaine said she used to think that the Raphael—this was probably his famous *Sistine Madonna* (1513–1514), in which baby Jesus has a girlish appearance—was a portrait of herself and her mother. Eleanor Munro, *Originals: American Women Artists*, 250.
9. Elaine de Kooning interview with Molly Barnes (radio broadcast).
10. Elaine de Kooning interview with Ann Gibson.
11. The median age for women in 1915 was less than twenty-three years, according to the U.S. Census. At www.census.gov/hhes/socdemo/marriage/data/acs/Elliottetal PAA2012figs.pdf.

12. Elaine said that Marie entered Hunter College to study law but dropped out when she was pregnant with Elaine (Munro, *Originals*, 251). This is unlikely; the college did not confer law degrees.

13. Conrad Fried said that Charles didn't speak English until he entered grade school. Conrad Fried interview with Mark Stevens and Annalyn Swan, May 31 and June 1, 1995.

14. In 1925, Charles Fried passed up the chance to join his friend Raoul Fleischmann, general manager of the baking company owned by his family, in a chancy-sounding new venture: *The New Yorker* magazine.

15. Munro, *Originals*, 250.

16. Elaine de Kooning, draft of a conversation with Eleanor Munro.

17. Munro, *Originals*, 249. The address was 1308 East 16th Street, according to the 1920 U.S. Census and the 1938 Brooklyn directory. Mark Stevens and Annalyn Swan (*de Kooning*, 156) incorrectly cite the address as 2308 East 14th Street.

18. It is unlikely that the reason would have been Armed Forces service in World War I. Charles's draft registration card for World War I is dated September 12, 1918, two months before the armistice was signed, on November 11, 1918.

19. At a party, someone who saw the four siblings together thought they were two married couples. Stevens and Swan, *de Kooning*, 158.

20. The Fried marriage predated by two years the 1917 Code of Canon Law, which promulgated this requirement.

21. In one interview, Elaine called her mother a lapsed Catholic who was actively anti-church, but if that were true, her children would not have been attending catechism class.

22. Henry Collins Brown, *Valentine's City of New York*.

23. Cultural resources in the 1920s included the Brooklyn Museum (then part of the Brooklyn Institute of Arts and Sciences), Pratt Institute, Brooklyn Academy of Music, art clubs, and dramatic societies.

24. Marjorie Luyckx interview with Mark Stevens and Annalyn Swan, June 14, 1994. All quotes from Marjorie in this chapter are from this interview unless otherwise specified.

25. Elaine de Kooning interview with Charles Hayes.

26. Stevens and Swan, *de Kooning*, 156.

27. Marjorie Luyckx interview.

28. Conrad Fried interview with Mark Stevens and Annalyn Swan.

29. Fellow Brooklyn-reared artist Jane Freilicher and painter Joop Sanders. Stevens and Swan, *de Kooning*, 156.

30. Elaine de Kooning interview with Minna Daniel.

31. Edith Burckhardt, *The Loft Generation*, unpaginated.

32. Elaine de Kooning interview with Charles Hayes. The usual invocation at that time was "the starving Armenians"—a reference to the aftermath of atrocities committed against Armenians in the Ottoman Empire between 1915 and 1918—so she may misremembered the phrase.

33. Stevens and Swan (*de Kooning*) credit family members for identifying the institution as Creedmoor. Founded in 1912 on a farm, with the idea that fresh air and a serene environment would be beneficial to patients, it developed a reputation for crowdedness and lack of sufficient staff decades later. Decades later, Elaine's nephew Clay Fried was told that Marie was taken somewhere where she "was allowed to sort through and settle down a lot of her issues, and came out as a whole human being." Author's interview with Clay Fried, Washington, D.C., March 13, 2015.

34. Conrad Fried interview with Mark Stevens and Annalyn Swan.

35. Ibid.

36. Stevens and Swan, *de Kooning*, 158.

37. Elaine de Kooning interview with Minna Daniel.

38. Ibid. The woman was artist Hazel McKinley (1903–1995), sister of Peggy Guggenheim. In October 1928, she was with her two sons, ages fourteen months and four and a half years (from the second of her four marriages), when they fell from the roof of the Surrey apartment-hotel on 76th Street onto a neighboring building. The deaths were pronounced accidental; McKinley, who was said to have spent some time afterward in a sanatorium, was not prosecuted. According to John H. Davis, *The Guggenheims: An American Epic* (New York: SPI Books, 1994, 328), the Guggenheim family bribed officials to achieve this result. The previous year, Hazel's older sister Benita had committed suicide in 1927 by jumping off a building.

39. Willem de Kooning, in Amei Wallach, "De Kooning Seeks Simplicity," 22.

40. Elaine de Kooning interview with Charles Hayes.

41. The biblical strongman's vulnerabilities were his long hair (he was powerless without it) and his attraction to the temptress Delilah, who maneuvered to have it shaved off and delivered him to his enemies.

42. Marjorie Luyckx interview.

43. He would become an inventor while continuing to paint in his free time.

44. "Elaine de Kooning," in Munro, *Originals*, 251.

45. Elaine de Kooning interview with Molly Barnes (radio broadcast).

46. Elaine de Kooning, in Candace Leigh, "Elaine de Kooning."

47. Elaine de Kooning, in Thomas B. Hess and Elizabeth C. Baker, *Art and Sexual Politics*, 68.

48. Lillie P. Bliss (1864–1931) was a leading art collector who loaned work to the Armory Show, served as deputy to A. Conger Goodyear (first chairman of the board of the Museum of Modern Art), and bequeathed 150 works to create a foundation collection for the museum.

49. Elaine de Kooning interview with Charles Hayes.

50. Elaine de Kooning interview with Molly Barnes (radio broadcast).

51. Ibid.

52. Didrikson (1911–1956) later became the first U.S. woman golf celebrity.

53. Elaine de Kooning interview with Charles Hayes.

54. Elaine de Kooning, in Richard Brown, "Artist's Work Reflects Intensity."

55. Elaine de Kooning, draft of a conversation with Eleanor Munro.

56. Marjorie Luyckx interview. Another of Marie's educational experiments consisted of sending Conrad to the best high school in New York for one year, followed by a year at the worst one. Author's telephone interview with Conrad's son Charles Fried, December 19, 2014.

57. *The Academy*, January 1936 yearbook of Erasmus Hall High School.

58. The quote is from Alfred Lord Tennyson's poem "Lancelot and Elaine." This Elaine is a lovely young woman infatuated with the married Lancelot, who leaves his shield with her so that he can take part in a tournament without being recognized. She gives him a token to wear in his helmet. When she hears that he is wounded, she searches for him and patiently nurses him back to health, always hoping that his love for her equals hers for him. But Lancelot tells her that they cannot marry. Heartbroken, she starves herself and dies. He spies her funeral barge and discovers that she clutches a letter in her hand lamenting her hopeless love. Did Elaine de Kooning pine for a fellow schoolmate, or was the quote just meant as a tribute to her beauty?

59. Barbara Stanwyck (1907–1990) was also a Brooklyn native.

60. Elaine de Kooning interview with John Jonas Gruen.

61. Information about the Leonardo da Vinci School from Joseph Sciorra and Peter Vellon, *The Art of Freedom*. The school was originally at 288 East 10th Street; it moved to East 34th Street in 1934.

62. Elaine de Kooning interview with John Jonas Gruen.

63. Milton Resnick (1917–2004) worked in both the Easel and the Mural divisions of the Federal Art Project. After serving in World War II, he spent three years in Paris. In 1948, when he returned to New York, he used his G.I. benefit to study with Hans Hofmann.

64. "Resnick Interviews," in Geoffrey Dorfman, *Out of the Picture*, 14.

65. Central Art Supply sold canvas for twenty-five dollars a roll; artists would put down five dollars at a time until they had paid for it and could take it home. Behlen's, on Sixth Avenue and 8th Street, sold a gallon of white paint for three dollars (Milton Resnick and Pat Passlof, oral history interview).

66. In the early 1950s, Elaine bravely defied McCarthy era paranoia to attend Harold Rosenberg's lectures on Marxism at The New School for Social Research. The other two students were FBI agents ("Passlof Remembers," in Dorfman, *Out of the Picture*, 305).

67. Beginning in November 1937, the fee was five dollars a month. Virginia Hagelstein Marquardt, "The American Artists School," 23n33.

68. Ibid., 18.

69. "American Artists School," *Art Front*, September-October 1937, 19, quoted in Marquardt, "The American Artists School," 19.

70. Munro, *Originals*, 252.

71. Milton Hebald (1917–2015) was a sculptor of monumental bronze figures. Ben Wilson (1913–2001) was painting in an expressionistic style in the late thirties,

preoccupied with themes of war and futility. Elaine's paintings of victims of the Spanish Civil War may have been influenced by his work. Russian-born Nahum Tschacbasov (1899–1984) was painting social satires in the late thirties and exhibiting his work at ACA Gallery.

72. Elaine de Kooning, C.F.S. Hancock Lecture.

73. Munro, *Originals*, 252.

74. Betty Comden (1917–2006) attended Erasmus Hall High School; she and Elaine may have known each other from that period.

75. Robert Jonas later became an illustrator and art director for Penguin Books.

76. Jane Freilicher, in Stevens and Swan, *de Kooning*, 160.

77. Elaine de Kooning interview with Molly Barnes (radio broadcast).

78. Elaine de Kooning interview with John Jonas Gruen.

79. Burckhardt, *The Loft Generation*.

80. Marjorie Luyckx interview.

81. According to Edvard Lieber, *Willem de Kooning: Reflections in the Studio*, 118.

82. Stevens and Swan, *de Kooning*, 154.

83. Elaine de Kooning, in Bert Schierbeek, *Willem de Kooning, A Portrait*, 18.

84. The Academie van Beeldende Kunsten en Technische Wetenschappen was renamed Willem de Kooning Academy in 1998.

85. According to Stevens and Swan, *de Kooning*, 92, the Capehart high fidelity system cost seven hundred dollars—about $12,000 in today's money—more than half de Kooning's annual salary; he had to take an advance to cover the cost. Sadly, he had to leave the hi-fi behind when he and Elaine were evicted from the 22nd Street loft.

86. Willem de Kooning became a U.S. citizen in 1962.

87. A year or two before Diaz died, Elaine gave her one of Bill's paintings. Learning that Diaz was destitute and didn't have a TV, she bought her one. Marjorie Luyckx interview.

88. She later claimed that when she asked why he always painted bald men, he said, "I don't understand hair." Elaine de Kooning, in Curtis Bill Pepper, "The Indomitable de Kooning," 43.

89. Pepper, "Indomitable de Kooning," 43.

90. Burckhardt, *The Loft Generation*. Elaine's style was a model for Grace Hartigan, who met her in 1948 and resolved—as she said later—to stop wearing grubby studio clothes in public.

91. The name of this stretch of Fourth Avenue was changed to Park Avenue South in 1959.

92. Ernestine Lassaw, in Ernestine Lassaw, *Pat Passlof/Milton Resnick 1917–2004*, 72.

93. Elaine sometimes referred to the women as "Chinese mothers," but the social relevance was similar: Japan invaded China in July 1937; during the Nanking Massacre the following December and January thousands of civilians were tortured and raped.

94. Munro, *Originals*, 253.

95. Elaine de Kooning, draft of a conversation with Eleanor Munro.

96. Elaine de Kooning interview with Jeffrey Potter.

97. Rick Setlowe, "The Pied Piper with a Palette," 10.
98. Elaine de Kooning, in *Strokes of Genius: de Kooning on de Kooning*. Rudy Burckhardt shared this sensibility; in an interview, he mentioned that he paid attention to the way a cigarette "lies on the pavement around it, and other spots on the pavement." See "Rudy Burckhardt and Edwin Denby in Conversation with Joe Giordano," ca. 1976; at http://jacketmagazine.com/21/denb-giord.html.
99. Quoted in Carol Strickland, "Shining a Light on the Other de Kooning."
100. Elaine de Kooning interview with Molly Barnes (radio broadcast).
101. Elaine de Kooning interview with Karl E. Fortress.
102. Red Grooms, "When de Kooning Was King."
103. Elaine de Kooning, in Nouritza Matoosian, *Black Angel: The Life of Arshile Gorky*, 273–74.
104. Bill's swollen knee sent him to the hospital; he was depressed to find out that recommended surgery might shorten the leg. Elaine and Gorky saved him from this fate by bringing him back to the loft. Lieber, *Willem de Kooning*, 19–20.
105. According to Agnes Magruder, who overheard this complaint of Elaine's. Matoosian, *Black Angel*, 300.
106. Elaine de Kooning interview with Judith Stein and Paul Schimmel.
107. Information about Elaine's continued involvement with Resnick comes from Pat Passlof, the artist he lived with in the mid-fifties and married in 1962. Stevens and Swan, *de Kooning*, 649 n163.
108. The de Koonings also learned about European developments from the French magazine *Cahiers d'Art*, which they read whenever they could borrow a copy.
109. The bombing was an experiment by the Condor Legion, an adjunct of the German Luftwaffe, to see how much force was needed to level a city. Some 1,650 people died in the attack. (The German forces were allied with General Franco against the Spanish Nationalists.)
110. Varèse returned from the United States to his native France in 1928, after a decade in this country; he came back in 1934 but did not settle in New York again until late 1938.
111. Ernestine Lassaw, in Stevens and Swan, *de Kooning*, 162. (Ernestine Blumberg married sculptor Ibram Lassaw.)
112. Marjorie Luyckx interview. She had read this letter from Bill to Elaine.
113. Stevens and Swan, *de Kooning*, 162.
114. Ibid.
115. Elaine de Kooning interview with Ann Gibson.
116. Ibid.

CHAPTER 2

1. Elaine de Kooning, in John Gruen, *The Party's Over Now*, 207–208.
2. Conrad Fried interview with Mark Stevens and Annalyn Swan. All quotes from Conrad Fried in this chapter are from this interview.

3. Ibid. He said this outing may have occurred in 1940.

4. In her November 21, 1969, interview with John Jonas Gruen, Elaine said that her mother was against marriage because it "betrayed some sacred trust." She refused to explain further. Confusingly, Elaine also said that her mother told the children not to marry before the age of forty. It's likely that Marie's jaundiced view was colored by the mismatch of personalities and interests in her own marriage.

5. Mark Stevens and Annalyn Swan, *de Kooning,* 197.

6. Biala Tworkovsky—her first name was changed to Janice after the family immigrated to the United States; she later changed her last name to Tworkov—was born in 1902; Biala was the Polish village of her birth. She died in 2000 after a noteworthy career as a painter of interiors, still lifes, and other subjects, in a style poised between figuration and abstraction. Her brother was the Abstract Expressionist painter Jack Tworkov. Most of her quoted remarks about Elaine are negative, unlike those of others who knew her at the time, suggesting some underlying friction between the two women. Daniel Brustlein signed his *New Yorker* cartoons "Alain."

7. Elaine de Kooning, in Gruen, *Party's Over Now,* 208.

8. See danielbrustlein.com/2014/05/new-website-dedicated-to-the-life-and-work-of-daniel-alain-brustlien

9. Marjorie Luyckx interview with Mark Stevens and Annalyn Swan. All quotes from Marjorie in this chapter are from this interview.

10. Ibid.

11. Elaine de Kooning interview with Ellen Auerbach.

12. Ibid.

13. Conrad Fried interview.

14. Elaine de Kooning interview with Ellen Auerbach.

15. Elaine de Kooning, C.F.S. Hancock Lecture.

16. Helen A. Harrison, "Witness to Immanent Drama: Elaine de Kooning and the New York School."

17. Elaine de Kooning interview with Antonia Zara.

18. Elaine de Kooning interview with Judith Stein and Paul Schimmel. It isn't clear which self-portrait she is talking about.

19. Henri Matisse, who died in 1954, began to collect Kuba textiles during the last decade of his life. It is not clear how Elaine would have known about this in 1946, other than from having seen a photograph of his studio. She may have discovered this textile on her own, without knowing about the Matisse connection.

20. Marjorie Luyckx interview.

21. Two of these *Self-Portrait* sketches, shown in the exhibition Elaine de Kooning Portrayed (Pollock-Krasner House & Study Center, August 6–October 31, 2015) are now in private collections.

22. Elaine de Kooning, in Gruen, *Party's Over Now,* 213.

23. See Sherwood Anderson, "A Reporter at Large: Stewart's On the Square," *The New Yorker,* June 9, 1934, 77–80. Patrons of Stewart's Cafeteria also included Alcoholics

Anonymous founder Bill Wilson and friends, members of the Oxford Group, a precursor of A.A.

24. At the Automats, you inserted nickels into a slot next to the prepared food you wanted—visible through a small glass door—and raised the door to remove your selection.

25. Elaine de Kooning interview with Arthur Tobier.

26. Ibid.

27. John Myers, *Tracking the Marvelous*, 98, 100–101.

28. Conrad Fried interview. "Joop" was their artist friend Joop Sanders.

29. Elaine de Kooning interview with Arthur Tobier.

30. She also paid Bill de Kooning fifty dollars to paint a 17-by-24-foot backdrop for one of her performances. Stevens and Swan, *de Kooning*, 226.

31. Elaine de Kooning, in Gruen, *Party's Over Now*, 215.

32. These sketches were related to Bill's exquisite pencil drawing of Elaine from ca. 1940–41.

33. Elaine de Kooning, in Curtis Bill Pepper, "The Indomitable de Kooning."

34. She also tried her hand at commercial work, including a sketch for a version of the Penguin Books logo.

35. Conrad Fried interview.

36. The de Koonings were introduced to Porter by Edwin Denby in late 1939. The painting was based on Elaine's modeling photos. Gruen, *Party's Over Now*, 209.

37. Stevens and Swan, *de Kooning*, 269.

38. Ibid. 236–37.

39. Ibid., 237.

40. Ibid., 237.

41. Ibid., 237. It's not clear whether this complaint was voiced by Bill's later lover Joan Ward or by someone else.

42. Elaine de Kooning interview with Molly Barnes (radio broadcast).

43. Alex Katz, "Starting Out," 4.

44. Elaine de Kooning interview with Ellen Auerbach.

45. Elaine de Kooning, in Gruen, *Party's Over Now*, 216.

46. Gruen, *Party's Over Now*, 214.

47. Conrad Fried interview.

48. Elaine de Kooning interview with Antonia Zara.

49. Ibid.

50. Elaine de Kooning interview with Charles Hayes.

51. Elaine de Kooning interview with Judith Stein and Paul Schimmel.

52. Elaine de Kooning interview with Minna Daniel.

53. Stevens and Swan, *de Kooning*, 214. Elaine's trips to Provincetown are not always possible to pin down accurately, though her stay there in 1949 can be corroborated by letters and the memories of others.

54. Elaine de Kooning, in Gruen, *Party's Over Now*, 211.

55. Elaine de Kooning interview with Molly Barnes (radio broadcast).

56. Elaine de Kooning interview with John Jonas Gruen.

57. Reliably unreliable when it came to dates, Elaine misremembered the date of the move as 1948 in interviews. Stevens and Swan—whose information came from her brother Conrad and a 1946 photograph that shows Bill already ensconced in his Fourth Avenue studio—wrote (*de Kooning*, 652, n214) that the move likely took place in December 1944 or early 1945.

58. Marjorie Luyckx interview

59. Elaine de Kooning interview with Arthur Tobier.

60. Conrad Fried interview.

61. In fall 1952, he would move again, to 88 East 10th Street, which became the nexus of an unofficial artists' colony and began to attract adventurous art galleries.

62. Marjorie Luyckx interview. According to her, Elaine did want children but deferred to Bill, who did not. Conrad Fried, in his interview with Stevens and Swan, said that Bill did want children.

63. Author's interview with Clay Fried, Washington, D.C., March 13, 2015.

64. Elaine de Kooning interview with Ann Gibson.

65. Marjorie Luyckx interview.

66. Author's telephone interview with Margaret Randall, January 7, 2015.

67. Author's telephone interview with Emily Mason, December 1, 2015.

68. Elaine de Kooning oral history interview.

69. Conrad Fried interview.

70. Elaine de Kooning oral history interview. She does not name the painting Bill was working on, but if she was correct in dating it to the year after the couple were at Black Mountain, *Attic* seems to fit the bill. (Confusingly, she also says that Bill "later" titled a painting *Light in August*, after Faulkner's novel. But that work dates from 1946.)

71. The nightclub, at Sheridan Square in Greenwich Village, was known as Café Society Downtown beginning in 1940, when an uptown branch opened.

72. Founded in 1933–34, the Artists Union flourished only until 1942.

73. Elaine de Kooning, "Mike Loew Memorial," Elaine de Kooning Papers, AAA. Michael Loew (1907–1985) was an abstract painter influenced by the grid style of Piet Mondrian.

74. Today, Sixth Avenue is known as Avenue of the Americas.

75. Elaine de Kooning oral history interview.

76. Natalie Edgar, *Club Without Walls*, 15.

77. From *The Subjects of the Artist Catalogue for 1948–49*, Joseph Cornell Papers, AAA.

78. Studio 35 lasted only until spring 1950; at a three-day concluding conference, open only to artists, it was determined that the evening sessions had grown tedious, largely because the general public kept asking the same questions.

79. Alcopley (Alfred L. Copley, 1910–1992) recalled that there were a dozen charter members, whom he named as de Kooning, Lassaw, Pavia, Kline, Marca-Relli, Landes Lewitin, Giorgio Cavallon, Milton Resnick, Joop Sanders, James Rosati, Jan

Roelants, and himself. "The Club: Its First Three Years," in *Issue: A Journal for Artists* #4 (New York: Reflex Horizons, n.d.). Thanks to Denise Lassaw for providing a copy of this article. Alcopley's recollections differ in several respects from Pavia's. However, because Pavia was the Club's treasurer and early chronicler, I believe his information is more reliable. See Edgar, *Club Without Walls.*

80. Esteban Vicente, Oral history interview, March 11, 1968, AAA.

81. Thomas Hess, "When Art Talk Was a Fine Art," 83.

82. Elaine de Kooning oral history interview.

83. Philip Pavia, in Edgar, *Club Without Walls,* 10.

84. Ibid., 64.

85. Ibid., 59. Visits by the police would have been related to the Club's non-manufacturing use of the loft space.

86. Author's telephone interview with Alex Katz, December 22, 2015.

87. Philip Pavia, in Edgar, *Club Without Walls,* 82.

88. Alfred Leslie interview with Celia Stahr. (Leslie has been hard of hearing all his life, but he said he had "a very particular kind of perception of the characteristics of people's speech.")

89. Adolph Gottlieb (1903–1974) was a leading Abstract Expressionist. Harry Holtzman (1912–1987) was a founding member of the American Abstract Artists who joined the Club in 1950. He served as executor of Piet Mondrian's estate. Burgoyne Diller (1906–1965) was influenced by the de Stijl movement; he was a founding member of the American Abstract Artists and directed the Mural Division of the Federal Art Project. Peter Busa (1914–1985) was an abstract painter influenced by Native American art who showed with Peggy Guggenheim's Art of This Century Gallery in the 1940s.

90. Raymond Hendler (1923–1998) had recently returned from Paris, where he was associated with the Surrealists. Frederick Kiesler (1890–1965), designer of the exhibitions at Peggy Guggenheim's Art of This Century Gallery, sometime architect, and (later) sculptor, immigrated to New York from Vienna in 1926. Emmanuel Navaretta (1914–1977) was a poet, painter, and art teacher. Lionel Abel (1910–2001) was a playwright, essayist, translator, and theatre critic.

91. Alfred L. Copley (1910–1992) was also a hemorheologist—a scientist who studies the properties of blood.

92. Alcopley, in *Elaine de Kooning: Portraits,* 13–14 (exhibition catalogue, Brooklyn College Art Gallery).

93. Frank O'Hara, "Nature and the New Painting," collected in O'Hara, *Standing Still and Walking in New York,* 41–51.

94. In Elaine de Kooning, *The Spirit of Abstract Expressionism,* 177–83. Published in 1959, this piece included Elaine's tongue-in-cheek note explaining that she wrote the original script based on "three evenings of private discussion" among the panel members (Elaine, Joan Mitchell, Frank O'Hara, Mike Goldberg, and Norman Bluhm). She paid "careful attention to misattribution and misquotation in keeping with the spirit of the art world," yet "some of the quotes . . . are accurate."

95. Irving Sandler, *A Sweeper-Up After Art*, 37. Before the Club was formed, the Waldorf Cafeteria gatherings occasionally included one black artist, Beauford Delaney (1901–1979), who would move to Paris in the 1950s.

96. Wayne Thiebaud, oral history interview.

97. Ibid.

98. Harold Rosenberg, "Tenth Street: A Geography of Modern Art." Walter Silver shot most of the outdoor photos.

99. Gruen, *Party's Over Now*, 217.

100. Elaine de Kooning interview with Irving Sandler.

101. Gruen, *Party's Over Now*, 207–208.

CHAPTER 3

1. Two years earlier, he was in a group show at the gallery that also included Josef Albers, Mark Rothko, Joseph Stella, Paul Klee, and Georges Braque.

2. Charles Stuckey, "Bill de Kooning and Joe Christmas," 70–71. (The painting *Orestes* had already been titled by editors at *The Tiger's Eye* magazine, when they reproduced it in the March issue.)

3. The following year, when Bill wanted to title one of his paintings "Interior," Elaine put her foot down. He had to name a specific room. So Bill said "Attic, because you put everything in it." Judith Zilczer, *A Way of Living*, 91n89.

4. Elaine de Kooning interview with Antonia Zara.

5. Elaine de Kooning interview with Amei Wallach.

6. Elaine de Kooning, "de Kooning Memories," 352. At some point—possibly after the show closed—there were three sales (dates are unknown).

7. From 1919 to 1933, the Bauhaus was a leading force for modernism, pioneering the integration of fine art, craft, and technology.

8. Sculptor Peter Grippe later said he had recommended Bill, "a painter who is starving," to Albers. Mark Stevens and Annalyn Swan, *de Kooning*, 254.

9. Elaine de Kooning, "de Kooning Memories," 352. The seventy-four students, ranging from teenagers to World War II veterans, each paid $350 for the summer session and were also expected to help with chores.

10. Ibid., 353.

11. Helen Frankenthaler interview with Barbara Rose. Frankenthaler had come to Black Mountain College because her then-lover Clement Greenberg was teaching there. See also Helen Frankenthaler, "A Few Days at Black Mountain," in Mervin Lane, ed., *Black Mountain College*, 279–80.

12. Elaine De Kooning, "de Kooning Memories," 394.

13. Ibid.

14. Pat Passlof, "1948: The Author Studies, 229; also cited in John Elderfield, *de Kooning: A Retrospective*, 190 [museum catalogue].) Two years later, as chair of the Department of Design at Yale, Albers would invite Bill to deliver

twice-weekly crits to student painters. Bill bowed out after two semesters; teaching was a métier that Elaine—a guest instructor at Yale in 1967—would find much more appealing.

15. Dome height according to Eva Diaz, *The Experimenters*, 116. It was to be fifty feet high, according to Martin Duberman, *Black Mountain*, 298. Duberman interviewed Fuller in 1969.

16. Duberman, *Black* Mountain, 298.

17. Elaine de Kooning interview with John Jonas Gruen.

18. Buckminster Fuller quote recalled by John Cage, in Kenneth Silverman, *Begin Again*, 74–75.

19. Elaine de Kooning interview with Judith Stein and Paul Schimmel.

20. Ray Johnson (1927–1995) was fascinated with the random and ephemeral; he worked primarily in collage and was an early conceptual and performance artist and a pioneer of mail art.

21. Edvard Lieber, *Willem de Kooning*, 33. Before the fast-food era, Americans often used utensils to eat a hamburger when dining out; many Europeans still do.

22. Peter Grippe and his wife Florence, in Stevens and Swan, *de Kooning*, 260. They also supplied the information about Bill sleeping in a dormitory.

23. Elaine de Kooning interview with Minna Daniel.

24. Helen Molesworth, *Leap Before You Look*, 253. "Solo for Piano, for Elaine de Kooning," 1958, can be heard on *John Cage: Complete Piano Music, Vol. 4: Pieces 1950–1960*, Steffen Schleiermacher, piano (Dabringhaus & Grimm MDG 613 0787-2); and *John Cage: Piano Works*, also with Schleiermacher as pianist (Phil. harmonie 06026). Elaine would remain at least tangentially connected with musical life in New York; in November 1985, she was photographed with Louise Nevelson at Aaron Copland's eighty-fifth birthday party, held after a program of his works at Avery Fisher Hall, conducted by Leonard Bernstein.

25. An alternate version has V.V. Rankine (known as Bunny), sister-in-law of the painter's wife, reading a newspaper story about the suicide that her mother had mailed to her.

26. Passlof, "1948: The Author Studies," 229.

27. Mary Caroline Richards, a literature and writing teacher married to another faculty member, translated the play.

28. In the French production, Frisette had been played by composer Darius Milhaud's wife Madeleine, an actress.

29. Elaine de Kooning, "de Kooning Memories," 394.

30. In 1962, Elaine came to Cunningham and Cage's rescue, helping to assemble donations of art for a sale to subsidize a prospective Broadway engagement for the Cunningham dance company. That goal was unsuccessful, but the effort raised about $45,000 (nearly $300,000 in today's money) to finance the company's six-month world tour.

31. Elaine de Kooning, "de Kooning Memories," 394.

32. Carol Strickland, "Shining a Light on the Other de Kooning."

33. In Graves's version of the myth, published in 1948 in his book *The White Goddess*, the Great Goddess took the form of a snake and copulated with the World-Snake Ophion. The issue of this union was the world, split open by Helios, the sun god.

34. Frank O'Hara, "Larry Rivers: A Memoir," in *Standing Still and Walking in New York*, 170.

35. In 1991, the Metropolitan Museum of Art purchased the Black Mountain painting *Untitled No. 15* from the Washburn Gallery, where Black Mountain Paintings from 1948 was on view from October 1 to November 30, 1991.

36. Lawrence Campbell, "Elaine de Kooning at Washburn," 116.

37. Roberta Smith, "17 Paintings by Elaine de Kooning," C28.

38. L. M. M. [Lisa M. Messenger], "Elaine de Kooning, *Untitled Number 15*," 68.

39. Lieber, *Willem de Kooning*, 33.

40. Elaine de Kooning, "de Kooning Memories," 394.

41. Stevens and Swan, *de Kooning*, 263. Bill introduced Passlof to Milton Resnick that fall; they became a couple and married in 1962.

42. Elaine de Kooning, "de Kooning Memories," 394.

43. Conrad Fried interview with Mark Stevens and Annalyn Swan.

44. Helen Frankenthaler interview with Barbara Rose.

45. Egan's wife, Betsy Duhrssen, later divorced him.

46. Stevens and Swan, *de Kooning*, 272.

47. Based on John Gruen's interview in 1969 with Willem de Kooning, in Gruen's *The Party's Over Now*, 224. Gruen paraphrases this part of the interview rather than quoting Bill directly.

48. Stevens and Swan, *de Kooning*, 253.

49. Bill quoted in Selden Rodman, *Conversations with Artists*, 102.

50. See Robert Genter, *Late Modernism*, 236–70, 254–55.

51. Willem de Kooning, in Rodman, *Conversations with Artists*, 102.

52. Unpublished interview from *Time* magazine background file, "An Analysis of Abstract Expressionism, Its Meaning, the Major Figures," July 20, 1958, quoted in Stevens and Swan, *de Kooning*, 341.

53. Paul Schimmel, "The Women," in Paul Schimmel and Judith Stein, *The Figurative Fifties*, 56 (exhibition catalogue).

54. In Elaine's interviews with Amei Wallach and with John Gruen (*Party's Over Now*), she wrongly remembered this visit to Provincetown as taking place in 1948, when she and Bill returned from Black Mountain College. She was also incorrect in remembering this as the Provincetown sojourn that lasted until early winter; she took that trip in 1945.

55. Elaine de Kooning, in Gruen, *Party's Over Now*, 210.

56. Elaine de Kooning, in Lawrence Campbell, "Elaine de Kooning Paints a Picture," 62.

57. Edith Burckhardt, *The Loft Generation*.

58. Elaine de Kooning letter to Denise Lassaw, Summer 1949, read by Lassaw in her talk at the National Portrait Gallery, March 13, 2015. The "September Song" lyric by

Maxwell Anderson (to music by Kurt Weill): "But the days grow short when you reach September."

59. These reminiscences are from Larry Rivers, *What Did I Do?*, 123–34.

60. In Elaine de Kooning, *The Spirit of Abstract Expressionism*, a collection of Elaine's writings published after her death, illustrated with photos from Marjorie Luyckx's collection, this photo is captioned "early 1940s." But in the film *Strokes of Genius: de Kooning on de Kooning* (1982), Elaine shows this photograph and says that it was taken in Provincetown in 1949. (Bill's paintings inspired by the Provincetown summer include *Sailcloth* and *Two Women on a Wharf*.)

61. Stevens and Swan, *de Kooning*, 284–85.

62. Willem de Kooning letter to Jack Tworkov, [n.d.], cited in John Elderfield, *de Kooning: A Retrospective*, 191, 235n22.

63. The painting, in the collection of the Tate Gallery in London, is now known as *Summertime: Number 9A*.

64. Steven Naifeh and Gregory Smith, *Jackson Pollock*, 595.

65. Lee Krasner repeatedly expressed scorn for Elaine's decision to use her husband's last name professionally (Gail Levin, *Lee Krasner*, 251, 509n10), and the two women were never friendly.

66. Husbands and Wives, December 28, 1946–January 16, 1947. A search of the microfilm reel of Laurel Gallery records, housed at the Archives of American Art, turned up no information about this exhibition.

67. Stuart Preston, "By Husband and Wife," X9; Gretchen Munson, "Man and Wife," 45.

CHAPTER 4

1. The magazine's most senior editor was known simply as "editor."

2. What we would now call serious conflicts of interest were rife in the cultural worlds of the 1950s. For example, Robert Joffrey, director of the fledgling Joffrey Ballet, had a brief affair with Walter Terry, dance critic of the *New York Herald Tribune*. Sasha Anawalt, *Robert Joffrey and the Making of an American Dance Company* (New York: Scribner, 1996), 72.

3. Thomas B. Hess, essay for the announcement for Elaine de Kooning's work at the Ellison Gallery, Fort Worth, 1960, reprinted in Arlene Bujese, *Twenty-Five Artists*, 40.

4. Hess was born in Rye, New York, seven miles east of New Rochelle.

5. Elaine de Kooning letter to Thomas Hess [undated], Thomas Hess Papers.

6. Audrey Hess was a financial supporter of social causes, including the Citizens Committee for Children of New York and the Longview Foundation (global education); she was a member of the advisory board of the Federal Reformatory for Women, which emphasized career education.

7. Elaine de Kooning letter to Mercedes Matter, August 30, 1974, Mercedes Matter Archive.

8. Eleanor Munro, *Memoirs*, 177.

9. Ibid., 151.

10. Bill Berkson oral history interview, September 29–October 2, 2015, AAA.

11. Natalie Pavia, *Club Without Walls*, 69.

12. Elaine de Kooning interview with John Jonas Gruen.

13. Elaine de Kooning, in John Gruen, *The Party's Over Now*, 217.

14. This was her April 1949 review of Larry Rivers's show (see note 35).

15. Elaine usually gave this figure in her interviews, but she told Gruen (*Party's Over Now*, 217) that it was four dollars.

16. Daniel Creamer and Martin Bernstein, "Average Hourly Wages in a Postwar Contraction," www.nber.org/chapters/c0783.

17. Elaine de Kooning interview with Amei Wallach.

18. Willem de Kooning, Letter to the Editor, 6.

19. In an interview years later with Amei Wallach (Elaine de Kooning Papers), she said that Hess gave her six "test" reviews, including one about the sculpture of Alberto Giacometti, which she praised highly, in terms similar to an as-yet unpublished review by Hess. Another of these reviews was about Misha Reznikoff's paintings, about which, Elaine said, "I was quite scathing." I have not been able to locate these reviews.

20. Writer and photographer John Jonas Gruen (married to painter Jane Wilson) remarked that when he and Wilson were in college in the Midwest, Elaine's "clear" and "cogent" writing "really ignited our imaginations about painting." Elaine de Kooning interview with John Jonas Gruen.

21. Elaine de Kooning interview with Amei Wallach. In another interview (with John Jonas Gruen), Elaine said that her interlocutor was Tom Hess.

22. Elaine de Kooning interview with Charles Hayes.

23. Elaine de Kooning, in Richard Brown, "Artist's Work Reflects Intensity," 15.

24. Elaine de Kooning, "Reviews & Previews: Frederick Sommer," 54.

25. In 1949, Denby published *Looking at the Dance*, a compendium of reviews that had appeared in the *Herald Tribune*, *The Kenyon Review*, *Dance News*, and other periodicals. A poet, he was noted for his memorable descriptions of moments from ballets, written in vivid, nontechnical language that painted a clear picture in the minds of readers.

26. Edith Burckhardt, *The Loft Generation*.

27. Elaine de Kooning, in Gruen, *Party's Over Now*, 214.

28. Elaine de Kooning, "Stuart Davis: True to Life."

29. Elaine de Kooning interview with Minna Daniel.

30. Elaine de Kooning, in Lawrence Campbell, "Elaine Paints a Picture," 63.

31. Elaine told Amei Wallach that the article was for *Mademoiselle* magazine but could not recall the date.

32. Elaine de Kooning, in Gruen, *Party's Over Now*, 217.

33. Elaine de Kooning conversation with Rose Slivka.

34. Elaine de Kooning, "Two Americans in Action."

35. Elaine de Kooning, "Larry Rivers."

36. Elaine de Kooning letter to Larry Rivers, [undated, possibly November 22 or 24, 1952; postmarks of envelopes in folder], Larry Rivers Papers.

37. Ibid.

38. She was probably thinking of "the drip, drip, drip of the raindrops," in Cole Porter's song "Night and Day."

39. Elaine de Kooning interview with Amei Wallach.

40. Elaine de Kooning letter to Larry Rivers, [undated, but likely written ca. November 22, 1952; postmark of envelope in folder], Larry Rivers Papers. Willem de Kooning's lecture at the Philadelphia Museum of Art was on November 18, according to the *Philadelphia Museum Bulletin* 48, no. 235 (Autumn 1952).

41. Jed Perl, *New Art City*, 103–105.

42. Email to author from Susan K. Anderson, Martha Hamilton Morris Archivist, Philadelphia Museum of Art, July 29, 2015. (This painting is no longer in the museum's collection.)

43. Elaine de Kooning letter to Josef Albers, [no date], Josef and Anni Albert Foundation. Although this letter is undated, Elaine mentions Albers's immanent departure from Black Mountain College (announced in March 1949), her *ARTnews* reviews of his two-gallery show (published in February 1949), and a present she received for her birthday (March 12).

44. Elaine de Kooning, in Brown, "Artist's Work Reflects Intensity," 15.

45. Later known as *The Ruin at Daphne*, the painting was not completed until 1953.

46. Elaine de Kooning interview with Antonia Zara.

47. Elaine de Kooning, "Albers Paints a Picture."

48. Elaine de Kooning, in Irving Sandler, "In the Art Galleries."

49. Ibid.

50. Elaine de Kooning, "Renoir: As if by Magic." This essay was published on the occasion of an exhibition of Renoir's paintings at the Clark Institute, Williamstown, Massachusetts.

51. Elaine de Kooning interview with Amei Wallach. Both Kroll and Kermit Lansner soon moved on to distinguished careers at *Newsweek*.

52. Fairfield Porter, oral history interview.

53. Ibid. Porter's admiration of Bill's work surely was another factor, as Justin Spring points out in *Fairfield Porter*, 182.

54. Elaine de Kooning letter to Larry Rivers, February 6–March 4, 1954, Larry Rivers Papers.

55. Elaine de Kooning, "Greene Paints a Picture."

56. Elaine de Kooning, "Subject: What, How, or Who," reprinted in Elaine de Kooning, *The Spirit of Abstract Expressionism*, 143–49.

57. Clement Greenberg, "American-Type Painting."

58. Elaine de Kooning interview with Ann Gibson.

59. Rosenberg was married to May Tabak, a writer.

60. Elaine de Kooning interview with Amei Wallach.

61. Elaine de Kooning interview with James Breslin about Mark Rothko.

62. In Vincent Katz, "Willem and Elaine de Kooning: An Appreciation," 196. Poet and art critic Vincent Katz singled out Elaine's "vivid sense... of the artist's mental processes in an approach [i.e., Abstract Expressionism] based largely on spontaneity."

63. Elaine de Kooning letter to "Sally," October 6, 1983, Elaine de Kooning Papers. She made a similar statement in her interview with Charles Hayes.

64. She actually said "1952," but her first one-person show was in April 1954, at the Stable Gallery, which was founded in 1953.

65. Elaine de Kooning interview with Ann Gibson.

66. Elaine de Kooning oral history interview.

67. Elaine de Kooning, in Gruen, *Party's Over Now,* 217.

68. Grace Hartigan, journal entry, April 2, 1953, in *The Journals of Grace Hartigan, 1951–1955* (Syracuse, NY: Syracuse University Press, 2009), 75.

CHAPTER 5

1. I have not been able to find any information about Elaine's painting in this show.

2. Weldon Kees, "Art," 430.

3. Clement Greenberg, in Jeffrey Potter, *To a Violent Grave,* 134–35. The show opened in November 1950.

4. Elaine de Kooning, "Gorky: Painter of His Own Legend."

5. Alcoply, in *Ninth Street Show* (video).

6. Thomas Hess, "New York Avant-Garde," 47.

7. I was unable to discover which painting of Elaine's was chosen for this show.

8. Elaine mentioned that she broke her tibia and fibula in early November and had finally recovered from this injury ("it is all in the past, wheelchair, crutches, canes, etc.") in an undated letter to Josef Albers. His reply, dated April 18, 1952, celebrates her recovery. Thanks to Mary Gabriel for pointing me toward this exchange of letters, housed at The Josef and Anni Albers Foundation.

9. Denby's former flatmate Rudy Burckhardt had moved out when he married.

10. Elaine de Kooning letter to Bill Brown, [n.d.], William T. Brown Papers.

11. Elaine de Kooning interview with Amei Wallach.

12. She mentioned to more than one interviewer that one of these excursions, in 1951, was to Joan Mitchell's "first one-man show at the New Gallery." But this show took place in January–February 1952. (It was actually not Mitchell's first solo gallery show, though it was her New York debut.)

13. Elaine de Kooning, Memorial for Gandy Brodie. Brodie (1924–1975) studied dance with Martha Graham and made friends with members of the New York jazz scene before taking up painting in 1946; he was in the Kootz Gallery's New Talent show of 1951. Although lacking formal training, he sat in on Hans Hofmann's student critiques and Meyer Schapiro's lectures at The New School for Social Research and Columbia University.

14. Elaine and Willem de Kooning Financial Records, Elaine de Kooning Papers, AAA.

15. Elaine enjoyed playing fairy godmother to Porter's daughters. The previous summer, Porter wrote to Larry Rivers, she took Katherine shopping "just like a sugar daddy in [the film] 'Gentlemen Prefer Blondes.'" Ted Leigh, *Material Witness*, 116.

16. Elaine de Kooning letter to Bill Brown, [n.d.], William T. Brown Papers.

17. Probably, Seurat's *Models (Poseuses)* from 1886–1888, and Cézanne's *The Large Bathers (Les grandes baigneuses)*, from 1895–1906.

18. Elaine de Kooning letter to Bill Brown, [n.d.], William T. Brown Papers.

19. Lionel Abel, who describes Hensler (he spelled it "Henzler") as a philosophy professor, recounted the night's doings in *The Intellectual Follies*, 215–16. Edvard Lieber, who tells this story in more and slightly varied detail (*Willem de Kooning*, 37), refers to the host as "sociologist Fritz Hensler" and places the party in July 1951, based on Elaine's recollections. But as we've seen, her accident occurred in November 1951, so if her leg was in a cast at the party, it probably took place in spring of 1952.

20. Elaine de Kooning interview with Ellen Auerbach.

21. Abel, *Intellectual Follies*, 215.

22. Elaine de Kooning interview with Amei Wallach.

23. Ibid. Although it might seem that Hensler would be loath to extend another invitation to artists, Elaine was apparently part of a smaller group who visited him in February 1954. Elaine de Kooning letter to Larry Rivers, February 26–March 4, 1954, Larry Rivers Papers.

24. Email to author from Denise Lassaw, Ernestine's daughter, February 16, 2016.

25. Elaine de Kooning, in Musa Mayer, *Night Studio*, 67.

26. Elaine de Kooning interview with Arthur Tobier.

27. Gail Levin (*Lee Krasner*, 251) places this visit in the summer of 1948, but the de Koonings were at Black Mountain then.

28. Elaine de Kooning letter to Mercedes Matter, August 23, 1950, Mercedes Matter Archive.

29. There has been a great deal of confusion about which summers the de Koonings spent at the Castelli house in East Hampton. There is no question that the couple was there in 1953, the summer Hans Namuth took their photograph on the porch and Bill painted *Two Women*. Some sources claim that the de Koonings were there in 1951, but Castelli himself said (in his AAA oral history interview) that the de Koonings stayed at the house "for two years running, for the whole summer," which points to 1952. (In the summer of 1954, the couple stayed at the Red House in Bridgehampton.)

30. Leo Castelli, oral history interview.

31. They included Jane Freilicher, Larry Rivers, Kenneth Koch, Frank O'Hara, John Ashbery, John Latouche, and Michael Sonnabend.

32. Elaine de Kooning interview with Minna Daniel.

33. *Leo Castelli*, dated (erroneously) as 1954, sold at Christie's New York on May 11, 2016 (lot 101) for $75,000, including the 25 percent buyer's premium; the estimate was $15,000 to $20,000. (This sale appears to be Elaine's auction record to date.)

34. *Portrait of John Bernard Myers*, dated ca. 1952–1953, was in Sotheby's contemporary auction of September 25, 2013 (lot 408), with an estimate of $8,000 to $12,000; it failed to reach its reserve price. The painting, admittedly not one of Elaine's better portraits, had sold at a 2007 Christie's auction.

35. John Myers, *Tracking the Marvelous*, 135–36.

36. Elaine gave her mother money and other gifts throughout her lifetime. Was this generosity prompted by simple concern for Marie's welfare, or by a feeling of guilt for her own need to distance herself from Marie's powerful influence?

37. Elaine de Kooning letter to Ernestine Lassaw, quoted by Denise Lassaw, "Elaine de Kooning, A Life in Frames: Portraits and Stories" (illustrated talk).

38. The article must have been "Dymaxion Artist," which was published in the September 1952 issue of *ARTnews*; it is surprising that the magazine's publication schedule allowed for such a quick turnaround. Elaine's article, "Diller Paints a Picture," wasn't published until January 1954.

39. The following year, Ward became pregnant with his child and had an abortion.

40. Elaine de Kooning telephone interview with Judith Wolfe, March 23, 1981, recalled in Judith Wolfe, *Willem de Kooning*, 9, 18n12 (exhibition catalogue).

41. Comments by Elaine in untitled video of Elaine de Kooning at the Whitney Museum's Willem de Kooning Retrospective.

42. Elaine de Kooning, in John Gruen, *The Party's Over Now*, 218.

43. Elaine de Kooning, in *Strokes of Genius: de Kooning on de Kooning* (video).

44. Curtis Bill Pepper, "The Indomitable de Kooning," 45. (De Kooning was actually two years old when his mother moved out; although he lived with his father for a brief period, his mother often showed up to take him home with her.)

45. Paintings on the Theme of the Woman opened on March 16 at the Janis Gallery. Only two works sold (curiously, the stately Mrs. John D. Rockefeller III was the purchaser of *Woman II*).

46. Elaine de Kooning letter to Bill Brown, [n.d.], William T. Brown Papers.

47. Reviews quoted in John Elderfield, *de Kooning*, 243–44, 299n68–70 (exhibition catalogue).

48. Thomas Hess, "de Kooning Paints a Picture," 32. Bill's first one-man show at Sidney Janis Gallery opened on March 16 with six of the *Woman* paintings and sixteen drawings and pastels on this theme.

49. Gruen, *Party's Over Now*, 215.

50. "The Art of Sherman Drexler: A 2002 Interview with Molly Barnes," at www.youtube.com/watch?v=khmeZSa7ofs.

51. Unfortunately, I was unable to find any evidence of her response to these performances.

52. The other Poet's Theater plays were by John Ashbery (sets by Nell Blaine), Kenneth Koch (Grace Hartigan), Frank O'Hara (Larry Rivers), Barbara Guest (Jane Freilicher), and James Merrill (Al Kresch).

53. *Artists Speak at the Art Barge: Elaine de Kooning* (video).

54. Bill Berkson and Joe LeSueur, *Homage to Frank O'Hara*, originally published in *Big Sky* 11/12, April 1978. The other artists include Jane Freilicher, Philip Guston, Alice Neel, Grace Hartigan, Larry Rivers, Alex Katz, and Fairfield Porter.

55. Author's telephone interview with David Shapiro, June 24, 2015.

56. Elaine met Droll at Black Mountain College in 1948, where he was a summer student.

57. Elaine de Kooning letter to Bill Brown, [n.d.], William T. Brown Papers.

58. Ibid.

59. Elaine said this when Fairfield Porter told her that his wife Anne had converted to Catholicism in 1954 because she believed that Elaine's and the poet Frank O'Hara's upbeat personalities came from their Catholic upbringing. Elaine de Kooning interview with Ellen Auerbach.

 Anne Porter's serious interest in Catholicism actually had its roots in her earlier experiences; see Justin Spring, *Fairfield Porter*, 178.

60. Elaine often claimed (for example, in her interview with Ann Gibson), that her first one-person show was in 1952; the actual date was first published in Jane K. Bledsoe, *Elaine de Kooning*, the Georgia Museum of Art catalogue, with a chronology by Elaine's sister Marjorie Luyckx, who oversaw her business affairs and for the most part kept a firm grip on details that eluded Elaine.

61. Elaine de Kooning letter to Bill Brown, [n.d.], William T. Brown Papers.

62. Stuart Preston, "About Art and Artists," 10.

63. Fairfield Porter, "Elaine de Kooning," 45.

64. Marisol Escobar (1930–2016) was then taking classes at The New School for Social Research while studying with Hans Hofmann. She had switched her focus from painting to sculpture in 1951, influenced by pre-Columbian art.

65. Mark Stevens and Annalyn Swan, *de Kooning*, 369.

66. Elaine de Kooning interview with John Jonas Gruen.

67. Steven Naifeh and Gregory Smith, *Jackson Pollock*, 733.

68. Elaine de Kooning letter to Philip Pavia, [n.d.], Philip Pavia Papers. (Probably from summer of 1958, because she mentions writing an *ARTnews Annual* piece, probably "Two Americans in Action: Kline and Rothko," published later that year.)

69. See Lindsey Gruson, "Is It Art or Just a Toilet Seat?"

70. The highest price offered was $7,500, from an anonymous bidder, below the auction house's reserve price.

71. Elaine de Kooning, in Pepper, "The Indomitable de Kooning," 45.

72. *Basketball Players* (oil, 79 by 53 inches), loaned by the Stable Gallery. Under the title *High Man*, the painting was loaned by Elaine to the 1988 exhibition, The Figurative Fifties: New York Figurative Expressionism, co-organized by the Newport Harbor Art Museum and the Pennsylvania Academy of the Fine Arts. The current whereabouts of the painting are unknown.

73. Sport in Art, work by eighty-four American and European artists, traveled to museums in Washington, D.C.; Louisville, Kentucky; Dallas; Denver; Los Angeles; and San Francisco. The U.S. Information Agency had planned to send the show to

Australia for the 1956 winter Olympic Games, but a conservative outcry over four artists considered to be communist sympathizers led to the abandonment of this plan.

74. American Federation of the Arts, *Sport in Art from American Collections Assembled in an Olympic Year*, unpaginated (exhibition catalogue).

75. The NBA was formed from the merger of the Basketball Association of America and the National Basketball League.

76. Jane Bledsoe (*Elaine de Kooning*, exhibition catalogue) dates *Basketball #86* as 1948, but it seems unlikely that *Scrimmage (Basketball #89)*—a murky, horizontally oriented painting from 1949—would predate *Basketball #86*, a brighter and considerably more accomplished painting in the vertical format Elaine would use for the rest of this series. She often used the same title for similar paintings—a blithe disregard for documentation that was exacerbated by her tendency to work in series and her inaccurate dating of some works. In the 1980s, someone instituted an arbitrary numbering system that that appears to have little or nothing to do with the order in which the pictures were painted.

77. Elaine de Kooning interview with Ann Gibson.

78. Elaine de Kooning interview with Judith Stein and Paul Schimmel.

79. Elaine de Kooning, in Laurie Johnston and Robert Thomas, "Notes on People: Sports as Seen Through the Eyes of an Artist," C30.

80. Elaine de Kooning, Skowhegan School Lecture.

81. Book of Revelations 6:9–11, known as The Fifth Seal.

82. *Men Playing Basketball* (1956; oil on canvas, 80 by 66 inches), whereabouts unknown. First published in Leo Steinberg, *The New York School*, 6 (exhibition catalogue).

83. This painting is identical to *Basketball #86*, except for the lighter color palette, typical of her mid-'50s work; poor reproduction quality in the 1992 catalogue likely accounts for the difference. See note 76..

84. Elaine de Kooning interview with Judith Stein and Paul Schimmel.

85. James Mellow, "In the Galleries: Elaine de Kooning," 51. The whereabouts of this painting are unknown.

86. Johnston and Thomas, "Notes on People."

87. Hilton Kramer, "Elaine de Kooning's Ode." The exhibition, Hoops & Homers, was on view May 7–29, 1981, at Spectrum Gallery.

88. *Elaine de Kooning: A Portrait* (video).

89. Elaine de Kooning, in Joseph Liss, "Elaine de Kooning and Pelé." This piece is based on coverage of the Brazilian soccer star's sittings for Elaine in 1982.

90. Author's telephone interview with Tom Ferrara, May 4, 2015.

91. Kent Biffle, "Davis Cup Scene," A-1. No paintings by Elaine of tennis matches have surfaced to date.

92. Gruen, *Party's Over Now*, 208.

93. Information about the hysterectomy and its timing from Stevens and Swan (*de Kooning*, 385); their source was Joan Ward. Hysterectomies were the second most common operation in the United States in the 1950s, according to S. Robert Kovac

and Gina M. Northington, "Vaginal Hysterectomy," in *Medical Management of the Surgical Patient*, ed. Michael F. Lubin, Thomas F. Dodson, et al. (Cambridge, UK: Cambridge University Press, 2013), 654.

94. The show ran from April 30 to May 19, 1956.

95. Parker Tyler [P.T.], "Elaine de Kooning," 51.

96. Mellow, "In the Galleries," 51.

97. Carlyle Burrows, "Talent Is New But Styles Are Not."

98. Thomas Hess, "U.S. Painting: Some Recent Directions," 178. The other painters he put in this category include Joan Mitchell, Milton Resnick, and Fairfield Porter. Hess's other two categories of artists were those who believed that only pure abstraction reflected the spirit of the times, and those who declared the subject of a painting paramount (and impossible to realize with abstraction).

99. Jill Chancey, *Elaine de Kooning*, 40.

100. Fairfield Porter, "Art," 379. It's noteworthy that he calls Elaine "Miss de Kooning" in this article, perhaps his way of stressing her significance as an artist in her own right rather than as an appendage of her husband.

101. Grace Hartigan interview with Celia Stahr.

102. Although her relationship with Bill had petered out, Joan Ward was anxious to remain close to him now that they had a child. She persuaded him to join her that summer.

103. Dord Fitz (1914–1989) recalled the date of this visit as 1955 in his essay in the catalogue for Eight Modern Masters (see note 111), but other sources place it in 1956.

104. Jeanne Reynal (1903–1983) was the only woman artist Elaine profiled in the *ARTnews* "X Paints a Picture" series. Reynal studied in Paris during the 1930s, moved to California in 1938, and then settled in New York in 1946, where she showed at the Stable Gallery in the 1950s. In addition to her freestanding and two-dimensional work in mosaic, she was also an art collector, particularly of work by her close friends Rothko and Gorky. In 1955, Reynal married African American painter Thomas Sills (1914–2000), who showed with Betty Parsons.

105. Joe Stefanelli (b. 1921) was a member of the Club who had shown in the Stable Annuals and the 1953 and 1955 Whitney Annuals; John Grillo (1917–2014) had turned from landscapes to brightly colored abstractions in the mid-forties, in San Francisco; Miles Forst (1923–2006) was also an abstract painter. All three artists were former students of Hans Hofmann.

106. Information about Fitz is from *Dord Fitz: The Broadcast Is Always On* (video); and Carolyn Fitz, "Biographical Essay," in *The Broadcast Is Always On: The Area Arts Foundation and Dord Fitz* (exhibition catalogue).

107. This initial exposure to the Southwest is probably why she always cited 1957 as her first year teaching at the University of New Mexico instead of 1958.

108. The artists included Elaine, Kline, Porter, Resnick, Rivers, Jane Freilicher, and Jane Wilson.

109. The others were Patricia Allen (1911–?), Linda Lindeberg (1915–1973, wife of artist Giorgio Cavallon); Yvonne Thomas (1913–2009); and Mickey Wagstaff (1899–1990).

110. Elaine de Kooning, April 24–May 2, 1965, Dord Fitz Gallery. The forty-three works (paintings and charcoal sketches) included portraits of Bill, Denise Lassaw, Robert Mallary, President John F. Kennedy, and artist Rosalyn Drexler, in addition to landscapes and images of bulls, crucifixes, and basketball and baseball players.

111. Eight Modern Masters, April 20–June 23, 1985, Amarillo Art Center. The other artists were Alfonso Ossorio, Leon Polk Smith, Hedda Sterne, Ibram Lassaw, Louise Nevelson, James Brooks, and Bill de Kooning. Elaine's paintings in the show were *Harold Rosenberg #3* (1956; see chapter 9), *Kaldis #8* (1967), *Basketball #40* (1977), *Bacchus #65* (1982), and *Green-Gold Wall* (*Cave #45*, 1985).

112. Carolyn Fitz email to author, March 23, 2016.

113. Brewster E. Fitz email to author, January 18, 2016.

114. Carolyn Fitz letter to author, March 2, 2016. She added: "In little towns across the Panhandle of Texas you will find homes featuring landscapes, bullfights, basketball and baseball games, and portraits by Elaine de Kooning."

115. Expressionism (1956) and Sixty American Painters: Abstract Expressionist Painting of the Fifties (1960).

116. The New York School: Second Generation, Paintings by Twenty-Three Artists (1957). Elaine's painting in the show was *Basketball* (1956; oil on canvas, 80 by 66 inches).

117. Carnegie International (1956, 1964). The museum's name changed to Carnegie Museum of Art in 1963.

118. Whitney Annual (1960, 1963, and 1974).

119. 67th Annual American Exhibition: Directions in Contemporary Painting and Sculpture (1964).

120. Recent Painting USA: The Figure (1962) also traveled to seven cities around the country; the seventy-five works were all offered for sale.

121. Young American Painters (1956).

122. Solo gallery shows at Spectrum Fine Arts (1981), Gruenebaum (1982, 1986), Phoenix (1984), and Fischbach (1988) galleries in New York; at Himmelfarb (1981), Veered (1984, 1987), Elaine Benson (1986, 1988) and Benton (1988) galleries, and the Guild Hall (1983) in the Hamptons; at Adelphi University, Garden City, New York (1984); and in other cities, including Santa Barbara (Ruth Schaffner Gallery, 1981), Baltimore (C. Grimaldis, 1980, 1984), Washington, D.C. (Phoenix II Gallery, 1982), Chicago (Arts Club of Chicago, 1983), Miami (Guggenheim Gallery, 1986), Berlin (Galerie Sylvia Menzel, 1986), Los Angeles (Wenger Gallery, 1987, 1988), Radford, Virginia (Flossie Martin Gallery, 1987), and St. Louis (Elliot Smith Gallery, 1988).

123. Hirshhorn Museum and Sculpture Garden, Washington, D.C. (1980).

124. Newport Harbor Art Museum, Newport Beach, California (1988); traveled to the Pennsylvania Academy of Fine Arts in Philadelphia and the Marion Kogler McNay Art Museum, San Antonio, Texas.

125. Museum of Contemporary Art, Los Angeles (1999); traveled to the Wexner Center for the Arts, Columbus, Ohio, and the Parrish Art Museum, Southampton, New York.

126. Elaine de Kooning interview with Jeffrey Potter.

127. Stevens and Swan, *de Kooning*, 396.

128. Elaine de Kooning interview with Arthur Tobier.

129. Elaine de Kooning interview with Antonia Zara.

130. Elaine de Kooning, in Gruen, *Party's Over Now*, 211.

131. Elaine de Kooning interview with James Breslin about Mark Rothko.

132. Author's telephone interview with Margaret Randall, January 7, 2015; and Randall's memoir, *My Town*, 90. This was the only time Elaine ever mentioned her father to Randall.

133. Irving Sandler, *A Sweeper-Up After Artists*, 55.

134. Elaine de Kooning interview with Antonia Zara.

135. See Stevens and Swan, *de Kooning*, 152.

136. Author's telephone interview with Mimi Gross, June 12, 2015.

137. *Willem de Kooning, 1981–1986*, 69 (exhibition catalogue).

138. Elaine de Kooning, Skowhegan School Lecture.

139. Krasner was born in 1908; Pollock, in 1912.

140. Quotes in this paragraph are from author's telephone interview with Mimi Gross, June 12, 2015.

141. Elaine de Kooning interview with Jeffrey Potter.

142. Author's telephone interview with Margaret Randall, January 7, 2015.

143. Elaine de Kooning interview with Charles Hayes.

144. Ibid.

145. Elaine de Kooning, C.F.S. Hancock Lecture.

146. Martica Sawin, "In the Galleries: Elaine de Kooning," 55.

147. James Schuyler, "Elaine de Kooning," *ARTnews* 56,(November 1957), 12. Reprinted in James Schuyler, *Selected Art Writings*, 201.

148. Lassaw, "Elaine de Kooning: A Life in Frames." She initially remembered the party as taking place in 1959, but Bill spent that summer with Ruth Kligman; in late July, they traveled to Rome. Thanks to Mary Gabriel for supplying the correct date.

CHAPTER 6

1. Elaine always recalled the year as 1957 in later interviews, but according to the *1957–1958 Annual Report of the University of New Mexico* (p. 293), "Elaine deKooning [*sic*], nationally known artist and critic, will serve on the Art Department staff during the first semester of next year" (i.e., the 1958–1959 academic year) "as replacement for Professor Ralph Douglass, who will be on sabbatical leave."

2. Elaine de Kooning, in John Gruen, *The Party's Over Now*, 220.

3. Elaine de Kooning, in Lloyd Stewart, "Artist to Be Here Today for Exhibit."

4. Her address was 400 San Felipe NW, Apt. E. This adobe structure is now a jewelry and bead shop.

5. Elaine and Willem de Kooning Financial Records, Elaine de Kooning Papers. A salary of $700 in 1959 was equal to about $5,700 in today's money.

6. Elaine de Kooning letter to Philip Pavia, [postmarked] November 3, 1958, Philip Pavia Papers.

7. Ibid. Elaine later told Ann Gibson that she didn't particularly like O'Keefe's work but "admired her as a personality."

8. Elaine de Kooning, Foreword, in Ed Garman, *The Art of Raymond Jonson*, xiii.

9. "Elaine de Kooning Exhibit October Feature at Museum," *Albuquerque Journal*, October 5, 1958, 15. Former students at the University of New Mexico art department included Agnes Martin (who taught courses while earning her undergraduate degree in the late 1940s) and Richard Diebenkorn, who received an MFA in 1952.

10. Elaine de Kooning, "New Mexico," reprinted in Elaine de Kooning, *The Spirit of Abstract Expressionism*, 185, 186.

11. Richard Diebenkorn (1922–1993) studied at the University of New Mexico on the G.I. Bill after working for a year in New York and teaching at the California School of Fine Arts. During his year in Albuquerque, his painting style was significantly influenced by an exhibition of Gorky's work (in San Francisco) and by viewing the landscape from a low-flying plane.

12. Elaine de Kooning, Foreword, in Ed Garman, *The Art of Raymond Jonson, Painter*, xiii. In "Dialogue," originally published in the January 1971 issue of *ARTnews*, Elaine said that this painter was Joan Oppenheimer.

13. All William Conger quotes are from his telephone interview with the author, July 15, 2015, unless otherwise noted.

14. Harry Gaugh, *Franz Kline*, 93.

15. University of New Mexico, *Annual Report 1957–1958*, 301.

16. Author's telephone interview with Wayne Thiebaud, October 17, 2014.

17. William Conger, in Jan Karabenick, "An Interview with Artist William Conger."

18. The exhibition, 14 Albuquerque Painters, was held in February 1960 at Great Jones Gallery.

19. Elaine de Kooning interview with Karl E. Fortress.

20. For images of these portraits, see Tim Keane, "Artist Unknown: Reflections on Works by Eddie Johnson."

21. *The Bird Film* (1965),was written and directed by Steven Poleskie, with cinematography by Eddie Johnson, sets and costumes by Poleskie and Johnson, and a score by John Herbert MacDowell, The film was shot in Johnson's East Broadway loft and on Elaine's family's upstate New York farm, which she had just repurchased. Actors included Deborah Lee, who had appeared in Warhol films. See Stephen Poleskie, "The Bird Film," www.ragzine.cc/2015/02/poleskie_v11n2/; and "Where Is Stephen (Steve) Poleskie Now?" August 13, 2011, www.stephenpoleskie.com/blog.htm?tag=The+Bird+Film.

22. Eddie Johnson died in 2012.

23. Albuquerque '50s, University of New Mexico Art Museum, September 24, 1989– January 21, 1990.

24. Years later, Elaine wrote to Conger to say that he and Johnson were "the only two out of the whole class" who were still working artists. Elaine de Kooning letter [undated], William Conger Papers.

25. John Taylor, "An Interview with Elaine de Kooning in Athens," 17.

26. Elaine de Kooning interview with Arthur Tobier.

27. Proverbs 27:17.

28. Connie Fox, author's notes from a panel discussion at the Pollock-Krasner House and Study Center, August 9, 2015, and author's telephone interview with Connie Fox, January 8, 2015.

29. Author's telephone interview with Connie Fox, January 22, 2015.

30. Elaine's abstract painting *Tijeras #5* (1959; oil on Masonite, 36 by 48 inches) sold at a Christie's New York auction on September 28, 2016, for $40,000 (lot 50).

31. All quotes from Margaret Randall are from the author's telephone interview, January 7, 2015, unless otherwise noted.

32. Margaret Randall, *My Town*, 88.

33. Robert Mallary was credited for the cover layout.

34. At the time, cancer, especially of "private" parts of the body, was considered a conversational taboo.

35. Randall, *My Town*, 91.

36. Margaret Randall interview.

37. Elaine and Willem de Kooning Financial Records, Elaine de Kooning Papers.

38. Elaine de Kooning letter to Philip Pavia, [postmarked] November 3, 1958, Philip Pavia Papers.

39. Elaine de Kooning, in Lawrence Campbell, "Elaine de Kooning Paints a Picture," 62.

40. Elaine de Kooning interview with Jeffrey Potter.

41. Stewart, "Artist to Be Here." Elaine is quoted as saying that the bull charged at her when she was painting it, but her bullfight paintings were actually done in the studio.

42. Elaine de Kooning interview with Judith Stein and Paul Schimmel.

43. Elaine de Kooning, "Statement," *It Is* 4 (Autumn 1959), reprinted in Elaine de Kooning, *The Spirit of Abstract Expressionism*, 175.

44. Ernest Hemingway, *Death in the Afternoon*, 22.

45. Elaine de Kooning letter to Philip Pavia, [postmarked] November 3, 1958, Philip Pavia Papers.

46. Many details of this description are summarized from Aficionados International, "What Happens in a Bullfight," www.aficionados-international.com/general-information/what-happens-in-a-bullfight.

47. Elaine de Kooning, *Faena* (1960; oil on Masonite, 18 1/4 by 24 inches). Wright, a Chicago auction house, sold the painting for $4,127 on September 23, 2014, lot 329. An abstract painting from 1959 with the same title (oil on paper, 19 1/2 by 24 5/8

inches) sold for $35,000 at a Christie's New York auction on March 4, 2016 (lot 126). Elaine's highest auction price to date for a Southwest-inspired painting is $50,000, for an untitled and apparently unsigned abstract work listed as "circa 1950s" (oil on paper; 37 by 72 inches), which sold at Christie's New York on July 22, 2015 (lot 138).

48. Author's telephone interview with Charles Fried, December 19, 2014.

49. Elaine de Kooning interview with Charles Hayes.

50. Elaine de Kooning, C.F.S. Hancock Lecture.

51. Elaine de Kooning, pages from an autobiographical statement.

52. Theologian and philosopher Søren Kierkegaard (1813–1855) is considered a precursor of the existentialist movement.

53. Harold Rosenberg, "The American Action Painters," 22.

54. In *Death in the Afternoon*, Hemingway writes about the bull's characteristics in the dispassionate terms of a breeder and discusses the interaction of a specific bull with a specific matador, rather than illuminating the way bulls look and move in the ring. In "Wright, Hemingway, and the Bullfight: An Aficionado's View," Kenneth Kinnamon notes that even in his 1926 novel *The Sun Also Rises*, Hemingway doesn't describe the bulls' appearance when they entered the ring.

55. Elaine de Kooning, draft of a conversation with Eleanor Munro.

56. Elaine de Kooning letter to Philip Pavia, [postmarked] November 3, 1958, Philip Pavia Papers. She probably meant a matador; the word *toreador* (from *torero*, a generic word for bullfighter) was invented by Georges Bizet for his opera *Carmen*.

57. Elaine de Kooning, in Campbell, "Elaine de Kooning Paints a Picture," 62.

58. Ibid., 63.

59. Elaine de Kooning, *Matador* (1959; oil on board, 49 by 60 inches); http://borghi.org/artworks/matador/.

60. Elaine de Kooning, *Bull/Matador* (1960; oil on canvas, 23 by 18 inches). Barridoff Galleries, Portland, Maine, sold the painting at auction for $9,600 on August 5, 2011.

61. Richard Wright, *Pagan Spain*, originally published by in 1957. In one passage, he describes the bull as "a wild, black horned beast, his eyes ablaze, his nostrils quivering, his mouth open and flinging foam, his throat emitting a bellow" (2002 ed., 111).

62. D.K., "Elaine de Kooning Paints Exciting, Colorful Conflict."

63. Elaine de Kooning, in Alfred Frankenstein, "Explosion in Art."

64. Titled Arena, after one of Elaine's paintings, the exhibition was on view in December 1960.

65. Stuart Preston, "Art: Semi-Abstract Oils," 33.

66. Elaine de Kooning, Skowhegan School Lecture.

67. "Architectural Ideas I & II, Norman Bluhm—Elaine de Kooning," exhibition announcement, Graham Gallery, New York, April 11–29, 1961. Courtesy of Jim Levis.

68. A "happening"—the term was coined in 1957 by artist Allen Kaprow—is an artist-conceived, improvisatory event that relies on audience participation.

69. Elaine de Kooning, Skowhegan School Lecture.

70. Valerie Peterson, "Art Without Walls," 36–37.
71. Elaine de Kooning interview with Karl E. Fortress.
72. Elaine de Kooning interview with Antonia Zara.
73. Robert Mallary (1917–1997) is said to have had many affairs over the years, but he remained married to his wife, Margot, until his death.
74. Wayne Thiebaud interview, May 27, 2011.
75. Robert Mallary oral history interview.
76. Margaret Randall interview.
77. Elaine de Kooning interview with Karl E. Fortress. A later portrait of Mallary by Elaine was reproduced on the cover of the April 1963 issue of *ARTnews*.
78. After illness forced him to stop working with polyester resin, which is highly toxic, he became an early creator of computer-designed sculpture.
79. Contemporary Sculpture U.S.A., and Sixteen Americans.
80. Elaine de Kooning interview with Karl E. Fortress.
81. Elaine de Kooning interview with Charles Hayes.
82. She also taught at Pennsylvania State University (1960), University of California, Davis (1964–64), Yale University (1967), Pratt Institute (1968), Carnegie Mellon University (Mellon Chair, 1968–70), Wagner College (1971), University of Pennsylvania (1971–72), Parsons School of Design (1974–75), Brandeis University (artist in residence, 1975), Cooper Union (spring 1976), University of Georgia (Lamar Dodd Chair, 1976–79), and Bard College (1982).
83. Robin White, "Interview of Elaine de Kooning," 14.
84. Barbara Schwartz (1948–2006), in *Elaine de Kooning: Portraits*, 15 (catalogue, Brooklyn College Art Gallery).
85. Elaine de Kooning interview with Charles Hayes.
86. *Artists Speak at the Art Barge* (video).
87. Ibid.
88. Harold Rosenberg journal, June 7, 1951, Harold Rosenberg Papers, Getty Research Institute, cited in Levin, *Lee Krasner*, 282, 513n63. Rosenberg wrote that he went to the Cedar to see Elaine, provoking Matter's wrath. Levin (282) says that Krasner believed Elaine's liaisons with Rosenberg and Hess were "part of her strategy to promote her husband's work."
89. Elaine de Kooning letter to Mercedes Matter, August 20, 1975, in Ellen Landau, *Mercedes Matter*, 57.
90. Mercedes Matter, "What's Wrong with U.S. Art Schools."
91. Author's telephone interview with Wayne Thiebaud, October 17, 2014.
92. Elaine de Kooning letter to Mercedes Matter, July 12, 1974, Mercedes Matter Archive.
93. Elaine de Kooning, draft of a conversation with Eleanor Munro.
94. Elaine de Kooning letter to Noah Goldowsky, July 12, 1960, B.C. Holland Gallery Records.
95. Jean Alter, "In the Spotlight: Show Must Go On," 33.
96. Elaine de Kooning, Skowhegan School Lecture.

97. Lamar Dodd (1909–1996) was an American Scene painter. A member of the Art Students League in New York in the late 1920s, he returned to his Georgia roots in 1937 to chair the fledgling art department at the University of Georgia, where he stayed until his retirement in 1975. Ironically, he was a member of the regional jury that selected work for the Metropolitan Museum of Art exhibition American Painting Today 1950, which was excoriated by a group of New York avant-garde artists—including Willem de Kooning—that became known as the Irascibles. See William U. Eiland, *The Truth in Things.*

98. Unless otherwise specified, all quotes in this paragraph are from Catherine Fox, "Elaine de Kooning: Portrait of the Artist."

99. Elaine de Kooning interview with Karl E. Fortress.

100. Author's telephone interview with Jim Touchton, November 24, 2015.

101. Jim Touchton, in *Elaine de Kooning: Portraits*, 22 (catalogue, Brooklyn College Art Gallery).

102. Jim Touchton, eulogy, Elaine de Kooning Memorial.

103. See chapter 7 for a discussion of the *Bacchus* series.

104. Fox, "Elaine de Kooning: Portrait of the Artist."

105. Organized by Jane Bledsoe, project director for the Georgia Museum of Art, the exhibition Elaine de Kooning was on view from March 21 to May 3, 1992. It traveled to the Santa Barbara Museum of Art; Maryland Institute College of Art, Baltimore; Arkansas Arts Center, Little Rock; and the Huntsville (Alabama) Museum of Art.

CHAPTER 7

1. Although hired only for the fall 1958 semester at the University of New Mexico, she seems to have lingered in Albuquerque through April, as shown by rental payments for her home and studio. Elaine and Willem de Kooning Financial Records, Elaine de Kooning Papers.

2. Elaine de Kooning, in John Gruen, *The Party's Over Now*, 220.

3. Harold Rosenberg, "Tenth Street: A Geography of Modern Art," 192.

4. Elaine de Kooning interview with Arthur Tobier.

5. In 1964, the Cedar moved to a new location (82 University Place), and its former shabbiness was replaced with a pub-style décor. It closed in 2006.

6. Elaine de Kooning, in Gruen, *Party's Over Now*, 221–22.

7. Elaine de Kooning, in Campbell Geeslin, "She Paints Many Ways," 3.

8. Elaine de Kooning, in Gruen, *Party's Over Now*, 219.

9. Email from Denise Lassaw to author, February 3, 2016.

10. Email from Judy Stein (from her interview with Mason) to author, December 9, 2015.

11. Elaine de Kooning, in Lawrence Campbell, "Elaine de Kooning Paints a Picture," 63.

12. Elaine de Kooning interview with Arthur Tobier.

13. D. K., "Elaine de Kooning Paints Exciting, Colorful Conflict."

14. Lawrence Campbell, in *Elaine de Kooning: Portraits*, 5 (catalogue, Brooklyn College Art Gallery).

15. Elaine and Willem de Kooning Financial Records, Elaine de Kooning Papers.

16. Ann Holmes, "10th Streeters Feeling Their Oats."

17. Her solo exhibitions in 1960 were at Holland Goldowsky Gallery, Chicago; Howard Wise Gallery, Cleveland; Ellison Gallery, Fort Worth; and Graham Gallery, New York. A show of her work opened in 1959 at Dord Fitz Gallery in Amarillo, Texas.

18. Joe LeSueur, *Digressions*, 148–49.

19. Lawrence Campbell (1914–1998), a landscape painter, was an associate editor at *ARTnews* from 1949 to 1976, and taught art practice and history at Pratt Institute and Brooklyn College.

20. Lawrence Campbell, in *Elaine de Kooning: Portraits*, 5 (catalogue, Brooklyn College Art Gallery).

21. Campbell, "Elaine de Kooning Paints a Picture," 13.

22. Elaine de Kooning, in Campbell, "Elaine de Kooning Paints a Picture," 61.

23. All financial information is from Elaine and Willem de Kooning Financial Records, Elaine de Kooning Papers.

24. The painting is now in the collection of the Arkansas Center Arts Foundation, credited as "gift of Robert Mallary, Conway, Mass, 1973."

25. The Guggenheim Museum would acquire this painting in 1983.

26. Lawrence Campbell, "New Blood in the Old Cross-Section," 39. The other new-comers he singled out for special praise included Yayoi Kusama [misspelled as "Kusami"], Kenneth Noland, Robert Rauschenberg, and Jane Wilson.

27. Elaine de Kooning letter to Joan Washburn, [undated; Tidelands Motor Inn, Houston, letterhead], John Graham & Sons Gallery Records.

28. Donald Barthelme letter to Harold Rosenberg, March 28, 1962, Harold Rosenberg Papers, Getty Research Institute, Los Angeles.

29. Helen Moore Barthelme, *Donald Barthelme*, 129.

30. Elaine de Kooning, in Geeslin, "She Paints Many Ways."

31. Barthelme, *Donald Barthelme*, 129.

32. Author's telephone interview with James Bohary, March 28, 2015.

33. Author's interview with Clay Fried, March 15, 2015, Washington, D.C.

34. Elaine de Kooning, in Agnes Murphy, "At Home with Elaine de Kooning."

35. Ibid.

36. Nell Blaine diary entry, December 20, 1975. Nell Blaine Papers, Houghton Library, Harvard University.

37. Bill Berkson, "The Portraitist," 42.

38. Irving Sandler, *A Sweeper-Up After Artists*, 194.

39. Elaine de Kooning, in Madeline Conway and Nancy Kirk, *The Museum of Modern Art Artists' Cookbook*, 77–81.

40. Ernestine Lassaw, in Amei Wallach, "The Private Face of a Master."

41. Jean Hoffmann, *Palette to Palate*, 147.

42. Author's telephone interview with Charles Fried, December 19, 2014.

43. Elaine de Kooning Papers.

44. Author's telephone interview with Guy Fried, December 12, 2015. In Freudian psychology, the superego has a critical, moralizing function, while the id consists of pure instinct.

45. *Masterpiece* was originally released by Parker Brothers in 1970.

46. Author's telephone interview with Emily Mason, December 1, 2015.

47. D.K., "Elaine de Kooning Paints Exciting, Colorful Conflict."

48. *Kill Me If You Can*, 1977. Screenplay by John Gay, directed by Buzz Kulik, with Talia Shire as attorney Rosalie Asher. See www.youtube.com/watch?v=gR2NeWDLrLo.

49. Elaine de Kooning interview with James Breslin about Mark Rothko.

50. Elaine de Kooning interview with John Jonas Gruen.

51. All quotes about the Chessman case are from materials in the Elaine de Kooning Papers.

52. According to a poster advertising the march, sponsors included Elaine, Bill, Alfred Barr Jr., Buckminster Fuller, Thomas B. Hess, and Harold Rosenberg.

53. When Marie Fried saw the canvas—which Elaine had stored in her sister Marjorie's garage—she thought it was a painting by Elaine "and was thrilled, because she thought Elaine should paint recognizable things." Author's telephone interview with Margaret Randall, January 7, 2015.

54. See Chancey, *Elaine de Kooning: Negotiating the Masculinity of Abstract Expressionism*, fig. 4. (Photo source: William Walton Papers, John F. Kennedy Library and Museum.)

55. Valerie Peterson, "Elaine de Kooning," 12.

56. Elaine de Kooning letter to Edith Schloss Burckhardt, [postmarked] February 4, 1963, Edith Schloss Burckhardt Papers.

57. Elaine de Kooning letter to Thomas Hess, [n.d.], Thomas Hess Papers. Jerry Brown's relevant term as governor of California began in 1975, and Hess died in 1978, so the workshop would have taken place in the mid-seventies.

58. Elaine de Kooning interview with Antonia Zara.

59. *Monthly Review* 13 (June 1961): 230.

60. Author's telephone interview with Margaret Randall, January 7, 2015.

61. Gilbert Milstein, "Portrait of the Loft Generation," 24.

62. Elaine de Kooning letter to James Gahagan (chair of the Artist's Tenant Association), *Village Voice*, August 2, 1961. Elaine de Kooning Papers.

63. Unlabeled audio recording with Elaine de Kooning and others, 1975 (?), Larry Rivers Papers.

64. The more than four hundred words of art were donated to create a legal fund to counter the Rand Corporation's recommendation that the U.S. military use the herbicide known as Agent Orange (because it was shipped in orange-striped barrels) on rural and forested land in Vietnam, in order to destroy the guerrillas' food sources and cover, as well as the crops that constituted the peasants' livelihood.

65. Elaine de Kooning interview with Charles Hayes.

66. In Defense of Sacred Lands, November 1987, at Harcus Gallery, Boston.

67. Elaine de Kooning interview with Molly Barnes (radio broadcast). Barnes was a lover of Bill's in the mid-1960s.

68. Yet she did take part in The Women, an exhibition at the Dord Fitz Gallery in Amarillo, Texas, in 1960 (see chapter 5). Her friendship with Fitz likely overrode any concerns she had about being lumped with other women.

69. Elaine de Kooning interview with Antonia Zara.

70. Elaine de Kooning, "Venus, Eve, Leda, Diana et al.," reprinted in Elaine de Kooning, *The Spirit of Abstract Expressionism*, 125–27. The authors of *Nus d'Autrefois 1850–1900* are Marcel Bovis and François St. Julien; *The Female Form in Painting* was written by Jean Cassou and Geoffrey Grigson.

71. Daniel Belasco attempts to make a case for Elaine's feminist approach to this review in his PhD dissertation, "Between the Waves: Feminist Positions in American Art, 1949–62." Yet, he concludes (227) that she "merely hinted at a larger critique of sexism in art and society." In my view, the perception of such hints is the product of retrospective wishful thinking.

72. Elaine de Kooning, in Geeslin, "She Paints Many Ways."

73. *Cosmpolitan* was then, in its pre-Helen Gurley Brown incarnation, a general-interest magazine, not the "Cosmo" we know today.

74. Jean Lipman and Cleve Gray, "The Amazing Inventiveness of Women Painters." Lipman was editor of *Art in America*. Gray, married to the writer Francine du Plessix Gray, was an Abstract Expressionist painter.

75. Nochlin's essay and responses by ten women in the art world, including Elaine de Kooning, was republished in Thomas Hess and Elizabeth Baker, *Art and Sexual Politics*.

76. Elaine de Kooning, draft of a conversation with Eleanor Munro.

77. Elaine de Kooning, in Suzanne Muchnic, "Projecting a Blitz of Women's Art," 3.

78. Author's telephone interview with Margaret Randall, January 7, 2015.

79. Elaine de Kooning, in Doris Paysour, "Her Art—Constant Escape From a Rut," 11.

80. Women Artists Paint Women Artists, Virginia Miller Gallery, Miami, and Living Gallery, North Cross School, Roanoke, Virginia (1978); Women Artists' Sketch Books, Women's Interart Center, New York (1979).

81. The N.Y. Feminist Art Institute was founded in 1979 to encourage women artists to use their personal experience in their work. Elaine was honored in 1984.

82. Elaine de Kooning, in "Women Artists Will Have Their Own Museum," *New York Times,* November 23, 1986, 80.

83. Author's telephone interview with Wayne Thiebaud, October 17, 2014.

84. Elaine viewed later art movements, like conceptual art, as equally dubious. Even if you started with a concept, she argued, intuition inevitably takes over: "So much of art is involved with…surprising yourself." Elaine de Kooning, Skowhegan School Lecture.

85. Elaine de Kooning interview with Irving Kaufman.

86. Ibid.

87. Elaine de Kooning interview with Charles Hayes.

88. Elaine de Kooning, in Gruen, *Party's Over Now,* 212.

89. Originally published in the November 1962 issue of *ARTnews,* reprinted in Elaine de Kooning, *The Spirit of Abstract Expressionism.*

90. Elaine de Kooning, "A Stroke of Genius," 40.

91. John Canaday, "Provincetown Report."

92. William Gill, "Colossal Collection of Fakes." The exposé was also based on the negative views of curators at the National Gallery of Canada, where the show traveled in September.

93. *New York Times,* October 14, 1962.

94. In a letter to an artist friend, Elaine reported that a highlight for Bill in Rome was that "the doors are so big and you feel so welcome." She added, "I feel so welcome at little doors. I don't know what I'd do if a big door opened." This wry remark likely refers to her relative position in the art world. Elaine de Kooning letter to Nell Blaine, [undated but probably October 1959], Nell Blaine Papers, Houghton Library, Harvard University.

95. Edwin Denby letter to Edith Schloss Burckhardt [undated], Edith Schloss Burckhardt Papers.

96. Author's telephone interview with Maud Fried-Goodnight, February 22, 2015.

97. Elaine was so fond of Italy that she bought a one-way ticket on her second visit, in the summer of 1978. "Don't know when I'll be coming back," she wrote in July to Mercedes Matter. "Feel very at home." Elaine de Kooning postcard to Mercedes Matter, July 1978, Mercedes Matter Archive, item 4655471.

98. Elaine de Kooning letters to Mercedes Matter, July 12, 1974, and July 25, 1974, Mercedes Matter Archive.

99. Jules Dalou (1838–1902) was a leading sculptor in nineteenth-century France. His original, plaster version of the statue of Silenus was exhibited at the Paris Salon of 1885 and subsequently acquired by the French government; the bronze version was sited in the Jardin du Luxembourg in 1899.

100. However, in a 1977 interview with Eleanor Munro—right around the time Elaine finally gave up alcohol—she said that on a recent nine-foot-high canvas, Bacchus's face "is stylized" because he was "wicked." Elaine de Kooning, draft of a conversation with Eleanor Munro.

101. *New York Review of the Arts: Elaine de Kooning* (video), Elaine de Kooning interview with Lee Hall.

102. Ibid. All quotes in this paragraph are from this source.

103. Elaine de Kooning interview with Dord Fitz at her studio (film/DVD).

104. An untitled Bacchus painting from 1983 (oil on canvas, 84 by 66 inches) sold for $42,000 at Christie's New York on July 10, 2007 (lot 185, sale 1949)—a high-water mark for her auction prices at the time.

105. The Bacchus Series, October 9–November 6, 1982, Gruenebaum Gallery.

106. Lawrence Campbell, "Elaine de Kooning at Gruenebaum."

107. Jim Touchton, talk at Pollock-Krasner House.

108. Clay Fried mentioned her accent in his interview with me, March 13, 2015. In the draft of her conversation with Elaine de Kooning in 1977, Eleanor Munro wrote, "terrible Fr. accent!"

109. Author's telephone interview with Jim Touchton, November 24, 2015.

110. Elaine de Kooning interview with James Breslin about Mark Rothko.

111. Mark Stevens and Annalyn Swan, *de Kooning,* 433; related by an anonymous Fried family friend.

112. John Ashbery, in Stevens and Swan, *de Kooning,* 577.

113. It is unclear whether Marie was diagnosed with histrionic personality disorder, or any other form of mental illness, but children of mentally ill parents have a greater chance of becoming mentally ill themselves, through a combination of nature and nurture. See Fritz Mattejat and Helmut Remschmidt, "The Children of Mentally Ill Parents," *Deutsches Ärtzeblatt International* 105, no. 23 (June 2008: 413–18), at www.ncbi.nlm.nih.gov/pmc/articles/PMC2696847/.

114. Berkson, "The Portraitist," 41.

115. Author's telephone interview with Alex Katz, December 22, 2015. His portrait of Frank O'Hara remained in Elaine's collection until her estate was auctioned at Christie's New York in 1989.

116. Elaine de Kooning letter to Mercedes Matter, August 15, 1966, Mercedes Matter Archive.

117. A shotgun house is a narrow building that has rooms arranged one behind the other, with doors at each end of the house.

118. Elaine de Kooning letter to John Cage, January 10, 1967, John Cage Correspondence.

119. Elaine de Kooning card to Nell Blaine, postmarked 1967. Nell Blaine Papers, Houghton Library, Harvard University.

120. George Booth is known for the bedraggled home interiors of his *New Yorker* cartoons.

121. Robert Dash, in Stevens and Swan, *de Kooning,* 577.

122. Stevens and Swan, *de Kooning,* 577.

123. Elaine's niece Maud Fried-Goodnight told me that a stone at the farm is carved with Konrad's name and "1840," likely the year he took possession of the land; he would have been about twenty years old. An indentured servant received ocean passage and, often a plot of land, in return for agreeing to work for an employer for a set number of years. Immigration from Bavaria swelled during the mid-nineteenth century, motivated by the search for economic opportunity at a time when increasingly industrialization threatened small family farms. Author's telephone interview with Maud Fried-Goodnight, February 22, 2015.

124. Ibid. Louisa's son William Appleton was an engineer who worked on the Manhattan Project (U.S. Corps of Engineers Manhattan District); like most of his colleagues, he was unaware that the goal was to produce the first nuclear weapons.

125. Ibid. Elaine later purchased the adjoining house, owned by a cousin.
126. Elaine de Kooning letter to William Conger [undated], William Conger Papers.
127. Email from Maud Fried-Goodnight to author, November 13, 2015.
128. Author's telephone interview with James Bohary, March 28, 2015.
129. Author's telephone interview with David Shapiro, June 24, 2015.
130. Elaine de Kooning, in Gruen, *Party's Over Now,* 218.
131. Stevens and Swan, *de Kooning,* 577. The friend was Betsy Egan Duhrssen, ex-wife of dealer Charles Egan.
132. Richard Rappaport, "Portraits & Passages."
133. Marjorie Fried had served in the American consulate in Belgium during World War II. Distraught over her father's death in 1951, she invited her brother Peter to join her overseas. He married two months after meeting his wife-to-be. Marjorie married her sister-in-law's brother, Edmond Luyckx, and the couple adopted three Belgian children, Luke, Michael, and Christopher Jean Pierre (known as Jempy). The two couples settled in New York, living around the block from each other.
134. Author's interview with Luke Luyckx, March 12, 2015, Washington, D.C.
135. Author's telephone interview with Charles Fried, December 19, 2014.
136. Author's interview with Clay Fried, March 13, 2015.
137. Dorothy Pearlstein letter to Edith Burckhardt, December 22, 1970, Edith Schloss Burckhardt Papers, Granary Books. (Edith Schloss Burckardt Papers are now at Columbia University: MS #1763, Rare Book and Manuscript Library.)
138. Elaine de Kooning interview with John Jonas Gruen.
139. Author's telephone interview with Margaret Randall, January 7, 2015.
140. In a letter from Palm Beach, Elaine wrote, "again I'm summoned on that damned intox. charge to appear in court." Since she had to return to New York from Houston, Washington, D.C., and San Francisco for three previous court dates, she decided to ignore this summons. Elaine de Kooning letter to Joan Washburn, [n.d.], John Graham & Sons Gallery Records.
141. "Jury Indicts Elaine de Kooning," *East Hampton Star,* February 18, 1970, 4.
142. Elaine de Kooning interview with John Jonas Gruen. This may have been the incident that gave her two black eyes. Without mentioning the cause of her injury, she told a friend that she had a speaking engagement and worried that she would show up "looking like a raccoon," so she took 30 milligrams of vitamin C. Author's telephone interview with Emily Mason, December 1, 2015.
143. Author's interview with Luke Luyckx, March 12, 2015.
144. Charles Fried interview with Mark Stevens and Annalyn Swan.
145. Elaine de Kooning interview with John Jonas Gruen.
146. Elaine de Kooning interview with Antonia Zara.
147. This happened "sometime around 1974," according to Stevens and Swan, *de Kooning,* 577.
148. Author's telephone interview with Charles Fried, December 19, 2014.
149. Elaine de Kooning letter to Robert Dash, June 5, 1977, Robert Dash Papers.

150. Elaine de Kooning interview with Amei Wallach.
151. Author's interview with Clay Fried, March 13, 2015.
152. Information about this visit and Jeffcoat's relationship with Mitchell is from Patricia Albers, *Joan Mitchell*, 344–45. Jeffcoat subsequently had an affair with Mitchell's long-time sparring partner and lover, painter Jean-Paul Riopelle, which led to a tug-of-war between Mitchell and Riopelle.

CHAPTER 8

1. Elaine de Kooning letter to Edith Schloss Burckhardt, [postmarked] February 4, 1963. Edith Schloss Burckhardt Papers.
2. Artists who took part in the program, Exhibition: Contemporary American Painters, included James Brooks, Hans Hofmann, Robert Motherwell, Barnett Newman, Claes Oldenberg, Robert Rauschenberg, Jack Tworkov, and Andy Warhol.
3. Elaine de Kooning, in Gerrit Henry, "Ten Portraitists," 35.
4. Elaine de Kooning, Skowhegan School Lecture.
5. Elaine de Kooning, in John Taylor, "An Interview with Elaine de Kooning in Athens," 17.
6. She expressed her dislike for commissions in Campbell Geeslin, "She Paints Many Ways."
7. Henry, "Ten Portraitists," 35.
8. Elaine de Kooning, in Geeslin, "She Paints Many Ways."
9. Elaine de Kooning letter to Philip Pavia, [postmarked] February 25, 1959, Philip Pavia Papers.
10. Elaine de Kooning interview with John Jonas Gruen.
11. Graham Gallery letter to Oliver Rowe, June 15, 1971, James Graham & Sons Gallery Records, Box 31, AAA. Alice Neel's portrait prices were similar. ($4,500 is the equivalent of about $26,000 today.)
12. Graham Gallery letter to Robert J. Northshield, May 14, 1965, James Graham & Sons Gallery Records, AAA.
13. A few years earlier, the gallery had quoted $600 for a small sketch to $3,600 for a full-size painted portrait. Graham Gallery letter to Mrs. Charles B. Buchanan, April 15, 1964, James Graham & Sons Gallery Records, AAA.
14. Except where noted, the quotes in this paragraph are from *Elaine de Kooning Paints a Portrait of Aladar Marberger* (video).
15. *Elaine de Kooning: A Portrait* (video).
16. Elaine de Kooning, in Lieber, "Elaine de Kooning."
17. Elaine de Kooning interview with Judith Stein and Paul Schimmel.
18. Sally Bivins, "Artist Schedules Series of Lectures."
19. Valerie Peterson, "Reviews and Previews: Elaine de Kooning, de Aenlle."
20. Elaine de Kooning, in Sally Bivins, "Visiting Artist Sees Southwest as Area of Distinctive Expression."

21. Elaine de Kooning, Skowhegan School Lecture.

22. Conrad C. Fried, in *Elaine de Kooning: Portraits,* 12 (exhibition catalogue, Brooklyn College Art Gallery).

23. Connie Fox, in *Elaine de Kooning: Portraits,* 17 (exhibition catalogue, Brooklyn College Art Gallery).

24. "Instant Summaries," *Time* magazine, May 3, 1963.

25. *Elaine de Kooning: A Portrait* (video).

26. Charles North, "Elaine de Kooning at Graham," 109.

27. Jack Kroll, in *Figures: A Show of Current Figure Painting in New York* (exhibition catalogue, Kornblee Gallery).

28. The gallery informed a potential client that Neel required "four sittings of two hours each" while Elaine—who prided herself on her quick work—stipulated "two sittings of up to three hours each." Graham Gallery letter to Oliver Rowe, James Graham & Sons Gallery Records, AAA.

29. Henry, "Ten Portraitists," 35.

30. Alice Neel interview with Jonathan Brand, December 4–5, 1969, quoted in Phoebe Hoban, *Alice Neel,* 245.

31. Elaine de Kooning interview with Karl E. Fortress.

32. Lawrence Campbell, quoting an anecdote told by Wolf Kahn, in *Elaine de Kooning: Portraits,* 5 (exhibition catalogue, Brooklyn College Art Gallery).

33. Gerrit Henry, "New York Reviews: Elaine de Kooning and Alice Neel."

34. Elaine de Kooning interview with Judith Stein and Paul Schimmel. Her initial charcoal sketch, she said, took a half-hour.

35. Elaine de Kooning, Skowhegan School Lecture.

36. This object has also been read as a beer can.

37. In the early 1960s, Elaine seemed to allot each of her visiting lovers a particular day of the week. Mark Stevens and Annalyn Swan, *de Kooning,* 576.

38. Lawrence Campbell, "Elaine de Kooning at Washburn."

39. Thomas Hess, "There's an 'I' in 'Likeness,'" 84.

40. Peterson, "Reviews and Previews: Elaine de Kooning."

41. Hilton Kramer, "An Era Comes to an End."

42. *Willem de Kooning* (1954; pencil on paper, 23 3/4 by 18 5/8 inches), National Portrait Gallery, Smithsonian Institution.

43. The title indicates that he posed at her St. Mark's Place studio. *Bill at St. Marks* (1956; oil on canvas, 72 by 43 1/2 inches), National Portrait Gallery, Smithsonian Institution.

44. Elaine de Kooning interview with Judith Stein and Paul Schimmel.

45. Elaine de Kooning interview with Karl E. Fortress.

46. Elaine de Kooning interview with Ann Gibson. In this interview, Elaine mistakenly said that "gyroscope men" was the title of May's book, and that it had come out in the 1960s. She may have been thinking of the 1973 reprint.

47. Rollo May, *Man's Search for Himself* (New York: W.W. Norton, 2009 [1953]), 7–8.

48. Elaine's sister, Marjorie Luycks, told the art historian Ann Gibson that Elaine viewed "gyroscope" as "a good name for an inertial entity that resists change." Telephone conversation, January 23, 1996, cited in Ann Gibson, "Narrative and Negation in the Art of Elaine de Kooning," note 12.

49. Elaine de Kooning, conversation with Rose Slivka.

50. Elaine de Kooning, Skowhegan School Lecture.

51. Elaine de Kooning interview with Charles Hayes.

52. Elaine de Kooning, Skowhegan School Lecture.

53. Rudy Burckhardt, who was close to Denby for many years, once remarked that the expression on his face was so changeable that he "had no rest point that would show [his] character." "Rudy Burckhardt and Edwin Denby, in conversation with Joe Giordano," ca. 1976, http://jacketmagazine.com/21/denb-giord.html.

54. Elaine de Kooning, in Edvard Lieber, *Willem de Kooning*, 21.

55. Elaine de Kooning interview with Arthur Tobier.

56. Author's telephone interview with Wolf Kahn, November 25, 2015. Elaine also painted Kahn's portrait and gave it to him; he judged it a lesser work and destroyed it so that (he said) it would not put a dent in her reputation.

57. Elaine de Kooning, in Henry, "Ten Portraitists," 35.

58. Elaine de Kooning interview with Karl E. Fortress. She told Eleanor Munro that her mother's reaction was alarm: "Elaine! Someone's painted out all the faces!" Elaine de Kooning, draft of a conversation with Eleanor Munro.

59. Grace Hartigan, *The Masker* (1954; oil on canvas), Frances Lehman Loeb Art Center, Vassar College. In this portrait, O'Hara's faceted eyes are covered by a transparent mask.

60. Frank O'Hara, "Nocturne" (1955), in *The Collected Poems of Frank O'Hara*, ed. Donald Allen, 224–25. See also Russell Ferguson, *In Memory of My Feelings*, 89.

61. *Bill* (1952; oil on canvas, 48 by 32 inches), formerly Joan Washburn Gallery.

62. *Portrait of Willem de Kooning* (ca. 1955; oil on canvas, 39 by 251/2 inches), sold in 2001 by William Doyle Galleries.

63. Frank O'Hara, "Nature and the New Painting" (1954), in O'Hara, *Standing Still and Walking in New York*, 44.

64. Leo Steinberg, "Month in Review," *Arts Magazine,* January 1946, 47.

65. Elaine de Kooning interview with Ellen Auerbach. Anne Porter was more forgiving of her husband's attitude. Although he respected her poetry, she said, he "couldn't be altogether supportive about our having children … because his own father was so aloof." Anne Porter, in Magda Salvesen and Diane Cousineau, eds., *Artists' Estates: Reputations in Trust* (New Brunswick, NJ: Rutgers University Press, 2005), 25–26. Elaine's 1963 pencil portrait of Anne Porter—reproduced in *Drawings &*, 32—captures her reserved, unworldly personality.

66. Conrad C. Fried, in *Elaine de Kooning: Portraits*, 12 (exhibition catalogue, Brooklyn College Art Gallery).

67. Perhaps it was this aspect—endowing a portrait with the residue of her conflicted feelings about the sitter—that Thomas Hess and Valerie Peterson were referring to when they wrote that Elaine's portraits were self-portraits.

68. John Wesle, "'Action Painter' de Kooning Lectures."

69. *Meg Randall* (1960; ink and gouache on paper, 14 1/2 by 11 inches), National Museum of Women in the Arts, Washington, D.C., gift of Marjorie Luyckx.

70. Elaine de Kooning interview with Rose Slivka.

71. Patia E. M. Yasin, in *Elaine de Kooning: Portraits*, 19 (exhibition catalogue, Brooklyn College Art Gallery).

72. Denise Lassaw, "Elaine de Kooning, A Life in Frames."

73. Denise Lassaw, in *Elaine de Kooning: Portraits*, 19 (exhibition catalogue, Brooklyn College Art Gallery).

74. Information about Bernice Sobel is from "Singing Lady," *TWA Skyliner* 47 (November 19, 1984): 6; *High Notes* (publication of The Academy of Vocal Arts, Philadelphia), Fall 2012, 12; and death notice, October 29, 2013, www.legacy.com/obituaries/philly/obituary.aspx?pid=167756498.

75. Elaine de Kooning interview with Ann Gibson.

76. None of these women were fellow painters. In October 1963, Elaine offered to paint a portrait of 41-year-old Nell Blaine: "two versions—one for you and one for me." But despite an assurance of speedy work ("I'm really fast"), this sitting never took place. Elaine de Kooning letter to Nell Blaine, [postmarked] October 9, 1963, Nell Blaine Papers, Houghton Library, Harvard University.

77. Elaine de Kooning interview with Rose Slivka.

78. Elaine de Kooning interview with Karl E. Fortress.

79. Conrad C. Fried, in *Elaine de Kooning: Portraits,* 12 (exhibition catalogue, Art Gallery of Brooklyn College).

80. As Carol Mason writes (*Oklohomo: Lessons in Unqueering America,* 125), "Fitz and his young lover from Cleveland were arrested at [a] rest stop." Local newspapers reported his dismissal from the university.

81. *Achievements in Art 2008* (exhibition catalogue).

82. The catalogue dates the portrait as "ca. 1968," but Dord Fitz paid Elaine a $1,000 commission on April 26, 1965, presumably for this painting. Elaine de Kooning Financial Statements, Elaine de Kooning Papers.

83. The former quarantine hospital had reopened in 1952 with a new mission—treatment of youthful drug users. The regimen was draconian: forced withdrawal without medication (except in life-threatening cases) in a deadbolted "seclusion room" furnished with only a mattress and a bucket. Afterward, patients were allowed to use the gym and classrooms. Drugs were often smuggled into the facility, abuse was rampant, and recidivism rates were high. In 1963, the facility was closed. See www.kingston-lounge.blogspot.com/2011/01/north-brother-island-riverside-hospital.html.

84. Because they were older than the others, it's not clear whether Johnson and Corless, both of whom struggled with addiction, were part of the program at that time.

85. Author's telephone interview with Margaret Randall, January 7, 2015.

86. Fairfield Porter, "Art," 379.

87. Nico Alvarado, "Frank Lima, 1939–2014." See also "Sherman Drexler with Phong Bui," *Brooklyn Rail*, July 9, 2009. Thanks to O'Hara and Koch's efforts, Lima attended Adelphi University on a scholarship. He also earned a master of fine arts degree from Columbia University. In the late seventies, he began working as a chef and continued to write poetry.

88. Rose Slivka, "From the Studio," *East Hampton Star,* January 14, 1999. Slivka relates a possibly apocryphal story: that the drug center authorities refused to allow Elaine to leave the premises with a painting that showed the men's faces, so she used a water-based paint to obscure them, which she removed in her studio.

89. See Samuel Roberts, "'Rehabilitation as Boundary Object: Medicalization, Local Activism, and Narcotics Addiction Policy in New York City, 1951–62," Alcohol and Drug History Society, https://alcoholanddrugshistorysociety.files.wordpress.com/2014/01/shad-26-2-roberts.pdf.

90. EHPP Narcotics Committee, *A Statement on Narcotic Addiction among Adolescents and Some Suggestions on Treatment* (New York City: East Harlem Protestant Parish, 1959).

91. April 23 to May 11, 1963. The other portrait subjects included Frank Lima, welterweight Emile Griffith (current whereabouts of both paintings are unknown), Frank O'Hara, Edwin Denby, Robert Mallary, Myron Jones (1930–2011, a poet who taught at Grace Church Episcopal School) and his son Christopher, and Lorraine Patterson.

92. "The Oldest Art," *Newsweek,* May 13, 1963, E11. The writer likened *Burghers* to Henri Rousseau's "jungle-Paris apparitions," a bizarre comparison, even if applied to a picture like *Artillerymen* (1894).

93. "Instant Summaries," *Time* magazine, May 3, 1963, 68.

94. Sargent's Ghost in Strange Place," *New York Herald Tribune,* April 28 1963, sec. 4, p. 7.

95. John Canaday, "Two Ways To Do It," X13. The critic received several dissenting letters from readers.

96. Hilton Kramer, "Elaine de Kooning's Ode to a Vanished New York."

97. Elaine de Kooning, C.F.S. Hancock Lecture.

98. *Conversations with Artists: Elaine Benson with Elaine de Kooning* (video).

99. Richard Rappaport, "A Heart of Darkness."

100. James Schuyler letter to Harry Matthews, November 15, 1970, in William Corbett, ed., *Just the Thing*, 319.

101. *Elaine de Kooning Paints a Portrait of Aladar Marberger* (video).

102. W. R. Grace Jr., son of the shipping executive, bought the 626 acres of woodland (and the abandoned homestead of the Van Scoy family) in 1925. The tract remained in the family until 1985, when it was purchased by Ben Heller, an art collector and real estate developer. The Town of East Hampton held a public referendum to acquire 516 acres, now known as the Grace Estate Preserve. http://easthampton-

star.com/Archive/3/Open-space-Marking-20-Years-Grace-Estate-How-and-why-huge-tract-Northwest-Woods-was-preserved.

103. Elaine de Kooning interview with Rose Slivka.

104. Ibid.

105. Elaine de Kooning interview with Charles Hayes.

106. Elaine de Kooning interview with Dord Fitz in her studio (film, untitled).

107. Lawrence Campbell, "Elaine de Kooning: Portraits in a New York Scene," 39.

108. Elaine de Kooning, Memorial for Gandie Brodie. Born in 1924, he began painting after studying modern dance and immersing himself in bebop. His subjects ranged from jazz players to seagulls and New York tenements.

109. Bill Berkson, "The Portraitist," 41.

110. Robert de Niro Sr. (1922–1993) studied briefly with Hans Hofmann and attended Black Mountain College for two terms, but was largely self-taught. His first solo show was at the Art of This Century Gallery in New York in 1946; he later showed at the Egan Gallery. He had struggled to come to terms with his homosexuality—he separated from his wife in 1949, after the birth of their son—and, despite a successful teaching career and continuing exhibition opportunities, felt left behind by a changing art world.

111. Elaine de Kooning interview with Judith Stein and Paul Schimmel; and Elaine de Kooning, Skowhegan School Lecture. Robert De Niro, who was prone to ranting about the art world, had complained to another artist years earlier that Elaine was a "star" who never bothered to answer her phone when he called. Robert De Niro letter to Nell Blaine, July 1, 1964, Nell Blaine Papers, Houghton Library, Harvard University.

112. Elaine de Kooning interview with Rose Slivka.

113. Author's telephone interview with Jim Touchton, November 24, 2015.

114. In the United States, this game is known as soccer.

115. A contender for Elaine's all-time record for ignoring distractions was her portrait of poet Alan Ginsburg, painted on camera for WNET-TV in 1973. As she remembered the scene a decade later, Alan was chanting OM, a rock group was playing, and an astrologer was talking about people's signs. *Elaine de Kooning: A Portrait* (video); in the video, she misstated the date as 1969.

116. *Elaine de Kooning: A Portrait* (video).

117. The first one was a portrait of one of her nephews.

118. Joseph Liss, "Elaine de Kooning and Pelé." Except where noted, all quotes from the sittings are from this article.

119. Elaine de Kooning interview with Dord Fitz in her studio and at the Guild Hall (film, untitled).

120. Elaine de Kooning, in Jean Alter, "In the Spotlight."

121. The oil painting is in a private collection in New York. Another portrait from these sessions, *Pelé #3* (1982), was sold at auction for $4,375 on May 10, 2016 by Doyle New York (lot 27).

122. Elaine de Kooning interview with Dord Fitz (film, untitled).

123. Valerie Peterson, "U.S. Figure Painting," 51.
124. Each painter was represented by one work, selected from submissions by 1,841 artists from across the United States. Exhibiting painters included Elmer Bischoff, Robert De Niro, Leon Golub, Lester Johnson, and Larry Rivers.
125. Elaine de Kooning, in Irving Sandler, "In the Art Galleries."
126. Elaine de Kooning, Skowhegan School Lecture.
127. Robert Walsh, "New Editions," 106. Elaine also painted what she called a "fast" portrait of Ashbery with his arms crossed. One of her students at Yale University had sparked her interest in men who habitually assumed this pose.
128. North, "Elaine de Kooning at Graham."
129. Elaine de Kooning: Portraits, Brooklyn College Art Gallery, February 28–April 19, 1991 (a full retrospective); Elaine de Kooning: Artists & Writers, Washburn Gallery, October 5–November 19, 1994.
130. Roberta Smith, "Five Shows Focus on World War II Generation."
131. Campbell, "Elaine de Kooning at Washburn."
132. Bruce Cole, Too Cool in the Capitol."
133. Tim Keane, "Instant Illuminations."
134. Aristodemos Kaldis was born in Turkey in 1899, into a family of bankers and shippers. He left home at age sixteen and made his way to New York in the 1930s. A self-taught painter who specialized in colorful remembered landscapes of Greece, he served as director of the mural division of the Federal Art Project. Although major museums ignored his work, he showed at two New York galleries in the 1960s and received two Guggenheim fellowships in the 1970s.
135. In June 1952, Elaine wrote to him that she had seen a photo of him with his "marvelous archaic smile," a reference to the seraphic smile on many Archaic Greek sculptures. Elaine de Kooning letter to Aristodemos Kaldis, Aristodemos Kaldis Papers.
136. Elaine de Kooning interview with Dord Fitz (film, untitled).
137. *Elaine de Kooning: A Portrait* (video).
138. Hilton Kramer, "Kaldis, a Greek Falstaff." In a largely critical review of Originals—a 1980 Graham Gallery show of work by women artists, based on Eleanor Munro's eponymous book—Kramer singled out one of Elaine's Kaldis portraits as "powerful." Hilton Kramer, "Does Feminism Conflict with Artistic Standards?" D1.
139. Elaine de Kooning in Rose Slivka, *Kaldis Art.*
140. Slivka, "From the Studio," *East Hampton Star,* January 14, 1999.
141. Elaine de Kooning, in "Crosscurrents USA" (panel discussion, unpublished).
142. Elaine de Kooning, Skowhegan School Lecture.
143. Pat Passlof, in Geoffrey Dorfman, *Out of the Picture,* 278.
144. Irving Marantz (1912–1972) was a painter (in his final years, he took up sculpture), who taught widely and served as director of the Provincetown School of Painting for a dozen years.
145. Elaine de Kooning, in "Crosscurrents USA."
146. The title and whereabouts of this painting are unknown. I have not been able to find a catalogue of the Crosscurrents USA exhibition.

CHAPTER 9

1. At a later date, she told an acquaintance that JFK wore "a gray sweat shirt." Edvard Lieber, "Elaine de Kooning: Her World and Persona," 2. In *Kennedy*, the 1983 TV miniseries, the president (Martin Sheen) wears a gray polo shirt when he is sketched by Elaine (Janet Sheen). For some reason, this scene is set in late 1960, soon after Kennedy is elected. But he does say, "Am I moving around too much, Mrs. de Kooning?" And the artist responds, "Yes."

2. Elaine de Kooning, "Painting a Portrait of the President."

3. Elaine de Kooning, in Jean White, "To Artist, JFK Was Always in Motion."

4. Elaine always said that December 28, 1962, was the first day of the sittings. But she invariably remembered this day as JFK's press conference. According to the president's daily schedule for this period (Miller Center of Public Affairs, JFK's only press conference during this period was on December 31. www.millercenter.org/presidentialrecordings/Kennedy/daily-diaries, In Elaine's last interviews about the portrait (July 19, 1985, and March 20, 1987)—which were combined into a single narrative in *Elaine de Kooning: Paintings 1955–1965* (exhibition catalogue)—she repeated the December 28 date and 10 A.M. hour for the first sitting but did not mention the press conference. By comparing her remarks in interviews to JFK's daily diary and *New York Times* coverage of his meetings during this period, I have settled on a likely sequence of events.

5. Ben Wolf, "Portrait of a President"; and Eleanor Munro, *Originals*, 256.

6. Wolf, "Portrait of a President."

7. Elaine de Kooning, in *President John F. Kennedy* (exhibition catalogue). The essay was based on her statements in Ben Wolf's "Portrait of a President" with some edits made by the artist.

8. Elaine de Kooning, in Delores Phillips, "Painter 'Shares' Kennedy."

9. Elaine de Kooning, in "HST Library Gets Painting," *Corpus Cristi Caller-Times*, February 13, 1965, 6.

10. Elaine de Kooning, in Ellen Sulkis, "Kennedy Looked Golden."

11. Robert C. Graham letter to David D. Lloyd, executive director, Truman Library, November 24, 1962, James Graham & Sons Gallery Records, AAA.

12. Thomas Hart Benton, *Independence and the Opening of the West* (1960). According to one account, Truman commented on Benton's work while the artist was standing on a scaffold to paint the mural. Asked to come up and help, the former president added a daub of blue to the sky. See www.trumanlibrary.org/teacher/benton.htm.

13. Robert Graham letter to "Paul" (an editor at *ARTnews*), January 6, 1965; and introduction to *President John F. Kennedy* (exhibition catalogue).

14. Charles Banks Wilson (1918–2013).

15. David Lloyd, executive director of the Harry S. Truman Library, letter to Robert Graham, December 10, 1962, Harry S. Truman Library, Elaine de Kooning Curatorial File.

16. Philip C. Brooks letter to David D. Lloyd, November 11, 1962, Harry S. Truman Library.

17. David D. Lloyd letter to Philip C. Brooks, November 23, 1962, Harry S. Truman Library.

18. David D. Lloyd letter to Robert C. Graham, December 10, 1962. Harry S. Truman Library. Lloyd died the next day; he was fifty-one years old.

19. Robert C. Graham letter to Philip C. Brooks, December 19, 1962, Harry S. Truman Library.

20. Elaine de Kooning letter to Edith Schloss Burckhardt, [postmarked] February 4, 1963, Edith Schloss Burckhardt Papers. Kennedy's staff had approved Elaine's visit to Palm Beach by November 19, the date of a letter from Graham to library director Philip C. Brooks confirming the plan (Elaine de Kooning Curatorial File, Harry S. Truman Library). It's not clear whether Graham delayed notifying Elaine, or whether she misremembered when she received the news.

21. Carol Strickland, "Shining a Light on the Other de Kooning." In numerous interviews about this meeting, Elaine usually omitted the name of the emissary. In a couple of late interviews, she said it was LeMoyne Billings.

22. Elaine de Kooning interview with Charles Hayes. Also in other interviews.

23. Lennart Anderson (1928–2015) was an academic painter who specialized in portraits, still lifes and street scenes. Ironically, Elaine was a supporter of Anderson's. In a May 1962 interview, she included his name in a list of portrait artists she said were doing serious work. Irving Sandler, "In the Art Galleries." Decades later, she claimed to have purchased "the first painting he ever sold," offering to pay the amount of his monthly rent: thirty-five dollars. Elaine de Kooning interview with Charles Hayes; and de Kooning interview with Molly Barnes (radio broadcast).

24. John Canaday, "Two Ways to Do It."

25. Elaine de Kooning, C.F.S. Hancock Lecture. She told the same story to several interviewers over the years; a similar version appears in Munro, *Originals*, 256. The painting, then known as *Double Portrait*, was an image of an intense-looking man (poet Myron Jones) in a belted coat, holding the hand of his son Christopher.

26. John Canaday, "Whitney Again."

27. Elaine de Kooning interview with Irving Kaufman.

28. See chapter 7.

29. Elaine de Kooning interview with Judith Stein and Paul Schimmel.

30. Elaine de Kooning, C.F.S. Hancock Lecture.

31. Joseph Hirshhorn, the art collector, didn't even grant her the luxury of multiple sittings. He asked if she could complete his life-size portrait in two hours, and somehow she did.

32. Elaine de Kooning, in Wolf, "Portrait of a President."

33. John Singer Sargent letter to James Ford Rhodes, April 19, 1920, quoted in Charles Mount, *John Singer Sargent: A Biography*, 249. Fourteen years later, when Sargent returned to the White House to paint a portrait of Woodrow Wilson, he remarked on how much more peaceful the sittings were and how "serene" the president appeared to be.

34. White, "To Artist, JFK Was Always in Motion."
35. Lord Harlech (William David Ormsby-Gore), oral history interview with Richard E. Neustadt for JFK Library, March 12, 1965, JFKOH-LWH-01, 74–75.
36. Wolf, "Portrait of a President."
37. Elaine de Kooning, in *Elaine de Kooning: A Portrait* (video).
38. Elaine de Kooning, quoted similarly in Tom Donnelly, "A Moving Portrait"; White, "To Artist, JFK Was Always in Motion"; and Elaine de Kooning, "Painting a Portrait of the President."
39. Elaine de Kooning, "Painting a Portrait of the President."
40. "Quest for a Famous Likeness," *Life* magazine, May 8, 1964, 120–22.
41. Lord Harlech oral history interview, 18 (see note 35). Robert McNamara had lost confidence in the Skybolt, the development of which was undertaken as a joint U.S.-U.K. endeavor. It was replaced by the technologically superior Polaris missile.
42. On January 3, Kennedy had a 9 A.M. appointment with Orville Freeman. The man speaking with the president in an unattributed photograph that shows Elaine at her easel is identified in Jane Bledsoe, *Elaine de Kooning,* 32, as Lawrence O'Brien Jr. The two men, Freeman and O'Brien, special assistant to the president for congressional relations, closely resembled each other, but because of the scheduled appointment, this would have been Freeman. In an undated letter to William Walton, ca. 1964, Elaine included this photo, which she wrote was taken "during a conference with Orville Freeman." On the back of the photo, she wrote the date: "Dec. 28, '62" (see note 4). However, that was that day the president met with Anthony J. Celebrezze, secretary of Health, Education and Welfare; Wilbur Cohen, HEW undersecretary; and Francis O. Keppel, commissioner of education, to discuss medical care and school aid bills. Tom Wicker, "President Plans No Basic Changes in Welfare Bills," *New York Times*, December 29, 1962, A1.
43. White, "To Artist, JFK Was Always in Motion."
44. Wolf, "Portrait of a President."
45. Phillips, "Painter 'Shares' Kennedy."
46. Donnelly, "A Moving Portrait"; and Rick Setlowe, "The Pied Piper with a Palette."
47. Elaine de Kooning, "Painting a Portrait of the President."
48. Lord Harlech oral history interview, 65 (see note 35).
49. Donnelly, "A Moving Portrait."
50. White, "To Artist, JFK Was Always in Motion."
51. "Quest for a Famous Likeness," *Life* magazine, May 8, 1964, 120–22.
52. Sulkis, "Kennedy Looked Golden."
53. Elaine de Kooning, in Munro, *Originals,* 256–57; and Elaine de Kooning, C.S.F. Hancock Lecture. In this talk, she said that it was Billings who initially contacted her with the portrait assignment, and she repeated the anachronistic story about the Canaday review.
54. Elaine de Kooning, Skowhegan School Lecture.
55. Elaine de Kooning, "Painting a Portrait of the President."

56. In her talk at the unveiling of the Truman Library portrait, Elaine said that Jacques Lowe (1930–2001), Kennedy's official photographer, had allowed her to rummage through his contract prints.

57. Elaine de Kooning, in Lawrence Campbell, "The Portraits," quoted in Bledsoe, *Elaine de Kooning*, 34.

58. *Elaine de Kooning: Paintings 1955–1965*, unpaginated (exhibition catalogue).

59. Elaine de Kooning letter to Edith Schloss Burckhardt, [postmarked] February 4, 1963. Edith Schloss Burckhardt Papers.

60. Elaine de Kooning, C.F.S. Hancock Lecture.

61. Elaine de Kooning letter to "Ernie" (Ernestine Lassaw), [undated; 1983], Elaine de Kooning Papers.

62. Or maybe he copied his own way of sitting. Someone who knew Ingres once described him as sitting "motionless…his hands stretched wide over parallel knees." Geraldine Pelles, *Art, Artists and Society*, 82.

63. Elaine de Kooning, quoted in wall label for EK23, *Tom Hess* (1963; oil on canvas, private collection), in the exhibition Elaine de Kooning: Portraits, at the National Portrait Gallery, Smithsonian Institution.

64. Munro, *Originals*, 257.

65. Elaine de Kooning interview with Charles Hayes.

66. Sulkis, "Kennedy Looked Golden."

67. Elaine de Kooning, C.F.S. Hancock Lecture.

68. Former President Harry S. Truman wanted the Truman Library to be "a museum about the American presidency," rather than about him. But the objects initially exhibited there were a "miscellany…that really didn't have much to with his presidency." Larry J. Hackman, oral history interview for JFK Library, April 16–17, 2004, JFKOH-ETS-01, 7–8.

69. Elaine de Kooning interview with Lynn Kienholz and Edward Goldman (radio broadcast).

70. Philip C. Brooks letter to Robert Graham, June 5, 1963, Harry S. Truman Library.

71. Elaine de Kooning interview with Antonia Zara. In this interview, Elaine places the visit in early November 1963, but in a talk she gave years earlier, she said it happened in October.

72. *Conversations with Artists: Elaine Benton with Elaine de Kooning* (video). Elaine also mentioned this in Doris Wilson, "Artist Captures Kennedy's Warmth."

73. Philip C. Brooks letter to Robert C. Graham, November 8, 1963, James Graham & Sons Gallery Records, AAA.

74. Robert C. Graham letter to Philip C. Brooks, November 20, 1963, James Graham & Sons Gallery Records, AAA.

75. Wolf, "Portrait of a President."

76. The painting, now in the collection of the Hirshhorn Museum and Sculpture Garden, Smithsonian Institution, is related stylistically to Willem de Kooning's *Clam Diggers* of the same period—which shares the pastel tonality and indeterminate body

contours of *Reclining Man*—but the latter painting is considerably more muted, and Kennedy's body appears almost dematerialized.

77. Tracy Daugherty, *Hiding Man*, 251.

78. Wolf, "Portrait of a President."

79. Ibid.

80. Elaine de Kooning interview with Charles Hayes. These pieces are not her sole sculptural works. In 1964, she made bronze sculptures of bulls (see chapter 10).

81. Author's telephone interview with Wayne Thiebaud, October 17, 2014.

82. Philip Brooks letter to Robert Graham, November 26, 1963, James Graham & Sons Gallery Records, AAA.

83. Robert Graham, handwritten note at the bottom of Brooks's letter of November 26, 1963 (see note 26).

84. Sulkis, "Kennedy Looked Golden." Elaine said later that Jacqueline Kennedy purchased four charcoal drawings. Elaine de Kooning interview with Antonia Zara. In 1968, Jacqueline Kennedy commissioned portrait artist Aaron Shikler, who had never met JFK, to paint an image of her husband and one of herself. She told the painter that she didn't want "that puffiness under the eyes and every shadow and crease magnified," as in other portraits—presumably including Elaine's. In stark contrast to Elaine's portraits, the Shikler painting—which hangs in the White House—shows JFK in a meditative pose, looking downward. Shikler said that he was trying to show him as "as a president who was a thinker." William Grimes, "Aaron Shikler, Portrait Artist."

85. Three of these drawings were sold by Sotheby's on April 23–26, 1996, in the much-ballyhooed Estate of Jacqueline Kennedy sale, no. 6834; catalogue pp. 78, 452. One of Elaine's charcoal portraits sold for a record $63,000, zooming past its estimate of $1,500 to $2,500.

86. Many of these works would be also be shown that fall at the Washington Gallery of Modern Art, in Washington, D.C., and at the Philadelphia Academy of Fine Arts. (The head of the Kansas City Art Institute School of Design, a Mr. Paul, had made edits in the catalogue essay, excerpted from Ben Wolf's newspaper article. Graham reinstated these cuts and also—at Elaine's urging—insisted on including Wolf's poem, "The Man Who Passed.")

87. Johnson's hometown newspaper printed a brief notice of his contribution to Elaine's portrait project: "Eddie Johnson Photographs the President," *Albuquerque Journal*, May 10, 1965, 20.

88. Elaine de Kooning letter to "Joan" [Joan Washburn] [undated], James Graham & Sons Gallery Records.

89. Jai alai is a fast-paced game in which a ball is thrown and caught in a wicker scoop strapped to a player's arm.

90. Elaine de Kooning letter to Evelyn Lincoln, December 19, 1962, James Graham & Sons Gallery Records.

91. Evelyn Lincoln letter to Elaine de Kooning, April 7, 1965, James Graham & Sons Gallery Records.

92. Elaine de Kooning letter to Evelyn Lincoln, April 13, 1965, James Graham & Sons Gallery Records.

93. Robert Graham letter to Evelyn Lincoln, April 17, 1965, James Graham & Sons Gallery Records.

94. Philip C. Brooks, "Memo for file," January 5, 1965, Harry S. Truman Library.

95. Elaine de Kooning letter to Robert Graham, April 29, 1964, James Graham & Sons Gallery Records.

96. Elaine de Kooning, Truman Library portrait dedication speech.

97. Dorothy Kilgallen, "The Voice of Broadway," King Features Syndicate column, January 3, 1963.

98. Elaine de Kooning, in Lieber, "Elaine de Kooning: Her World and Persona," 4.

99. *Seated Figure (John F. Kennedy)*, Harry S. Truman Library, Independence, Missouri. Kennedy's pose is similar to his seated position in the National Portrait Gallery version. Other artists who painted portraits of Kennedy include James Wyeth (who worked from photographs in 1967), Norman Rockwell (who inserted Kennedy's face in his 1966 painting *The Peace Corps*), and Bernard Fuchs (*The Kennedy I Knew [JFK in Rocker]*, 1963). None of these images conveys the New Frontier spirit of Elaine de Kooning's portrait.

100. Elaine de Kooning, Skowhegan School Lecture.

101. It was a gift from William J. van den Heuvel (assistant to Robert F. Kennedy, then attorney general), his wife Melinda Fuller, and Susan Stein.

CHAPTER 10

1. Mark Stevens and Annalyn Swan, *de Kooning*, 683n578.

2. The road has always been known by its ungrammatical name. (An alewife, a small, bony, silvery-blue fish, is a species of herring.) The house number is now 55, but when Elaine owned the house, it was 45.

3. This house sold "for $8,000 less than the asking price (which was $5,000 more than it should have been realistically) so I'm just as happy," Elaine wrote to Israel and Idee Levitan (who sold her the Alewive Brook Road house) on February 25, 1976. Israel and Idee Levitan Papers.

4. Elaine de Kooning letter to Robert Dash, February 2 [1976], Robert Dash Papers.

5. Elaine de Kooning letter to Judy Booth (assistant director, Tamarind Studio), April 22, 1976, Tamarind Institute Papers.

6. Elaine de Kooning, in Rose Slivka, "Elaine de Kooning: The Bacchus Paintings," 69.

7. Author's telephone interview with Tom Ferrara, May 4, 2015. According to Stevens and Swan (*de Kooning*, 570), attorney Lee Eastman urged Bill to ask Elaine to help. The authors date this conversation to the summer of 1977; however, that was a year and a half after Elaine had already returned to East Hampton for that purpose.

8. Stevens and Swan, *de Kooning*, 560.

9. Although multiple sources, including her sister Marjorie's chronology in Jane Bledsoe, *Elaine de Kooning*, 108—which is not always accurate—state that this

was the summer of 1977, Elaine was traveling in Paris and elsewhere in Europe then. A representative of the University of Georgia summer program told me she was not able to access the paper records to verify the date.

10. Elaine de Kooning interview with Antonia Zara.

11. Elaine de Kooning letter to Tom Hess, from Paris, [postmarked] July 25, 1977, Thomas Hess Papers. All quotes in this paragraph are from this source. She writes about her New York Studio School course and adds that she will travel to several cities in Italy in August, but does not mention any other summer teaching position.

12. Elaine de Kooning letter to John Cage, October 16, 1976, John Cage Correspondence.

13. Stevens and Swan, *de Kooning,* 581–82. Information about Elaine's salary and financial arrangement with Bill also comes from this source.

14. After her death, a scholarship fund for graduate students was established at Bard in Elaine's name.

15. Elaine de Kooning, Image Gallery lecture.

16. He invented an early bar-code reader.

17. Author's telephone interview with Tom Ferrara, May 4, 2015. (In Stevens and Swan, *de Kooning,* Ferrara's arrival is given as January 1979; he said it was in the autumn.)

18. Elaine de Kooning, in Curtis Pepper, "The Indomitable de Kooning," 90.

19. Stevens and Swan, *de Kooning,* 587–88.

20. Author's telephone interview with Bill Berkson, January 5, 2016. In his oral history interview for the Archives of America Art (September 29–October 2, 2015), Berkson remembered Elaine's request as "soda water" and said that Bill—who also delivered a zinger about painter Clyfford Still—disparaged Guston's recent work as "all these clocks and shoes."

21. When the previous owners' home insurance policy was rewritten for Connie, it neglected to specify that her possessions had to be *in* her home to be covered. The move was serendipitous in other ways, including the stimulating presence of other artists, one of whom, the sculptor Bill King, became her beloved husband.

22. Author's telephone interview with Connie Fox, January 22, 2015.

23. Ibid.

24. Herman Cherry, in *Elaine de Kooning: Portraits,* 13 (exhibition catalogue, Brooklyn College Art Gallery).

25. Author's telephone interview with Connie Fox, February 6, 2015.

26. It is now SUNY Stony Brook.

27. Quotes are from author's interview with Lawrence Castagna in East Hampton, July 18, 2015. He is now an art conservator in East Hampton.

28. Lieber, who declined to be interviewed for this book, met Elaine and Bill in 1978, after premiering his piano composition *24 de Kooning Preludes* at Lincoln Center. In 1983, he began interviewing the couple for a film he planned to make. By 1986, he had begun working for Elaine on a regular basis. Edvard Lieber, *Willem de Kooning,* 7, 9. According to Tom Ferrara, Elaine asked Lieber to transcribe some of her journals. After he spoke on a panel about Elaine at the Pollock-Krasner House in August

254 Notes to Pages 179–182

2015, I asked him if he knew what had happened to the journals. He sidestepped the question, saying only, "It's complicated."

29. Herman Cherry, in *Elaine de Kooning: Portraits*, 12 (exhibition catalogue, Brooklyn College Art Gallery).

30. Marcia Marcus, in Alexander Russo, *Profiles on Women Artists*, 165–66.

31. Painter Irma Cavat, in Stevens and Swan, *de Kooning,* 597. The authors write that this event occurred in spring 1982, but Kaldis died on May 2, 1979. Elaine also steered Bill to Kaldis's studio just before the opening reception for his Guggenheim Museum show in February 1978. This was a way to kill two birds with one stone: keeping Bill from away from the bars and cheering up their old friend.

32. Elaine's only show that year was at C. Grimaldis Gallery in Baltimore.

33. Carl Schoettler, "E de K is Seldom at a Loss for Words."

34. Author's telephone interview with Tom Ferrara, May 4, 2015.

35. Joan Carson, "AD Visits: Willem de Kooning."

36. Author's interview with Arlene Bujese, July 20, 2015, East Hampton, New York.

37. Jo Ann Lewis, "The Sweet Exuberant Moments of 'Italian Summers.'"

38. Elaine de Kooning interview with Molly Barnes (radio broadcast).

39. Author's telephone interview with Jim Touchton, November 24, 2015.

40. Emilie Kilgore, in Stevens and Swan, *de Kooning,* 599.

41. Richard Marshall, *Fifty New York Artists*, 34. In a telephone interview with art historian Richard Shiff, Marshall suggested that Elaine likely had a hand in this piece. Karen Painter and Thomas Crow, *Late Thoughts*, 48n2.

42. *Artists Speak at the Art Barge: Elaine de Kooning* (video).

43. The colors were made from iron ore (red), iron oxide (yellow), charcoal or manganese (black), and chalk or burned bone (white), combined with talc or feldspar and animal and plant oils.

44. In 1979, Lascaux was declared a World Heritage Site.

45. Margaret Randall, *My Town*, 92.

46. It is possible that she visited Lascaux II, which opened that year with information about the history and layout of the original caves and replicas of the two main Lascaux chambers.

47. These caves are in the *département* of Ariège, in southern France; from titles of her prints, we know that she also visited caves in Lot, east of the Dordogne.

48. *Artists Speak at the Art Barge: Elaine de Kooning* (video). Except where noted, all quotes in this paragraph are from this source.

49. Elaine de Kooning (from a taped discussion, 1982), in Rose Slivka, "Essay," quoted in Elaine de Kooning, *The Spirit of Abstract Expressionism*, 33.

50. Elaine de Kooning, in Leigh, "Honoring the Artists of the Hamptons: Elaine de Kooning."

51. Elaine de Kooning interview with Lyn Kienholz and Edward Goldman (radio broadcast).

52. Elaine de Kooning letter to "Sally," October 6, 1983, Rose Slivka Papers. "Sally" may be the dancer Sally Gross, who posed for Elaine years earlier and from whom Elaine once took exercise classes.

53. Elaine had met Schell at a party to raise funds for No First Use, an anti-nuclear group.

54. Elaine had asked Randall, who had contacts with Fidel Castro, to get him to agree to a portrait sitting, but he never responded. "That's the way she operated," Randall said. "She went right to the top and as far as she could go." Author's telephone interview with Margaret Randall, June 17, 2015.

55. Defended by the Center for Constitutional Rights, Randall won her case in 1989.

56. Randall, *My Town*, 91.

57. Zan Dubin, "Elaine de Kooning Finds Light in Paintings of 'Cave Walls.'"

58. *Artists Speak at the Art Barge: Elaine de Kooning* (video).

59. Elaine de Kooning interview with Charles Hayes.

60. Jill Chancey, *Elaine de Kooning*, 145.

61. Helen Frankenthaler letter to Clement Greenberg, August 9, 1953, Clement Greenberg Papers, AAA.

62. Elaine de Kooning interview with Judith Stein and Paul Schimmel.

63. All otherwise unattributed quotes in this and the following paragraph are from Elaine de Kooning's 1987 conversation with Rose Slivka, Rose Slivka Papers.

64. Elaine de Kooning: Time of the Bison, Gruenebaum Gallery, May 3–31, 1986.

65. Miriam Brumer, "New York Reviews: Elaine de Kooning," 135.

66. Vivian Raynor, "Art: Elaine de Kooning."

67. Elaine de Kooning, in Lawrence Campbell, "Elaine de Kooning Paints a Picture," 44.

68. Elaine de Kooning interview with Karl E. Fortress.

69. *New York Review of the Arts: Elaine de Kooning* (video).

70. Elaine de Kooning letter to "Sally," March 28, 1985, Rose Slivka Papers.

71. Author's telephone interview with Art Schade, February 10, 2016.

72. It is now in San Francisco.

73. Though best known as a composer, John Cage began making etchings and monotypes at Crown Point Press in 1978.

74. It was founded by June Wayne in 1970, in Los Angeles, as the Tamarind Workshop. In a 1977 statement sent to Eleanor Munro, Elaine claimed to have spent three months at the workshop "working sixteen hours a day"—one of her boastful false memories. Elaine de Kooning, pages from an autobiographical statement, 1977, Eleanor Munro Papers.

75. Robin White, "Interview of Elaine de Kooning," 3.

76. The others included David Hare, Nathan Oliveira, Kenneth Price, Deborah Remington, Ed Ruscha, June Wayne, and Emerson Woelffer. Other prominent artists had been invited but declined to participate.

77. John Sommers letter to Elaine de Kooning, November 24, 1976, Box 61, folder 55, Center for Southwest Research, University Libraries, University of New Mexico.

For some reason, these prints were all titled after the park (*Jardin de* [*sic*] *Luxembourg I–IV*) rather than the statue.

78. Marjorie Luyckx's chronology, in Bledsoe, *Elaine de Kooning*, 109 (exhibition catalogue), is in error here (and in a few other places); it states that Elaine was at Crown Point in 1977.

79. A variation that allows the artist to control the shape of an image with brush marks. The drawing is done on a sugar syrup base before beginning the aquatint process.

80. Author's telephone interview with Kathan Brown, November 10, 2015.

81. *Conversations with Artists: Elaine Benson with Elaine de Kooning* (video).

82. Kathan Brown, *Know That You Are Lucky*, 172.

83. Elaine de Kooning letter to Mercedes Matter, August 31, 1974, Mercedes Matter Archive.

84. Author's interview with Clay Fried, March 15, 2015, Washington, D.C.

85. Email from Marguerite Harris to author, January 10, 2016.

86. Information from author's telephone interview with Bill Berkson, January 5, 2016; and email from Marguerite Harris to author, January 7, 2016.

87. Information is from author's telephone interview with Dr. Guy Fried, Elaine's nephew, December 12, 2015.

88. Ibid. Marberger died on November 1, 1988.

89. Elaine de Kooning interview with Judith Stein and Paul Schimmel.

90. An Etch-a-Sketch enables users to make a drawing by twisting two knobs that scrape off the aluminum powder on the back of the screen to draw lines. Shaking the toy erases the picture.

91. Dubin, "Elaine de Kooning Finds Light in Paintings of Cave Walls."

92. Elaine de Kooning letter to "Mike," February 5, 1985, Elaine de Kooning Papers.

93. Leslie Bennetts, "L.I. Center Honors 3 Famous Locals."

94. As early as 1966, she mentioned that she was writing "a book on the 'lean years' '40–'54 or so—and enjoying it immensely." Elaine de Kooning letter to Nell Blaine, April 1, 1966. Nell Blaine Papers, Houghton Library, Harvard University.

95. Elaine de Kooning letter to "Sally," October 6, 1983. Elaine de Kooning Papers.

96. Ibid.

97. Author's telephone interview with David Shapiro, June 24, 2016.

98. Elaine de Kooning interview with Antonia Zara.

99. *Conversation with Artists: Elaine Benson with Elaine de Kooning* (video).

100. According to "In the Air," *Art & Auction* 2 (January 2003): 7, a contract was signed in 1987. Elaine mentioned the contract in her interview with Antonia Zara.

101. Elaine de Kooning interview with Minna Daniel.

102. Brown, *Know That You Are Lucky*, 272.

103. Pepper, "The Indomitable de Kooning," 86.

104. Elaine de Kooning interview with Charles Hayes.

105. Ibid. Her interview with Charles Hayes occurred on a Friday; perhaps that's why Elaine told him the "business" day was Friday; Larry Castagna, a longtime studio assistant, remembers it as Monday.

106. Author's telephone interview with Art Schade, February 10, 2016.
107. Elaine once said that the *Murder, She Wrote*, starring Angela Lansbury as the amateur sleuth, was her favorite TV show.
108. Michael Gross, "Star Hamptons," 38.
109. It is also known as *Strokes of Genius: Willem de Kooning*.
110. Author's telephone interview with Ernestine Lassaw, August 24, 2011. The medal, kept in a drawer, was missing after the couple left.
111. Author's interview with Arlene Bujese, July 20, 2015, East Hampton.
112. The de Koonings also attended a formal dinner with the queen in New York, in the company of Arthur Schlesinger, Henry Kissinger, and other notables.
113. *Ecstasy Is a Number*, a collection of Margaret Randall's poems, included several of Elaine's drawings, one on the cover. Elaine also contributed a drawing to Randall's poetry collection *Giant of Tears* (New York: Tejon Press, 1959).
114. Arnold Schwerner (1927–1999) is best known for his epic, multipart poem *The Tablets*, which he framed as translations from clay tablets from the ancient Near East.
115. Author's telephone interview with Toni Ross, November 17, 2015; and author's interview with Ross after the panel discussion at Pollock-Krasner House, August 9, 2015.
116. Willem de Kooning: Painting and Sculpture, December 15, 1983–February 26, 1984.
117. Anne-Marie Schiro, "Partying for de Kooning."
118. Stevens and Swan, *de Kooning*, 603–604, 612.
119. Ibid., 617.
120. Ibid., 618.
121. Elaine de Kooning interview with Charles Hayes. Unfortunately, the notes have disappeared, and the book remained unwritten. Elaine died seven months after this interview.
122. Ibid.
123. Elaine de Kooning interview by Amei Wallach.
124. Elaine de Kooning interview with Antonia Zara.
125. Author's telephone interview with Charles Fried, December 19, 2014
126. Author's telephone interview with Tom Ferrara, May 4, 2015.
127. Author's telephone interview with Charles Fried,
128. Charles received a Masonic funeral service in Brooklyn on April 8, 1951, and was buried in Roscoe, New York, near the family's ancestral home. "Charles F. Fried, Baking Executive" [obituary], *Brooklyn Daily Eagle*, April 8, 1951, 35. According to Elaine, he had planned to retire from General Baking the next day. Elaine de Kooning, draft of a conversation with Eleanor Munro, Eleanor Munro Papers.
129. Paul, Weiss, Rifkind, Wharton, and Garrison was the law firm.
130. John Eastman, who had taken over the firm from his father, Lee Eastman.
131. Stevens and Swan, *de Kooning*, 623.
132. Conrad Fried interview with Mark Stevens and Annalyn Swan.
133. Robert Storr, "At Last Light," in Robert Storr and Gary Garrels, *Willem de Kooning: The Late Paintings, the 1980s*, 43. In 1987, Willem de Kooning's sales at the Xavier Fourcade Gallery totaled $9.3 million. Stevens and Swan, *de Kooning*, 625.

134. Stevens and Swan, *de Kooning,* 621–22, 688n; and Carol Vogel, "Inside Art." Pavia filed a $3 million lawsuit against Bill and Elaine's estate in 1990 to recover the remainder of his compensation plus damages.

135. Alcopley, in *Elaine de Kooning: Portraits,* 15 (exhibition catalogue, Brooklyn College Art Gallery).

136. Appointments: author's telephone interview with Jennifer McLauchlen, March 18, 2016. Rescue dog information: email from Brewster E. Fitz to author, January 18, 2016.

137. Author's telephone interview with Dr. Guy Fried, December 12, 2015.

138. Author's telephone interview with Yvonne Jacquette Burckhardt, January 13, 2015.

139. Author's telephone interview with Tom Ferrara, May 4, 2015, who said this information came from Conrad Fried.

140. Upon her death, Michael bought out his brother's share.

141. Stevens and Swan, *de Kooning,* 621. This information came from the authors' multiple interviews with attorney John Eastman.

142. "Sally" letter to Rose Slivka, April 17, 1992, Rose Slivka Papers.

143. Peter Fried letter to Ernestine and Ibram Lassaw, February 1, 1989, quoted in Denise Lassaw, "Elaine de Kooning, A Life in Frames: Portraits and Stories"; and Brandon Brame Fortune, *Elaine de Kooning: Portraits,* 74 (exhibition catalogue).

144. When Elaine planned an outdoor June wedding for one of her students, the woman fretted about potential bad weather. "Don't worry," Elaine replied. "You take care of getting married. I'll take care of the weather." Quoted in Rose Slivka, "From the Studio." *East Hampton Star,* February 23, 1989.

145. Stevens and Swan, *de Kooning,* 624.

146. Elaine de Kooning interview with James Breslin about Mark Rothko.

147. Edvard Lieber, eulogy at Elaine's Cooper Union memorial service, March 12, 1990, as cited by Stevens and Swan, *de Kooning,* 624.

148. Black Mountain Paintings from 1948 (1991); Drawings from 1947 (1992); Elaine de Kooning: Artists and Writers (1994).

149. Although listed on the program, Larry Rivers was not present.

150. Jim Touchton, eulogy, memorial for Elaine de Kooning.

151. Grace Hartigan, eulogy, memorial for Elaine de Kooning.

152. Thanks to Jim Touchton for providing a copy of the program.

153. Christie's New York, Contemporary Art Part I: The Properties of the May Family Collection, The Estate of Elaine de Kooning, The Estate of Robert Mapplethorpe, November 7, 1989; and Contemporary Art Part II: Collections of Robert B. Mayer, Elliot Blinder, Hannah Wilke, Annie Witzel, Robert Mapplethorpe, Hellen P. Donnelly, Elaine de Kooning, Paul Warhola Family, Richard L Weismann, Manilow, May Family of Beverly Hills, Hirshhorn Museum, November 8, 1989. At the latter auction, all four of the paintings from Elaine's estate exceeded their estimates; the late de Kooning sold for $742,500, not including the 10 percent buyer's premium.

154. Author's telephone interview with Jennifer McLauchlen, March 18, 2016.

155. An article in *New York Magazine* in the summer of 1991 mentioned that Marjorie, "who is editing Elaine's memoirs," had been spotted at a gallery opening in the Hamptons. Phoebe Hoban, "Artists on the Beach," July 1, 1991, 40.

156. Author's interview with Luke Luyckx, March 12, 2015, Washington, D.C.

157. Marjorie's husband, Edmond Luyckx, died in 2011. Peter Fried had died in 1995.

158. "In the Air," *Art & Auction* 2 (January 2003): 17.

159. The person who best fits this description is art writer Rose Slivka, who died in 2004. She had begun working on a biography of Elaine shortly before the artist's death. In a grant application from the early 1990s, Slivka wrote that she had been given access to material from the notebooks.

160. A staff member of the Getty curatorial department emailed me in June 2016 to say that such information is confidential, "But in any case, the person who would have handled it is long retired, and we do not have information about it in our files."

161. Conrad's wife Marian had predeceased him in 1976, as had his brother Peter (1995), and his daughter Yolanda (2007).

162. The whereabouts of the floppy disks containing Marjorie's transcriptions are also unknown.

163. John Taylor, "An Interview with Elaine de Kooning in Athens."

164. Elaine de Kooning interview with Lyn Kienholz and Edward Goldman (radio broadcast).

165. While her auction sales have generally been modest, a recent Christie's auction of an untitled abstract oil painting on paper (ca. 1959), from a private collection far surpassed its $3,000 to $5,000 estimate, to sell for $50,000. Christie's New York, sale 3757, lot 138, July 22, 2015.

166. Elaine de Kooning interview with Molly Barnes (radio broadcast).

Bibliography

AAA = Archives of American Art, Smithsonian Institution, Washington, D.C.

PUBLISHED ART WRITING BY ELAINE DE KOONING

"Albers Paints a Picture." *ARTnews* 49 (November 1950): 40–43.

"Andrew Wyeth Paints a Picture." *ARTnews* 49 (March 1950): 38–41.

"Artist's Statement." *It Is* 4 (Autumn 1959): 29–30.

"Busa's Festive Imagery." *East Hampton Star,* August 8, 1985.

"David Smith Makes a Sculpture," *ARTnews* 50 (September 1951), 38–41.

"De Kooning Memories." *Vogue* (December 1983): 352–53, 393–94.

"Dialogue" [with Roslyn Drexler]. In Thomas B. Hess and Elizabeth C. Baker, eds., *Art and Sexual Politics: Why Have There Been No Great Women Artists,* 56–70. New York: Collier/Macmillan, 1973. (Originally published in *ARTnews,* January 1971.)

"Diller Paints a Picture." *ARTnews* 51 (January 1954): 26–29.

"Dymaxion Artist." *ARTnews* 51 (September 1952): 14–17.

"Edwin Denby Remembered, Part I." *Ballet Review* 12 (Spring 1984): 29–33.

"Edwin Dickinson Paints a Picture." *ARTnews* 48 (September 1949): 26–28.

"5 Stars for February: Albers." *ARTnews* 47 (February 1949): 15, 19.

Foreword. In Ed Garman, *The Art of Raymond Jonson, Painter,* xiii–xv. Albuquerque: University of New Mexico Press, 1976.

"Franz Kline: Painter of His Own Life." *ARTnews* 61 (November 1962): 28–31, 64–69. Reprinted in *Franz Kline, Memorial Exhibition,* 8–18. Washington, DC: Washington Gallery of Modern Art, 1962. Exhibition catalogue.

"Friedman." *ARTnews* 47 (May 1946): 37.

"Gorky: Painter of His Own Legend." *ARTnews* 49 (January 1951): 38–44, 63–65.

"Greene Paints a Picture." *ARTnews* 53 (May 1954): 34–37, 48–51.

"Hans Hofmann Paints a Picture. *ARTnews* 48 (February 1950): 38–41.

"Hyman Bloom." *ARTnews* 54 (March 1955): 32, 66.

"Hyman Bloom Paints a Picture. *ARTnews* 49 (January 1950): 30–33.

"International Watercolor to Brooklyn." *ARTnews* 48 (Summer 1949): 39, 62.

"Is There a New Academy?" *ARTnews* 58 (Summer 1959): 36.

"Jeanne Reynal: Mosaic Portraits." *Craft Horizons* 36 (August 1976): 32–35.

"Kerkam Paints a Picture." *ARTnews* 49 (February 1951): 42–45.

"Knaths Paints a Picture." *ARTnews* 48 (November 1949): 36–39.

"Lamar Dodd: The Open Heart." In *Lamar Dodd: The Heart,* 58–62. Athens: Georgia Museum of Art, 1984. Exhibition catalogue.

"Larry Rivers." *ARTnews* 48 (April 1949), 47.

Letter to James Gahagan. *Village Voice*, August 2, 1961.

"Margulies Paints a Picture." *ARTnews* 50 (December 1951): 42–45.

"Modern Museum's Fifteen: Dickinson and Kiesler." *ARTnews* 52 (April 1953): 20–23.

"New Mexico." *Art in America* 49 (April 1961): 56–59.

"New York Without Tears." In *Elias Goldberg: From Ashcan to Abstract*. New York: Janos Gat Gallery, 1999. Originally published in *The City*. New York: Egan Gallery, 1948.

"Painting a Portrait of the President." *ARTnews* (Summer 1964): 37, 64–65.

"Participants in a Hearsay Panel." *It Is* 3 (Winter-Spring 1959): 59.

"Pure Paints a Picture." *ARTnews* 56 (Summer 1957): 86–87.

"A Recollection." In Douglas Dreishpoon et al., *Edwin Dickinson: Dreams and Realities,* 90-91. New York: Hudson Hills Press/Albright Knox Art Gallery, 2002. Originally published in *Edwin Dickinson: Draftsman/Painter*. New York: National Academy of Design, 1982.

"Renoir: As if by Magic." *ARTnews* 55 (October 1956): 66–67.

"Reviews and Previews: Frederick Sommer." *ARTnews* 47 (February 1949): 45–49, 58–59.

"Reviews and Previews." *ARTnews* 48 (March 1949): 43–46, 52–55.

"Reviews and Previews." *ARTnews* 48 (April 1949): 45–50, 55–59.

"Reviews and Previews." *ARTnews* 48 (May 1949): 42–48, 50.

"Reviews and Previews." *ARTnews* 48 (Summer 1949): 52–56, 58.

"Reynal Makes a Mosaic." *ARTnews* 52 (December 1953): 34–37, 51–53.

Spirit of Abstract Expressionism: Selected Writings. Edited by Rose Slivka. New York: George Braziller, 1994. (Includes many of the magazine pieces listed here.)

"Statement." *It Is: A Magazine for Abstract Art* 4 (Autumn 1959): 29–30.

"A Stroke of Genius." *Horizon* 26 (May 1984): 37–43.

"Stuart Davis: True to Life." *ARTnews* (April 1957): 40–42, 54–55.

"Subject: What, How, or Who." *ARTnews* 54 (April 1955): 26–29, 61–62.

"Two Americans in Action: Franz Kline & Mark Rothko." *ARTnews Annual* 27, 1958: 86–97.

"Venus, Eve, Leda, Diana, et al." *ARTnews* 52 (September 1953): 20–22, 54.

"Vicente Paints a Collage." *ARTnews* 52 (September 1953): 38.

ARCHIVES CONTAINING ELAINE DE KOONING CORRESPONDENCE

Josef and Anni Albers Foundation, Bethany, Connecticut

Edith Schloss Burckhardt Papers, Rare Book and Manuscript Library, Columbia University

Nell Blaine Papers, AAA

Nell Blaine Papers, Houghton Library, Harvard University

William T. Brown Papers, Reel 1095, AAA

John Cage Correspondence, Northwestern University Music Library, Chicago, Illinois

William Conger Papers, AAA

Robert Dash Papers, Box 2, GEN MSS 792, Beinecke Rare Book and Manuscript Library, Yale University, New Haven, Connecticut

Elaine de Kooning Papers (including Willem and Elaine de Kooning Financial Records), AAA

B.C. Holland Gallery Records, AAA

John Graham & Sons Gallery Records, AAA

Clement Greenberg Papers, AAA

Thomas Hess Papers, AAA

Aristodemos Kaldis Papers, D117-512, AAA

Israel and Idee Levitan Papers, AAA

Mercedes Matter Archive, Dobkin Family Collection of Feminism. Courtesy of Glenn Horowitz, bookseller

Philip Pavia Papers, Manuscript, Archives, and Rare Book Library, Emory University, Atlanta, Georgia

Larry Rivers Papers, Box 3, Folder 31, Fales Library, New York University, New York

Rose Slivka Papers, AAA

Stable Gallery Records, AAA

Tamarind Institute Papers, Box 4, Folder 54, Center for Southwest Research, University Libraries, University of New Mexico, Albuquerque, New Mexico

UNPUBLISHED INTERVIEWS, LECTURES, EULOGIES, AND MEMOIR

Berkson, Bill. Oral history interview, September 29–October 2, 2015. AAA.

Blaine, Nell. Oral history interview, June 15, 1967. AAA.

Burckhardt, Edith. *The Loft Generation*. Unpublished memoir. Courtesy of Jacob Burckhardt.

Castelli, Leo. Oral history interview, May 14, 1969–June 8, 1973. AAA.

"Crosscurrents USA." Recording of panel discussion, 1969, Detroit Institute of the Arts. AAA.

de Kooning, Elaine. C.F.S. Hancock Lecture, May 1985, San Francisco Art Institute. Elaine de Kooning Papers. AAA (transcript); San Francisco Art Institute (recording).

de Kooning, Elaine. Conversation with Rose Slivka, 1987. Rose Slivka Papers, AAA.

de Kooning, Elaine. Draft of a conversation with Eleanor Munro, ca. January 5, 1977, Eleanor Munro Papers, AAA.

de Kooning, Elaine. Memorial for Gandie Brodie, November 10, 1975, New School for Social Research. Elaine de Kooning Papers, AAA.

de Kooning, Elaine. Michael Loew Memorial, November 18, 1985. Elaine de Kooning Papers, AAA.

de Kooning, Elaine. Image Gallery lecture on Willem de Kooning, April 1978, University of Georgia. Elaine de Kooning Papers, AAA.

de Kooning, Elaine. Interview with Ellen Auerbach, February 24, 1988. Elaine de Kooning Papers, AAA.

de Kooning, Elaine. Interview with James Breslin about Mark Rothko, March 23, 1976. James Breslin Papers, Box 2, Folder 29, Getty Research Institute, Los Angeles.

de Kooning, Elaine. Interview with Minna Daniel, June 28, 1988. Elaine de Kooning Papers, AAA.

de Kooning, Elaine. Interview with Karl E. Fortress, March 12, 1961. Elaine de Kooning Papers, AAA.

de Kooning, Elaine. Interview with Ann Gibson, October 3, 1987, East Hampton. Courtesy of Ann Gibson.

de Kooning, Elaine. Interview with John Jonas Gruen, November 21, 1969 (tape recording). John Jonas Gruen and Jane Wilson Papers, AAA.

de Kooning, Elaine. Interview with Charles Hayes, July 15, 1988. Elaine de Kooning Papers, AAA.

de Kooning, Elaine. Interview with Irving Kaufman, ca. 1960s. Pollock-Krasner House and Study Center Archives, 122B, East Hampton, New York.

de Kooning, Elaine. Interview with Jeffrey Potter, July 22, 1980. Jeffrey Potter Collection of audiotaped interviews, Pollock-Krasner House and Study Center Archives, East Hampton, New York.

de Kooning, Elaine. Interview with Irving Sandler, n.d. Irving Sandler Papers, Box 6, Folder 7, Getty Research Institute, Los Angeles.

de Kooning, Elaine. Interview with Rose Slivka, 1993. Elaine de Kooning Papers, AAA.

de Kooning, Elaine. Interview with Judith Stein and Paul Schimmel, February 5, 1988. Courtesy of Judith Stein.

de Kooning, Elaine. Interview with Arthur Tobier, St. Marks on the Bowery, New York, 1985. Elaine de Kooning Papers, AAA.

de Kooning, Elaine. Interview with Amei Wallach, March 17, 1988. Elaine de Kooning Papers, AAA.

de Kooning, Elaine. Interview with Antonia Zara, May 6, 1988. Elaine de Kooning Papers, AAA.

de Kooning, Elaine. Oral history interview, August 27, 1981. AAA.

de Kooning, Elaine. Pages from an autobiographical statement, ca. January 5, 1977. Eleanor Munro Papers, AAA.

de Kooning, Elaine. Skowhegan School of Painting and Sculpture Lecture, August 17, 1969, Skowhegan, Maine. Elaine de Kooning Papers, AAA.

de Kooning, Elaine. Truman Library portrait dedication speech, February 12, 1965. James Graham & Sons Gallery Records, AAA.

Frankenthaler, Helen. Interview with Barbara Rose, August 1968. AAA.

Fried, Conrad. Interview with Mark Stevens and Analyn Swan, May 31 and June 1, 1995. Courtesy of Annalyn Swan.

Gibson, Ann. "Narrative and Negation in the Art of Elaine de Kooning." Paper presented at Modernisms III Conference, October 14, 2001, Houston. Courtesy of Judith Stein.

Hartigan, Grace. Memorial for Elaine de Kooning, March 12, 1989, Cooper Union, New York. Grace Hartigan Papers, Syracuse University.

Hartigan, Grace. Interview with Celia Stahr, April 12, 1992. Courtesy of Celia Stahr.

Kennedy, John F. Presidential Daily Diaries. Miller Center of Public Affairs, University of Virginia. At www.millercenter.org/presidentialrecordings/Kennedy/daily-diaries.

Lassaw, Denise. "Elaine de Kooning, A Life in Frames: Portraits and Stories." Illustrated talk, March 13, 2015, National Portrait Gallery, Smithsonian Institution, Washington, DC.

Leslie, Alfred. Interview with Celia Stahr, March 23, 2004. Courtesy of Celia Stahr.

Luyckx, Marjorie. Interview with Mark Stevens and Annalyn Swan, June 14, 1994. Courtesy of Annalyn Swan.

Mallary, Robert. Oral history interview, May 17–18, 2001. AAA.

Pavia, Philip. Oral history interview, January 19, 1965. AAA.

Porter, Fairfield. Oral history interview, June 6, 1968. AAA.

Resnick, Milton, and Pat Passlof. Oral history interview, July 13, 1988. AAA.

Thiebaud, Wayne. Interview, May 27, 2011, Sacramento, California. Academy of Achievement, Washington, D.C. At http://www.achievement.org/autodoc/page/thioint-1.

Thiebaud, Wayne. Oral history interview, May 17–18, 2001, AAA.

Touchton, Jim. Eulogy. Elaine de Kooning Memorial, March 12, 1989, Cooper Union, New York. Courtesy of Jim Touchton.

Touchton, Jim. Talk at Pollock-Krasner House and Study Center Archives, September 27, 2015. Courtesy of Helen Harrison.

Vicente, Esteban. Oral history interview, March 11, 1968. AAA.

BOOKS, CATALOGUES, DISSERTATIONS, AND PAMPHLETS

Abel, Lionel. *The Intellectual Follies*. New York: W.W. Norton, 1984.

Achievements in Art 2008: Area Arts Foundation and Dord Fitz. Amarillo, TX: Amarillo Museum of Art, 2008. Exhibition catalogue.

Albers, Patricia. *Joan Mitchell, Lady Painter*. New York: Knopf, 2010.

"American Artists School, Fall-Spring Sessions, 1939–1940." Ben and Evelyn Wilson Papers, AAA.

American Federation of the Arts. *Sport in Art from American Collections: Assembled for an Olympic Year*, 1955. Exhibition catalogue.

Barthelme, Helen Moore. *Donald Barthelme: The Genesis of a Cool Sound*. College Station: Texas A&M University Press, 2001.

Belasco, Daniel. "Between the Waves: Feminist Positions in American Art, 1949–62." PhD dissertation, Institute of Fine Arts, New York University, September 2008.

Berkson, Bill, and Joe LeSueur. *Homage to Frank O'Hara*. Bolinas, CA: Big Sky, 1988.

Bledsoe, Jane K. *Elaine de Kooning*. Athens: Georgia Museum of Art, University of Georgia, 1992. Exhibition catalogue.

Boll, Deborah, Peter Walch, and Malin Wilson. *Albuquerque '50s*. Albuquerque: University of New Mexico, 1989.

Braff, Phyllis. *Elaine de Kooning Portrayed*. East Hampton, NY: Pollock-Krasner House and Study Center, 2015.

Brown, Henry Collins. *Valentine's City of New York Guidebook*. New York: Chauncey Holt Co., 1920. At https://archive.org/stream/valentinescityof00browa#page/n7/mode/2up.

Brown, Kathan. *Know That You Are Lucky*. San Francisco: Crown Point Press, 2012.

Bujese, Arlene, ed. *Twenty-Five Artists*. Frederick, MD: University Publications of America, 1982.

Chancey, Jill. "Elaine de Kooning: Negotiating the Masculinity of Abstract Expressionism." PhD dissertation, University of Kansas, 2006.

Conway, Madeline, and Nancy Kirk, eds. *The Museum of Modern Art Artists' Cookbook*. New York: Museum of Modern Art, 1977.

Corbett, William, ed. *Just the Thing: Selected Letters of James Schuyler, 1951–1991*. New York: Turtle Point Press, 2004.

Daugherty, Tracy. *Hiding Man: A Biography of Donald Barthelme*. New York: St. Martin's, 2009.

de Kooning, Elaine. *The Spirit of Abstract Expressionism*. New York: George Braziller, 1994.

Diaz, Eva. *The Experimenters: Chance and Design at Black Mountain College*. Chicago: University of Chicago Press, 2015.

Dorfman, Geoffrey, ed. *Out of the Picture: Milton Resnick and the New York School*. New York: Midmarch Arts Press, 2003.

Downs, Rackstraw, ed. *Art in Its Own Terms: Selected Criticism 1953–1975*. Cambridge, MA: Zoland Books, 1979.

Drawings &. Austin: University Art Museum, University of Texas, 1966. Exhibition catalogue.

Duberman, Martin. *Black Mountain: An Exploration in Community*. New York: W.W. Norton, 1993.

Edgar, Natalie, ed. *Club Without Walls: Selections from the Journals of Philip Pavia*. New York: Midmarch Arts Press, 2007.

Eiland, William U. *The Truth in Things: The Life and Career of Lamar Dodd*. Athens: University of Georgia Press, 1996.

Elaine de Kooning: Artists and Writers. New York: Washburn Gallery, 1994. Exhibition catalogue.

Elaine de Kooning: Full Circle, 1943–1988. New York: Levis Fine Art, 2012. Exhibition catalogue.

Elaine de Kooning: Paintings 1955–1965. New York: Washburn Gallery, 1996. Exhibition catalogue.

Elaine de Kooning: Portraits. Edited by Maria Catalano Rand. Brooklyn, NY: Brooklyn College Art Gallery, 1991. Exhibition catalogue.

Elaine de Kooning: Portraits. New York: Salander-O'Reilly Galleries, 1999. Exhibition catalogue.

Elderfield, John. *de Kooning: A Retrospective*. New York: Museum of Modern Art, 2011. Exhibition catalogue.

Ferguson, Russell. *In Memory of My Feelings: Frank O'Hara and American Art*. Berkeley: University of California Press, 1999.

Figures: A Show of Current Figure Painting in New York. New York: Kornblee Gallery, 1962. Exhibition catalogue.

Fitz, Carolyn. *The Broadcast Is Always On: The Area Arts Foundation and Dord Fitz*. Amarillo [Texas] Museum of Art, January 14–March 23, 2008. Exhibition catalogue.

Fortune, Brandon Brame, Ann Eden Gibson, and Simona Cupic. *Elaine de Kooning: Portraits*. New York: Prestel for National Gallery of Art, Smithsonian Institution, 2015. Exhibition catalogue.

Fortune, Brandon Brame, Wendy Wick Reaves, and David C. Ward. *Face Value: Portraiture in the Age of Abstraction*. London: D. Giles Limited and National Portrait Gallery, Smithsonian Institution, 2014. Exhibition catalogue.

Frankenthaler, Helen. "A Few Days at Black Mountain." In *Black Mountain College: Sprouted Seeds, An Anthology of Personal* Accounts, ed. Mervin Lane, 279–80. Knoxville: University of Tennessee Press, 1990.

Franz Kline Memorial Exhibition. Washington, DC: Washington Gallery of Art, 1962.

Gaugh, Harry F. *de Kooning*. New York: Cross River Press, 1983.

Gaugh, Harry F. *Franz Kline*. New York: Abbeville, 1994.

Genter, Robert. *Late Modernism: Art, Culture, and Politics in Cold War America*. Philadelphia: University of Pennsylvania Press, 2010.

Gibson, Ann W. *Abstract Expressionism: Other Politics*. New Haven, CT: Yale University Press, 1997.

Gruen, John. *The Party's Over Now*. New York: Pushcart Press, 1989.

Harrison, Helen. "Witness to Immanent Drama: Elaine de Kooning and the New York School." In *Elaine de Kooning*, 5–13. Board of Governors of the Federal Reserve System: 1994. Exhibition catalogue.

Hemingway, Ernest. *Death in the Afternoon*. New York: Simon & Schuster: 1932.

Herrera, Hayden. *Arshile Gorky: His Life and Work*. New York: Farrar, Straus, and Giroux, 2003.

Hess, Thomas B. *Willem de Kooning*. New York: George Braziller, 1959.

Hess, Thomas B. *Willem de Kooning*. New York: Museum of Modern Art, 1968. Exhibition catalogue.

Hoban, Phoebe. *Alice Neel: The Art of Not Sitting Pretty*. New York: St. Martin's, 2010.

Hoffmann, Jean Kemper, ed. *Palette to Palate: The Hamptons Artists Cookbook*. New York: New York Times Books, 1978.

Katz, Vincent, ed. *Black Mountain College: Experiment in Art*. Cambridge, MA: MIT Press, 2013.

Kavass, Veronica. *Artists in Love*. New York: Welcome Books, 2012.

Kinnamon, Kenneth. "Wright, Hemingway, and the Bullfight: An Aficionado's View." In *Richard Wright's Travel Writings*, ed. Virginia Whatley Smith, 157–65. Jackson: University Press of Mississippi, 2014.

Landau, Ellen. *Mercedes Matter*. New York: MB Art Publishing, 2009.

Lane, Mervin, ed. *Black Mountain College: Sprouted Seeds, An Anthology of Personal Accounts*. Knoxville: University of Tennessee Press, 1990.

Lassaw, Ernestine. *Pat Passlof/Milton Resnick 1917–2004*. Privately published, 2005.

Leigh, Ted, ed. *Material Witness: The Selected Letters of Fairfield Porter*. Ann Arbor: University of Michigan Press, 2005.

Leja, Michael. *Reframing Abstract Expressionism: Subjectivity and Painting in the 1940s*. New Haven, CT: Yale University Press, 1993.

LeSueur, Joe. *Digressions on Some Poems by Frank O'Hara: A Memoir*. New York: Farrar, Straus and Giroux, 2003.

Levin, Gail. *Lee Krasner: A Biography*. New York: William Morrow, 2011.

Lieber, Edvard. *Willem de Kooning: Reflections in the Studio*. New York: Abrams, 2000.

Marshall, Richard. *Fifty New York Artists: A Critical Selection of Painters and Sculptors Working in New York*. San Francisco: Chronicle Books, 1986.

Mason, Carol. *Oklahomo: Lessons in Unqueering America*. New York: SUNY Press, 2015.

Matossian, Nouritza. *Black Angel: The Life of Arshile Gorky*. Woodstock, NY: Overlook Press, 2000.

Mayer, Musa. *Night Studio: A Memoir of Philip Guston*. New York: Knopf, 1988.

Molesworth, Helen. *Leap Before You Look: Black Mountain College, 1933–1957*. New Haven, CT: Yale University Press: 2015.

Mount, Charles Merrill. *John Singer Sargent: A Biography*. New York: W.W. Norton, 1955.

Myers, John. *Tracking the Marvelous*. New York: Random House, 1983.

Munro, Eleanor. *Originals: American Women Artists*. New York: Simon & Schuster, 1979.

Munro, Eleanor. *Memoirs of a Modernist's Daughter*. New York: Penguin, 1988.

Naifeh, Steven, and Gregory Smith. *Jackson Pollock: An American Saga*. New York: Clarkson N. Potter, 1989.

New York School: Second Generation. New York: Jewish Museum, 1957. Exhibition catalogue.

O'Hara, Frank. *Collected Poems of Frank O'Hara*, edited by Donald Allen. Berkeley: University of California Press, 1995.

O'Hara, Frank. *Standing Still and Walking in New York*. San Francisco: Grey Fox Press, 1983.

Painter, Karen, and Thomas Crow. *Late Thoughts: Reflections on Artists and Composers at Work*. Los Angeles: Getty Publications, 2006.

Pavia, Natalie, ed. *Club Without Walls: Selections from the Journals of Philip Pavia*. New York: Midmarch Arts Press, 2007.

Pelles, Geraldine. *Art, Artists and Society: Origins of a Modern Dilemma; Painting in England and France, 1750–1850*. Englewood Cliffs, NJ: Prentice-Hall, 1963.

Perl, Jed, ed. *Art in America 1945–1970*. New York: Library of America, 2014.

Perl, Jed. *New Art City: Manhattan at Mid-Century*. New York: Vintage, 2007.

Polcari, Stephen. *Abstract Expressionism and the Modern Experience*. New York: Cambridge University Press, 1991.

Porter, Fairfield. *Art in Its Own Terms: Selected Criticism 1955–1975*. Cambridge, MA: Zoland Books, 1979.

Potter, Jeffrey. *To a Violent Grave: An Oral Biography of Jackson Pollock*. Wainscott, NY: Pushcart Press, 1987.

President John F. Kennedy: An Exhibition of Portraits and Sketches by Elaine de Kooning. Charlotte Crosby Kemper Gallery, Kansas City Art Institute & School of Design, February 12–March 7, 1965. Exhibition catalogue.

Puniello, Françoise S., and Halina R. Rusak. *Abstract Expressionist Women Painters: An Annotated Bibliography*. Lanham, MD: Scarecrow Press, 1996.

Randall, Margaret. *Ecstasy Is a Number*. Brooklyn, NY: Orion Press, 1961.

Randall, Margaret. *My Town: A Memoir of Albuquerque, New Mexico*. San Antonio, TX: Wings Press, 2010.

Rivers, Larry [with Arnold Weinstein]. *What Did I Do? The Unauthorized Autobiography*. New York: Thunder's Mouth Press: 1992.

Rodman, Selden. *Conversations with Artists*. New York: Devin-Adair Co., 1957.

Rosenzweig, Phyllis D. *The Fifties: Aspects of Painting in New York*. Washington, DC: Hirshhorn Museum and Sculpture Garden, Smithsonian Institution, 1980. Exhibition catalogue.

Russo, Alexander. *Profiles on Women Artists*. Frederick, MD: University Publications of America, 1985.

Sandler, Irving. *A Sweeper-Up After Artists*. London: Thames & Hudson, 2004.

Schierbeek, Bert. *Willem de Kooning, A Portrait*. Leiden: Menken Kasander & Wigman Uitgevers, 2005.

Schimmel, Paul, and Judith Stein. *The Figurative Fifties: New York Figurative Expressionism*, Newport Beach, CA: Newport Harbor Art Museum, 1988. Exhibition catalogue,

Schuyler, James. *Selected Art Writings*. Edited by Simon Pettit. Boston: David R. Godine/Black Sparrow Books, 1998.

Sciorra, Joseph, and Peter Vellon. *The Art of Freedom: Onorio Ruotolo and the Leonardo da Vinci School*. Italian American Museum, 2004. Exhibition catalogue.

Shiff, Richard. *Between Sense and de Kooning*. London: Reaktion Books, 2011.

Silver, Kenneth E., Cynthia Drayton, and Nancy Hall-Duncan. *JFK and Art*. London: Frances Lincoln in association with Bruce Museum, Greenwich, Connecticut, 2003. Exhibition catalogue.

Silverman, Kenneth. *Begin Again: A Biography of John Cage*. New York: Knopf, 2010.

Slivka, Rose. *Kaldis Art*. Privately printed, n.d. Rose Slivka Papers, AAA.

Spender, Matthew. *From a High Place: A Life of Arshile Gorky*. Berkeley: University of California Press, 2000.

Spring, Justin. *Fairfield Porter: A Life in Art.* New Haven, CT: Yale University Press, 2000.

Steinberg, Leo. Introduction. In *The New York School: Second Generation.* New York: Jewish Museum, 1957. Exhibition catalogue.

Stevens, Mark, and Annalyn Swan. *de Kooning: An American Master.* New York: Knopf, 2005.

Storr, Robert, and Gary Garrels. *Willem de Kooning: The Late Paintings, The 1980s.* San Francisco & Minneapolis: San Francisco Museum of Modern Art & Walker Art Center, 1996. Exhibition catalogue.

Strahl, Lisa Beth. "Gender Construction and Manifestation in the Art of Elaine de Kooning." PhD dissertation, Temple University, 2009.

Subjects of the Artist Catalog, 1948–49, Joseph Cornell Papers, AAA. Digital ID 18111.

Udall, Sharon R. *Inside Looking Out: The Life and Art of Gina Knee.* Lubbock: Texas Tech University Press, 1994.

University of New Mexico. *Annual Report, 1957–1958.* Albuquerque: University of New Mexico.

Waldman, Diane. *Willem de Kooning in East Hampton.* New York: Guggenheim Museum, 1978.

Willem de Kooning, 1981–1986. New York: L&M Arts, 2007. Exhibition catalogue.

Wolfe, Judith. *Willem de Kooning: Works from 1951–1981.* East Hampton, NY: Guild Hall, 1981. Exhibition catalogue.

Wright, Richard. *Pagan Spain.* Jackson: University Press of Mississippi, 2002.

Yard, Sally. *Willem de Kooning: Works, Writings, and Interviews.* Barcelona: Ediciones Polygrafa, 2007.

Zilczer, Judith. *A Way of Living: The Art of Willem de Kooning.* New York: Phaidon, 2014.

JOURNAL, MAGAZINE, NEWSPAPER, AND WEB ARTICLES

Alcopley, "The Club: Its First Three Years." *Issue: A Journal for Artists* #4 (New York: Reflex Horizons, n.d.).

Alter, Jean. "In the Spotlight: Show Must Go On." *Amarillo Globe-Times,* May 4, 1966, 33.

Alvarado, Nico. "Frank Lima, 1939–2014." *Boston Review,* March 26, 2014. At http://bostonreview.net/blog/nico-alvarado-frank-lima-1939-2013.

Bass, Ruth. "New York Reviews: Elaine de Kooning, Gruenebaum." *ARTnews* 82 (January 1983): 82.

Bennetts, Leslie. "L.I. Center Honors 3 Famous Locals." *New York Times,* December 4, 1985.

Berkson, Bill. "The Portraitist." *Modern Painters* 12 (Summer 1999): 40–42.

Biffle, Kent. "Davis Cup Scene: Crowd Proves Tennis Really a Polite Sport." *Dallas Morning News,* August 3, 1965, A1.

Bivins, Sally. "Artist Schedules Series of Lectures." *Amarillo Daily News,* October 26, 1962, 37.

Bivins, Sally. "Visiting Artist Sees Southwest as Area of Distinctive Expression." *Amarillo Globe Times,* October 25, 1962, 12.

Brown, Richard L. "Artist's Work Reflects Intensity." *Kansas City Times*, February 11, 1985, 15.

Brumer, Miriam. "Elaine de Kooning: Time of the Bison." *Women Artists News* 11 (September 1986): 17.

Brumer, Miriam. "New York Reviews: Elaine de Kooning." *ARTnews* 85 (October 1986): 135–35.

Burrows, Carlyle. "Talent Is New But Styles Are Not: Figures at the Stable," *New York Herald Tribune Book Review*, May 6, 1959.

Campbell, Lawrence [L.C.]. "Elaine de Kooning, Exhibition at Graham Gallery." *ARTnews* 59 (December 1960): 12–13.

Campbell, Lawrence. "Elaine de Kooning at Gruenebaum." *Art in America* 71 (January 1983): 119.

Campbell, Lawrence. "Elaine de Kooning Paints a Picture." *ARTnews* 59 (December 1960): 42–45, 61–63.

Campbell, Lawrence. "Elaine de Kooning: Portraits in a New York Scene." *ARTnews* 62 (April 1963): 38–39, 63–64.

Campbell, Lawrence. "Elaine de Kooning at Washburn." *Art in America* 80 (March 1992): 116.

Campbell, Lawrence. "Elaine de Kooning at Washburn." *Art in America* 83 (January 1995): 102–103.

Campbell, Lawrence. "New Blood in the Old Cross-Section." *ARTnews* 60 (January 1962), 38–40.

Canaday, John. "High and Low in the Whitney Show." *New York Times*, October 14, 1962.

Canaday, John. "Provincetown Report: Good Exhibition Opens the Season in Art's Summer Capital." *New York Times*, June 17, 1962, X19.

Canaday, John. "Two Ways to Do It: Paired Shows Show Different Routes to Creation and Reputation." *New York Times*, April 28, 1963, X11–13.

Canaday, John. "Whitney Again: The Annual Shows Regulars Along with Twenty-Two Newcomers." *New York Times,* December 17, 1961, X21.

Carson, Joan Tyor. "AD Visits: Willem de Kooning." *Architectural Digest* 39 (January 1982): 58–67.

Colacello, Bob. "Studios by the Sea." *Vanity Fair* 17 (August 2000). At http://www .vanityfair.com/news/2000/08/studios200008.

Cole, Bruce. "Too Cool in the Capitol." *The New Criterion*, June 2015. At http://eppc .org/publications/too-cool-in-the-capital-national-portrait-gallery/.

Collins, Tom. "Elaine de Kooning's Figures." *Santa Fe Reporter*, September 20, 1995, 39.

Crehan, Hubert. "Reviews and Previews: Elaine de Kooning, Alex Katz, and Jane Freilicher." *ARTnews* 59 (February 1960): 14.

D.K. "Elaine de Kooning Paints Exciting, Colorful Conflict." *Milwaukee Journal*, June 5, 1960, sec. 5, p. 6.

de Kooning, Willem. Letter to the Editor. *ARTnews* 47 (January 1949): 6.

Donnelly, Tom. "A Moving Portrait." *Washington News*, October 29, 1964.

Dubin, Zan. "Elaine de Kooning Finds Light in Paintings of 'Cave Walls.'" *Los Angeles Times*, March 10, 1987. At http://articles.latimes.com/1987-03-10/entertainment/ca-5882_1_cave-paintings.

"Elaine de Kooning Exhibit October Feature at Museum." *Albuquerque Journal* [no byline], October 5, 1958, 15.

"Elaine de Kooning: Her World and Persona." *Auction News From Christie's*, October 1989, 2.

Fox, Catherine. "Elaine de Kooning: Portrait of the Artist." *Atlanta Journal*, April 15, 1992, B1, B6.

Frankenstein, Alfred. "Explosion in Art: Elaine de Kooning's Works Shown Here." *San Francisco Chronicle*, n.d. In Elaine de Kooning Papers, AAA.

"From the Reviews: Elaine de Kooning—Stable." *New York Times*, April 18, 1954, X12.

Geeslin, Campbell. "Art Collectors." *Houston Post*, June 17, 1962.

Geeslin, Campbell. "She Paints Many Ways." *Houston Post*, June 17, 1962, "Now" section, 3.

Gill, William J. "Colossal Collection of Fakes: Strange Story of Walter Chrysler Jr. Art Scandal." *Life*, November 2, 1962, 80–87.

Glueck, Grace. "Elaine de Kooning, Artist and Teacher, Dies at 68." *New York Times*, February 2, 1989, B8.

Greenberg, Clement. "American-Type Painting." *Partisan Review* 22 (Spring 1955). Reprinted in Greenberg, *Art and Culture: Critical Essays,* 208–29. New York: Beacon Press, 1961.

Grimes, William. "Aaron Shikler, Portrait Artist Known for Images of America's Elite, Dies at 93." *New York Times*, November 17, 2015, B14.

Grooms, Red. "When de Kooning Was King." *New York Times*, December 12, 2004.

Gross, Michael. "Star Hamptons." *New York Magazine* 23 (July 2–9, 1990): 33–38.

Gruson, Lindsey. "Is It Art or Just a Toilet Seat? Bidders to Decide on a de Kooning." *New York Times*, January 15, 1992, C1, C18.

Harrison, Helen A. "Elaine de Kooning's Vibrant Portraits." *New York Times,* October 24, 1982, LI 22.

Henry, Gerrit. "The Artist and the Face: A Modern American Sampling." *Art in America* 63 (January/February 1975): 34–36.

Henry, Gerrit. "New York Reviews: Elaine de Kooning and Alice Neel." *ARTnews* 83 (March 1984): 210.

Henry, Gerrit. Ten Portraitists: Interviews/Statements." *Art in America* 63 (January/February 1975): 35–41.

Hess, Thomas B. "de Kooning Paints a Picture." *ARTnews* 52 (March 1953): 30–33, 64–67. At http://www.artnews.com/2012/11/12/de-kooning-paints-a-picture/

Hess, Thomas B. "New York Avant-Garde." *ARTnews* 50 (Summer 1951): 47.

Hess, Thomas B. "Seeing the Young New Yorkers." *ARTnews* 49 (May 1950): 23.

Hess, Thomas B. "There's an 'I' in Likeness: Elaine de Kooning's Portraits of Family and Friends Gain in Vividness as They Approach Her Own Imaginary Self-Portraits." *New York Magazine*, November 24, 1975, 84–87.

Hess, Thomas B. "U.S. Painting: Some Recent Directions. *ARTnews Annual* XV (1956): 76–98, 174, 176, 178, 180.

Hess, Thomas B. "When Art Talk Was a Fine Art." *New York Magazine*, December 30, 1974–January 6, 1975, 82–83.

Hoban, Phoebe. "Artists on the Beach." *New York Magazine*, July 1, 1991, 38–44.

Holmes, Ann. "10th Streeters Feeling Their Oats." *Houston Chronicle*, June 17, 1962.

"HST Library Gets Painting." *Corpus Christi Caller-Times*, February 13, 1965, 6.

"Instant Summaries." *Time* magazine, May 3, 1963, 68.

"In the Air." *Art & Auction* 2 (January 2003): 17.

"Jackson Pollock: An Artists Symposium, Part I." *ARTnews* 66 (April 1967): 29ff.

Johnson, Ken. "Art in Review: Challenging Tradition: Women of the Academy, 1826–2003." *New York Times*, July 11, 2003. At http://nytimes.com/2003/07/11/arts/arts-in-review-challenging-tradition-women-of-the-academy-1826-2003.html.

Johnston, Laurie, and Robert McG. Thomas. "Notes on People: Sports as Seen Through the Eyes of an Artist." *New York Times*, May 8, 1981, C30.

"Jury Indicts Elaine de Kooning." *East Hampton Star*, February 18, 1970, 4.

Karabenick, Jan. "An Interview with Artist William Conger." *Geoform*, January 8, 2008. At http://geoform.net/interviews/an-interview-with-artist-william-conger/.

Katz, Alex. "Starting Out." *New Criterion* 21 (December 2002): 4.

Katz, Vincent. "Willem and Elaine de Kooning: An Appreciation." *Print Collector's Newsletter* 25 (November-December 1994): 195–98.

Keane, Tim. "Artist Unknown: Reflections on Works by Eddie Johnson." *Hyperallergic*, January 20, 2013. At http://hyperallergic.com/63743/artist-unknown-reflections-on-works-by-eddie-johnson/.

Keane, Tim. "Instant Illuminations: Elaine de Kooning's Early Portraiture." *Hyperallergic*, April 4, 2015. At http://hyperallergic.com/194805/instant-illuminations-elaine-de-koonings-early-portraiture/.

Keane, Tim. "Recurring Waves of Arrival: Elaine de Kooning's Portraits from Loft Dwellers to JFK." *Hyperallergic*, April 11, 2015. At http://hyperallergic.com/tag/elaine-de-kooning/.

Kees, Weldon. "Art." *The Nation* 159 (May 6, 1950): 430.

Kilgallen, Dorothy. "The Voice of Broadway." King Features syndicated column. January 3, 1963.

Kramer, Hilton. "An Era Comes to an End." *New York Times*, July 23, 1978, D1.

Kramer, Hilton. "Does Feminism Conflict with Artistic Standards?" *New York Times*. January 27, 1980, D1.

Kramer, Hilton. "Elaine de Kooning's Ode to a Vanished New York." *Observer*, January 18, 1999. At www.observer.com/1999/01/elaine-de-koonings-ode-to-a-vanished-New-York/.

Kramer, Hilton. "Kaldis, a Greek Falstaff, Comes Back to New York." *Observer*, July 12, 1999. At http://observer.com/1999/07/kaldis-a-greek-falstaff-comes-back-to-new-york/.

Leigh, Candace. "Honoring the Artists of the Hamptons: Elaine de Kooning." *Dan's Papers*, June 12, 1987.

LeSueur, Joe. "Elaine's 'Tons' of Eulogies." *East Hampton Star*, March 22, 1989.

Lewis, Jo Ann. "The Sweet Exuberant Moments of 'Italian Summers." *Washington Post,* January 23, 1982, C3.

Lieber, Edvard. "Elaine de Kooning: Her World and Persona." *Auction News from Christie's,* October 1989, 2, 4.

Lipman, Jean, and Cleve Gray. "The Amazing Inventiveness of Women Painters." *Cosmopolitan,* October 1961, 62–69.

Liss, Joseph. "Elaine de Kooning and Pelé." *East Hampton Star,* September 5, 1985, II-1, 10.

Marquardt, Virginia Hagelstein. "The American Artists School: Radical Heritage and Social Content Art." *Archives of American Art Journal* 26 (1986): 17–23.

Matter, Mercedes. "What's Wrong with U.S. Art Schools?" *ARTnews* 62 (September 1963): 40–41, 56–58.

Mellow, James R. [J.R.M.]. "In the Galleries: Elaine de Kooning." *Arts Magazine* 30 (June 1956): 51.

Lisa M. Messinger (L.M.M.). "Elaine de Kooning, *Untitled Number 15*." *Metropolitan Museum of Art Bulletin* 50 (Fall 1992): 68.

Millstein, Gilbert. "Portrait of the Loft Generation." *New York Times Magazine,* January 7, 1962, 24, 28, 31, 33, 35.

Muchnic, Suzanne. "Projecting a Blitz of Women's Art." *Los Angeles Times,* April 16, 1981, 3.

Munson, Gretchen T. "Man and Wife." *ARTnews* 48 (October 1949): 45.

Murphy, Agnes. "At Home with Elaine de Kooning." *Provincetown Advocate,* October 21, 1962, 15.

North, Charles. "Elaine de Kooning at Graham." *Art in America* 64 (May-June 1976): 108–109.

"The Oldest Art." *Newsweek,* May 13, 1963, E11.

Pardee, Hearne. "Elaine de Kooning." *ARTnews* 93 (May 1994): 159.

Passlof, Pat. "1948: The Author Studies with Willem de Kooning." *Art Journal* 48 (Autumn 1989).

Paysour, Doris Dale. "Her Art—Constant Escape From a Rut," *Greensboro Record,* April 26, 1974, 11.

Pepper, Curtis Bill. "The Indomitable de Kooning." *New York Times Magazine,* November 20, 1983, 42–47, 66, 70, 86, 90, 94. (In Willem de Kooning Foundation files.)

Peterson, Valerie. "Art Without Walls." *ARTnews* 60 (April 1961): 36–38.

Peterson, Valerie. "Elaine de Kooning," *ARTnews* 60 (April 1962): 12.

Peterson, Valerie [V.P.]. "Norman Bluhm and Elaine de Kooning." *ARTnews* 60 (April 1961): 36–37.

Peterson, Valerie. "Reviews and Previews: Elaine de Kooning." *ARTnews* 63 (Summer 1965): 6.

Peterson, Valerie. "Reviews and Previews: Elaine de Kooning, de Aenlle." *ARTnews* 60 (April 1961): 12.

Peterson, Valerie. "U.S. Figure Painting: Continuity and Cliché." *ARTnews* 61 (Summer 1962): 36–38, 51–52.

Peterson, William. "Unfolding Art in Albuquerque, Part III." *New Mexico Mercury,* May 7, 2013. At http://newmexicomercury.com/blog/comments/unfolding_art_in_albuquerque_part_iii.

Phillips, Dolores. "Painter 'Shares' Kennedy." *Washington Evening Star*, October 29, 1964, 34.

Porter, Fairfield. "Art." *The Nation* 192 (April 29, 1961): 378–79.

Porter, Fairfield [F.P.]. "Elaine de Kooning: Work of the Last Five Years at Stable Gallery." *ARTnews* 53 (April 1954): 45.

Preston, Stuart. "About Art and Artists: Brooklyn Museum Exhibition Covers 200 Years in American Painting." *New York Times*, April 10, 1954, 13.

Preston, Stuart. "Art: Semi-Abstract Oils, Elaine de Kooning's Work at Graham Gallery." *New York Times*, December 2, 1960, 33.

Preston, Stuart. "By Husband and Wife: A Group Show by Teams." *New York Times*, September 25, 1949, X9.

Preston, Stuart. "A Melange of Summer Shows." *New York Times*, August 2, 1955, X7.

"Quest for a Famous Likeness." *Life* magazine, May 8, 1964, 120–22.

Rappaport, Richard. "A Heart of Darkness: Aladar Marberger Fischbach Gallery." At www.richard-rappaport.net/6_-_aladar_marburger_-__a_hear.html.

Rappaport, Richard. "Portraits & Passages: Elaine de Kooning, Spring of 1971, New York." At www.richard-rappaport.net/5_-_elaine_de_kooning.html.

Raynor, Vivian. "Art: Elaine de Kooning." *New York Times*, May 16, 1986.

Reed, David. "Milton Resnick." *Art in America* 99 (September 2011). At http://www .artinamericamagazine.com/news-features/magazine/milton-resnick/.

Robinson, Walter, and Cathy Lebowitz. "*Obituaries: Elaine de Kooning.*" *Art in America* 77 (March 1989): 174.

Rosenberg, Harold. "The American Action Painters." *ARTnews* 51 (December 1952): 22–23, 48–50. Reprinted in Harold Rosenberg, *The Tradition of the New,* 135–53. Chicago: University of Chicago Press, 1982.

Rosenberg, Harold. "Tenth Street: A Geography of Modern Art." *ARTnews Annual* 27 (1959): 120–37, 184–92.

Sandler, Irving. "In the Art Galleries." *New York Post,* August 5, 1962, 12.

Sandler, Irving. "The Club." *Artforum* 4 (September 1965): 27–31.

"Sargent's Ghost in Strange Place." *New York Herald Tribune*, April 28, 1963, 4: 7.

Sawin, Martica. "In the Galleries: Elaine de Kooning." *Arts Magazine* 32 (December 1957): 55–56.

Schiro, Anne-Marie. "Partying for de Kooning." *New York Times*, December 16, 1983, A28.

Schoenfeld, Ann. "Reviews: Elaine de Kooning: Gruenebaum." *Arts Magazine* 57 (December 1982): 41.

Schoettler, Carl. "E de K is Seldom at a Loss for Words." *Baltimore Evening Sun*, December 19, 1980, 4C.

Schuyler, James. "Reviews and Previews: Exhibition at De Nagy Gallery." *ARTnews* 56 (November 1957): 12.

Setlowe, Rick. "The Pied Piper with a Palette." *People: The California Weekly (San Francisco Examiner)*, January 5, 1964, 10.

"Sherman Drexler with Phong Bui." *Brooklyn Rail*, July 9, 2009. At www.brooklynrail. org/2009/07/art/sherman-drexler-with-phong-bui.

Slivka, Rose. "Elaine de Kooning: The Bacchus Paintings." *Arts Magazine* 57 (October 1982): 66–69.

Slivka, Rose. "From the Studio." *East Hampton Star*, February 23, 1989, II-7.

Slivka, Rose. "From the Studio." *East Hampton Star*, January 14, 1999. At http://easthamptonstar.com/Archive/1/Studio-25.

Slivka, Rose. "Painting Paleolithic." *Art in America* 76 (December 1988): 134–39.

Smith, Roberta. "Art in Review: 17 Paintings by Elaine de Kooning." *New York Times*, October 11, 1991, C28.

Smith, Roberta. "Elaine de Kooning's Telling Portrait Drawings." *New York Times*, August 24, 1989, C15.

Smith, Roberta. "Five Shows Focus on World War II Generation," *New York Times*, November 18, 1994.

Spring, Justin. "Barefoot and Bohemian." *ARTnews* 98 (Summer 1999): 88, 90.

Stahr, Cecilia S. "Elaine de Kooning, Portraiture and the Politics of Sexuality." *Genders* 38 (2003). At archive.li/rmUWg.

Steinberg, Leo. "Month in Review." *Arts Magazine* 31 (January 1956): 46–48.

Stewart, Lloyd. "Artist to Be Here Today for Exhibit." *Fort Worth Star-Telegram*, November 21, 1960.

Strickland, Carol. "Shining a Light on the Other de Kooning." *New York Times*, November 21, 1993, C27.

Stuckey, Charles F. "Bill de Kooning and Joe Christmas." *Art in America* 68 (March 1980): 70–71.

Sulkis, Ellen. "Kennedy Looked Golden, Elaine de Kooning Says." *Philadelphia Evening Bulletin*, November 16, 1964.

Taylor, John. "An Interview with Elaine de Kooning in Athens." *Contemporary Art/ Southeast* 1 (April/May 1977): 16–19.

Tyler, Parker [P.T.]. "Elaine de Kooning." *ARTnews* 55 (May 1956): 51.

Tully, Jud. "A Second Look." *Art + Auction*, May 2010. At www.blouinartinfo.com/news/story/276778/a-second-look.

Vogel, Carol. "Inside Art." *New York Times*, July 23, 1993. At www.nytimes.com/1993/07/23/arts/inside-art.html.

Wallach, Amei. "de Kooning Seeks Simplicity." *Newsday*, December 4, 1983, 22.

Wallach, Amei. "The Private Face of a Master." *New York Times*, March 30, 1997, H39.

Walsh, Robert. "New Editions." *ARTnews* 83 (October 1984): 105–106.

Wesle, John. "'Action Painter' de Kooning Lectures, Has Show at IWU." *Pantagraph* (Bloomington, IN), March 16, 1975, 46.

White, Jean M. "To Artist, JFK Was Always in Motion." *Washington Post*, October 29, 1964.

White, Robin. "Interview of Elaine de Kooning at East Hampton, New York." *View* 5 (Spring 1988): 1–22.

Wilson, Doris E. "Artist Captures Kennedy's Warmth," *Pampa Daily News*, November 21, 1966, 4. (With thanks to Carolyn Fitz.)

Wolf, Ben. "Portrait of a President." *Jewish Exponent*, November 20, 1964.

"Women Artists Will Have Their Own Museum." *New York Times*, November 23, 1986, 80.

Yarrow, Andrew L. "Celebrating a Life Steeped in Art, Friends Honor Elaine de Kooning." *New York Times*, March 13, 1990, B14.

Yau, John. "Review of Exhibition, New York: Elaine de Kooning at Spectrum." *Art in America* 69 (October 1981): 142.

FILM, RADIO, AND VIDEO

Artists Speak at the Art Barge: Elaine de Kooning. Video, July 16, 1983. LTV, East Hampton.

Conversations with Artists: Elaine Benson with Elaine de Kooning. Video, December 9, 1987. LTV, East Hampton, #2403.

Dogwood Maiden. Silent film, 1949. Conceived, directed, and filmed by Rudy Burckhardt.

Dord Fitz: The Broadcast Is Always On. Video and text. Carolyn Fitz, Amarillo Museum of Art. At http://www.amarilloart.org/pachyderms/,DordFitz/.

Elaine de Kooning: A Portrait. Video, 1983. Directed and produced by Gerald McCarthy for Smartview Productions.

Elaine de Kooning at the Whitney Museum's Willem de Kooning Retrospective. Video, 1983, untitled. Produced by Connie Fox.

Elaine de Kooning interview with Dord Fitz. Film, Super-8, and DVD, 1983. In her studio and at Guild Hall. Dord Fitz Collection, Western History Collection, University of Oklahoma. Courtesy of Carolyn Fitz.

Elaine de Kooning interview with Lyn Kienholz. Radio broadcast, KCRW *Arts LA*, March 23, 1987. Transcript in Elaine de Kooning Papers, AAA.

Elaine de Kooning interview with Lynn Kienholz and Edward Goldman. Radio broadcast, KCRW *Arts LA*, April 1, 1987. Transcript in Elaine de Kooning Papers, AAA.

Elaine de Kooning interview with Molly Barnes. Radio broadcast, KPFK *Art News*, Los Angeles, April 17, 1988. Transcript in Elaine de Kooning Papers, AAA.

Elaine de Kooning on the Joop Sanders Portraits. VHS, 1984. Directed, produced, and filmed by Timothy Greenfield-Sanders.

Elaine de Kooning Paints a Portrait. Film, 16mm color, 1976. Directed and produced by Betty Jean Thiebaud.

Elaine de Kooning Paints a Portrait of Aladar Marberger. Video, 1986. Directed and produced by E. Deidre Pribram, Muriel Wiener, executive producer.

New York Review of the Arts: Elaine de Kooning. Video, September 2, 1982. Produced by Connie Fox and Bill King, LTV, East Hampton, #9267.

Ninth Street Show—Abstract Expressionism 1950s: Artists Reminisce. Video, n.d. Uploaded August 23, 2010 by Marika Herskovic, www.youtube.com/watch?v=9R6cnawfnCI

Strokes of Genius: Arshile Gorky. Film, DVD, VHS, 1982. Written and directed by Charlotte Zwerin. Courtney Sale, producer; Francis Kenny, director of photography.

Strokes of Genius: de Kooning on de Kooning [also known as *Strokes of Genius: Willem de Kooning*]. Film, DVD, VHS, color, 1982. Directed by Charlotte Zwerin. Courtney Sale, producer; Tom McDonough and Don Lenzer, photography.

Index

"EdeK" indicates a reference to Elaine de Kooning. Paintings by Elaine and Willem de Kooning are listed under entries for their names. Works by other artists are listed by their titles. Endnote references are denoted by "n" after the page number.